GENTILE DA FABRIANO

GENTILE DA FABRIANO

KEITH CHRISTIANSEN

1982
CHATTO & WINDUS
LONDON

Published by
Chatto & Windus Ltd
40 William IV Street
London WC2N 4DF

ISBN 0 7011 2468 7

1001458589

for
MARY

CONTENTS

PREFACE

When I began work on this project as a doctoral dissertation, I envisaged a study of the relationship between Gentile da Fabriano and Florentine art and culture. In its present form the scope is both broader in its chronological limits and more restricted in its approach. On the one hand, I have included a section on the origins of Gentile's art and gathered the material for a *catalogue raisonné*. This would have been impossible without the two travel fellowships I received from Harvard University and a Fulbright-Hays Grant for 1975–76. These enabled me to spend two years in Florence and undertake necessarily extensive travelling. On the other hand, the cultural milieu in which Gentile worked while in Florence has remained elusive. Here too, however, I have had sound advice and guidance. A scholarship from the Renaissance Society of America gave me the opportunity to participate in their summer workshop in palaeography. Anthony Molho provided an introduction to the organization of the Florentine archives and Gino Corti guided me through the scrawls of early fifteenth-century account books. His patience and geniality never failed to revive my spirits. Unfortunately, discoveries were few. What I did find indicated more what could not than what might be said. In the course of those two years in Florence I especially benefited from conversations with Fabio Bisogni and Ulrich Middeldorf. At I Tatti, Fiorello Superbi-Giofredi was ever helpful, and the staff at the Kunsthistorisches Institut was most cooperative. Private collectors were generous with their time. In the final stages James Ackerman and Sir John Pope-Hennessy have given much needed criticism. Sydney Freedberg has been equally helpful.

Special thanks are due to Elizabeth Jones, conservator of paintings, for her friendly advice during my years at the Fogg, to John Brealey, conservator of paintings at the Metropolitan Museum in New York, to Christopher MacLehose, and to my editor at Chatto & Windus, Nicholas Robinson.

Above all I am indebted to my wife, Mary. Her participation in this project has ranged from making up travel itineraries to sharing the burden of archival research. She has been the critic, at times the source, of various ideas, and has kept me from despairing of the whole business.

GENTILE DA FABRIANO

INTRODUCTION

Renaissance painting is the creation of Masaccio in the years 1424–27, but that achievement was partly dependent upon the labours of others. Brunelleschi's experiments in perspective made it possible to determine mathematically on a flat surface the spatial diminution we perceive in nature, and several years before Masaccio's first dated work Donatello had experimented with a pictorial relief in which the relation of a figure to its setting and to nature was convincingly established. By applying the procedures of the one and the results of the other, Masaccio was able to endow painting with a human dimension and rational basis that was fundamentally novel. In the decade before 1425 only one other Italian painter participated in the discovery of this new pictorial mode, Gentile da Fabriano. Giovanni Santi probably intended to refer to this fact when he placed Gentile's name at the head of his list of famous Italian painters of the century.[1] About 1440 the Florentine, Giovanni Cavalcanti, mentioned Gentile's name along with those of Brunelleschi, Ghiberti, and Pesello in a passage on the diversity of human genius,[2] and not much later Flavio Biondo, the humanist, referred to him as 'gentilem . . . pictorum sui seculi celeberium'.[3] However, the fullest and most perceptive treatment of Gentile by a contemporary is found in Bartolomeo Fazio's *De viris illustribus,* composed in 1456.[4]

Fazio was in a peculiar position to appreciate artistic events in the early Quattrocento. He had travelled extensively before moving to Naples in 1444, and had used the opportunity to take notes on those works that most impressed him. Moreover, his critical judgments reflect those expressed in Leon Battista Alberti's *De Pictura* of 1435, which contained the most thorough exposition of the principles of Renaissance painting.[5] A picture must show attention to invention and composition (*dispositione*); the figures must be true to nature; the artist should attempt to depict the inner emotions of a man, 'so that the picture may seem to be alive and sentient and somehow move and have action'; above all, the artist should seek 'to move the hearts and feelings of men'. Among Gentile's paintings, he praises the action of a St. Christopher, the horrific appearance of a depiction of a whirlwind uprooting trees, the way in which painted prophets appear to be marble statues, and the truthfulness of a portrait of Martin V and ten cardinals. Fazio records that this portrait so impressed the Flemish artist, Rogier van der Weyden, that 'heaping praise on him [Rogier] preferred [Gentile] to the other Italian painters'.

The pre-eminent position Gentile's works held in the first half of the century necessarily diminished with time. In 1440 only a handful of artists – mostly

Florentine – had mastered the difficulties of convincingly representing the world around them. But a decade later the science was spreading and by 1470 masters of Renaissance painting could be found throughout Italy. When Vasari wrote the *Vite* in 1550 Gentile was a largely forgotten figure – the author of some frescoes in S. Giovanni Laterano and the likely candidate for any number of works in the Marches.[6] The dates of his activity were so obscured that he is discussed together with those artists who succeeded him. Seeking an appropriate epithet to conclude the amplified *Vite* of 1568, Vasari recalled how Michelangelo had esteemed Gentile's fresco in S. Maria Nova in Rome, saying that 'nel dipignere Gentile aveva avuto la mano simile al nome'. For the first time Gentile was praised not as the master of naturalistic representation, but as a practitioner of a genteel style. For better or worse, this verdict of Michelangelo has influenced all subsequent criticism. It underlies A. Rio's classification of Gentile, along with Fra Angelico and Lorenzo Monaco, as an exponent of the *école mystique*,[7] and is echoed by Crowe and Cavalcaselle, who declared that:

> It is not to be denied that Gentile da Fabriano concentrated the better qualities of the Gubbians, and that he brought their peculiar art to a combination as complete as it was capable of attaining; but his masterpieces are only remarkable for their longing softness, their affectation of grace, their laborious fusion, and for a profuse ornamentation inherited from the Umbrian and Siennese schools.[8]

There is, of course, some truth to these judgments. No one who studies the *Adoration of the Magi* in the Uffizi can help but be impressed by its rich, varied surface. But Gentile's contemporaries saw more. To that extent post-Vasarian criticism is an historical falsification. So far as possible, an attempt has been made in this book to view Gentile historically, and thereby to establish a fuller critical appreciation of his work.

I ⌐ LIFE

THE ARTIST known as Gentile da Fabriano was born Gentile di Niccolò di Massio. His family was of some standing in Fabriano, where an uncle Onofrio represented the Arte dei Guarnellari (makers of flax and cotton goods) in 1436, and his grandfather, Giovanni de Massio, served as syndic of the more important Arte dei Fabbri (blacksmiths) in 1377.[9] Additionally, Giovanni was thrice prior of the confraternity of S. Maria del Mercato (in 1371, 1383, 1390) and syndic of the monastery of S. Caterina in Castelvecchio. By 1390 Gentile's father, Niccolò, is listed as one of the brothers of this Silvestrine community, and by 1399 another uncle, Ludovico, had also joined, though under the leadership of Fra Giovanni di Bartolomeo the monastery had adopted the Olivetan rule in 1397. Niccolò died in 1400, Ludovico sometime after 1403. In 1410 Ludovico's son was in the custody of Giovanni. By that date Gentile had left home, but it is reasonable to suppose that he too had been raised by his grandfather.

The first document which may be assumed to refer to Gentile is a payment, dated 27 July 1408, from Francesco Amadi in Venice for a panel which Gentile was to paint (Document I). On 25 May of the following year and again in April 1411, the Maggior Consiglio in Venice voted funds to repair the picture cycle in the Sala del Maggior Consiglio of the Doge's Palace. Later authors record that Gentile executed one of the scenes (Catalogue LVIII). To secure such a commission he must have been at least twenty-five, placing his birth no later than c. 1385.[10]

Gentile's stay in Venice was evidently of some duration, since a number of works in the city were attributed to him in the sixteenth and seventeenth centuries (Catalogue LIX–LXII) and his name appears in the Scuola di S. Cristoforo dei Mercanti (Document II). An index of the fame he achieved there is transmitted by Francesco Sansovino, who recorded that Gentile's services were so lavishly rewarded that he dressed 'a maniche aperte' – a reference to the large, rolled back sleeves that Cesare Vecellio says were popular among young nobles.[11] By January 1414, however, he was in Brescia, where he was engaged to decorate a chapel for the new ruler of the city, Pandolfo Malatesta (Document III, codex 55, f.3v.). The task kept him busy until late 1419, when a letter (Document IV) informs us that on 22 September Gentile intended to leave Brescia in the company of seven others, among whom may have been a wife and daughter (Document III, codex 55,f.74v.), in order to work for the newly elected Pope Martin V. The Pope had stopped in Brescia in October 1418 on his trip from the council at Constance to

Rome, and while he was in nearby Mantua a panel painting by Gentile had been given to him (Catalogue LII). This may have occasioned the invitation.

Whether or not Gentile proceeded directly from Brescia to Florence, where Martin V resided from 26 February 1419 until 9 September 1420, is not altogether clear. He was evidently in Fabriano in March 1420, when he requested exemption from taxes and declared his intention to live and die in his home town (Document V). However, between 6 August and 24 October of the same year he paid the equivalent of a year's rent for a house in the quarter of S. Trinita in Florence (Document VI), and he may, therefore, have settled in the city prior to visiting Fabriano. In November 1422 he enrolled in the painter's guild in Florence (Document VII), and the following May he signed the *Adoration of the Magi* now in the Uffizi – the earliest documented painting to have survived (Document VIII) – and in May 1425 he completed the high altar-piece for the church of S. Niccolò sopr'Arno. As a quantity of surviving works suggests, this was a period of great activity for Gentile. He employed at least two assistants, one probably to be identified with the young Jacopo Bellini (Document IX).

From 22 June to September 1425 he rented a house in Siena while he painted a polyptych for the notaries' palace on the main square of the city (Document X). Work was interrupted shortly thereafter by a commission from the *opera* of the cathedral of Orvieto to paint a fresco of the Virgin and Child – the second of his surviving, documented paintings (Document XI) – but he evidently returned to Siena sometime after October to finish the commission (Catalogue LVI). Then, from 28 January to August 1427 he was, at last, working for Martin V at S. Giovanni Laterano in Rome for a substantial monthly salary of twenty-five gold florins. Several recorded commissions from the circle of the Pope again suggest the pressures under which Gentile still laboured (Catalogue XVIII, LIV, LV). His last payment at the papal basilica is dated 2 August. Perhaps that same month, and certainly before 14 October Gentile died and was buried in the Olivetan monastery of S. Maria Nova in the Roman Forum (Document XIV).

II ~ EARLY WORKS

Two works stand apart from those which may be credibly attributed to Gentile. One, originally signed on its frame, came from S. Niccolò, Fabriano and is now in Berlin (Catalogue II, Plate 2). The other was painted for S. Domenico, Perugia and is in the Galleria Nazionale of that city (Catalogue I, Plate 1). Both paintings, the first possibly part of a sepulchral monument and the other an altar-piece, show the Virgin and Child seated in a flowery meadow against a gold background. In both the Madonnas share the same blocky silhouette and the hemline describes the same pattern, passing beneath the protruding foot, turning over it, and then losing itself in other folds. The same prominent ridge on the nose, a small chin and deeply cut lips characterize the faces; only the folds of Mary's cloak in the Berlin painting are simpler, less heavy in their fall, the silhouette more continuous, the overall movement suggested by curves rather than broken by intersecting lines. Where the Madonna in the Perugia painting is dainty and spry, in the Berlin painting she is elegant and reserved. While in one the Christ Child is posed in a straightforward, lively fashion, in the other he is withdrawn and his body inscribes a lovely arabesque. Such traits clearly link the Berlin painting with Gentile's subsequent works and indicate that it is the Perugia *Madonna and Child* that is his earliest creation.

Nothing could speak more eloquently against the old tradition that Gentile's teacher was Allegretto Nuzi, who in any case had died in 1373, almost certainly prior to Gentile's birth. Even the works of Gentile's contemporaries offer no more than superficial resemblances. Lorenzo Salimbeni's triptych of 1400 at Sanseverino (Fig. 1) is as foreign to the Perugia *Madonna and Child* as are the taut, wooden forms of Ottaviano Nelli's polyptych of 1403 (Fig. 2). What these three works share is a debt to non-Marchigian art. In the case of Lorenzo's triptych the colours and the network of patterned folds derive from Lombard miniatures of the style associated with Giovannino dei Grassi.[12] Proof of this is furnished by his frescoes of 1416 in the Oratorio di San Giovanni at Urbino, where gold and silver are used in a way paralleled only in miniatures and the decorative borders have little relation to any fresco tradition. The peculiarities of the Perugia *Madonna and Child* may be shown to derive not from such miniatures, but from a body of works painted by an itinerant artist who was apparently active in the region at two distinct moments.

The first of these works is a painting, once in the Paolini Collection, which shows the Virgin and Child on a flowery turf with SS. Jerome, Francis, and a young gallant identifiable either as St. Julian or St. Venanzio (Catalogue XLVI,

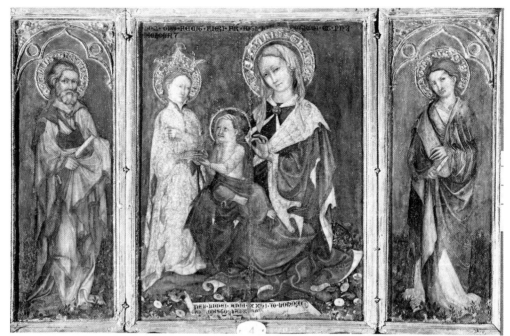

1 Lorenzo Salimbeni *Marriage of St. Catherine* (signed and dated 1400)
Galleria Comunale, Sanseverino

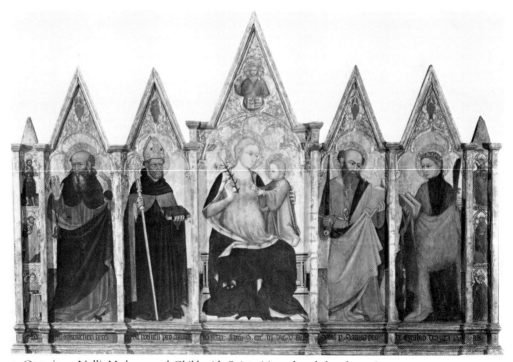

2 Ottaviano Nelli *Madonna and Child with Saints* (signed and dated 1403)
Pinacoteca Nazionale, Perugia

6

Plate 105). Even more than the setting, the block-like silhouette of the Madonna and the unexpected, angular movement of the Child, crossing her body diagonally, associate this picture with Gentile's – it was for a time attributed to him. The same artist was responsible for a saint in the communal gallery at Gubbio, somewhat larger in size (Fig. 3), where the supple outline, careful tooling, and loosely modelled features again recall the figures of the Perugia painting, and the colours – deep red, ochre, and blue – parallel those Gentile chose: blue, maroon, near rust, and brighter spots of orange-red and pink in the faces. The author of these two works, one from a neighbouring city to Fabriano and the other possibly showing the city's patron saint, is identified by an altar-piece now at Rieti that depicts the Crucifixion and is inscribed *Hoc opus depinxit zani|ni petri h[ab]itator ve[n]eciis i[n] contrata sa[nc]te a[ppol]liaris* (Figs. 4–7). There Zanino di Pietro reveals his traits in their most original and intense form. The main scene takes place on a shallow and steeply inclined stage marked off by clustered groups of figures and fragmentary views of landscapes. Emotion is high-pitched: at times concentrated in a rhetorical gesture, as where the rabbi argumentatively thrusts forward a scroll; at other times taking the form of an abrupt movement, as in the Magdalene at the foot of the Cross. This agitated mood is contrasted with intimate colloquies between pairs of figures. An extreme effort has been made to differentiate the psychological state of each character. A similar range and intensity of feeling is found only in the art of Bologna and Rimini, especially in the works of Vitale and Jacopino. Paintings very like Vitale's *Miracles of St. Anthony* in the Pinacoteca at Bologna lie behind the unexpected outcrops of hills that lend a special pungent flavour to Zanino's *Crucifixion*. With their soft lighting and delicate, Venetian buildings, these landscapes are perhaps the most remarkable passages in the altar-piece. Along with the plants of the Paolini *Madonna and Saints,* they certainly provided the impetus for Gentile's carefully rendered leaves and flowers which engulf the throne of the Perugia *Madonna and Child*.

Proof that Zanino evolved his style from Bolognese art is provided by his documented presence in that city as early as 1389. From 1394 to about 1405 he seems to have taken up residence near S. Michele de foro medii, but by June 1407 he is listed in a testament in Venice as 'Joannes quondam ser petri pictor de S. Appolinare'.[13] Thus the Rieti *Crucifixion* arguably dates no earlier than 1405, and the Gubbio saint and Paolini *Madonna and Saints* must be nearly contemporary. In the latter are repeated the faces and attitudes of the bystanders of the *Crucifixion,* while the podium on which the Gubbio saint stands has the same shape and pale green colour employed on the wings of that work.

The Rieti *Crucifixion* represents a favoured moment in Zanino's *oeuvre,* for in what is certainly a later work, a fragmentary altar-piece for the town of Valcarecce between Fabriano and Cingoli, he lapsed into the uninspired mannerisms characteristic of mediocre talent (Fig. 8), while in an earlier work, a polyptych now at Avignon, the forms are stiffer and the debt to Bolognese art less profound. It was in the years just after the turn of the century that Zanino, his art freshly

3 Zanino di Pietro
St. Peter (?)
Galleria Comunale,
Gubbio

4 Zanino di Pietro *The Crucifixion*
Galleria Comunale, Rieti

5 Detail of Fig. 4

6 *Angels* (detail of Fig. 4)

7 *Franciscan saints* (detail of Fig. 4)

invigorated by contact with the most diversified narrative tradition in Italy, could acquaint Marchigian painters with a richer, more expressive idiom than had been seen since a group of artists from Rimini frescoed the chapel of St. Nicholas in Tolentino in the early years of the fourteenth century. As others have suggested, his presence in the Marches may account for some of the peculiarities of Lorenzo Salimbeni's contemporary frescoes in the crypt of S. Lorenzo in Doliolo in Sanseverino. Gentile's debt to Zanino is more certain and deeper than that of other Marchigian painters. He owed to Zanino not only the emotional tenor and angular movements of his figures, the exquisite drawing on gold by which he created angels suspending a crown over the Virgin's head, but a rhapsodic feeling for nature that was utterly foreign to local traditions. This last element was to become the object of passionate interest and constitutes the most novel aspect of the Perugia *Madonna and Child,* affecting not only the flora but the figures.

The distance between the Perugia altar-piece and the Berlin painting is measurable not so much in terms of time as in terms of the diverse influences to which Gentile was open. In the Berlin painting the loosely modelled flesh of the donor, the intent gaze of St. Nicholas, and the attitudes of the bird-like angels playing instruments still derive from Zanino and bear comparison to the *Madonna and Child* at Perugia. It is true that the carefully placed trees and projecting wooden dais are evidence of a more ambitious spatial composition, but it is the figure of the Virgin that is most unexpected. Her distant gaze and reserve, the self-conscious elegance with which she enshrouds her delicate Son are far removed from the warm humanity of the earlier painting. Yet a comparable transformation is documented between Ottaviano Nelli's 1403 polyptych and his fresco at S. Maria Nuova in Gubbio (Fig. 9), where curving rhythms order the composition and the bearing of the Virgin and Child has assumed a graceful elegance. The source for the transformation in this work and in Gentile's Berlin *Madonna and Child* again lies in Lombard miniatures. This fact is confirmed by Gentile's figure of St. Catherine, whose round, flattened face, grey-blue dress pulled tightly from behind, and flower-embroidered cloak in a deep plum-coloured glaze laid over silver derive from a miniature like that in a *Tacuinum Sanitatis* at Paris (Ms. Nouv. Acq. 1673, f.52v.). The fine gilt leaves that edge the dais come directly from manuscript border designs. However, whereas Nelli used the curving rhythms characteristic of such miniatures to generate a dance-like movement across the picture surface, Gentile employed them solely as a basis of figure construction. Their continuous flow rounds off the angular folds of the earlier work and inscribes the Child within the silhouette of the Virgin to create an effect of greater bulk and simplicity. An element of artificiality has been introduced, and pictorial unity has been sacrificed to an alarming degree, but just such a drastic transformation testifies to the immense prestige such Lombard miniatures enjoyed.

Because of its strict dependence upon Zanino, the Perugia *Madonna and Child* may be dated *c.*1405–06, roughly contemporary with the Paolini *Madonna and*

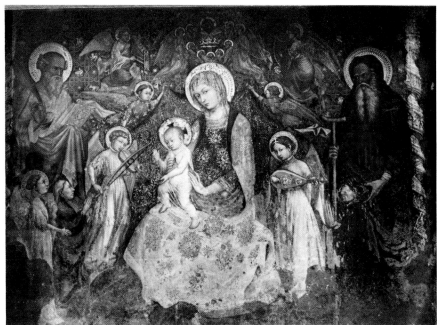

8 Zanino di Pietro
St. Andrew (detail of *The*
Valcarecce Altar-piece)
Museo Diocesano,
Camerino

9 Ottaviano Nelli *Madonna del Bevedere*
S. Maria Nuova, Gubbio

Child with Saints and the Rieti *Crucifixion*. It is not improbable that the Berlin painting was executed only a year or two later, and in any case prior to July 1408, when Gentile was employed in Venice by Francesco Amadi.

The panel, now lost, that Gentile painted for Amadi in 1408 seems to have been only one of several commissions he received in Venice over a period of years, of which the most important was his work in the Sala del Maggior Consiglio in the Doge's Palace. As the most prominent room in the palace and the assembly hall for the chief governing body of Venice, the Sala had long been a focus of artistic activity. Between 1366 and 1367 the Paduan artist, Guariento, had frescoed a scene of Paradise on the end wall, parts of which survive, and commenced a cycle devoted to a popular narrative of the concluding struggle between Pope Alexander III and Frederick Barbarossa at Venice and the role Doge Sebastiano Ziani played in bringing about a papal victory. The importance attached to this partly fictitious history may be gauged by the fact that it included the institution in 1177 of the celebration of the symbolic marriage of Venice to the Adriatic. These frescoes may already have been in need of repair by 1382, when a custodian was hired. In May 1409, after completion of the elaborate balcony on the southern façade, carried out by Pier Paolo dalle Masegne between 1400 and 1405, artists

were hired to 're-adapt' (*faciant reaptari*) the cycle. More funds were voted in 1411, and work seems to have been finished by 1415. Although the names of the participating artists are not mentioned, Fazio states that Gentile represented the naval battle at Salboro between the Venetians and Barbarossa while Pisanello showed the Emperor's son as a suppliant before his father. A drawing in the Louvre (No. 2432r.) has been thought to relate to the latter, but Gentile's scene has vanished without a trace. Already by 1456 it was scarcely visible, and in 1577 a fire gutted the room, necessitating a complete redecoration. Despite the loss of this and Gentile's other documented work in the city, the outlines of his activity there may be reconstructed on the basis of local artistic events.

The two dominant Venetian painters were Niccolò di Pietro and Jacobello del Fiore. The first is the 'Nicolo in Calle al Canton' who, like Gentile, was to paint a panel for Francesco Amadi in 1408.[14] The panel, evidently half the size of Gentile's, still exists, though in a much ruined state. A clear idea of his style at this moment is provided by a crucifix dated 1404 and some panels in the Vatican with scenes from the life of Saint Augustine that seem to be approximately contemporary (Fig. 10). In the caricatural approach to facial expression these show hints of contact with Emilian art, but the space is flat and the naturalistic interests that gave vitality to Zanino's work are absent. Jacobello practised a deliberately archaistic idiom that was even less open to outside influences.[15] His earliest work, a triptych dated 1407 and destined for a town near Pesaro, is conceived in a formalized, late Trecento mode with simple outlines, stiff postures, and bright colours (Fig. 11). Neither artist could have interested Gentile much. However, the concomitant of the parochialism of local artists was a demand among patrons for foreign artists from the mainland. In the early fifteenth century the most important of these was without doubt Michelino da Besozzo, who is recorded in Venice in 1410.

Michelino was perhaps the most famous artist of his day.[16] During his lifetime the humanist Umberto Decembrio had praised him as 'the most distinguished painter of our time' and singled out his ability to draw the most minute living creature. Unfortunately, little remains to give us a clear idea of his art. In 1403 he illuminated a eulogy composed for Gian Galeazzo Visconti's funeral (Paris, Bib. Nat. Ms. Lat. 5888), and this shows that to the jewelled world of his predecessor, Giovannino dei Grassi, Michelino brought a more structural approach to design. The figures are grouped in a semi-circle with a finality scarcely surpassed by Tuscan artists, and the composition is united by a supple undulation. Colours are used to reinforce the symmetrical design and establish a balance against the single, off-centred figure of Visconti. These compositional procedures are further advanced in some pages Michelino decorated for the Venetian Cornaro family in 1414. Here the space is defined by a series of parallel planes and greater attention is applied to describing individual features of the figures and endowing the settings with a new intimacy. His only signed panel, a *Marriage of St. Catherine with SS. Anthony and John the Baptist* now in Siena, must date from this moment

10 Niccolò di Pietro *St. Augustine teaching rhetoric*
Pinacoteca, Vatican

11 Jacobello del Fiore *Madonna of Mercy and SS. James and Anthony* (signed and dated 1407)
Private collection

(Fig. 12). It shows the same heavy movement, the same agitated hair, the same technique of suggesting space – here established by the sweeping train of St. Catherine's drapery and the two forward arms of the throne – and the singular ability to create an impression of solidity by constructing the figure on a system of interlocking curves.

The effect of Michelino's stay in Venice was momentous: the works he left there exerted an influence throughout the region into the 1440s. In Verona Stefano and Giovanni Badile abandoned the neo-Giottesque forms of Altichiero, perpetuated into the 1390s by Martino da Verona, in favour of Michelino's rhythmic pictures populated with languorous figures and incidental details of flora and fauna. In Venice the reaction was as profound but less explicit. It consisted of softer forms and an emphasis on curving rhythms and was accompanied by a revival of local traditions. Niccolò di Pietro's *Madonna and Child* at the Fogg Art Museum is modelled with greater force and has adopted the heavy-limbed child of Michelino (Fig. 13). His later painting of St. Ursula and her maidens at New York interprets this fuller idiom in the light of related Bohemian elements in Lorenzo Veneziano's 1371 altar-piece. Flat brocades are used to establish a contrast with animated, bulbous faces. The transformation of Jacobello's art was still more marked. The figures of his *Madonna of Mercy* at Venice begin to sway (Fig. 14). Areas of gold ornament are wilfully opposed to a lively network of folds. In the series of St. Lucy's life at Fermo, close in time to the triptych of Justice of 1421, these new curving rhythms set in motion one of the most inspired narratives in the whole Quattrocento. Here the references to Paolo Veneziano are

12

12 Michelino da Besozzo *Marriage of St. Catherine with SS. Anthony and John the Baptist* (signed) Pinacoteca, Siena

13 Niccolò di Pietro *Madonna and Child* Fogg Art Museum, Cambridge

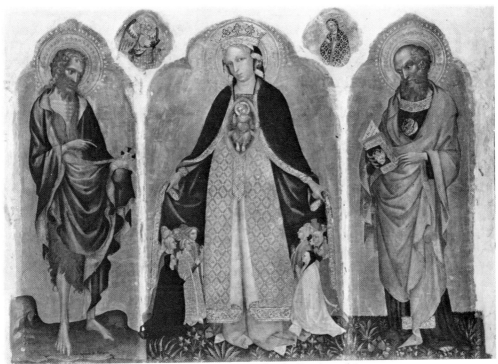

14 Jacobello del Fiore *Madonna of Mercy and SS. John the Baptist and Jerome* Accademia, Venice

almost explicit in the contracted space of the buildings and the sudden but delicate outbursts of emotion.[17] Michelino may also lie behind the transformation in Zanino's Valcarecce altar (Fig. 8), where vehemence is exchanged for debased loveliness.

These circumstances alone strongly suggest that while at Venice Gentile also fell under Michelino's influence. This is born out by two paintings. The earlier is a *Madonna and Child* in the Metropolitan Museum in New York (Catalogue III, Plates 3–4) in which the iconography of the Perugia *Madonna and Child* is repeated but the formal content has been radically altered. Space is more clearly articulated and the figures have an organic structure lacking in the earlier work. A comparison with Michelino's *Marriage of St. Catherine* (Fig. 12) leaves the source for these changes in no doubt. The arc described by the banderole at the base of Gentile's painting repeats the function of St. Catherine's drapery in Michelino's and the two angels seated at the extremities of the turfy throne in the one replace the front arm posts in the other. Even the pose of Gentile's Madonna clearly depends on an image very like that at Siena.

The second work is the great *Valle Romita Altar-piece* or *Coronation of the Virgin,* which is reassembled in the Brera in Milan (Catalogue IV, Plates 5–15 and colour plate A). In no other work did Gentile give himself so completely to an ideal of beauty and technical perfection. Isolated against a gold background, tooled so as to represent an aureole of tongues of fire, sit the Virgin and her Son, suspended between the arched gesture of the Almighty and the tiled pavement marking the final circle of the heavens. To the sides, in a paradisiacal garden, stand the two most important saints of the preaching orders, Francis and Dominic, and the richly garbed figures of Jerome and Mary Magdalene. Their full, swaying bodies describe a single, pervasive rhythm, as though in response to the music played by the angels inscribing arabesques on the tessellation. The effect is not unlike that of a motet by Guillaume de Machaut (d. 1377), where each inflexion is immediately re-absorbed in the continuous flow so that no single passage or object predominates over another. Symmetry serves as the basic structural principle and, for the first time in his paintings, colour reinforces the design. The way in which Gentile has carefully subdued the magenta cloak and purple dress of Mary Magdalene, which otherwise echo the colours of St. Jerome, in order to offset the necessary discrepancy between the dull brown of Francis's habit and the brilliant black and white one of Dominic, is an index of a new awareness of colour as a unifying medium. These procedures, much more than the figure types, depend upon a full understanding of the achievement of Michelino. But through the use of various media and technical refinements Gentile has added an element of textural richness. The tunics worn by Christ and God the Father have been created by a glaze laid over the tooled leaf. These translucent pigments contrast with the opaque wall of seraphim, which have been painted in tempera scratched through to reveal the underlying gold. In the Magdalene's ointment jar, the crowns and haloes, tooling has reached a perfection paralleled

only in the Uffizi *Annunciation* by Simone Martini. Such physical splendour seems the embodiment of the inscriptions ornamenting the various surfaces. The hem of the Virgin's dress proclaims her a precious gem more beautiful than the sun, and the page in Dominic's book compares her to the spotless lily he holds. Christ is the light of the world whose victory is complete. This palpable interpretation of a heavenly vision is yet more apparent in the carefully described flora of the heavenly garden or in the scrupulously detailed wool of Dominic's habit and the ermine lining of the Magdalene's cloak. Nowhere do Michelino and his followers exhibit such a mimetic approach. In Stefano da Verona's painting of the Madonna in a garden with St. Catherine plaiting crowns, the flowers and birds conform to a pre-determined pattern, emphasizing the unreality of the scene. Not so Gentile's dove of the Holy Spirit. Such differences mark the limits to his acceptance of Michelino's style.

Gentile's fundamental interest in the world of actuality is best documented in the narrative scenes of the superstructure (Plates 12–15). Each event takes place in a carefully defined, though empirically constructed, space. Attention is given to minute description of each object and building: setting becomes an essential factor in the mood created. The Franciscan reading in his small garden outside his cell, the church in ready view, is a matter-of-fact portrayal of monastic life. The murder of St. Peter Martyr involves wholly believable actors: the ruffian heretic who wedges a cleaver in the saint's skull, and Peter, clasping his head as he staggers under the blow. These narratives have a straightforwardness that distinguishes them both from the ecstatic world of Venetian painting and the artificiality of Michelino. The soft lighting, the emphasis on characterization and landscape settings still proclaim a debt to the Rieti *Crucifixion;* perhaps also to the more austere and monumental scenes of Altichiero in nearby Padua (Fig. 37). They contained the most fertile ideas for the future.

The *Coronation of the Virgin* is not only Gentile's first masterpiece, it is also the painting in which he comes closest to the defined traits of the so-called 'International Style': meticulous attention to naturalistic details, a courtly elegance in costume and bearing, the curve employed as a basis of composition. The main panels of the altar-piece especially show an extraordinary concern for continuous rhythms and elegance of bearing. But Gentile has maintained a weight and sense of structure absent from the majority of works usually associated with this style. He has, moreover, carefully distinguished between levels of reality. The lush garden of the saints is divided from the more removed and more hieratic realm of heaven by less lavishly tooled surfaces and by the use of two bushes on the innermost edges of two of the side panels. For these reasons, the true comparison for this phase in Gentile's career is not the work of Michelino, on which the altar none the less depends, but the miniatures of a French artist, the Boucicaut Master (Fig. 34). In the work of that artist, as compared to his contemporaries, may be found a similar concern for mass and weight and an interest in natural phenomena paralleled in Gentile's later paintings. Both artists were indebted to the formulas

of their predecessors, whether Lombard or Franco-Flemish, but such works constituted the point of departure for a fuller, more actual idiom.

The *Coronation of the Virgin* was designed as the high altar-piece for S. Maria di Valdisasso, about six kilometres from Fabriano. Though originally Benedictine, this monastery had long been abandoned when St. Francis reputedly visited it in the thirteenth century. Since then, it had sheltered occasional Franciscans.

Chiavello Chiavelli, lord of Fabriano, purchased it for the followers of the Blessed Paul of Trinci (d. 1390) in December 1405 and rebuilt it as a Franciscan establishment of the Observant movement, planning to be buried within its walls. Gentile's altar-piece must, therefore, post-date 1405. Indeed because of its dependence upon works by Michelino, it can hardly pre-date 1410, when Gentile was almost certainly still in Venice. There Chiavello died in 1412 in the service of the Venetian Republic. Between those two years he had probably called upon the now famous expatriate to adorn the new church. Whether or not Gentile returned to Fabriano to execute this commission is unknown, but it was completed by 1414, when he is documented in Brescia. Proof that this style evolved in Venice is provided by several paintings which depend upon Gentile and show a decided Veneto-Paduan character (Catalogue XXIII and XXXV, Plates 78 and 93), and by some fresco fragments in the cathedral of Pordenone, north of Venice (Catalogue XXXVI, Plates 94–97), where a ruined lunette with buildings set into a landscape may give the only clue as to the appearance of Gentile's lost fresco for the Doge's Palace.

While Gentile was living in Venice a series of political events occurred that were to affect him directly. On 9 June 1409 the Venetian Republic purchased from Ladislas of Naples his rights and pretensions over Dalmatia, thereby incurring the wrath of the King of Naples's rival, Sigismund of Hungary. War broke out between the Republic and Sigismund the following year, and in December 1410 or January 1411, the city enlisted Carlo Malatesta, lord of Rimini, as general. When Carlo was wounded that August his brother, Pandolfo, took command. After a victory over Pippo Spano at Motta, a truce was concluded on 17 April 1413. That May Pandolfo was awarded Venetian citizenship and received a yearly allowance and a house on the Grand Canal. He must have taken this opportunity to select an artist to direct the decoration of a chapel in the Broletto at Brescia. He had seized the city from the Visconti in 1404, following the funeral of Gian Galeazzo, and intended to make it the focus of a Lombard court. Gentile's success in the decoration in the Doge's Palace no less than his common Marchigian origins must have recommended him to Pandolfo. By January 1414 Gentile had moved to Brescia.

Nothing remains of this chapel on which Gentile laboured the better part of five years (Catalogue L). The paintings were destroyed when Calisto da Lodi redecorated the chapel in the early sixteenth century. The subject-matter is known only because it offered the sort of material that local humanists could turn to their own purposes. In his *De laudibus Brixiae oratio* of 1458 Umbertino Posculo re-

counts that one of the scenes showed St. George slaying the dragon, represented in a lifelike fashion that the ancient sculptors Phidias and Polyclitus or the painter Apelles might have envied. Ironically, a remarkably detailed set of documents has survived (Document III). These hint not only at the accessories, such as enamel work, but record the variety of materials employed and the places where they were purchased. Ultramarine blue came from Venice, lake from Florence. The numerous orders of gold leaf give the impression that the finished work must have resembled panel-painting as much as fresco. Pisanello's mural at S. Fermo in Verona or that of Giambono in S. Anastasia may give an idea of the splendour, as well as fragility, these extravagant materials could produce. But it is wrong to confuse the style Gentile practised at Brescia with that which Pisanello seems to have evolved from Stefano and Altichiero independently.[18] Giambono's work, on the other hand, was more profoundly connected with Venetian events and may reflect Gentile's previous work in that city.

In October 1418 the newly elected Pope Martin V entered Brescia on his return from the Council at Constance. The following month, while he stayed at Mantua, a painting was made by Gentile as a gift from Pandolfo. Evidently pleased with this and the nearly finished chapel, Martin invited Gentile to follow him to Rome. On 22 September 1419 Gentile set out on horseback with seven others to join the Pope, who had been residing in Florence since 26 February.

III ~ FLORENCE

MARTIN V had anticipated a relatively direct and swift journey to the Holy City, but this was not to be. Braccio da Montone, who controlled much of Umbria, blocked the passage south, and on 20 January 1420 a rebellion in Bologna demanded the Pope's attention to the North. It was not until September, after a humiliating truce with Braccio, that Martin was able to quit Florence. During that year and a half stay the Pope commissioned a mitre and morse for a cope from Ghiberti and established a committee to see to the restoration of the basilicas in Rome, but Gentile must have realized from the outset that his own involvement would necessarily be postponed. Although he seems to have settled provisionally in Florence, in late March and again in early April 1420, he made an appeal to Tomasso Chiavelli in Fabriano for tax exemption and expressed the wish to 'live and die and practise his trade on Fabriano soil'. In 1419 Tomasso Chiavelli had received a group of lands in vicariate from Martin V and the title of Vicar of Fabriano enjoyed by his predecessors was confirmed. It is quite possible that Gentile's trip to his home town was connected with these events. In any case, it was certainly at this time that he received a commission for a double-sided processional standard from the Franciscans or their supporters, one of whom had been Tomasso's father. The standard showed the Coronation of the Virgin on one side and St. Francis receiving the stigmata on the other (Catalogue VIII, Plates 20–21 and Colour Plate B). Its original format is documented by two similar standards by a later local artist, one formerly in the Grassi collection in Rome and the other in the Pinacoteca Nazionale at Perugia (Figs. 15 and 16). Additionally, one side of a direct copy painted by Antonio da Fabriano in 1452 is preserved in Vienna (Catalogue XLIV, Plate 103).

Even allowing for the difference in size there are few points of contact between the Coronation of the Virgin in the altar-piece at Milan and that commissioned about ten years later. The figures in the standard are modelled with a new strength and their faces are less generalised; the posture of both figures is more erect and the long, flowing curve created by Christ's hand resting on his knee in the earlier painting is here replaced by a vigorous gesture. The drapery falls in heavier folds that relate more functionally to the underlying forms, and rich brocades are used to contrast one area against another, though damage to much of the glazing that modelled the surface and defined the back edge of the seat has resulted in an apparent flatness. This fuller, more sculptural treatment of the figures would alone provide proof of contact with Florentine art. However, the iconography is also Tuscan, for the depiction of the enthroned Virgin simultane-

15 Francesco di Gentile da Fabriano (?)
Coronation of the Virgin (from a processional
standard) Whereabouts unknown

16 Francesco di Gentile da Fabriano *Annunciation*
(from a processional standard)
Galleria Nazionale, Perugia

ously crowned and blessed by Christ is seldom found elsewhere. It appears first in
a late thirteenth-century mosaic on the inside of the Florence cathedral, where
music-making angels already appear at the sides (Fig. 17), and it was apparently
revived at precisely the moment Gentile painted his processional standard. In a
purse made for the Medici's friend Baldassare Coscia, Pope John XXIII, a reversal
of the cartoon has resulted in Christ blessing with his left hand (Fig. 18), but the
scene is once again completed by angels playing instruments.[19] It is conceivable
that the image carried papal connotations.

It is only initially surprising that the style of the *Coronation* is indebted not to
contemporary Florentine art, but to a work painted some fifty years previously
like Jacopo di Cione's *Coronation of the Virgin* in the National Gallery in London
(Fig. 19). However, in 1420 Florentine painting was dominated by Lorenzo
Monaco, whose fervently emotional work with its restless, abstract forms was
essentially antipathetic to Gentile. In the work of the Cione, Gentile could find a
richly tooled surface combined with solid figural construction. The unprece-

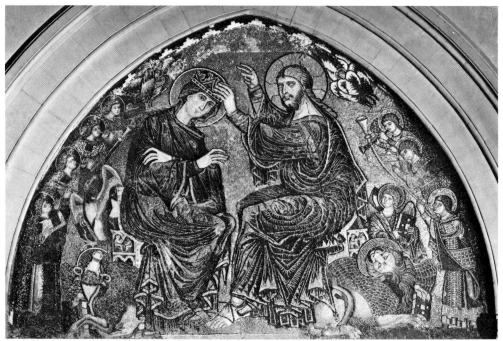

17 Gaddo Gaddi *Coronation of the Virgin*
Cathedral, Florence

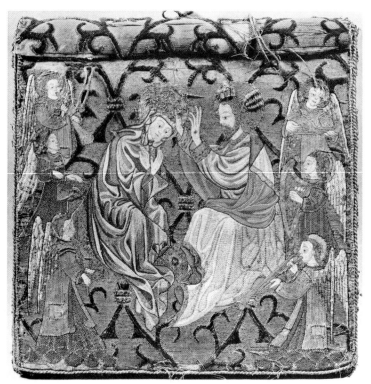

18 *Coronation of the Virgin* (front of a liturgical purse)
Ambrosiana, Milan

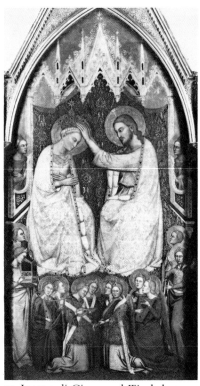

19 Jacopo di Cione and Workshop
Coronation of the Virgin
National Gallery, London

A. *The Valle Romita Altar-piece* (Cat. IV)
Pinacoteca di Brera, Milan

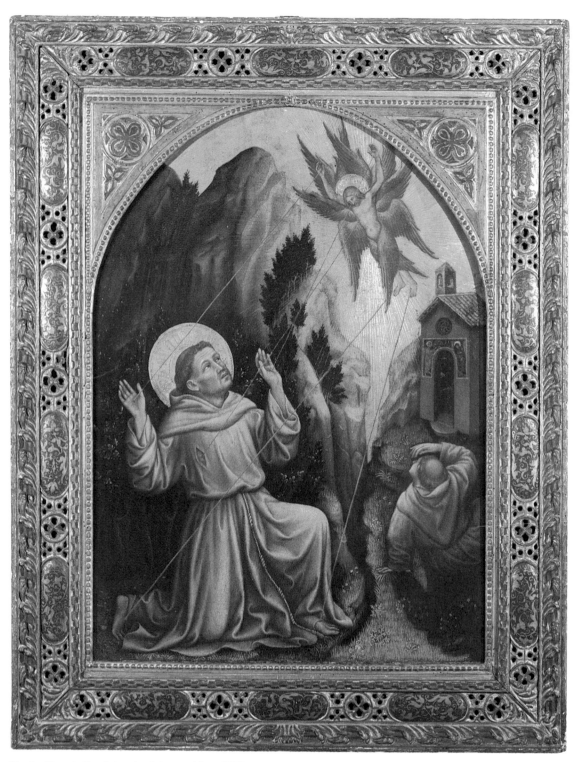

B. *St. Francis Receiving the Stigmata* (Cat. VIII)
Private collection, Italy

dented brocades Gentile created leave little doubt that this kind of painting lay behind his conception. Few facts are more significant than this deliberate repudiation of Lorenzo and his contemporaries in favour of an older but more monumental style.

This same choice is evident in the *Madonna and Child* at Washington (Catalogue VII, Plates 18–19), which seems to have preceded the *Coronation*: the faces are more schematic, while the rhythm of the hem and the receding delicate tiles of the background pavement, picked out in gold, still recall the altar-piece at Milan. In Brescia Gentile may have seen some French panel-paintings, such as the *Madonna and Child* attributed to Malouel now at Berlin, which influenced his choice of colours – deep maroon for the Virgin's dress, blue for Christ's robe. But the careful construction of the figures, no longer based on a succession of curves, and the brocaded sleeve, lead inevitably to Florence and the works of the Cione, and confirm a dating after 1419. The tentative lettering on the hem of the Virgin's dress is the earliest evidence of Gentile's contact with the humanist culture of Florence. A noteworthy aspect of this painting is the use of the tethered moth, symbol of the Resurrection, and the placement of the Child's hand beneath the word MATER inscribed on the Virgin's collar to underscore the mood of tenderness.

Despite their novelties, neither the *Madonna and Child* at Washington nor the *Coronation of the Virgin* are adequate preparation for the reverse side of the processional standard, where St. Francis is shown receiving the stigmata. The *Fioretti* best describes the event depicted.

> And being thus inflamed by this contemplation (St. Francis) beheld, that same morning, a seraph with six resplendent and flaming wings come down from heaven; which seraph, with swift flight, drew nigh to St. Francis so that he could discern him, and he knew clearly that he had the form of a man crucified . . . St. Francis, beholding this, was sore afraid and yet was he filled with sweetness and sorrow mingled with wonder . . . Then the whole mount of La Verna seemed to flame forth with dazzling splendour, that shone and illuminated all the mountains and the valleys round about, as were the sun shining on the earth.[20]

Having taken refuge on a grassy ledge close by the barren peak of La Verna, Francis kneels down to receive the stigmata. On the other side of a ravine, not as wide as that described earlier in the *Fioretti,* Brother Leo shields his face from the divine radiance of the seraph, whose wings have been increased to ten to give a more flame-like appearance. In the early Trecento Taddeo Gaddi had shown interest in luminary displays; his fresco of the *Annunciation to the Shepherds* in S. Croce depicts the trees, hills, and figures coloured by a yellow radiance. These ideas had become conventional in the works of Lorenzo Monaco almost a century later. From the beginning, however, the result had always lacked that element which gives substance to Gentile's painting: the cast shadow. As the seraph appears to St. Francis, his rays become a source of naturalistic illumination which, 'like the sun shining on the earth', leave shadows extending from those bodies they intercept. Not only Brother Leo but also the small chapel cast distinct

shadows over the grassy ground. What's more, the bright light that strikes the mountain and highlights the accurately rendered oak grove behind Francis is contrasted to the dim interior of the chapel. This chapel is no longer conceived in a contemporary architectural style, but is a Romanesque building adorned by a Duecento mosaic or fresco and containing a Duecento altar-piece. There can be little doubt that Gentile has intended it as an accurate depiction of the little church of S. Maria degli Angeli, erected by St. Francis on the slopes of La Verna, as a further means to pictorial verity.

It is not possible to trace the path by which Gentile was led to interpret a divine radiance as natural light, but the means of achieving this vision were traditional. The gamut of medieval painting techniques codified in Cennino Cennini's handbook are employed here. The golden sky has been incised and gold rays extend from Christ's wounds to those of St. Francis. Gold leaf has been laid under the pigments in those areas most intensely lit, such as the right side of the mountain, the hill behind the chapel, and St. Francis's left hand. Christ is also painted entirely over leaf. These areas thereby obtain a glowing effect when struck by actual rays of light. Such devices are the natural outgrowth of the concerns for texture Gentile had already shown in the Milan *Coronation,* and they prove that there is no necessary contradiction between medieval technical procedures and a desire to imitate the effects of nature. Indeed, the transfiguring effect produced by this association of gold with light is somewhat lost in later painting, as Domenico Veneziano's lovely predella scene of the same subject at Washington reveals. It is in Sassetta's remarkable panel at London that Gentile's achievement is most closely paralleled.

This painting of St. Francis receiving the stigmata marks a new chapter in the history of Italian art. Perhaps only in the work of Pietro Lorenzetti a century earlier would it be possible to find comparable passages depicting real illumination.[21] In his fresco of the Last Supper in the lower church of S. Francesco at Assisi, Pietro depicted a kitchen with servants cleaning plates before a blazing fire which causes the cat and dog to cast shadows. The experiment was not carried over to the main part of the composition, and in a sacred scene, like the *St. Francis,* light is treated in the manner found in Taddeo's *Annunciation to the Shepherds.* In panel-painting, always more conservative than fresco practice, such luminary depictions are still rarer. Byzantine painting had retained vestiges of shadows from late Antique art, but these were seldom used to produce a naturalistic effect. In Bonaventura's altar-piece of 1235 at Pescia dark areas are used to set off a figure or distinguish overlapping buildings, and it is essentially this system that is employed by the St. Cecilia Master in his dossal in the Uffizi almost a century later (Fig. 20). Ambrogio Lorenzetti's series of *Miracles of St. Nicholas* in the Uffizi is exceptional for the relation of areas of dark value with an implied source of light (Fig. 21). Not only does colour become darker as a given surface recedes, but beneath an overhang a darker value is used to suggest a shadow cast on the wall. Even here, however, there are no distinctly outlined shadows. Basically Ambrogio

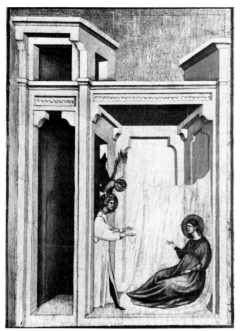

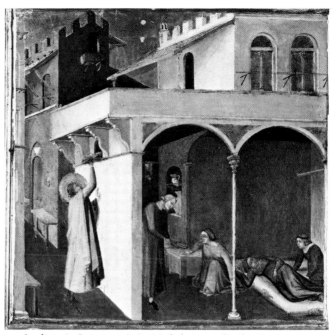

20 Master of St. Cecilia
Cecilia greets Valerian
Uffizi, Florence

21 Ambrogio Lorenzetti *St. Nicholas provides the dowry for three poor maidens*
Uffizi, Florence

rationalized a practice inherited from Byzantine painting in the same way he brought a greater regularity to perspective studies.

In Florence such attempts at rationalization broke down by the middle of the fourteenth century. In the work of Orcagna the graded modelling of a wall, such as is found in Byzantine art, gave way to a generally uniform hue or value, used to assure the integrity of each surface (Fig. 22). Paradoxically, this apparent regression meant that when, under a new wave of naturalism, an artist again sought to render the effects of light, none of the previous ambiguities would return. Gentile's painting marks the beginning of this phase. His naturalistic interpretation of the seraph's heavenly radiance permanently severed his ties with the art he had known in Venice and Lombardy.

Though the *Coronation of the Virgin* and the *St. Francis receiving the Stigmata* were painted on two sides of a single standard, the difference of conception between them is profound, and this difference is only partly explained by the literary source he obviously employed. The *St. Francis* opens a new stage in Gentile's career with the altar-piece of the *Adoration of the Magi* (Catalogue IX, Plates 22–38 and colour plate C), painted for the Florentine banker, Palla Strozzi, its most significant successor.

Palla was the subject of a laudatory biography by the fifteenth-century book dealer, Vespasiano da Bisticci, and was described among the four great citizens of Florence worthy of fame in the *Zibaldone* of his son-in-law, Giovanni Ruccellai. That list included Cosimo de'Medici ('of whom it is said that there has never been

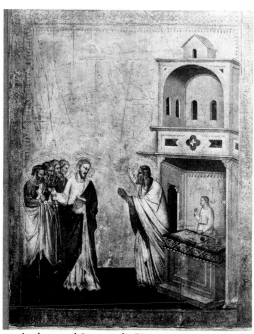

22 Andrea and Jacopo di Cione
The calling of St. Matthew
Uffizi, Florence

a greater citizen than he, and who ruled the city and government as though at pleasure'), Leonardo Bruni ('more learned than any other citizen'), and Brunelleschi ('since the time of the Romans there has never been a more singular man in architecture, a master of geometry, and a perfect master of sculpture'). Palla was especially distinguished as possessing the seven parts of happiness: a noble fatherland, noble blood, virtuous in knowledge ('he was most learned in all disciplines – in tutte le scienzie – and understood Latin, Greek, and Hebrew'), handsome and in good health, rich, beloved ('he had a marvellous grace that proceeded from innate virtue and goodness'), and blessed with a beautiful family. He had been largely responsible for bringing Manuel Chrysoloras to Florence to teach Greek in 1397 and was among the foremost supporters of the humanist movement in the city. Prior to his exile in 1434, no citizen enjoyed greater esteem.

When Palla's father, Onofrio, died in 1418, leaving him with the obligation of 'completing' or 'perfecting' a chapel and sacristy dedicated to SS. Onuphrius and Nicholas at the Vallombrosan church of S. Trinita, Palla acted quickly to carry out the task.[22] An eighteenth-century history summarizes the construction:

> Palla distinguished himself in the undertaking because, in the first place, he bought all the houses between the side door and the door of the monastery – which is that space containing the sacristy – and raised from the foundations a high and noble wall of cut and strong stone with which he embellished the choir of the monks where they used to officiate at night. He made large windows and two chapels, one dedicated to

St. Onuphrius – the patron saint of his father – which is in the first sacristy, having a noble pavement of square, black and white marble slabs, and the other in the sacristy above or next to the first. In this sacristy, behind the altar, is a lovely painting from the hand of Gentile da Fabriano, made about the year 1430, which represents the Adoration of the Magi.[23]

Despite this testimony, which attributes the entire building to Palla, there is reason to believe that a certain amount of work had been carried out prior to 1418, when Palla's first payments for construction are recorded. The arch leading into the altar area is of a different stone and more archaic style than the rest of the structure, and an altar-piece commissioned from Fra Angelico in the 1430s, evidently for the smaller of the chapels, is inserted into a pre-existing frame with gables painted by Lorenzo Monaco, whose documented activity extends only to 1423, and whose name never occurs in the ledgers relating to Palla's work in the chapel. Since a predella by Lorenzo Monaco exists which depicts miracles of SS. Onuphrius and Nicholas and is of such dimensions and style as to suggest that it once formed part of that frame, there is a strong probability that prior to Palla's funding of the chapel an altar-piece had already been commissioned.[24] Palla's work seems, therefore, to have involved a change of plan necessitating massive remodelling of a complex begun by his father.[25] Whatever the truth, the present structure testifies to a taste consistent with Palla's learned character.[26] Designs for the detailing, perhaps including the polychrome marble pavement, came from Lorenzo Ghiberti, who ornamented the exterior with the first Antique-inspired tabernacle windows of the fifteenth century (Fig. 23). The putti decoration on the arch of the tomb, which may reflect a project by Donatello, was the first of its kind (Fig. 24).[27] The decision to give the commission for the main altar-piece to Gentile denoted no less perspicacious a choice and resulted in an even more revolutionary work. Gentile must have been employed by 1421, when the chapel, still unfinished, was dedicated, and he may have been engaged somewhat earlier. The altar-piece is dated MCCCCXXIII MENSIIS MAI; on 8 June of that year he received one hundred and fifty gold florins 'per resto di paghamento di dipintura della tavola a fatto alla sagrestia di Santa Trinita'.

In the two works that preceded the *Adoration of the Magi* Gentile had exhibited an acute awareness of the new milieu in which he worked. But in 1420 the most exciting artistic experiments were in the medium of sculpture, not painting. The Strozzi commission put Gentile in direct contact with the two leading sculptors of Florence. The fruits of that contact may be read in the framework to his altar-piece (Plate 22). Its large, structural members and rich ornamentation enclosing a triple-arched, open field place it firmly in the Florentine tradition that traces its ancestry to Orcagna's altar-piece for the Strozzi family some three-quarters of a century earlier. Perhaps because of this descent from a painter-architect, Florentine frames were distinguished from those elsewhere in Italy by their structural logic and architectonic members.[28] Their form was intimately

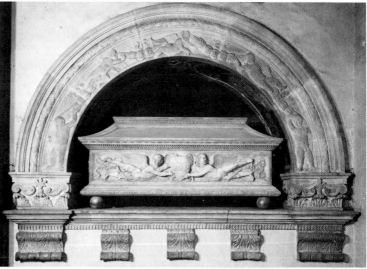

23 Lorenzo Ghiberti, Exterior of the
Strozzi Chapel (begun 1418)
S. Trinita, Florence

24 Pietro di Niccolò Lamberti, Tomb of Onofrio Strozzi (1418)
S. Trinita, Florence

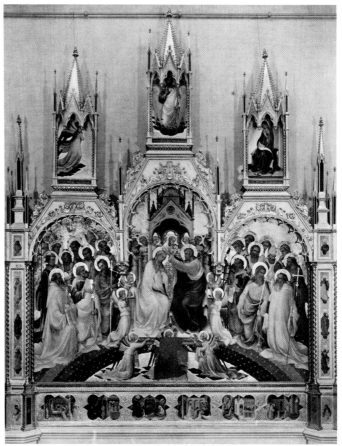

25 Lorenzo Monaco *Coronation of the Virgin* (signed and dated 1414)
Uffizi, Florence

26 Niccolò Lamberti, Door frame
Orsanmichele, Florence

27 Master of the Straus Madonna
Madonna and Child with Saints
Walters Art Gallery, Baltimore

28 Console, Strozzi Chapel
S. Trinita, Florence

29 Donatello, Tympanum of the tabernacolo dei Armaioli
Orsanmichele, Florence

linked with the decoration of niches and windows, so that even the most elaborate possessed a structural solidity absent in other Italian centres. The frame on Giovanni del Biondo's extravagant production in S. Croce still bears comparison with the window and door frames on the south side of the Florence cathedral. The one on Lorenzo Monaco's *Coronation of the Virgin* in the Uffizi (Fig. 25), with its deep vaults, vies with porches of contemporary buildings; it also bears witness to a process of simplification that accompanied the renewal of the arts in Florence at the turn of the century. Its gables have a simpler, more functional shape, and the proportions are sturdier to contain the more sculpturally conceived figures. The most beautiful framing solution appears in altar-pieces at about the same time it does on buildings, though it had been popular in small devotional works for decades. A vertical moulding, adorned either with a pilaster or spiral column, supports an arch; an extension of the moulding carries a tympanum of a double or mixti-curve shape, usually with a roundel in its centre. This form, of great elegance and linear tension, first appeared on Orsanmichele between 1410–18 (Fig. 26) and in the windows of the apse of the Florence cathedral. A nearly contemporary frame surrounds an image of the Madonna of Humility now in Baltimore (Fig. 27). Its lifespan was considerable, lasting through the first half of the century and enclosing some of the most famous paintings by Angelico. The frame of Gentile's *Adoration* is the direct descendant of this form, but with some remarkable alterations. The crowning curve is more complex, its peak repeating the lower portion of the tympanum. In this it elaborates upon a form like that crowning the niche of Donatello's *St. Mark* or that adorning a *Madonna and Child* by Mariotto di Nardo at Assisi. The consoles echo those used in the chapel itself (Fig. 28) and are rigorously architectural in their relation to the other members. The side pillars are turned on axis so that a less planar effect is achieved. Although Gentile probably did not design the frame, he has used it to full effect.[29] Behind and within the tracery on the side pillars he has depicted plants where images of saints were usually placed (Plate 23). There is no source for this device and no parallel for the accurate treatment, except in the frames to Ghiberti's first bronze doors.[30] The invention appears to be Gentile's, since Ghiberti had not yet displayed a similarly subtle response to nature. These flowers relate iconographically to the figures and theme of the main scene,[31] but their visual effect is not only to enrich the frame but to establish a play between it and the painting. They twine and turn; here facing inward, there outward. At casual intervals a leaf overlaps the gilt tracery. By this device the flowers partake of the three dimensional form of the frame, which ceases to limit the painted surface and marks, instead, that point at which the painted realm becomes real.

This play on painted fiction and three dimensional form is carried into the gables, where the prophets are made to recline on the underlying arches. The gold ground ceases to be a hard surface just behind the picture plane and becomes an indeterminate ambience, an impression partly due to the absence of those tooled borders traditionally used to bind the gold ground to the frame. Nowhere is this

concept of gold as enveloping space more explicit than where the Holy Dove flies across it towards the Virgin's chamber which its rays illuminate. Conversely, the manner in which the upper moulding clips the haloes of the prophets firmly situates them behind its edge. A similar relation of figure to frame is found in the arch of the Strozzi tomb (Fig. 24), which could have served as Gentile's model. Another relief, Donatello's gable with God the Father on the niche of his statue of St. George (Fig. 29), offers the closest comparison to Gentile's central roundel, where Christ's left hand is foreshortened to break the picture plane.

The most singular use of the frame is in the roundel of the Annunciate Virgin (Plate 26). She is shown humbly seated in a simply furnished dwelling with a garden just visible through the door. The frame arbitrarily crops the scene, giving it the potential of infinite extension. This incomplete view also serves to enhance the intimacy of the moment. Like a window opening that offers only a partial view, the frame here reveals a world both fictive and believable.

Gentile was plainly indebted to Florentine sculpture for many of the novel aspects of his frame, but as in the roundel of the Annunciate, the representational problems encountered in the main field of the altar-piece were pictorial in nature. He could not turn to other media for ideas. Additionally, he had to conform to an iconographic tradition that set specific limits on the composition. The originality of his solutions is, consequently, more remarkable.

Perhaps as early as 1367 Bartolo di Fredi had shown the train of the Magi winding through a rocky landscape into a Jerusalem resembling Siena, then reappearing in the foreground to worship the Christ Child (Fig. 30). As part of his fresco at S. Donato in Polverosa outside Florence, dated 1383, Cenni di Francesco had depicted the cave and stable, a rich retinue, and two midwives greedily examining the gifts (Fig. 31). Gentile was evidently required to create an amalgam of these two types. Like Bartolo he separated the main event from the earlier episodes, attempting to rationalize their simultaneous appearance by the expedient of foreground and background. By overlapping the arched lunettes with the foreground he was also able to treat the background incidents as three independent scenes. But whereas for Bartolo these divisions were accomplished by the rising or flattened hills of conventional practice, Gentile wished to maintain the fiction of a spatial continuum. The foreground is delimited by holly and pomegranate bushes interspersed among the rocks. On the right a winding gorge connects the main scene with distant Bethlehem, where two camels have just left the city to join the cavalcade. Behind this foreground screen unfolds the first continuous landscape in Italian painting since Ambrogio Lorenzetti decorated the city hall of Siena. In the left lunette (Plate 27) the eye moves from a raised middle ground, where a fight is about to be decided, through a wall and up the mount of Golgotha where the three kings have sighted the star, or across a bridge into a port where clouds are settling over the towers. Beyond is the sea and the distant hills of a peninsula. In the central lunette (Plage 28) the middle ground rises just below the peaks of the shrubs, supporting a hunter and his dog who has spotted a hind. A

30 Bartolo di Fredi *Adoration of the Magi*
Pinacoteca Nazionale, Siena

31 Cenni di Francesco *Adoration of the Magi*
S. Donato, Florence

gully separates this area from the path on which the caravan travels. Here a horse
has kicked another steed behind it, and a fight between the riders is about to
ensue. As the horses pass over the crest of the hill a vision of natural beauty
unfolds as barren vines and rows of newly sprung grass rise and fall away. A small
farm crowns one hill with three cows outside a twig enclosure. Beyond is the city
of Jerusalem, where an excited crowd has gathered. This spatial progression is
enhanced by loosening, ultimately disconnected brushstrokes. The right hand
scene (Plate 29) where the Magi ride uphill to the drawbridge of Bethlehem, is
more barren; its rocky aspect effects a union with the foreground. Here, perhaps
for the first time, is noticed the fourth protagonist, as it were, in each scene: the
star. Directing the Kings from the beginning, its brilliance has increased until, in a
flood of light, the horses and the bushes hard against the city wall cast shadows.
Its intensity is maintained in the main Epiphany, where all illumination comes
from it. Strongest over the cave and Joseph, the star's rays fade out on the right
side, while carefully observed shadows flicker on the wall of the stable and the
rocks behind the bushes (Plate 30). Evidently for reasons of clarity, the figures
cast no shadows, though they are everywhere touched by the star's soft light.

Using this light Gentile expounds a new principle of pictorial unity and
consistency. Colours have been carefully adjusted. Salmon, bright green or char-
treuse – the preferred colours of the Tuscan palette – have been omitted. The red
has been slightly greyed, as have other high-keyed hues; and the gold of brocades

was originally more fully modelled with glazes to bring it into accord. The rich colours of the Washington *Madonna and Child* and the brilliant, contrasting brocades of the *Coronation* processional standard have disappeared. A first attempt has been made to achieve harmony by tonal accord rather than a balancing of contrasting colours such as Lorenzo Monaco regularly employed and Gentile had used in his polyptych at Milan. There could be no greater contrast to Lorenzo Monaco's nearly contemporary *Adoration* (Fig. 32), in which the marvellously attenuated, rocking figures are depicted in precisely those colours Gentile avoids and where the suggested light source suddenly alters by 180° in the right hand section. The same comparison underlines Gentile's naturalistic approach to the figures. For all their elegance of bearing, each is modelled with great subtlety, features drawn with great care. A glance back at the *Coronation* standard confirms the steadiness of Gentile's growing command.

By creating the impression of an extended space bound by light, Gentile aimed at rationalizing the setting. His elaboration of peripheral incidents in the lunettes and in the main Epiphany is meant to lend the sacred legend a human dimension. To the same end each figure is finely characterized: the kindliness evident on Joseph's face, the enraptured pleasure of the Virgin, the excited curiosity of the Christ Child, the wonder of the attending page (Plate 33). Such a range of expression had been beyond the capabilities of earlier art, which depended upon a variety of types to differentiate characters. An index to this new mastery is found in the two onlookers who stand apart from the other actors, between the Magi and the cavalcade. Vasari thought the younger one a self-portrait, but they almost certainly represent Palla and his son, Lorenzo, aged respectively fifty and eighteen in 1422.[32] Their presence provided an immediacy that is only partly lost to the modern viewer. Such elements of verisimilitude renew the attention of the spectator who, exhausted by the dazzling splendour of brocades, is charmed into believing what seems less a commemorative evocation than a rich chronicle of a holy event. The humble aspect of the Virgin and her Child, the ruined state of the stable, the beauty of an abundant nature – all favoured themes of medieval preachers – gain thereby a poignancy seldom again equalled.

Wonderful though the *Adoration of the Magi* is, its form was necessarily compromised by compositional demands stemming from its iconographic tradition. These were too artificial to permit Gentile to achieve the unified vision evident in the individual panels of the predella. In the main picture field each lunette begs to be read separately, even though connecting links with the foreground have been carefully provided. The result is a composite image. The format of the predella was more conducive to coherent, focused compositions. Each scene elaborates on a specific facet of the new pictorial vocabulary.

The first scene portrays the Nativity (Plate 35) in a setting scarcely altered from that of the Epiphany. The viewpoint is taken from a greater distance, so that a lean-to is visible, and the background is more plausibly related to the foreground by means of a lower horizon. Much as St. Bridget had described in her

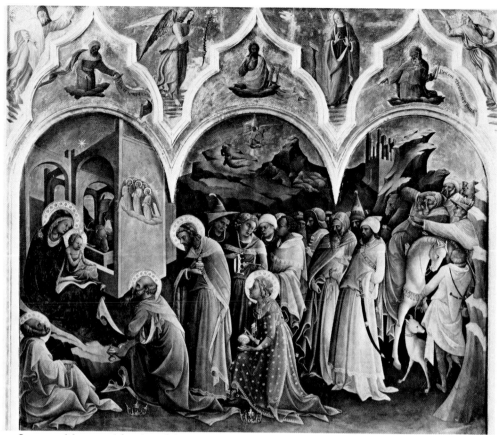

32 Lorenzo Monaco *Adoration of the Magi*
Uffizi, Florence

Revelations, the Virgin kneels in adoration and the Christ Child is the source of a resplendent, gold light. This light touches the underside of the cave and the overhang of the shed, illuminates half of the lean-to – leaving the other half in dark shadow – and plays on the bare, winter branches against which Joseph sleeps. Rather than the candlelight of Bridget's vision, the soft natural light of a silver moon contrasts with this brilliance. The highlights on the sleeping midwife and the muted shadow on the side of the shed stem from this secondary source. In the distant hills the angel who proclaims Christ's birth to frightened shepherds creates yet a third source of light. This plotting of sources of illumination, both divine and natural, has the precision of a scientific demonstration and marks a new, rational attitude to picture making. The mental discipline lying behind such a magical representation is easily overlooked in the presence of such details as the kneeling ass and the kindly face of the ox. As recounted in chapter seven of the *Meditations on the Life of Christ,* they breathe on the infant 'as though they possessed reason and knew that the Child was so poorly wrapped that he needed to be warmed, in that cold season'. As in Gentile's depiction of St. Francis receiving the

stigmata, so here attention to naturalistic luminary effects is the basis for a humane and deeply poetic image.

The *Flight into Egypt* is perhaps even more remarkable (Plates 36–37). Again the expressions of the figures are sympathetically described and care has been taken to repeat the details of their costumes. But the setting is a panoramic landscape. Low in the sky hangs the morning sun: a raised, gold disc. Its warming rays beat intently upon the fields below and begin to dissipate the vaporous clouds that hang over the distant city on the right. Because of damage to the surface, a moment is required to reconstruct the fine layer of pigment which originally coloured the gold furrows on the left and to restore the glaze of the rectangular patch in front of the trees. The effect of the flowers lightly etched into the surface is then felt together with the long shadows of the trees which fall across them. A crack of light brightens the path between the two women while beyond, the ass carries Mary into the cool, damp shadow of the sun-crested hill. On the other side a softer light touches the grey-green foliage of the trees. In the distance details are lost in small dabs of colour. For those who have walked on a spring morning over the flower-filled hills towards Settignano, or looked out to the hills surrounding Siena or San Gimignano, each crowned with a walled city, this scene will be hauntingly familiar. Such are its powers of evocation that the principles of its organisation are not immediately apparent. Yet Gentile has perfectly solved the most difficult problem in landscape painting: the transition from foreground to background. Several devices have been employed. First, a low viewpoint has been adopted so that the distance appears largely as a succession of hills. Second, a narrow foreground space has been marked off from the picture plane by use of a small hill and clump of diminutive trees. A larger, centralized hill separates this area from the middle ground. This arrangement describes an arc tangential to the picture plane, its sides extending into space. Lastly, natural elements such as winding paths, rows of trees, the furrows of the fields, control the speed with which the eye penetrates the distance. Giovanni Bellini made no further advances on this arrangement in his *Agony in the Garden*. In Florence Domenico Veneziano, in his *Adoration of the Magi* at Berlin, and Angelico, in his *Flight into Egypt* from the silver chest panels at S. Marco, seem to have drawn lessons from Gentile's precocious masterpiece. Yet in Veneziano's *Adoration* the grid-regularity of a perspective system determines the slopes of the hills and the beam of the stable, giving the landscape a preternatural precision.

The use of light and compositional procedures that characterize Gentile's *Flight into Egypt* mark the same stage in Italian painting as the Master of Flémalle's contemporary *Nativity* in Dijon (Fig. 33) does for Northern art. In that picture the golden disc of the sun, the careful definition of the foreground area, and the path twisting around a hill into space, disclose an apparent debt to the miniatures of the Boucicaut Master, the forerunner of modern landscape painting.[33] This debt in turn suggests a possible source for Gentile's landscape design. It is true that there is no certain work by him datable to the period he was at Brescia, when contact

with Franco-Flemish illuminations would seem most likely, but the evidence is none the less suggestive. In the miniatures by the Boucicaut Master is found the same association of gold with light that characterizes Gentile's paintings, and in his late works he anticipated Gentile in effecting a continuous movement from the foreground to the background. This is not the case in the early miniatures executed for the Maréchal Boucicaut, now at the Jacquemart-André Museum in Paris and usually dated in the first decade of the century. In even the most advanced of these the foreground is schematically constructed from a series of intersecting diagonals unrelated to the more naturalistic, horizontally disposed background, and untouched by the sources of illumination. But in the *Annunciation to the Shepherds* in London, later in date, figures have a plausible relation to the landscape and progression into an atmospheric distance is accomplished by a succession of rounded hills (Fig. 34). A composition very similar to this one must lie between the narrative scenes of Gentile's *Coronation of the Virgin* at Milan and the predella of the *Adoration of the Magi*. The availability of such manuscripts at Brescia is suggested by the close, if often hostile, relations between the Maréchal Boucicaut, the Visconti, and Pandolfo Malatesta. From 1408 Giovanni Maria Visconti, who had married Pandolfo's niece in July, was in touch with the Maréchal. The latter served briefly as governor of Milan in August 1409. An illuminated Book of Hours with the Visconti insignia may have been commissioned from the Maréchal's great artist at this time; and there is no reason to believe Pandolfo would have been ignorant of it.[34]

There is another illuminator whose work at times bears close comparison to Gentile's: the Brussels Initials Master.[35] Apparently Bolognese in origin, this artist collaborated with Jacquemart de Hesdin and his landscapes proclaim the effects of that collaboration. His architectural forms, however, betray repeated contact with the work of Altichiero at Padua, and the last notice of him is an illumination for the *Statutes* of the Compagnia dello Spedale di S. Maria della Vita at Bologna in 1408. There is some possibility, then, that his works may also have been known to Gentile. Though he usually applied himself to a pungent mode of narration, his *Nativity* at London is set in a landscape of suffused light with hills traversed by a winding path (Fig. 35). Gentile would have shied from his garrulous figures, but he could not help but be captivated by the setting. In another miniature, the *Flight into Egypt,* a hillock is used to obtain the same sort of spatial progression found with Gentile and the sky is filled with vaporous clouds (Fig. 36). However, the Brussels Master did not share the interest of Gentile and the Boucicaut Master in light effects. His role would have been primarily catalytic.

Despite such parallels of style, it should be noted that Gentile never employs iconographic formulas associated with Northern art, and the colours of the *Madonna and Child* at Washington recall French panel-painting rather than miniatures. Moreover, nearer at hand, in Altichiero's frescoes at Padua, Gentile could have found a more truthful proportion of figure to landscape, a carefully constructed foreground, and a congenial mode of narration (Fig. 37). His own incli-

33 Master of Flémalle *Nativity*
Musée des Beaux-Arts, Dijon

34 Boucicaut Master
Annunciation to the Shepherds
British Museum, London

35 Brussels Initials Master
The Nativity
British Museum, London

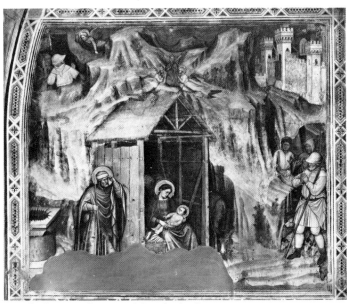

37 Altichiero *Adoration of the Shepherds*
Oratio di S. Giorgio, Padua

36 Brussels Initials Master
The Flight into Egypt
British Museum, London

nations may have been sufficient to effect the transformation from these architectonic compositions to those of the *Adoration*. Regardless of whether the features shared by the predella scene of the *Flight into Egypt* and the Dijon *Nativity* represent a common background or are simply coincidental, the Tuscan aspect of the hills Gentile portrays reveals to what extent traditional schemas have been replaced by visual experience.

The last scene in the predella (Plate 38) is the only one set in an outdoor architectural environment with the primary source of light outside the picture surface. This *Presentation in the Temple* is, in fact, the first convincingly depicted civic scene since Ambrogio Lorenzetti's frescoes of *Good Government* at Siena some eighty years prior. Gentile has portrayed an open rectangular piazza with buildings in strong recession. In the centre is a polygonal porch attached to the temple. An oil lamp marks the central axis and illuminates the figures of Simeon holding the Child, the Virgin, and a crowd of onlookers pressing forward for a glimpse. To one side of this stand two elegantly attired, upper middle-class women. To the other side are the poverty-stricken beneficiaries of Christ's future ministry. Despite such Venetian architectural details as the lanceolate windows and the foliated decoration, the rusticated lower stories of two of the palaces and the open loggia have a distinctly Florentine flavour. The diamond-faceted stones of two of the buildings are less easily localized, since they appear with frequency only later in the century.[36] The composition itself recalls in a remarkable fashion the description Manetti has left of Brunelleschi's first perspective study. This was on a square panel and portrayed to scale the rectangular piazza in front of the cathedral dominated by the receding walls of the octagonal baptistry. Gentile was not a theorist; his scene observes no perspectival logic and sacrifices scale. In one respect, though, his representation is more truthful. Brunelleschi burnished silver on to the back of his panel 'so that the real air and atmosphere were reflected in it, and thus the clouds seen in the silver are carried along by the wind as it blows'.[37] He thereby introduced a confusion between the pictorial and natural light source. This solution suggests that, in fact, there was no pictorial lighting. The painting must have resembled a tinted architectural drawing. In Gentile's scene the painted sky allows no such ambiguity. Light falls uniformly from the left, so that the tie bars of the loggia cast angled shadows and the narrow streets move into darkness. At only one point does Gentile relinquish control of this ambient light: in the raised, gilt discs in the spandrels of the porch. Even here some lost glaze may have been used to gradate their brilliance.

This scene precedes not only the famed piazza frescoed by Masolino in the Carmine, it is at least a decade earlier than Ghiberti's *Meeting of Solomon and Sheba* on the *Gates of Paradise,* where a similar centralized piazza is used as the setting for a biblical event. Such scenes were the product of perspectival composition and appear with frequency only after the writing of Alberti's treatise in 1435.[38] It is tempting to see here an approximation by Gentile to experiments in which Brunelleschi's circle was involved, but information is too scanty. The *Presentation*

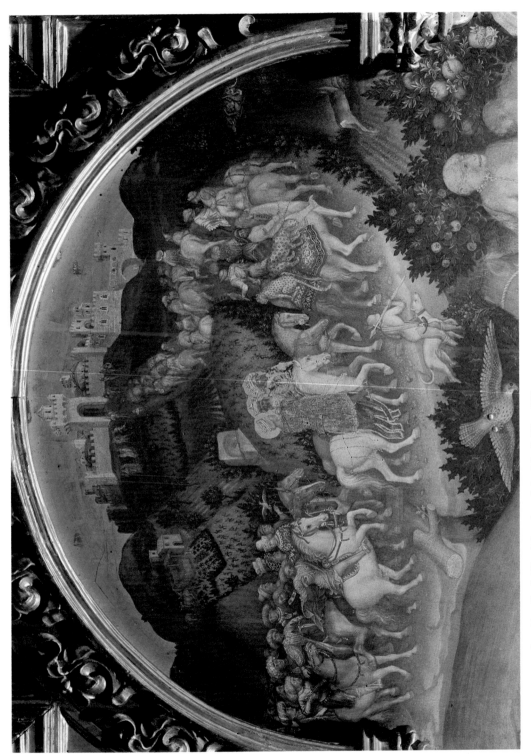

C. *Journey to Jerusalem* (detail of *The Adoration of the Magi*) (Cat. IX)
Uffizi, Florence

D. *Madonna and Child with angels
and, in roundel, Christ Blessing*
(from *The Quaratesi Altar-piece*)
(Cat. XIV)
H.M. The Queen,
Hampton Court

thus remains, like the *Annunciation to the Shepherds* with its carefully plotted, multi-light sources, the most remarkable and precocious painting executed up to that moment in the fifteenth century.

Nowhere had the concerns that would dominate Renaissance painting – naturalism, spatial depth, light, relation to the viewer – been so richly investigated as in this altar-piece by a non-Florentine. If, however, the apparent relations with Ghiberti, Donatello, and Brunelleschi are taken into account along with the differences that separate the *Adoration of the Magi* from those two works which preceded it, then it is clear that Gentile had become a participant in peculiarly Florentine events. The beautiful humanist capitals with which Gentile signed his name and lettered the scrolls may be taken to signify more than a qualitative advance over the inscription on the hem of the Washington *Madonna*. Conversely, the pseudo-cufic script Ghiberti chased onto the hem of his St. Matthew, like the flower reliefs on the inner jambs of the north doors to the baptistry, seem indebted to Gentile. The most puzzling of these connections is posed by Donatello's composition on the predella to his statue of St. George, generally thought to pre-date Gentile's arrival in Florence.[39] It does not attempt the fluid movement into space found in the *Flight into Egypt,* but its atmospheric background is without precedent in Florentine art.

Gentile's relations with these artists were, in a sense, superficial. He never evinces the theoretical inclination that later distinguished the work of Masaccio, but in 1423 no other painter possessed the capabilities of reacting in such a dramatic fashion to the novel ideas being expressed in sculpture. Partly because of this unique position, partly because of Gentile's presence in the city, the effect of the *Adoration of the Magi* on Florentine painters was even greater than that of Hugo Van der Goes's *Adoration of the Shepherds* half a century later. To a greater or lesser extent each leading artist recognized in the naturalistic premise of the *Adoration of the Magi* the potential for a more varied and richer style. Gentile became the chief painter of Florence. The heavier, less abstract forms of Lorenzo Monaco's *Annunciation* in the Bartolini-Salimbeni Chapel at S. Trinita and the fairytale landscapes of Paolo Schiavo's predella in the Johnson Collection, Philadelphia,[40] both proclaim Gentile's ascendancy. One artist in particular seems to have become a direct disciple of Gentile: Masolino da Panicale. Remembered primarily for his later partnership with Masaccio, in 1423 he painted a polyptych, the central panel of which survives at Bremen. There is no Florentine precedent for the soft forms of the Virgin and the ringlets of the Child's hair. They descend from Gentile's *Madonna and Child* at Washington just as the composition derives from Ghiberti, in whose workshop Masolino is known to have worked.[41]

The proof of Gentile's pre-eminent position is in the quantity of commissions which fell to him. These ranged from small, precious works, like the *Madonna and Child* at Pisa (Catalogue X, Plates 39–41), to altar-pieces, like that in the Frick Collection, New York. Both works seem contemporary with the *Adoration,* though the Pisa painting dates more towards the early stages of that work.

Double-sided, it was intended as a portable, devotional image; it displays the care of execution and delicacy of sentiment meant to inspire admiration and love. To have combined flowing rhythms and rich brocades with convincingly human types was Gentile's greatest gift. No other contemporary could have drawn the Child's hands or so perfectly placed his rounded legs. No other would have conceived the touching gestures. The success of even this small work may be judged from a contemporary variant by a follower who has capitalized on the fame of the *Adoration of the Magi* to enrich the theme (Catalogue XXXI, Plate 90). Fifteen or twenty years later a more faithful homage was paid by a painting from the workshop of Fra Angelico (Fig. 38).

Utterly different in facture and sentiment is the *Madonna and Child with SS. Julian and Lawrence* in the Frick Collection (Catalogue XI, Plates 42–43). Combined with an insistent corporeality are the livelier, less poignant, expressions of the Virgin and Child, set off by the fervent devotion of saints in the flower of youth. The way the Child's attention is diverted by the captive bird, symbol of Christ's Passion, is a particularly felicitous idea. No less ingenious is the way space is defined by the painted ledge, by arbitrarily cropping off the foreground figures, and by carefully describing the planes of the throne. The subtle displacement of the haloes in order to free a profile again indicates Gentile's concerns. However, the colours of this work mark a departure from his previous practice. The bright orange cloth of honour lined in green contrasts sharply both with the Virgin's deep blue cloak and its dark green lining as well as with the lavender-to-grey pavement and raspberry boots of St. Julian. Some of the very colours which had been excluded from the *Adoration of the Magi* appear here. There is an explanation. Gentile probably noticed that for all their abstraction, the figures of Lorenzo Monaco's *Coronation of the Virgin* (Fig. 25) had a solid definition that could not be achieved by chiaroscuro modelling alone. The extraordinary range in values obtained as oranges changed to yellows, blues to white or yellow, endowed each surface with the tactility of polychromed sculpture. Gentile has adapted similar contrasting colours for that form which most clearly defines space: the throne. Where the yellow highlighting has remained intact the effect is impressive, but even the loss of almost all the deep red that once defined the area behind the Virgin cannot have much lessened the cut-out effect which results from setting the deep blue cloak in front of the warm colours of the throne. It is easy to understand why this experiment remained isolated. Partly to compensate for this disparity, the intensity of the light has been increased, thereby extending the value range of each colour. Entering from the right side, this light picks out every projection. Highlights have a brilliance paralleled only in the *St. Francis* of the processional standard. Though such concerns were forecast in the *Adoration of the Magi,* the conclusion reached here marks a radical break with tradition.

At the same time as Trecento artists lost interest in the evocation of natural light they abandoned the suggestion of a uniform source of light in their altarpieces, though in frescoes the old practice continued. Occasionally the effects of a

general, emanating light were preferred – as in Gentile's *Coronation of the Virgin* at Milan. But in Florence the tendency was to use a centralized source or opposing sources of light for the side panels. This is already true in the altar-piece which bears Giotto's name in the Baroncelli Chapel at S. Croce, where the figures surrounding the central throne are lit from opposite sides. The results were similar and complementary to what has been called 'reverse perspective': light and space ceased to make reference to the world of experience, they gained a purely formal meaning. The central panel often reveals most clearly this retreat from a naturalistic premise. The Madonna is sometimes lit from one side, the Child from another, thereby emphasizing an independence of form and of ambience. Masolino's *Madonna and Child* at Bremen and two contemporary panels by Fra Angelico[42] still retain the marks of this phase. With Gentile's altar-piece in the Frick Collection this ambiguity comes to an end. The *Madonna and Child* at Munich, which Masolino conceived probably no more than two years later, takes into account the effects of light uniformly falling from the left side. The sculptural effect of the figures, however, is the result not only of the lighting, but also bears the unmistakeable imprint of Masaccio.

The Bremen *Madonna and Child* proves that in 1423 Gentile, not Masaccio, was the leading painter in Florence. That this was no longer true two years later is due to Masaccio's meteoric rise. Two works survive which document this transformation. One is an altar-piece Masaccio executed for the church of S. Giovenale in the Valdarno, dated 22 April 1422.[43] The other is a painting of the Madonna and Child with St. Anne originally in S. Ambrogio, Florence, now in the Uffizi (Fig. 41). In the latter work Masolino acted in the capacity of a collaborator, a role he repeated in the Brancacci Chapel at S. Maria del Carmine. For this reason that painting is not likely to pre-date November 1424, when Masolino completed his frescoes at Empoli, nor post-date September 1425, when he was preparing to depart for Hungary.

The figures in the altar-piece of 1422 (Fig. 39) show Masaccio to be a Gothic artist; the last great follower of Orcagna. Only in the spatial structure does he depart significantly from his model. Where in Orcagna's Strozzi altar (Fig. 40) the pavement is tilted to the point that it is parallel to the picture plane, here it sweeps past the figures, the receding lines converging in a single focus below the Virgin's chin. That this uniform setting is intentional is proved by the construction of the central panel, where the upper edges of the throne are overlapped by the frame, establishing a backmost plane, while the rear-viewed angels mark the foreground and initiate the centripetal movement. But this perspectival unity remains an intellectual abstraction and is contradicted by the absence of light and atmosphere. As in Orcagna, volume is created by altering the value of each hue wherever the surface plane is broken. Thus, at the point where Bartholomew's cloak falls over the side of his arm the value abruptly darkens. As a result each surface has a solidity independent of the accidents of light or its position. Masaccio has taken this concept to its logical conclusion, rejecting even the use of harmonious col-

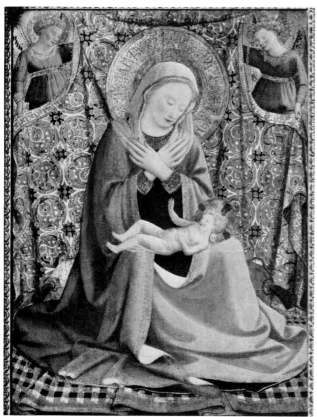

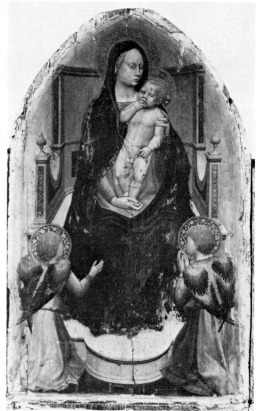

38 Workshop of Fra Angelico *Madonna of Humility*
National Gallery, Washington DC

39 Masaccio *Madonna and Child* (1422)
S. Giovenale, Cascia

ours. The violent contrasts in S. Giovenale's cloak, purplish-pink with a yellow
lining, or between the angels' robes and wings, the former in greyed pink, the
latter in bright orange, red, yellow, olive, and blue, are used to underline the
integrity of each surface. Just as the figures seem to be created from discrete plastic
substances, so there is no psychological focus to the altar-piece. The impassive
face of the Virgin and the concentrated stare of St. Anthony both proclaim a
self-absorption that precludes a shared focus. It is this heroic denial of conven-
tional sentiment, this concentration on form that separates Masaccio's earliest
work from those produced in Florence after the death of Orcagna.

In the S. Ambrogio altar (Fig. 41) the forms are as three-dimensional, the
gestures as resolute as those in the earlier triptych, but the figures share a common
ambience measured by perspective and illuminated from the left. The first tell-tale
sign of Masaccio's awareness of light as a means of asserting the homogeneity of
space occurs in the shadow cast by the Virgin on the grey-coloured dais. Despite
the poor condition of the painting this shadow seems to lack the subtlety of those

40

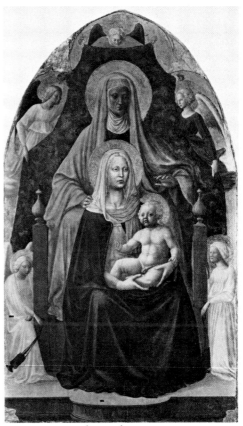

40 Andrea di Cione, called Orcagna *St. Peter*
(detail of *The Strozzi Altar-piece*) (1357)
S. Maria Novella, Florence

41 Masaccio and Masolino
Madonna and Child and St. Anne
Uffizi, Florence

found in the *Adoration of the Magi,* where edges often blur or fade into the sur-
roundings. It all the more firmly indicates the figure's position. The colours have
also undergone a transformation: they are more harmonious. The Virgin's pink
dress is less greyed and therefore better balanced with her yellow hair; the throne
has been neutralized in an attempt to focus attention on the figures. Again,
Masaccio has not achieved the tonal accord found in the *Adoration;* that would
have required too great a sacrifice in formal definition. Masaccio was not in-
terested in light as an end in itself but as a means of creating a more palpable
image. It is by a continued emphasis on the mass and solidity of the figures and
their concomitant seriousness of purpose that his painting differs most radically
from that of Gentile. Even in the Frick altar Gentile preferred softer forms, less
assertive expressions, and a composition enlivened by a continuous play of
curves. His paintings lack the finality which is present even in Masaccio's earliest
work by virtue of its perspectively constructed space. Yet these fundamental
differences cannot alter the historical fact that in those works Gentile painted

41

between *c.* 1420–23 he revealed to Florentine artists many of the tools Masaccio first employs in the S. Ambrogio altar. There is, indeed, a strong possibility that the S. Ambrogio *Madonna and Child with St. Anne* is a reaction to a specific work by Gentile. If it is set beside the central panel to the *Quaratesi Altar-piece* (Plate 48) similarities of layout are evident: the maroon-glazed cloth of honour used to close off the space, the frontal Virgin, the projecting dais, and the incidence of light from the left. In three places these affinities extend to individual motifs: Masolino's angels who peer around the sides of the throne depend upon those of Gentile; the topmost angel seen in foreshortening seems to derive from the tondo of Christ blessing; and the Virgin's veil, with its fine gold embroidery, repeats that of Gentile's Madonna. Each of these motifs has a precedent in Gentile's work, but represents a novel aspect in that of Masaccio and Masolino. If the apparent relation between these two panels is real, the changes Masaccio has made gain an added poignancy. It is also easier to understand that two works Gentile executed before the *Quaratesi Altar-piece* show no awareness of Masaccio's genius. One of these works is a *Madonna and Child* in the Harvard Collection at I Tatti, the other a *Madonna and Child* at Yale University.

The I Tatti *Madonna and Child* (Catalogue XII, Plate 44), though now a fragment, must have been one of Gentile's most delightful works, combining sure drawing with firm modelling and lively expressions. The Child's direct glance and open smile still arrest the viewer's attention. The brilliant colours of the Frick altar have been replaced by the more familiar, but also more delicate and harmonious, brocades, while the careful, overlapping haloes, the projected irises of the Virgin's eyes, and the dense highlighting of the faces evolve logically out of the earlier works.

Less fragmentary but more ruinous is the signed *Madonna and Child* at Yale (Catalogue XIII, Plate 45). In no comparable work did Gentile attempt a similar fiction of figures inhabiting a space that is an extension of the viewer's. Not only setting but attitudes enhance this impression. Physical action accompanies and underlines a more genial mood. Only the delicate touch of the Virgin restrains the Child from crossing the boundary between pictorial and real space, and her expression betokens pleasure at the admiration her Son has elicited. The conceit of the feigned window, sadly compromised by loss of the lower section, grows naturally out of Gentile's exploitation of the frame in the *Adoration of the Magi.* More than a century earlier Duccio had attempted a like fiction by depicting a ledge supported on corbels along the base of his Madonna and Child in the Stoclet Collection, and in Florence Bernardo Daddi had employed a window frame to separate the Virgin from lay donors in his altar-piece in the Museo dell'Opera del Duomo (Fig. 42). But Donatello's relief in Berlin, where the figures of the Virgin and Christ Child are compressed into a window frame viewed from below, is the closest parallel for Gentile's painting, where the window frame is shown as though viewed to the right of the central axis. The Yale painting stands at the head of a long succession of Madonna and Child compositions in which the play

of the frame, real or fictive, and the beauty of a foliated background provide the essential accompaniments to a mood of warm refinement. Domenico Veneziano's painting at Washington is perhaps the noblest heir to this tradition.

Though the perspective of Gentile's window casement remains empirical, the colours show a new logic. The vermilion found in the throne of the Frick altar is here used to colour the pillow on which Christ stands. It is brought into harmony, however, by the pink of the Madonna's dress. Moreover, by placing these higher-keyed colors in the foreground a progression is established into the picture, where the background is black. This logical manipulation of colour is the basis for the *Quaratesi Altar-piece* (Catalogue XIV, Plates 46–59 and colour plate D).

Evidently in the last years of the fourteenth century Bernardo Quaratesi had provided funds for rebuilding the church of S. Niccolò. In return the Quaratesi family's patronage of the side chapel of St. John the Baptist was transferred to the high altar. Construction may have been finished by 1418, the date that appears on a dedicatory stone once near the high altar; in 1421 Bernardo was called 're-staurator, innovator et benefactor ecclesie'. Though Bernardo was a prominent citizen – he was *Gonfaloniere* in 1419 – the undistinguished style of the church does not indicate much interest in the arts, and Gentile's altar-piece was probably commissioned by another member of the family: Bernardo died on 10 March 1423 while Gentile did not complete the *Adoration of the Magi* until that May. But no documentary record has survived beyond a transcription of the lost inscription on the altar-piece itself: OPUS GENTILIS DE FABRIANO 1425 MENSIS MAII.[44]

Vasari referred to the *Quaratesi Altar-piece* as the best work he had seen from Gentile's hand. Unfortunately, in the early nineteenth century the central panel and the predella were removed from the church and the altar-piece is now divided between several museums. Were it in the state of the *Adoration of the Magi* its qualities would be instantly perceived. As it is, an act of reconstruction necessarily precedes a proper evaluation (Plate 46). The central panel was originally joined to the sides in such a fashion that the springing of the arches was at the same height and the painted pavement at a continuous level.[45] There was an equal penetration of space such as is found in Angelico's later *St. Peter Martyr Altar-piece* at S. Marco.[46] This carefully controlled depth marks a decided departure from the normal practice of late Gothic Florentine painting, where the central image is usually placed deeper in space and therefore higher in the picture field than the side figures.[47] Here the Virgin's face is approximately level with those of the saints and her scale is more consistent with theirs than was traditional. Such unified planning within the painting was complemented by the frame, the five-panel arrangement of which eschewed the current formula of placing two side figures on a single, bi-lobed panel. Such a form necessarily generated surface movement between the frame's silhouette and the figures it contained. The form adopted here had been used for Orcagna's altar-piece now in the Accademia in Florence (Fig. 43).[48] This choice certainly represents a directive of Gentile, who employed much the same form in his frescoes in Rome and who seems to have

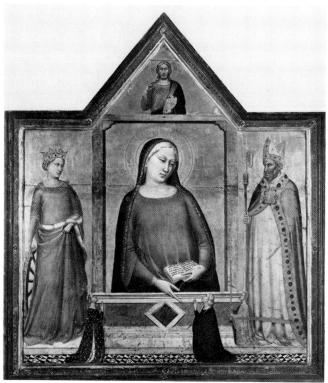

42 Bernardo Daddi *Madonna of the Magnificat*
Museo del Opera del Duomo, Florence

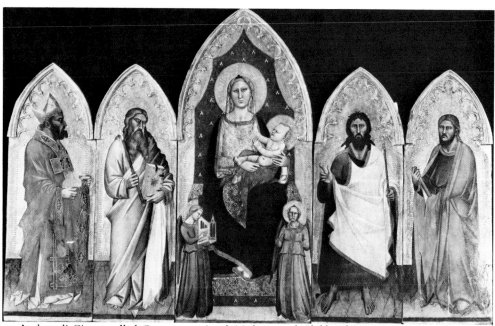

43 Andrea di Cione, called Orcagna, assisted *Madonna and Child and Saints*
Accademia, Florence

turned to Orcagna's work for general compositional ideas as well, as the posture of his Virgin and the gesture of St. John the Baptist reveal. This multi-panel altar-piece format had the advantage of laying equal stress on each figure without generating psychological or physical tension between them. By recessing the panels behind the gabled frame he extended the fictive space forward. When the panels were separated by applied colonnettes, the solution would have been one of great consistency, like viewing the figures through a loggia. Behind the frame the angled placement of the two end figures and frontal posture of the Virgin combined to create the impression of a semicircle. In the gables bust-length figures lean on and out of the circular mouldings, extending the concepts articulated in the *Adoration of the Magi,* and the halo of Christ is foreshortened in response to his posture.

In this scheme attention naturally focuses on the Madonna and Child (Plates 48–49). She is seated on a brocaded bench, surrounded on three sides by a curtain executed in a deep maroon glaze. The patterns on this carefully follow the folds at the sides and describe a tent-like top, creating a spatial box closed at the bottom by the upper surface of the bench. Three angels at either side gently push back the curtain to steal glimpses of the holy group, their presence recognized only by the smiling Child who holds a daisy. Thus isolated the Virgin appears both aloof and approachable. She is, perhaps, Gentile's greatest creation; a paragon of an ideal of earthly beauty in courtly surroundings as an analogue to the divine. At the same time, she is modelled with new force. In no earlier work had Gentile drawn such beautiful hands, nor combined so monumental a silhouette with gently flowing rhythms. In no previous work does his drapery reveal the underlying forms to an equal extent.

The colours of the central panel perfect those of the Yale painting. The pale pink carpet, ornamented with gold and dark green, gives way to the pale blue dress of the Virgin. These colours are set against the dark brocade and complemented by the pale lavender robes of the angels, whose deep salmon wings pick up the lining of the Child's blanket. As in the *Adoration,* so a tonal accord is struck here by means of a limited palette and an intermixing of hues. Again, the effect is to heighten the impression of a soft light, which is noticeable especially where the pavement darkens as it recedes. But so pale have the colours become, with the exception of the brocade, that highlights now tend towards white. The same principle that Domenico Veneziano was to employ in his altar-piece for S. Lucia de'Magnoli is here first expounded: a controlled value range produces an equal impression of sculptural form. This accord was but partly understood by Masaccio in the *Madonna and Child with St. Anne;* certainly one of the reasons he exchanged the pink dress on the Uffizi Virgin for the maroon glaze over tooled leaf in the Virgin of the Pisa Altar-piece was to ensure greater harmony with the deep blue cloak.

Each side panel establishes an accord based upon one of the hues of the central image: the Magdalene takes the maroon, Nicholas the green of Christ's blanket,

St. John the pink, and St. George a neutral silver leaf. The green pavement and leafed background bind the parts in a way not dissimilar to the pavement and architecture of Domenico's altar-piece. The whole scheme is repeated in the predella. In the first scene, of St. Nicholas's birth, the accord is based on a salmon-grey, while in the last, showing pilgrims at St. Nicholas's tomb, it is based on a brown-grey. The stormy sky in the central scene negotiates this progressive sequence as it changes from blue to grey-purple. These non-assertive colours enhance the slightly diffident expressions of the saints. Even the brilliantly realized figure of St. John, whose function is to call attention to the Virgin and Child, is not permitted to part the veil that seems to separate them from the spectator. In the context of a demonstrated rapport with the viewer's space, this containment is the firmest evidence of an ideal that renounces crass realism or illusionism as unsuitable to a sacred theme, even though an impression of sculptural form is greater than in any earlier work.

The predella scenes (Plates 55–59) especially attracted Vasari and, despite their generally poor state, they are among Gentile's most compelling narratives. Whether one turns to the scene of the saint's birth, where a satisfied baby firmly plants his foot on the edge of a tub while the golden blaze of the fire casts a warming glow on the floor and figures, or the scene where three youths, barbarously pickled during a famine, are resuscitated while the guilty landlord kneels in astonished veneration, there are always present those details culled from the world of everyday life which give heightened interest and a human dimension to the sacred stories. These observations, however, are scrupulously submitted to a consistent pictorial organization. A foreground wall or arch defines a plane just behind the picture surface. Originally a frame of small arches overlapped the architectural elements or, in the case of the storm scene, intersected the main figure, thereby clarifying this foremost plane. To assure even emphasis on each story, the architecture in three scenes recedes away from the central axis of the predella, and even the church interior is viewed from slightly off-centre. Spatial penetration is controlled by walls, stairs, and other objects placed parallel to the picture plane. The naturalistic observations are used to enliven this system. In the scene of St. Nicholas's birth, not only does the fire throw off a glow, but the sun has penetrated the three windows, leaving pools of light on the floor of the inner room and lighting the back of the left-hand servant. The garden outside is portrayed with a freshness recurring only later in the century. In the storm scene St. Nicholas appears in an aureole of yellow to pale coral and holds a torch with a gold and vermilion flame. The horizon curves and the churning sky darkens the sea below. J. Pope-Hennessy has rightly pointed to the lessons Angelico derived from study of such a depiction when he painted the *Martyrdom of St. Mark* beneath the Linaiuoli *Madonna and Child*. Of all the scenes that at Washington is perhaps the most beautiful. In the soft, half light of an ancient basilica, whose classicizing capitals are carefully depicted, a steady flux of pilgrims moves along the loosely determined orthogonals towards the dim apse, where a Renaissance, almost

44 Masaccio *St. Peter*
(detail of *The Tribute Money*)
S. Maria del Carmine, Florence

45 Masaccio *St. Peter*
(detail of *St. Peter distributing alms*)
S. Maria del Carmine, Florence

Ghibertian, tomb holds St. Nicholas's remains. At one point the cry of an obsessed woman breaks the magical silence. She is watched by a figure who has taken refuge behind a column, and by a priest in the still dimmer transept. Above the tomb Gentile has commemorated the five predella scenes in feigned mosaics surmounted by Christ, the Virgin, St. Nicholas, and the evangelists' symbols. On the triumphal arch the lower portions of a Romanesque Annunciation are visible, and the paintings range from a twelfth-century *Madonna and Child,* a thirteenth-century fresco of the Crucifixion, to fourteenth-century altar-pieces. These are all parts of a minutely observed event, perhaps taking place in the eleventh- or twelfth-century church of S. Niccolò, which was still standing in 1438.[49] Action is portrayed with human sympathy, exemplified by the touching glance which the healed cripple, bearing his crutches, gives to the man being carried to the sarcophagus. Such a scene retains its freshness even in a city that counted Fra Angelico, Filippo Lippi, and Domenico Veneziano among its artists.

The *Quaratesi Altar-piece* had an effect almost as great as the *Adoration of the Magi.* Its central image and general organization were the starting points not only for Angelico's *St. Peter Martyr Altar,* but probably also for Masaccio's *Madonna*

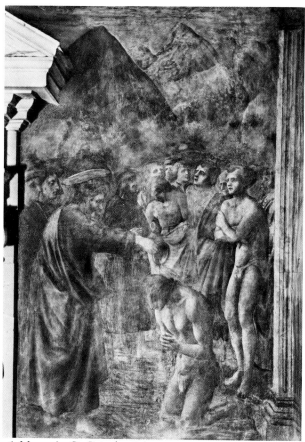

46 Masaccio *St. Peter baptizing*
S. Maria del Carmine, Florence

and Child with St. Anne. A lesser artist like Bicci di Lorenzo made references to it well into the 1430s, when he was evidently commissioned to copy it. In 1425, however, an event of far greater importance for Florentine art took place. Probably in late 1424 Masolino began frescoing two lunettes in the Brancacci Chapel. The following year he was joined by Masaccio, who painted *St. Peter baptizing* (Fig. 46) in a space on the end wall, and *St. Peter paying the Tribute Money* (Fig. 44) on a side wall. In style these frescoes must be contemporary with the S. Ambrogio altar (Fig. 41), but the narrative format offered Masaccio the opportunity to deploy his unparalleled gifts as a composer and dramatic story-teller. Possibly for the first time all the elements of the new pictorial vocabulary – one-point perspective, consistent illumination, mastery of figural construction, a naturalistic setting – were welded around a story of high moral content and represented on a monumental scale. No attentive artist could ignore the results. Not surprisingly, Gentile seems to have been among those most impressed. Though he left for Siena sometime in June 1425, he had time at least to design a work that documents

his first reactions to these frescoes. It is a dossal which shows St. Bernard on the far right, at the opposite end St. Louis of Toulouse, in the centre the Virgin and Christ imploring God's mercy, and in the remaining scenes a Resurrection of Lazarus and SS. Cosmas, Damian and Julian meeting on a street (Catalogue XV, Plates 60–62). The first mention of this work dates from the mid-nineteenth century, but the iconography leaves little doubt that it was commissioned to commemorate Bernardo Quaratesi's death. The appearance of his patron saint and the references to the Resurrection prove this as much as the provenance from S. Niccolò. It is in a lamentably bad condition and a workshop hand seems to have been responsible for the execution, but there can be no doubt that Gentile designed the scenes. Only he could have conceived the receding row of buildings behind SS. Cosmas and Damian, or the hills behind the Resurrection of Lazarus, dotted with small houses and rows of vines. The composition of that scene, with the tight group of onlookers and the reciprocal action of Christ and Lazarus, is modelled on Masaccio's *St. Peter baptizing* (Fig. 46). The stern rhythms of the fresco are here quick and curving, elaborating on indications in the background figures. The accentuation of these rhythms is due to the assistant, but evidence of Gentile's first contact with Masaccio is clear; a contact of consequence for his future works.

IV ~ SIENA AND ROME

ON 22 June 1425 Gentile rented a house in Siena for two and a half months while he worked on a polyptych for the notaries of the city. Completed the following year, it was placed outside their palace on the Piazza del Campo beneath a protective baldachin (Fig. 47). Fazio saw it in the middle of the century and described it as 'the Mother Mary holding the Christ Child in her lap as if she would wrap him round with fine linen, John the Baptist, the Apostles Peter and Paul, and Christopher carrying Christ on his shoulders'. Below, in a tondo, was portrayed the dead Christ in a sepulchre with an angel to either side. Of this nothing survives, though a painting done one or two years later for the church of SS. Cosma e Damiano in Rome, now at Velletri, seems to echo the composition in so far as the iconography and the type of intarsiated bench depicted in it are frequently encountered in Sienese art. A similar painting certainly lies behind the transformation between the centre panels of Giovanni di Paolo's first two dated works: the *Pecci Altar-piece* of 1426 (Fig. 48), with its traditional composition reminiscent of Taddeo di Bartolo, and the *Branchini Altar-piece* of 1427, in which the action of the Child and the expression of the Virgin have been thought out anew (Fig. 49). The naturalistic depiction of flowers in both confirms Gentile's rising influence, while a predella scene of the Entombment from the *Pecci Altar* makes an overt reference to one of his favourite devices: St. John casts a shadow over a golden light emanating from the tomb chamber (Fig. 50). The peculiar iconography of this scene was repeated only once, by one of Gentile's earliest followers in Florence, Arcangelo di Cola. His version shows a landscape of rounded hills to the right of the figures illuminated by the evening sun, whose rays are incised into the gold background (Fig. 51).[50] The three crosses cast long shadows and the path is strewn with pebbles. Thus, both representations seem to reflect a prototype by Gentile. He alone could have conceived of an evening Entombment or the lit tomb chamber – though for a Resurrection. Very possibly his polyptych was adorned with a full predella, since only in Siena could Giovanni have studied such a scene in 1426. Arcangelo probably passed through the city on his return from Rome, where he had gone in 1422, or while journeying from Camerino to Florence in 1427.[51]

Giovanni's predella is apparently only one piece of evidence relating to Gentile's presence in the city. Two years before his arrival Giovanni di Stefano, known as Sassetta, had been given a commission for an important altar-piece by the Arte della Lana. Work must have been well advanced in 1425, since it was completed by December of the following year.[52] Those parts that have survived

47 Piazza del Campo, Siena (with indication of position
of Gentile's lost Altar-piece)

48 Giovanni di Paolo *Madonna and Child*
(signed and dated 1426)
Castelnuovo Berardenga

reveal to what an astonishing degree Sassetta revived and developed the century-
old modes of the Lorenzetti brothers. Space is penetrated with a regularity and
audacity paralleled only in their paintings, and the landscapes elaborate on hints in
Pietro Lorenzetti's predella to the Carmine altar-piece in the Pinacoteca of Siena.
However, as the scene with the temptation of St. Anthony at Siena reveals,
Sassetta enveloped the rocky slopes and triangular trees in a true atmosphere.
Ambrogio's vast bird's-eye panorama of southern Tuscany in the Palazzo
Pubblico may have provided the model for the central panel, which showed a
monstrance supported by music-making angels above a landscape with two for-
tified towns or castles. It is possible that the two landscapes in the Pinacoteca at
Siena, usually ascribed to Ambrogio, are in fact fragments from this panel (Fig.
52).[53] Such an artist must have been deeply impressed by the naturalistic elements
of Gentile's art. Were it certain that the notaries' polyptych included a predella of
the Passion, it would be possible to attribute some of the remarkable atmospheric
feeling of Sassetta to contact with the foreigner. There are other hints of such an
influence. The blazing fire in the predella scene showing the burning of a heretic
(Fig. 53), in the National Gallery of Victoria, Melbourne, is created by laying
pigment over gold – as Gentile did in the *Birth of St. Nicholas*. Some of the

51

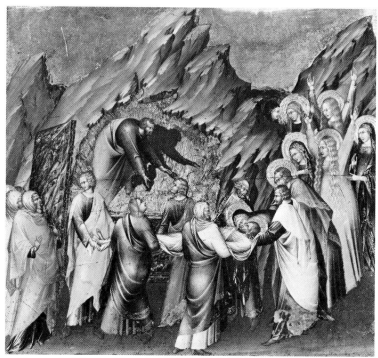

49 Giovanni di Paolo
Madonna and Child
(signed and dated 1427)
Norton Simon Museum, Pasadena

50 Giovanni di Paolo *The Entombment* (1426)
Walters Art Gallery, Baltimore

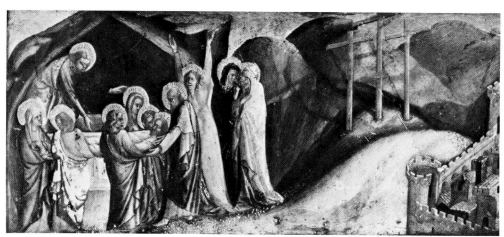

51 Arcangelo di Cola *The Entombment*
Private collection, Florence

garments are executed in oil glazes over tooled leaf, an uncommon but not un-precedented technique in Siena. The most tantalizing suggestion involves the composition of the scene of the *Miracle of the Host* at the Bowes Museum (Fig. 54). The manner in which Sassetta has closed off the composition with a group of figures, one of whom stands in profile view, is an invention of the highest order not readily paralleled in Sienese painting. The spatial implications of such an arrangement strongly recall a small, much overpainted work by Gentile depicting the *Stoning of St. Stephen* (Catalogue XVI, Plate 63), datable close in time to the *Quaratesi Altar-piece.* The source for this composition is a panel by Bernardo Daddi which had great currency in the fourteenth and early fifteenth centuries. Gentile's is based upon one of the later versions. He has, however, made the group of executioners more coherent by the addition of several figures and by emphasizing a semi-circular arrangement, thereby elaborating upon a compo-sitional device of Masaccio's employed earlier in the *Resurrection of Lazarus.*[54] It is possible that Sassetta's painting reflects this or a similar predella scene by Gentile, as both technical details and the emotional tenor suggest.

Whether or not Sassetta turned to models of Gentile's at this time, arrived at such a composition independently, or had early contact with Masaccio at Pisa, as others have supposed,[55] it is undeniable that the human sympathy and rich surface texture characteristic of Gentile's work made a deep impression on the young Sienese artist. This is proved by the *Madonna of the Snow,* undertaken in 1430, which looks both to the *Quaratesi Altar-piece* and to the fresco Gentile painted in Orvieto.

Shortly after August 1425, Gentile interrupted work on the notaries' com-mission to paint a Madonna and Child in the left aisle of the cathedral of Orvieto (Catalogue XVII, Plates 64–69). It must have been finished in October, when he was paid eighteen gold florins. Despite sixteenth-century alterations to its setting it remains an impressive image. A monumental Virgin with her Child impetu-ously leaning towards the viewer is seated on a gold, brocaded throne raised on a Gothic dais. The whole is projected from a low view-point. The sides of the dais slope downwards and the underside of the Madonna's chin is visible. Originally an architectural niche, still partly visible, framed the figures, giving depth and resonance to the composition (Plate 69). The outward extension of this frame was created by a feigned marble moulding surmounted by a Gothic arch decorated by a feigned mosaic without and small coffering on the intrados. The dais rested on a ledge in front of this. Spatial penetration was controlled by a simple, intarsiated wainscoting, above which appears a gold background with tooled angels. Both these and the central figures are off-centre, the view-point being both below and to the left. Though the frame develops naturally out of Gentile's earlier works, especially the Yale *Madonna and Child* or the shallow tent of the Quaratesi Virgin, the complication and projection of the fresco imply fuller perspectival knowledge than Gentile had yet displayed. There can be little doubt that he was approximat-ing the most recent and remarkable perspective demonstration of the early Quat-

52 Sassetta (?) *Landscape fragment*
Pinacoteca Nazionale, Siena

53 Sassetta *The Burning of a Heretic*
National Gallery of Victoria, Melbourne

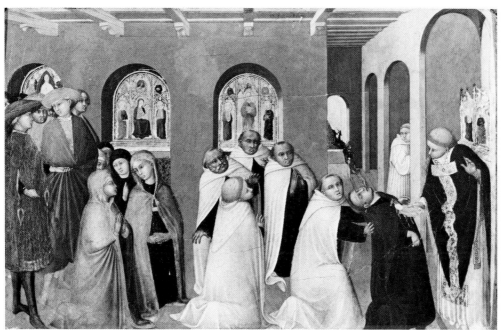

54 Sassetta *A Miracle of the Host*
Bowes Museum, Barnard Castle

trocento: Masaccio's Trinity fresco in S. Maria Novella (Fig. 55).[56] From that work Gentile has derived not only the play between projection from and penetration into the wall, he has repeated the receding shape made by the pink architrave. In this illusion he has used an approximative method which could not have coped with the detailed precision of Masaccio's coffered vault, but he strove for a similar effect, using the niche to heighten the impression of reality by insisting upon the actual presence of the Virgin and Child, now fully corporeal to accord with less courtly surroundings. Fazio probably wished to allude to such an effect when he declared '. . . to this it seems nothing could be added', while an official proceeding involving the *opera del duomo* in December 1425 refers to the fresco in laudatory terms. In few works of the following decade would artists show such an intelligent exploitation of an invention stemming from Masaccio. By comparison Domenico Veneziano's Carnesecchi tabernacle is tentative; its space confused by the meeting of frame and throne; the figures victimized by a tunnelling perspective.

Upon completion of the Orvieto fresco, Gentile returned to Siena[57] before travelling to Rome to work in S. Giovanni Laterano. As cathedral of the city the basilica had been among the first monuments with whose restoration Martin V was concerned, but work was necessarily slow. When Martin arrived in Rome on 30 September 1420, the churches were in disrepair, the streets deserted, and the

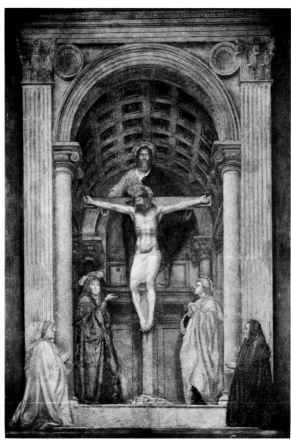

55 Masaccio *The Trinity*
S. Maria Novella, Florence

inhabitants living in squalor. 'What more?', exclaims Platina, 'neither the aspect
of a city nor evidence of city life was to be seen'. Streets had to be cleaned and
brigandage controlled. In addition, the Pope had to contend with opposition to
his attempts at establishing his authority in the region. When at last he could
attend to restoration of the Lateran, he had first to provide for a new roof. Then,
on 1 July 1425, provision was made for restoring the pavement, and, beginning
on 28 January 1427, Gentile was paid a salary for decorating the walls above the
north nave arcade with a fresco cycle showing the life of St. John the Baptist and
monochrome figures of prophets in niches between the four windows, 'repre-
sented in such a way as to appear not painted, but portrayed in marble'.[58] The
narrative scenes were completed in 1431–32 under Pope Eugenius IV by Pisanello.
Gentile's scheme and one of the five prophets are recorded in a drawing done in
Borromini's studio before their destruction (Catalogue XIX, Plates 72–74). The
divisions of the *Quaratesi Altar-piece,* the low view-point and the free movement
of the figures of the Orvieto *Madonna and Child* were all marvellously developed

56

56 Donatello and Michelozzo *Tomb of Pope John XXIII* (detail)
Baptistry, Florence

in this decoration. The prophet Jeremiah stands on a receding dais placed in a shell
niche enclosed by a tripartite gothic frame, whose tracery recalls details of the
Orvieto fresco. Applied colonettes rest on fluted bases similar to those first used
on the *Porta della Mandorla* of the Florence cathedral, while the inscription, as in
the halo of the Orvieto Virgin, is comparable to the most evolved letters on
Ghiberti's second bronze doors or Donatello's tomb of John XXIII (Fig. 56).
Below a feigned cornice are half-length prophets in arched balconies, between
which hangings with the evangelists' symbols are suspended. The upper portion
of one of these prophets, by an assistant, has survived. Such details as the fore-
shortened halo confirm the accuracy of the seventeenth-century drawing. The
projection lacks the precision Brunelleschi's perspective method would have con-
ferred, but especially in the feigned, full-length statues of prophets Gentile's art
shows a new complexity and grandeur that make the cycle a fitting harbinger of
Rome's renewal. Indeed, the general layout seems to have served as a model for
the decoration of the Sistine Chapel, where figures of popes in fictive niches be-
tween the windows surmount scenes from the Old and New Testament.

Besides the fresco fragment in the Vatican, the only remnant of these last
years is the *Madonna and Child* now at Velletri (Catalogue XVIII, Plates 70–71),

57

which was evidently commissioned by Cardinal Ardicino della Porta to celebrate the nine hundredth anniversary of the founding of SS. Cosma e Damiano. It shows the defects of a work done in haste with the help of an assistant, but also preserves autograph passages of high quality. The strong modelling of the Child's and the Virgin's faces marks the continuing tendency to robustness and an expressive intensity avoided in the *Quaratesi Altar-piece*. Despite the enormous loss in the paint surface, the composition is clearly less curvilinear than in earlier works, and the placement of the Child is both bolder and simpler. Harmonious pale blues, greens, and pinks have been replaced by an accord of earth tones: a brownish grey bench, a veil of brownish purple, a deep blue robe, and a bright orange and vermilion floor. These stronger, less ethereal colours lend a mundane cast to the image and establish a progression from a warm foreground to a cooler background. The brilliant pavement also acted as a foil for the bulky shape of the figures, while the bold highlights on the bench result from a more intense illumination than previously found. Though abrasion has altered the fragmentary surface of the painting, Gentile's attempt to approximate Masaccio's serious manner is apparent. The Velletri *Madonna and Child* thus testifies to an expansion of means and a more concrete expressive goal. This new direction was not accompanied by hesitation but it is not possible to know the outcome of this broadening scope. On 2 August 1427 Gentile received his last payment at S. Giovanni Laterano and by 14 October he is recorded as dead.

V ⨍ CONCLUSION

GENTILE'S POSITION in the history of fifteenth-century Italian painting is unique. He has been called a typical representative of the International Gothic style, but his diversity of contacts and the breadth of his interest in the phenomena of nature were without parallel among contemporary artists. To an unusual degree he has been the victim of arbitrarily applied art historical categories and critical lassitude. Nowhere is this more apparent than in the myths surrounding his origins and a misunderstanding of his development.

At one time or another Gentile has been linked with every centre of Italian art. Vasari's notion that he was the pupil of Fra Angelico is easily dismissed, but even such astute critics as Crowe and Cavalcaselle accepted the alternative tradition that he was taught by Allegretto Nuzi and influenced by Taddeo di Bartolo. Since then some have hypothesized the effect of Venetian art on his formation, while recently attention has focussed on Lombardy and Orvieto, divorced though each of these centres were from each other. The problem of Gentile's origins was compounded by the feeling that it was impossible to date any of the early works with precision, and proposals for the date of his birth have oscillated between *c.*1360 and *c.*1380. In response to this confusion the sequence of his works has been permitted an incoherence explained away by reference to his love of travelling: he was made the victim of scholarly perplexity. But when, beginning in 1408, his activity is documented, his movements prove to have been determined by specific commissions rather than by personal volition; and his works may be shown to exhibit a perfectly coherent development. The very fact that the three earliest paintings were done for churches in or near Fabriano should have led to a re-examination of local and Marchigian art, for Gentile's awareness of Lombard miniatures is paralleled in the contemporary work of the Salimbeni and Ottaviano Nelli, while the possibility of cultural ties with Venice is suggested by a series of Venetian altar-pieces from Pesaro to Teramo. A northern orientation, as against Nuzi's Florentine background, finds a parallel in the political climate of the Marches, for not only the Malatesta, but the Chiavelli had political ties with both Milan and Venice. The presence of works by Zanino di Pietro near Fabriano is tangible evidence of cultural ties with the latter city. Zanino's work, moreover, seems the key to Gentile's formation as documented in the Perugia *Madonna and Child*.

Local events provided the background of Gentile's first paintings, and it is possible that the citizenship of Zanino or the political contacts of Chiavello motivated his move to Venice. Motherless by 1390, orphaned in 1400, he had few

59

personal reasons for remaining in Fabriano. Gentile's biography thus parallels in a surprising fashion that of Raphael a century later. In both cases the move from the Marches to a major artistic centre provided the opportunity of transforming a provincial style into one of cosmopolitan sophistication through contact with the leading artists of the day. In 1410 this meant contact with a representative of the International Style.

Ever since Courajod first used the word 'international' to describe the common traits of a group of artists painting at the end of the fourteenth and beginning of the fifteenth centuries, the term has suffered from the sort of abuses familiar to writers on Mannerism. On the one hand, its chronological limits have been extended to include artists, like Giovanni di Paolo, who responded to a historical situation markedly different from that prior to *c.*1430. On the other hand, it has lost precise meaning through its application to the Master of Flémalle or Gentile da Fabriano – for both of whom approximation to the dominating style of the preceding generation represented an early phase of their development. There is, however, no question that a great number of paintings produced between *c.*1380 and 1430 show a striking uniformity explicable only by a common social background and cross-fertilization. In works like the Wilton Diptych in the National Gallery, London, the Třeboň Altar at Prague, and Stefano da Verona's *Madonna and Child with St. Catherine* in his native city, a feeling for strongly modelled form is combined with a love of fine features and elegant postures, careful transcriptions of flora and fauna are subsumed into a sinuous surface pattern, and overt expressions are eschewed in favour of textural richness. The disparate achievements of earlier regional schools are miraculously synthesized so that the works possess a superficial complexity and sophistication justifying their widespread appeal and predominance over local traditions. Gentile's *Coronation of the Virgin* at Milan pays homage to one of the leading masters of this style, Michelino da Besozzo.

In terms of Gentile's earlier paintings there can be little doubt that this phase in his career marks a measurable advance in mastery of pictorial form. Especially the manner in which Michelino gave unity and generated movement in his compositions by a system of responding colours and curving forms was novel to Gentile. Indeed, Michelino stands at the centre of artistic events in the Veneto in the second decade of the century. This fact is responsible for the confusion which persists between the early paintings of artists like Gentile, Giambono, and Pisanello. All three are of the same generation; Pisanello may have worked in Venice during the years of Gentile's and Michelino's activity.[59] In Giambono's altar-piece at Fano the Virgin seems to echo Gentile's painting in the Metropolitan Museum, but the Child type proves that in both cases the source is a lost work by Michelino – re-evoked by Giambono at a distance of perhaps two decades.[60] Even the superficial resemblances between the figures of Pisanello's earliest certain work, the *Annunciation* at S. Fermo, Verona, and Gentile's Milan *Coronation of the Virgin,* seem best understood in terms of a common background – or at least by

taking account of Stefano's role as a transmitter of Michelino's style. The heavy, flowing drapery, waving wisps of hair, the distended haloes, and the manner in which the Child's posture is described by two successive curves are elements derived either directly from Michelino or through Stefano. Just as the similarities between these artists depend upon a common experience, so their fundamental differences stem from a preceding, local training. A Venetian ambivalence to structural logic is present in Giambono's works as late as *c*. 1440, while Pisanello's architecture and landscapes and the relation of figure to space derive from Altichiero. Gentile alone shows no debt to the moribund traditions of his native city. Once the common sources and regional differences are recognized, much of the confusion surrounding the early works of these artists disappears. In the series of paintings depicting events from St. Benedict's life, now divided between the Uffizi and Poldi-Pezzoli museums, the undulating rhythms of the figures and the soft modelling of the forms has been considered a reflection of the Venetian works of Gentile and proof that Pisanello – their presumed author – was his pupil. In fact the relation is not with the more staid figures of the *Coronation of the Virgin* but with the ductile ones of Michelino, and the contracted space of the architecture reveals a Venetian approach to representation for which there is no parallel in Pisanello's paintings. The series thus stands at the head of a new pictorial mode in Venice whose catalyst was Michelino.

Of the above three artists, it is Gentile whose contact with Michelino is the best documented, and whose subsequent transformation of the International Style was the most radical. Even in Pisanello's mature fresco of *St. George and the Princess of Trebizond* in S. Anastasia, Verona, the notion that man is but part of an infinite space infused with light – as expounded in Gentile's *Adoration of the Magi* – is only hinted at. Depth is suggested by a succession of overlapping elements disposed like stage wings and by a radical diminution in scale – as in frescoes by Altichiero. The result is a series of spatial compartments which inhibit free movement. Light is evoked by the traditional method of placing lighter values to the same side of each object. Pisanello's genius resided rather in his acute transcription of details and an uncanny gift for characterization. Oddly enough, Gentile evidently made the first essays in what became the style of the *Adoration of the Magi* while employed as a court artist on the periphery of Lombardy in competition with Michelino.

This paradox makes an analysis of Gentile's relation with his patrons and an evaluation of the part they may have played in the creation of a work like the *Adoration of the Magi* difficult. Indeed, in the case of Pandolfo Malatesta, there is virtually no evidence: nothing remains of his artistic projects in Brescia, and the surviving documents relating to Gentile's fresco testify only to a taste for opulent materials. Yet there is a strong possibility that while there Gentile came into contact with Franco-Flemish painting – at least panels, perhaps manuscripts – from the most advanced artists. This may have been due to chance or the result of Pandolfo's interests as a collector.

With Palla Strozzi there are firmer grounds for speculation. His place as one of the leading intellects in Florence is testified not only by such contemporaries as Vespasiano da Bisticci, but by the variety of classical texts he collected and studied.[61] Moreover, as one of three supervisors over Ghiberti's first bronze doors for the baptistry, he was intimately involved with artistic events in the city. Significantly, he seems to have commissioned Ghiberti to design the building for which Gentile's *Adoration of the Magi* was the principal ornament. This building has survived with only minor alterations. It is essentially a traditional Gothic structure and bears an abundance of medieval heraldic devices, but such novel elements as the fluted columns of the entrance door, the triangular pediments of the exterior windows, and the double-sided tomb with its decoration of putti, are as unmistakably humanist in intent as the letters on the sarcophagus and dedicatory plaque, or those with which Gentile signed the altar-piece. The fact that Palla may have employed Donatello as well as Ghiberti underlines his patronage of the most advanced artists of the day.[62] His preference of Gentile over Lorenzo Monaco, who in 1422 was the leading local painter, ought to be evaluated with this in mind.[63] All the same, the religious content of Gentile's painting necessarily limited its value as a direct symbol of classical culture. The reasons Palla was moved to choose Gentile – excluding those of celebrity or skill – consequently depended more upon ideas he may have had about painting. These ideas, it is legitimate to assume, must have been similar to those of his teacher, Manuel Chrysoloras, and of a fellow pupil and contemporary, Guarino of Verona.

Chrysoloras, it seems, was the source for a peculiarly literary approach to the visual arts among early fifteenth-century humanists.[64] This approach was conditioned by the *ekphrasis,* a descriptive poem or essay. As in any criticism based upon description, those *ekphrases* which were composed around paintings emphasize copious variety as a measure of greatness. Similarly, individual expressions are praised. One of these poems by Guarino, dating from around 1427, is addressed to Pisanello and may serve as an example of the genre:

> . . . you equal Nature's works, whether you are depicting birds or beasts, perilous straits and calm seas; we would swear we saw the spray gleaming and heard the breakers roar. I put out a hand to wipe the sweat from the brow of the labouring peasant; we seem to hear the whinny of a war horse and tremble at the blare of trumpets. When you paint a nocturnal scene you make the night-birds flit about and not one of the birds of the day is to be seen; you pick out the stars, the moon's sphere, the sunless darkness. If you paint a winter scene everything bristles with frost and the leafless trees grate in the wind. If you set the action in spring varied flowers smile in the green meadows, the old brilliance returns to the trees and the hills bloom; here the air quivers with the songs of birds.[65]

The naturalistic bias of such a poem could serve as a basis of appreciation for a painting like the *Adoration of the Magi*. The nocturnal predella scene, which takes place in the dead of winter; the warming rays of the sun and flower-filled meadows of the *Flight into Egypt;* the rapt faces in the *Epiphany* and careful

transcription of birds and beasts; these constitute some of the real beauties of Gentile's altar-piece. In fact, Gentile was one of the three artists Guarino most esteemed, and his pupil, Fazio, shared this choice. When it is recalled that Guarino was in Florence between 1410 and 1414, during which time he received the letters from Chrysoloras which gave the strongest impulse to a concern for the visual arts, then it does not seem improbable that Palla's choice of Gentile was motivated by similar criteria. He may even have envisaged a programme that would give Gentile an ample opportunity to display his skills, but this is pure conjecture and gains little support from the matter-of-fact approach of surviving artists' contracts from the early fifteenth century. The problem is twofold. First, with few exceptions – Alberti and Fazio being among the most conspicuous – humanists seem to have had little real regard for the visual arts. Despite his influential writings in praise of Pisanello, even Guarino considered paintings vastly inferior to literary descriptions of the same subject. Secondly, the *ekphrasis* depended less upon the actual qualities of the picture it might describe as a determining factor of what it praised, than upon a well-established tradition of what should be said. When Manuel II Paleologus visited Paris between 1399 and 1402 he composed an *ekphrasis* much like Guarino's about a tapestry that he had seen. Those tapestries which have survived, while filled with incidents and an abundance of animals and flowers, show none of the naturalism one would expect from the poem. Thus, while this humanist background may have heightened Palla's appreciation for various qualities of the *Adoration of the Magi,* it is not legitimate to posit a causal relation between humanism and the altar-piece.

In one of the letters Manuel Chrysoloras wrote from Rome during his two-year stay beginning in 1411, he remarked that 'we admire not so much the beauties of the bodies in statues and paintings as the beauty of the mind of their maker'.[66] While he intended something quite different, there is little doubt that the major barrier between artists and patrons of high social standing in the fifteenth century was the fact that artists were regarded as craftsmen with little intellectual capacity. At the end of the century artists still battled against that prejudice. Gentile may have been something of an exception. This conjecture is based upon his one autograph letter requesting a safe conduct from Pandolfo (Doc. IV). The handwriting is clear and elegant, the grammar correct. Most unusual is the way Gentile expresses his wishes in a forthright manner, without any of the toadying found in the similar correspondance of Domenico Veneziano, Filippo Lippi, and Benozzo Gozzoli when dealing with the Medici. It is also notable that among the various payments made by Palla for the chapel, only Gentile is continually referred to as 'maestro Gentile da Fabriano' rather than the more common 'Filippo di Giovanni maestro di murare', 'Ventura di Moro dipintore'. Few of the later surviving documents refer simply to 'Gentile da Fabriano' – at Orvieto and Rome the prefix 'egregio' often appears. These hints lend credence to the legend Sansovino recorded in the sixteenth century that Gentile's reputation was so great that he dressed in open sleeves. However, the image that emerges of

Gentile's intellectual stature may be misleading. It is true that Gentile was attentive to such details as pseudo-cufic script and humanist letters as few others were; such things were of great importance to his patrons. The fact remains that the *Adoration of the Magi* is a revolutionary work not because of the social standing of its artist or its relation to the hypothetical taste of a Palla Strozzi, but because it expounds a new relation between painting and experience.

The *Adoration of the Magi* stands at the very centre of fifteenth-century Italian art. On the one hand it is a *summa* of medieval painting techniques as presented in Cennino Cennini's *Libro dell'arte*. On the other hand it firmly repudiates the notion that the value of art is its ability to symbolize sacred truths. It also alters the balance between an aesthetic norm and a study of nature as postulated by Michelino and his contemporaries. The distant vistas unified by a careful study of light, the differentiation of figure types, the manifold aspects of nature crystallized in its several panels, concretize an interpretation of painting as an extension of visual experience. In 1423 this was a novel idea among Florentine painters, though the Master of Flémalle was, contemporaneously, giving form to it north of the Alps. Its importance is proved not only by the immediate impact but in the long-term effect of the *Adoration*. It is significant that whereas there are no copies of works by Lorenzo Monaco after the mid-1430s, when Andrea di Giusto executed his altar-piece at Prato, the *Adoration* served as a model throughout the fifteenth century to artists as diverse as Benozzo Gozzoli and Giovanni di Paolo, Cosimo Rosselli and Benvenuto di Giovanni. The reason its historical position has received so little attention is due partly to the technical means Gentile employed, which have seduced even the most sensitive critics, partly to the blinding effect of art-historical categories, especially that of International Gothic, and partly to the fact that Gentile's innovations were quickly dwarfed by those of Masaccio. Interchange between these two artists is none the less evidenced, though in Gentile's case it was limited to those works Masaccio seems to have painted before 1426: the *Madonna and Child with St. Anne* and the frescoes of the upper tier of the Brancacci Chapel, and the *Trinity* in S. Maria Novella. These works already exhibited an approach to picture-making that was foreign to Gentile. In a fresco like the *Tribute Money,* the vanishing point and dramatic focus coincide, figures are grouped according to clear, geometrical configurations – especially the circle projected into space – and the intensity and incidence of light play uniformly on the forms. In the later works – the altar-piece executed for the Carmelite church at Pisa, the frescoes of the lower tier of the Brancacci Chapel, and the panel of SS. John the Baptist and Jerome now in the National Gallery, London – Masaccio went even further, achieving a new kind of pictorial unity through an interaction rather than a co-ordination of these elements. Space is still defined by perspective and geometric forms, but frequently a dramatic tension is generated by opposing the narrative to the spatial focus. When St. Peter heals with his shadow, his movement is directed against the recession of the buildings, and the vanishing point is outside the picture field. The Madonna of the Pisa altar-piece

and St. Peter on his cathedra rise above the focus indicated by their thrones, and thereby gain in grandeur. By such means the static world of the earlier scenes is activated. To a similar end the previous accord between light and form is discarded. Masaccio abandoned the traditional mode of continuous modelling, which emphasized the actual construction of individual features, and concentrated on the way form is revealed by light (Figs. 44, 45). In his last works the appearance of any form is determined by the nature of its setting just as the expression of individual figures depends upon the dramatic content of the event. The rich language of these paintings was the starting point for a new generation of artists. Gentile, unlike Masolino, never saw them. It may be conjectured that even if he had the effect would have been inconsequential. Gentile perceived and imitated the external phenomena of nature, but even in works like the Orvieto fresco and the decorative scheme at S. Giovanni Laterano, where he attempted to achieve the finality of a perspective setting, her laws remained mysterious.

Recognition of the limitations of Gentile's art does not diminish his historic role in the evolution of Renaissance painting and should not obscure the influence his works exerted after Masaccio's death. Not only the predella scenes, but the central image of Angelico's Linaiuoli tabernacle owe more than a little to the example of the *Quaratesi Altar-piece*. The rich brocades defining a shallow niche and the warm humanity of the Virgin and Child were unique in their time. When Angelico was commissioned to paint the *Deposition from the Cross* for the sacristy of S. Trinita, Gentile's *Adoration of the Magi* served as the model for relating large figures to a distant landscape enveloped in soft light. Sometime in the 1440s Domenico Veneziano relinquished the stronger colours and assertive forms of his *Madonna and Child* at Bucharest for others which, as already noted, recall in a striking fashion the procedures of Gentile. So similar is the effect produced by Domenico's *Madonna and Child* at I Tatti to that of images by Gentile that it has been adduced as proof that Domenico was his pupil. In examples like these it is apparent that the pictorial logic of Masaccio had not resolved the problems which naturally occurred when artists attempted to speak the new language while still using forms and materials sanctioned by time and often dictated by a tradition-minded public. A decade passed after Masaccio's death before the creation of the S. Marco altar-piece with its rectangular, open picture field and a naturalistic setting organized according to the laws of perspective. At the middle of the century Piero della Francesca was still required to accommodate his style to a multi-panelled, gold background format. Gentile's use of gold and the structure of the *Quaratesi Altar-piece* must have seemed as relevant to these artists as anything Masaccio had left.

To an unusual degree the history of Florentine painting between the years 1420–40 chronicles the resolution of problems posed by a new relation between painting and nature. In this history Gentile played a primary role. But the enduring appeal of his works depends less upon their historical place than upon their peculiar qualities. The wealth of details, textural richness, warmth of expression,

and the primitive's fascination with the world of appearances that are found in the *Adoration of the Magi* or the *Quaratesi Altar-piece* still constitute their fundamental novelty.

NOTES

Introduction, pp. 1–2

1 Gentile's name is followed by those of Fra Angelico and Pisanello. J. D. Passavant (*Raphael d'Urbin et son père Giovanni Santi,* Paris, 1860, vol.I, p.427) prints the relevant passage of the rhymed chronicle.

2 G. Cavalcanti, *Istorie fiorentine,* Tip. all'Insegna di Dante, Florence, 1839, vol.II, p.499.

3 F. Biondo, *Italia illustrata libri VIII,* Regio quinta Picenum sive Machia Anconitana incipit, 1453.

4 All quotes from the *De viris* are taken from M. Baxandall (*Giotto and the Orators,* Clarendon Press, Oxford, 1971, pp.103ff.) who also analyses the terms employed. The most up-to-date biographical information on Fazio is in P. Kristeller, 'The Humanist Bartolomeo Fazio and His Unknown Correspondence', *From the Renaissance to the Counter-Reformation: Essays in Honor of Garrett Mattingly,* ed. C. Carter, Random House, New York, 1965, pp.56–74.

5 Because the painters Fazio discusses are two non-Florentines, Gentile and Pisanello, and two Flemings, Jan van Eyck and Rogier van der Weyden, he is often characterized as a typical representative of courtly patronage. This opinion is unjustified. On the one hand, Fazio heaps praise on Donatello, who he says is "approaching very near to the glory of the ancients', as well as Ghiberti. On the other hand, there is no doubt that he had read Alberti's *De pictura.* Fazio's direct knowledge of Florentine art dates from the 1430s, at a time when Fra Angelico, Filippo Lippi, Domenico Veneziano, and Paolo Uccello had not yet produced the masterpieces for which they are remembered. The single, surprising omission is Masaccio's name. But if one excepts Alberti's reference to Masaccio in his dedication in *Della pittura* of 1436, it is quite clear that his stature was only recognized by critics – as opposed to artists – later in the century. It has, in fact, been suggested that Alberti was referring to the sculptor Maso di Bartolomeo rather than to Masaccio, whom he probably never met and whose death eight years earlier is not noted. See H. Janitschek, 'L. B. Alberti's kleinere kunsttheoretische Schriften', *Quellenschriften für Kunstgeschichte,* XI, 1877, pp. 257–258, and R. Krautheimer, *Lorenzo Ghiberti,* Princeton University Press, Princeton, 1970, p.319, n.20.

6 In both editions of the *Vite* Vasari mentions 'infiniti lavori nella Marca, et particularmente in Agobbio... et similmente per tutto lo stato d'Urbino'. These are certainly references to the works of Ottaviano Nelli in Gubbio; perhaps also to his frescoes in and around Urbino; possibly to the Salimbeni brothers' frescoes in the Oratorio di S. Giovanni or those by Antonio Alberti in Urbino.

7 *De l'art chrétien,* Librairie de L. Hachette et C., Paris 1861, vol.I, p.323.

8 *A New History of Painting in Italy,* John Murray, London, 1866, vol.III, p.96.

Chapter I, pp. 3–4

9 Information concerning Gentile's family is contained in three articles by R. Sassi: 'La famiglia di Gentile da Fabriano', *Rassegna Marchigiana,* II, 1923, pp.21–28; 'Il padre di Gentile e l'ordine di Monteoliveto', *loc. cit.,* III, 1925, pp.247–51; 'Altri appunti su la famiglia di Gentile da Fabriano', ibid., VI, 1928, pp. 259–67.

10 L. Grassi (*Tutta la pittura di Gentile da Fabriano,* Rizzoli Editore, Milan, 1953, p.9) inexplicably records Niccolò as having died *c.*1385 and assumes Gentile must have been at least thirty-five when he was commissioned to work in the Doge's Palace.

11 F. Sansovino, *Venetia, citta nobilissima et singolare,* Venice, 1581, p.124a; C. Vecellio, *Degli abiti antichi e moderni...,* 1590, pl.50. See text p.63 and Catalogue LVIII.

Chapter II, pp. 5–17

12 A. Rossi (*I Salimbeni,* Electa Editrice, Milan, 1976, pp.42–43) makes the most recent case for the influence of Lombard miniatures on

Lorenzo. Despite its usefulness, this book contains much unverifiable information and several serious mis-attributions. The paintings of St. James the Greater and St. James the Lesser at Baltimore, for example, are by a follower of Pietro di Domenico da Montepulciano and date from the second quarter of the century.

13 S. Padovani ('Materiale per la storia della pittura ferrarese nel primo quattrocento'. *Antichità Viva*, XIII, no.5, 1974, pp.3–21) first referred to the Bolognese documents published by F. Filippini (*Miniatori e pittori a Bologna*, Sansoni, Florence, 1947, pp.219–40) thereby localizing Zanino's style. U. Gnoli ('La quadreria civica di Rieti', *Bollettino d'Arte*, 1911, pp.328–30) had suggested the works of Antonio Veneziano or a Veronese artist as the source for the 'popular', 'Giottesque' idiom of the Rieti *Crucifixion*. M. Salmi ('Antonio Veneziano', *ibid.*, 1928–29, pp.448–50) went so far as to associate Zanino with a 'Giovanni' listed as Antonio's assistant at Pisa in 1386. Even R. Longhi (*Viatico per cinque secoli di pittura veneziana*, Florence, 1952, p.49), who first enlarged the *corpus* of Zanino and gave it coherent form, did not question the notion of influence from Antonio, though he also pointed to northern contacts. F. Zeri ('Aggiunte a Zanino di Pietro', *Paragone* XIII, No. 153, 1962, pp.56–60) saw Veronese art as the source for motifs in works he attributed to the artist, an idea rebuffed by Longhi ('Ancora un pannello di Zanino di Pietro', *ibid.*, p.60). With knowledge of Zanino's presence in Bologna, speculation as to northern influences in the Rieti *Crucifixion* may be discounted. Any connection with Antonio Veneziano seems also highly unlikely, since that artist reveals a completely Tuscan training at odds with the Veneto-Emilian traits in Zanino's works. From 11 October 1394 to 1 March 1403 Zanino is repeatedly listed as 'habitans Bononie', and at the latter date he rented a house and some property for five years. Since in 1407 he was living in the *contrada* of S. Appollinaris, Venice, this lease must have been broken (the Venetian document was published by G. Ludwig, *Archivalische Beiträge zur Geschichte der Venezianischen Kunst*, Bruno Cassirer Verlag, Berlin, 1911, p.106). On 7 May 1405 he made a will, perhaps signalling an intention to travel, and on 18 May 1406 he was reimbursed for land improvements. The Rieti *Crucifixion*, with its inscription indicating that Zanino was living in the above mentioned *contrada*, may therefore date from late 1405 or 1406. It cannot post-date Michelino's visit to Venice in 1410 (see below in text).

If theories as to Zanino's origins must be discarded, the attributions of Zeri and Longhi seem, in the main, correct, and Padovani's attempt to attribute all but the Campana and Rieti Crucifixions to the author of a *Madonna and Child,* signed Giovanni di Francia and dated 1429, now in the Palazzo Venezia, Rome, must be rejected, though confusion is great between the style of Zanino's latest productions and that work. The saint at Gubbio is not mentioned in the literature but is correctly labelled; both the ex-Paolini *Madonna and Saints* (Catalogue XLVI) and the *Madonna and Child* at Athens (Catalogue XX) also seem to me to be certain works by Zanino, and a *Madonna and Child with St. Dorothy* at the ducal palace in Urbino revealed itself, after cleaning, as virtually contemporary with Zanino's Valcarecce altar-piece – it is one more work that has mistakenly passed under Gentile's name (Catalogue XLII). What follows is a chronological list of Zanino's primary works with an asterisk to signal my attributions.

(*c.* 1395–1400)
Crucifixion
 Galerie du Petit-Palais, Avignon

Post-Bologna (*c.* 1405–10)
Crucifixion
 Pinacoteca, Rieti
Madonna and Saints
 ex-Paolini Collection
Saint
 Palazzo Comunale, Gubbio
Flagellation
 Museo Correr, Venice
**Madonna and Child*
 Athens
Entry into Jerusalem
 Private collection
Crucifixion
 ex-Chillingworth Collection

Post-1410, with the rising
influence of Michelino,
followed by that of
mature Gentile

Valcarecce altar
 Diocesan Museum, Camerino
**Madonna with St. Dorothy*
 Ducal Palace, Urbino
Altar-piece
 Convento del Beato Sante, Mombarroccio
Iconostasis
 Cathedral, Torcello

68

The saints in a Swiss private collection, attributed by Zeri, seem probably late school pieces, while the *Crucifixion* at the Museo Correr may well be an early work by Giovanni di Francia. Of the numerous other works, especially those portraying the Madonna and Child, most are school; some, like that in the Heimann Collection, New York, are by Giovanni. The altar at Monterubbiano (L. Dania, *La pittura a Fermo e nel suo circondario,* Cassa di Risparmio di Fermo, 1967, pp.74–75) is not by Zanino.

14 A reconstruction of Niccolò di Pietro's career departs from a basis of only two works; a Madonna and Child in the Accademia, Venice, dated 1394, and a crucifix at Verrucchio, dated 1404. He was still alive in 1430. Another Madonna and Child, now at S. Maria dei Miracoli, is probably the painting Francesco Amadi made a payment for in 1408, though both the date and attribution have been unjustifiably confused (see P. Paoletti, *l'Architettura e la scultura in Venezia,* Ongania, Venice, 1893, I, pp.205–6, for a history of the panel; L. Testi, *Storia della Pittura Veneziana,* Istituto Italiano d'Arti Grafiche, Bergamo, 1909, I, pp.340–42, for the confusion of dates; and S. Padovani, *op. cit.,* p.10, n.31, for the attribution to Giovanni di Francia). The condition of this painting makes any critical judgement nearly impossible. E. Sandberg-Vavalà ('Maestro Stefano und Niccolò di Pietro" *Jahrbuch der Preussischen Kunstsammlungen,* LI, 1930, pp.94–109, and 'Niccolò di Pietro Veneziano', *Art Quarterly,* II, 1939, pp.287–91) first attempted to enlarge and organize his œuvre, while R. Longhi (*Viatico per cinque secoli di pittura veneziana,* Sansoni, Florence, 1952, pp.48–49) conceived the idea of Niccolò as *capo-scuola* by attributing to him the series of panels depicting miracles of St. Benedict, now in the Uffizi (a fourth panel, in the Poldi-Pezzoli Museum, Milan, was not then recognized as belonging with the series). These last (Catalogue XXVIII) have proved to be the stumbling block for any critical consensus of Niccolò's role, since they bear a variety of attributions ranging from Pisanello to the so-called Maestro Venceslao or another master responsible for some frescoes in the church of S. Caterina, Treviso. Linked with their attribution is the notion of northern, perhaps Bohemian, influence on Venetian art. As in the case of Zanino (see note 13 above) such an idea is probably incorrect; the series does not appear in the chronology which follows.

The 1394 *Madonna and Child* shows motifs possibly derived from Stefano di Sant'Agnese, as Sandberg-Vavalà pointed out. Its style, however, stems in part from Bologna. It is no coincidence that a small Coronation of the Virgin in the Pinacoteca of that city is signed Lippo Dalmasio and dated the same year as Niccolò's painting. The crucifix at Verrucchio shows a greater linearity and caricatural mode. It enables the attribution of a group of works, certainly later in time, that reveal a new concern for pattern, coupled with a brighter palette. Foremost among these is the *St. Lawrence* in the Accademia, Venice and the *St. Ursula* at the Metropolitan Museum, New York. With this group, and not with the 1394 *Madonna,* belongs the Fogg Museum's *Madonna and Child* and the *Coronation* in the National Gallery, Rome. They share none of the colour of the earlier works, while condition alone is responsible for the former's appearance, in photographs, as schematically modelled. Niccolò's primary works are as follows:

1394

Madonna and Child (signed and dated)
 Accademia, Venice
Coronation
 Brera, Milan

1404

Crucifix (signed and dated)
 S. Agostino, Verrucchio
Stories of St. Augustine
 Vatican, Rome
Series of Saints
 Museo Civico, Pesaro, and Institute of Arts, Detroit

Post-1410, showing the
impact of Michelino and
a consequent study of the
Bohemian traits of
Lorenzo Veneziano.

Coronation
 Pinacoteca dei Concordi, Rovigo
Madonna and Child
 Fogg Art Museum, Cambridge, Mass.
Madonna of Humility
 Museum of Fine Arts, Budapest
Coronation
 National Gallery, Rome
St. Lawrence
 Accademia, Venice
St. Ursula
 Metropolitan Museum, New York

Madonna and Child with SS. Mary Magdalene and Catherine
Accademia, Venice

To this list the frescoes at S. Donato, Murano should probably be added, between 1404–10, as well as the much-damaged series of saints in the National Gallery Rome. The *Madonna of Humility* at Cologne is late fourteenth-century Venetian as F. Bologna ('Contributi allo studio della pittura veneziana del trecento', *Arte Veneta*, VI, 1952, p.9) observed, while the St. Bonaventure published by Sandberg-Vavalà (*op. cit.*, p.291) has been properly restored to the anonymous master of a *Madonna of Mercy* in the Accademia, Venice (see M. Laclotte, *Avignon-Musée du Petit Palais*, Editions des Musées Nationaux, Paris, 1976, Cats. 310–11).

15 Jacobello del Fiore suffers from a greater critical misunderstanding than any other early Venetian artist. R. Longhi (*op. cit.*, p.49) judged him a lesser personality than Niccolò di Pietro or Zanino because his works seemed deeply linked to Venetian painting rather than that of the mainland. In fact, Jacobello was the greatest local artist of his generation. I. Chiappini di Sorio ('Per una datazione tarda della Madonna Correr di Jacobello del Fiore'. *Bollettino dei musei civici veneziani*, IV, 1968, pp.11–25, and 'Note e appunti su Jacobello del Fiore', *Notizie da Palazzo Albani*, II, 1973, pp.23–28) summarizes the primary documents first reviewed by L. Testi (*op. cit.*, pp.393–411). In Venice in 1400, Jacobello was in Pesaro in 1401, when he signed a work now lost. In 1407 he dated an altar-piece 'in vieniexia' destined for Montegranaro, near Pesaro. He polychromed a crucifix in 1408 and the following year made a will (i.e. January 1409, 1408 Venetian style), perhaps intending to travel. In 1412 his stipend from the *Signoria* was reduced and in 1415 he was elected *gastaldo* of the Scuola dei Pittori. The *Lion of St. Mark* in the Ducal Palace is dated 1415; the *Justice* triptych 1421.

Unfortunately, the 1407 Montegranaro altar-piece, published by F. Mason-Perkins ('A Rediscovered Painting by Jacobello del Fiore', *Apollo*, X, 1929, pp.38–40) was overlooked by scholars until recently. R. Pallucchini (*La Pittura veneta del quattrocento*, Casa Editrice Prof. Riccardo Patron, Bologna, 1956, p.52) presumed it lost. Paradoxically, it has been arbitrarily integrated into a chronology which, in fact, it disproves. It stands at the beginning of Jacobello's career; the *Justice* triptych of 1421 at the opposite end. Between the two fall the signed altar-piece at

Teramo and related works. (The signature on the *Madonna of Mercy*, Venice, is probably false; that on the altar-piece at Bergamo has come off during cleaning; the *Coronation* from Ceneda, now at Venice, also has a false signature. The last two works are not by Jacobello. C. Huter, 'The Ceneda Master', *Arte Veneta*, XXVII, 1973, pp.25–37 and XXVIII, 1974, pp.16–17, has attempted to identify the master of the *Coronation*, but his effort is only partly convincing.) These works show a progressively freer, more rhythmic movement, probably stemming in the first place from Michelino. Chronologically, the principal works would be as follows.

1407

Altar for Montegranaro (signed and dated)
 Private collection
Beata Michelina Altar
 Pinacoteca, Pesaro
SS. Anthony and Lucy on reverse of Lucy cycle
 Palazzo Comunale, Fermo
Portable altar (signed)
 Lederer Collection, Vienna

Post-1410

Altar-piece (signed)
 Cathedral, Teramo
Parts to an altar-piece:
 St. Catherine
 Longhi Collection, Florence
 St. Augustine
 Private collection, Rome
 St. Francis
 Private collection, Bologna (see *Arte Antica e Moderna*, III, 1958, p. 284)
Madonna of Mercy
 Accademia, Venice
Death of St. Peter Martyr
 Dumbarton Oaks, Washington

1421

Justice triptych (signed and dated)
 Accademia, Venice
Series of St. Lucy's life
 Palazzo Comunale, Fermo
Madonna and Child
 Harvard University, I Tatti, Florence

The signed *Madonna and Child* in the Museo Correr, Venice is too damaged to place with any assurance, as is the *Crucifixion* in the museum at Padua; they seem towards the middle of the above group. The *Adoration of the Magi* at Stockholm, if autograph, is very early. Close to

70

it is a small painting at the Philbrook Art Museum, Tulsa, depicting Tobit blessing his son; wrongly attributed by F. Shapley (*Paintings from the S. H. Kress Collection,* Phaidon, London, 1966, p.74) to the Lucchese artist Angelo Puccinelli, and by F. Zeri and B. Fredericksen (*Census of Pre-Nineteenth Century Italian Paintings in North American Public Collections,* Harvard University Press, Cambridge, 1972) to the Florentine, Cenni di Francesco. Jacobello's influence was great. An altar-piece now at Denver, published by F. Zeri ('La pala di S. Pietro a Fermo', *Diari di Lavoro,* Emblema Editrice, Bergamo, 1971, pp.36–40) is by one such follower at *c.* 1430–40, as the diminishing hills, buildings, more particularized flora, and atmospheric skies indicate. The panels at Omisali (Isola di Veglia) are by another follower. Closer to Jacobello is a *Madonna of Humility* at Trieste, but caution is in order for these and numerous other works which pass under his name.

16 The documents concerning Michelino are gathered by C. Baroni and S. Samek Ludovici (*La pittura lombarda del quattrocento,* Casa Editrice G. d'Anna, Florence, 1952, pp.53–54). He is documented in Milan in 1404 and again in 1418. Giovanni Alcherio met him in Venice in 1410. It seems quite possible that Michelino's stay was of some duration, given the profound effect he had on artists in the Veneto and the fact that his illuminations for the Venetian Cornaro family date from 1414. It is not at all impossible that he was among the artists working in the Doge's Palace, though documents mention no names. The British Library Ms. was first cited by O. Pächt ('Early Italian Nature Studies and the Early Calendar Landscape', *Journal of the Warburg and Courtauld Institutes,* XIII, 1950, p.14, n.4).

17 The most interesting and explicit revival of Paolo's modes is documented in the work of a follower of Jacobello now at Denver (see F. Zeri, *op.cit.,* 1971, p.40).

18 The question of Pisanello's relation to Gentile is complex and unclear, since it is not certain when Pisanello worked at the Doge's Palace. If he was born shortly before 1395, when his father named him heir, then he cannot have been old enough to receive such an important commission before *c.*1420, long after Gentile left Venice. If he was born *c.*1385–90, then he may have been Gentile's contemporary rather than pupil, in which case Michelino's influence would have outweighed Gentile's. All this is conjecture, since his earliest surviving work is the S. Fermo fresco of *c.*1424–26. In that work Pisanello reveals a development parallel to Stefano's with a deep debt to the settings of Altichiero. In an area of so little certainty the hypotheses of B. Degenhart (*Pisanello,* Tip. V. Bona, Turin, 1945, pp.23–25; 'Le quattro tavole della leggenda di S. Benedetto opere giovanile del Pisanello', *Arte Veneta,* III, 1949, p.22; 'Gentile da Fabriano in Rom und die Anfänge des Antikenstudiums', *Münchner Jahrbuch der Bildenden Kunst,* XI, 1960, p.71) are dubious. Beginning in his monograph, he evolved the theory of Gentile as Pisanello's teacher and collaborator. Prolonged contact in Venice seemed assured by Gentile's 'sporadic' presence in Brescia; and Pisanello's participation on the *Adoration of the Magi* at Florence seemed probable. Though these ideas have often been accepted, most recently by G. Paccagnini (*Pisanello e il ciclo cavalleresco di Mantova,* Electa Editrice, Venice, 1973, pp.117–55) they contradict the known documents (see, for example, Document III) and our knowledge of artistic practice in the fifteenth century. It would be impossible to cite a partnership between two major artists lasting over twenty years. Better interpretations of Pisanello's development are found in G. Hill (*Pisanello,* Duckworth & Co., London, 1905, pp.27–49) and M. Fossi-Todorow (*I disegni del Pisanello e della sua cerchia,* L. Olschki, Florence, 1966, pp.3–12).

Chapter III, pp. 18–49

19 Another, earlier, example occurs in an unpublished fresco at Paganico (my thanks to Gaudenz Freuler for sharing his photograph with me), while Botticelli's *Coronation* in the Uffizi takes up the iconography late in the century. God blesses and crowns a kneeling Virgin in Filippo Lippi's fresco in the cathedral at Spoleto, making a variant used also by Niccolò da Foligno in his altar-piece at S. Niccolò, Foligno. In a French miniature reproduced by M. Meiss (*French Painting in the Time of Jean de Berry, the late fourteenth century,* Phaidon, London, 1967, Pl.40) the seated Virgin is crowned by God the Father, who blesses with His right hand placed below His left arm. This non-Tuscan example underlines, by its differences, the relation of Gentile's to the Florentine type. Interestingly, in Antonio Veneziano's *Coronation* in the Hurd Collection, New York, the gesture is one of 'incipient blessing'.

20 The translation is that of T. Okey, J. M. Dent & Sons, London, 1910, reprinted 1973, p.114.

21 H. Maginnis ('Cast Shadows in the Passion Cycle at S. Francesco, Assisi: a note', *Gazette des Beaux-Arts*, LXXVII, 1971, pp.63–64) gives some interesting examples of early Trecento representations of cast shadows. Unfortunately, he does not carefully distinguish between those examples that are mere survivals of ancient art, whose appearance is without rationale, and those which seem to reveal an intent to depict natural phenomena. For this reason the short survey of M. Meiss ('Some Remarkable Early Shadows in a Rare Type of Threnos', *Festschrift for U. Middeldorf,* Walter de Gruyter & Co., Berlin, 1968, pp.112–17) is more accurate, though he incorrectly evaluated Gentile's role (see below in text). One of the most curious representations of shadows occurs in a series of the *Acts of Mercy* in the Vatican. Light is not generally uniform, but shadows are prominently portrayed. The attribution to Lorenzo Monaco is incorrect. Equally puzzling is the shadow made by a cloth hanging over the tomb in a diptych at the Louvre dated 1408, correctly attributed to Monaco.

22 The testament reads: 'Item che compiuta over perfattamente fatta la detta cappella e sagrestia come di sopra e detto et per lo detto testatore fu ordinato et proveduto...' (ASF, Arte di Calimala, 119, ff.31v.–32). The testament has been published, though with errors and incompletely, by S. Orlandi (*Beato Angelico,* Florence, 1964, p.180). The old sacristy was located in a narrow room parallel to the *Porta del Parione* which still exists: 'Sotto l'Organo è una Stanza quale anticamente serviva per Sagrestia e si domandava la sagrestia delli Ardinghelli...' (ASF, Conventi Soppressi, LXXXIX, 135, f.124v., dated 1661) and 'Anticamente la sagrestia non era in questo luogo delle sudette cappelle della prefata famiglia de signori Strozzi ma era nelle stanze sopra la porta (here, as on f.318, meaning 'beyond' rather than 'above')... ed è quella stanza grande dove in oggi abita il Portinaro (B. Davanzati, *Istoria della Venerabile Basilica delle Ssma. Trinità di Firenze,* 1740, Ms. at the convent of S. Trinita, f.319).

23 '[Palla] si singolarizzò nelli impresa, perche in primo luogo comprò tutte le case, che erano dalla Porta del fianco sino alla Porta del monastero che è appunto quello spazio che contiene la nostra sagrestia... gentò sin da fondamenti una alta e nobil muraglia di pietra lavo-rate e forte con esso abbellì il coro di monaci nel quale offisiavano i monaci in notte... Fece il sudetto signore i Finestroni e vi fece due cappelle una intitolata e dedicata a S. Onofrio, il quale portava il nome e la devozione il sudetto suo genitore la quale è nella prima sagrestia che ha il pavimento nobile di lastre quadre di marmi bianchi e neri e l'altra nella sagrestia di sopra o accanto all sudetta... In detta Sagrestia dietro all'Altare vi è una bellissima tavola di mano di Gentile da Fabriano, fatte l'anno 1430 in circa, la quale rappresenta l'adorazione dei Magi.' B. Davanzati, *op. cit.,* ff.317–20.

24 R. Baldaccini ('S. Trinità nel periodo gotico' *Rivista d'Arte,* XXVII, 1951/52, p.73, n.31) and W. Paatz (*Die Kirchen von Florenz,* V. Klostermann, Frankfurt, 1953, V, p.283) first suggested an earlier, even Trecento, date for the triumphal arch, which has, in fact, exact parallels in the fourteenth-century nave pillars. However, it is quite clear from references like that cited in the text and below, note 25, that prior to the Strozzi building campaign the site was occupied by houses: the differences are of style rather than date. G. Marchini ('Aggiunte a Michelozzo', *Rinascità,* VII, 1944, p.38) has hypothesized that Ghiberti was responsible for the arch, Michelozzo for the vaulting and consoles (see below, note 26).

Since there are no payments for any altarpiece other than Gentile's between 1418–23, Lorenzo Monaco's work would have to pre-date that period. A hypothetical reconstruction, showing a Madonna and Child with saints, has been proposed by D. Davisson ('The Iconology of the S. Trinita Sacristy, 1418–35: A Study of the Private and Public Functions of Religious Art in the Early Quattrocento', *Art Bulletin,* LVII, 1975, pp.320–22). It is incorrect for several reasons. First, there is no parallel for representing the Madonna and Child with saints on three panels of equal dimensions. Second, the iconography of the pinnacles, on which the *Noli me Tangere,* the Resurrection and the three Marys at the tomb are depicted, suggests that the main scene was intended from the beginning to show a Deposition, Crucifixion, or Lamentation. The hypothesis that a finished altar-piece by Lorenzo Monaco was destroyed after the exile of Palla Strozzi (1434) because it contained portraits of the family, as maintained by M. Cämmerer-George (*Die Rahmung der toskanischen Altarbilder im Trecento,* Strasbourg, 1966, pp.187–88) is also invalid, since both Gentile's and Angelico's altar-pieces contain such por-

traits (see below in text and note 32). My own conclusion is that the altar-piece, commissioned by Onofrio, was not completed because of his death. The commission, with a new format, was transferred by Palla to Gentile, and Angelico was later called upon to paint an altar-piece for the adjacent chapel, using Lorenzo's frame – but not the predella which was never recorded in the chapel and whose provenance remains mysterious (Davisson, *op. cit.*, p.321, inexplicably records a reference by Richa to paintings of SS. Onuphrius and Nicholas). For further information concerning Angelico's altar-piece see J. Pope-Hennessy, *Fra Angelico,* Cornell University Press, Ithaca, 1974, p.210, and below, note 32. It should additionally be noted that ever since the Angelico *Mostra* in 1955 the measurements of his altar-piece have been given as 176 × 185 cm. They are 276 × 285 cm., with spaces approximately 60 cm. between the projections of the lower frame.

25 This idea is suggested both by the wording of Onofrio's will (see above, note 22) and a seventeenth-century record book that states, 'La famiglia delli Strozzi aveva prima la sua cappella quella di S. Lucia, ma nel 1421 o prima Mess. Noferi Padre di Palla Strozzi comperò tre case che erano vicine alla Porta del Nostro Monasterio e vi fabricò la Cappella ch oggi si vede...' (ASF, Conventi Soppressi, LXXXIX, 135, f.100v.).

26 The most complete publication of documents for the sacristy remains that of G. Poggi, *La Cappella e la tomba de Onofrio Strozzi nella chiesa di S. Trinità,* Tip. Barberà, Florence, 1903. The recent article by D. Davisson (*op. cit.,* pp.315–35) must be viewed with scepticism, since it is filled with incorrect archival references and invalid assumptions. M. Reymond ('Les débuts de l'architecture de la Renaissance (1418–40)', *Gazette des Beaux-Arts,* 1900, pp.89ff.; pp.425ff., and 'La Porte de la Chapelle Strozzi', *Miscellanea d'Arte,* I, 1903, pp.4–11) first called attention to the innovative decorative elements of the chapel. G. Marchini (*op. cit.,* pp.24ff.) made a strong case for attributing these elements to Ghiberti, with Michelozzo responsible for the architecture (also, *Ghiberti architetto,* La Nuova Italia Ed., Florence, 1978, pp.22–23). Both of the notions have received wide acceptance with one notable exception: R. Krautheimer (*op. cit.,* 1956, pp.256ff.; and 1970, pp.xiii, 261) acknowledged the stylistic affinities of the entrance portal with Ghiberti's works, but pointed out both its poor workmanship and the

fact that the famed sculptor is documented only for work on the choir stalls (Poggi, *op. cit.,* pp.16–17). Unfortunately, he did not discuss the exterior façade, which is one of the most beautiful and innovative examples of fifteenth-century ecclesiastical architecture prior to the Pazzi Chapel. He also did not know of a further archival reference which firmly links Ghiberti to Strozzi projects. This occurs in a notebook that is filled with payments for various architectural commissions of Palla Strozzi between 1420–23, among which the chapel at S. Trinita figures prominently. On f.190v., where the page is headed MCCCCXXIII, one reads, 'Lorenzzo di Bartoluccio fa le porti di Santo Giovanni de' dare lire sesanta quattro soldi 16, levamo da libro dare segnato F. c. 80 + no s'ànno a chiedere sanza licenzia di messer Palla'. Opposite, on f.191r., is the cancellation: 'La conttrascritta partita disse messer Palla si canciellasse per più disegni e servigi ch'l contrascritto llorezo gli avea per insino a questo dì 15 di diciebre 1426' (ASF, Carte Strozziane, ser. IV, 343, Giornale dal 1420 al 1423; this reference has been published independently by J. R. Sale, 'Palla Strozzi and Lorenzo Ghiberti: New Documents', *Mitteilungen des Kunsthistorischen Institutes in Florenz,* XXII, 1978, pp.355–8). In view of this reference and the singular style of the chapel, Ghiberti may be considered the consulting architect, responsible above all for the designing of details. Michelozzo's role, however, is questionable. A Pippo di Giovanni, 'maestro di murare', is explicitly credited with having built the chapel, 'a fatto la sagrestia di Santa Trinita' (*loc. cit.,* f.192v.). It is debatable to what extent three rather than two men should be held responsible for a building of this size, especially when one is never mentioned in the documents. (The most recent, though modified, argument associating the architectural design with Michelozzo is given by H. Caplow, *Michelozzo,* Garland Publishing, New York, 1977, pp.80 ff.). Proper evaluation of the chapel's architecture is still lacking in even so thorough a handbook as that of L. Heydenreich (*Architecture in Italy,* 'The Fifteenth Century', Penguin Books, 1974).

27 The tomb and enframing arch were attributed to Donatello and an assistant by M. Lisner ('Zur frühen Bildhauerarchitektur Donatellos', *Münchner Jahrbuch der Bildenden Kunst,* IX–X, 1958–59, pp.94–101). Arguing that the arch and the tomb are of different dates, U. Middeldorf ('Additions to Lorenzo Ghiberti's Work', *Burlington,* CXIII, 1971, p.76) attributed the tomb

design to Ghiberti and the arch design to a follower of Donatello in the 1430s, an opinion shared by H. Caplow (*op. cit.,* p.83, n.60) and by G. Goldner (*Niccolò and Piero Lamberti,* Garland Publishing, 1978, pp.95–103). A similar conclusion was reached by M. Reymond ('La tomba di Onofrio Strozzi', *l'Arte,* VI, 1903, pp.7–14). Since Middeldorf's conclusions were based on the false notion that the Strozzi did not have patronage to both chapels in the 1420s, this separation of dates is unlikely (see Catalogue XXVII). Moreover, at least one side of the arch seems to be by the same hand as the tomb. The latter is certainly the 'cassone di marmo' for which Pietro di Niccolò was paid six florins in 1418 (Bib. Com., Siena, Ms. vol. XV, 44, III, P, f.51; G. Milanesi, *Miscellanee*).

28 C. Gilbert ('Peintre et menuisier au début de la Renaissance en Italie', *Revue de l'Art,* XXXVII, 1977, pp.9–28) has demonstrated that frames were frequently made prior to engaging a painter and their design was often entrusted to a professional wood-worker or architect. This is not surprising when a frame of traditional format was desired, but the complicated and novel form of an altar-piece like Orcagna's presupposes the pictorial programme. In as much as Orcagna was a sculptor and architect as well as painter, it seems unlikely that a patron would have turned elsewhere for a design for the frame.

29 By 1421–23 Gentile can hardly have sufficiently mastered Florentine architectural principles to design the frame for the *Adoration.* Still, its singular form argues some kind of collaboration between Gentile and its executant. A. Conti ('Quadri alluvionati", *Paragone,* XIX, No. 215, 1968, p.17) has called it 'Ghibertian'.

30 R. Krautheimer, *op. cit.,* 1970, p.146, gives the best analysis.

31 The plants' symbolism, primarily Mariological and Christological, is given by L. Behling ('Das Italienische Pflanzenbild um 1400 – zum Wesen des pflanzlichen Dekors auf dem Epiphaniasbild des Gentile da Fabriano in den Uffizien', *Pantheon,* XXIV, 1966, pp.347–59).

32 The identification of these two figures as Onofrio and Palla, made by D. Davisson (*op. cit.,* p.324) is without sufficient foundation. Onofrio was 73 when he died in 1418 – a year and a half before Gentile could have arrived in Florence. The identification as Palla and his son, however, is supported not only by the apparent ages of the two figures in question, but by their recurrence in Fra Angelico's *Deposition,* also des-

tined for the sacristy. The still youthful, round face of Lorenzo is at the far right, wearing the same hat. The older man is depicted as Nicodemus, on a ladder to the right of Christ. Despite the beard and Angelico's more generalized approach to portraiture, Palla's features are recognisable. The embroidered hem of his tunic reads MAGISTER P (blank due to drapery fold) L (i.e. Palla?; my thanks to Diane Cole for calling this inscription to my attention). Vasari thought this a portrait of Michelozzo. The altarpiece has been variously dated; most recently at *c.*1443 by J. Pope-Hennessy (*op. cit.,* pp.27, 210). However, the absence of a particularized study of light, which begins to appear in Angelico's works from 1436, the date of the *Lamentation* at S. Marco, and the relation of figure types to those of the *Linaiuoli Tabernacle,* commissioned in 1433, points to a date in the mid-1430s—at a time when the Strozzi family was still present in Florence to commission it. Palla was exiled in 1434, Lorenzo in 1438. S. Orlandi (*op. cit.,* pp.45–53) has suggested biographical elements in the unusual iconography.

33 The best analysis of the Master of Flémalle's sources remains that of E. Panofsky (*Early Netherlandish Painting,* Harvard University Press, Cambridge, 1953, pp.158–59). O. Pächt ('Panofsky's Early Netherlandish Painting, I', *Burlington,* XCVIII, 1956, p.114) admits the influence of miniatures on the landscape but points to Burgundian work, especially Malouel, as the source of figure style for the Master of Flémalle. The notion expressed by M. Meiss (*French Painting in the Time of Jean de Berry, the Boucicaut Master,* Phaidon, London, 1968, p.72) that 'the Boucicaut Master was not, however, crucial to the Master of Flémalle's art. It was Malouel and painting in Dijon that had the greater effect on the formation of his style', is perhaps a bit hasty. Earlier evaluations of the place of the Limbourg brothers in the evolution of landscape painting must be modified in light of the findings of L. Bellosi ('I Limbourg precursori di Van Eyck?', *Prospettiva,* I, 1975, pp.24ff.).

34 Turin, Biblioteca Reale, Var. 74 and 77. The fact that the script is Italian may indicate that the miniatures were executed in Italy. It may be significant that the manuscript in the Morgan Library (M. 944) illuminated by Michelino da Besozzo (*c.*1420) seems to show the influence of the Boucicaut Master. Meiss (*op. cit.,* pp.68, 137–38) dates the Turin manuscript 1410–11 and considers Filippo Maria the probable patron. Giovanni, as duke of Milan from 1403 until 1412, is perhaps the likelier can-

didate. His wife, Antonia Malatesta, joined Pandolfo at Brescia in 1413. The political events of these years are recounted in detail by F. Cognasso in *Storia di Milano,* Fondazione Treccani degli Alfieri, Milan, 1955, pt. I.

35 See now M. Meiss, *French Painting in the Time of Jean de Berry, the late fourteenth century,* Phaidon, London, 1967, chap. X, 'The Master of the Brussels Initials', pp.229ff.

36 I owe these suggestions to J. Ackerman. The origin of the diamond-facetted stones is discussed, briefly, by L. Heydenreich (*op. cit.,* pp.97, 124, 127, 349, n.7).

37 The translation is taken from H. Saalman's edition of A. Manetti, *The Life of Brunelleschi,* Pennsylvania State University Press, 1970, p.44.

38 R. Krautheimer (*op. cit.,* 1970, pp.229–53, 315–34) has convincingly analysed the importance of Alberti's ideas for Ghiberti's *Gates of Paradise.* No similar investigation has attempted to trace the transformation from pre- to post-Albertian painting, though J. White (*The Birth and Rebirth of Pictorial Space,* 2nd. edition, Harper and Row, New York, 1967) deals with perspective in general and its use by specific artists. Comparison of the predella scenes of Angelico's *Linaiuoli Tabernacle* (commissioned 1433) with those of the *S. Marco Altar-piece* (*c.*1438–*c.*1440) clearly reveals the difference between an empirical and a theoretical application of perspective. In the earlier scenes buildings are conceived as separate blocks, used to reinforce the figural composition in a fashion typical of Trecento art; the oblique view predominates. In the later scenes a spatial stage preceded and predetermined the placement of figures, which are often aligned along converging orthogonals; frontal views predominate and the vanishing point is inevitably central. Angelico had experimented with this latter type of composition in the predella of the *Annunciation* at Cortona (figural style places it before the *Linaiuoli Tabernacle, c.*1430), but without the necessary theoretical apparatus. A scene like the *Marriage of the Virgin* testifies to the difficulty of achieving the certitude apparent in the *S. Marco Altar-piece* by empirical means. This first effort represents a reaction to the procedures of Masaccio, which were sufficiently complicated that they were not employed in his own predella scenes and completely escaped the capacities of his associate, Masolino (see R. Krautheimer, *op. cit.,* pp.240–43, for an analysis of the frescoes at S. Clemente). Not surprisingly, the first works of Angelico to experiment with the new methods

date from 1436 and 1437: the *Lamentation,* where perspective is applied to landscape composition, and the *Perugia Altar,* where it is somewhat hesitatingly applied to architectural scenes. Because the certain, datable works of Filippo Lippi and Domenico Veneziano postdate 1435, those of Angelico are paramount to an understanding of Florentine painting after Masaccio.

39 In February 1416 (1417 modern reckoning) the marble for the base of the tabernacle was sold to the Armourers and Swordsmiths' guild by the workshop of the Florence cathedral. H. Janson (*The Sculpture of Donatello,* Princeton University Press, Princeton, 1963, pp.29–31) gives an extensive analysis of the variety of opinions about the style of the relief.

40 These panels have been repeatedly attributed to Arcangelo di Cola, despite the correct opinion of R. Longhi ('Fatti di Masolino e di Masaccio', *Critica d'Arte,* XV–XVI, 1940, p.188) and the fact that as early as 1927 R. Offner (*Italian Primitives at Yale University,* Yale University Press, New Haven, 1927, p.24) recognised them as Florentine, close to Paolo.

41 Masolino is probably the Maso di Cristofano documented in Ghiberti's shop prior to 1407 (See R. Krautheimer, *op. cit.,* 1970, p.108, n.7). The composition for the *Madonna and Child* at Bremen may derive from a work like the *Madonna and Child* at Washington (see U. Middeldorf, *Sculptures from the S. Kress Collection, European Schools, XIV–XIX Centuries,* Phaidon, London, 1976, p.14).

42 These panels, showing SS. Catherine, John the Baptist, Nicholas, and Agnes are published in J. Pope-Hennessy, *op. cit.,* p. 190.

43 U. Procacci, R. Longhi ('Un incontro col'Maestro dei Santi Quirico e Giuletta', *Paragone* XVI, No. 185, 1965, pp.40–42) and C. Gilbert (*Journal of Aesthetics,* XXVII, 1969, pp.465–66) have not accepted this work as autograph. First-hand examination leaves no doubt as to authorship. The handling of paint and drawing are consistent with Masaccio's known works, as is the printing and tooling. Only on the panel with SS. Bartholomew and Biagio is a second hand discernible.

44 The most complete information on the history of S. Niccolò sopr' Arno is contained in a sixteenth-century manuscript by Lionardo Tanci, still in the possession of the church. Relevant sections may be found, with minor errors, in I. Moretti, *La chiesa di S. Niccolò Oltrarno,* Istituto Professionale Leonardo da Vinci, Florence, pp.72–73. On f.266v. Tanci records that

Bernardo died on 10 March 1422 (1423, modern reckoning) and Richa (*Notizie delle chiese fiorentine*, 1762, X, pp.268–69) copied from a testament dated 14 October 1421. The marble disc which bears Bernardo's name as well as the date 1418 seems, therefore, to commemorate the foundation of the chapel. W. Paatz (*op. cit.*, IV, pp.358ff.) and A. Alinari ('La chiesa di S. Niccolò Oltrarno di Firenze', *Rivista d'Arte*, XX, 1938, pp.316–31) review the building history of the church.

45 The paint surface between the base of the spandrel and the bottom of the picture measures 92.7 cm. for the central panel and 92.6 cm. for the St. Catherine. This fact alone disqualifies the reconstructions in *Rivista d'Arte*, III, 1905, pp.174f.; Berenson, *Italian Pictures of the Renaissance, Central and North Italian Schools*, Phaidon, London, 1968, fig. 533; and L. Grassi, *Tutta la pittura di Gentile da Fabriano*, Rizzoli Ed., Milan, 1953, p.62. My thanks to the staff of the Uffizi and National Gallery, London for permitting me to make these measurements, and to John Shearman, who communicated further information to me.

46 The *St. Peter Martyr Altar-piece* was not yet paid for in 1429 (see J. Pope-Hennessy, *op. cit.*, p.190). Examination during restoration of the (certainly earlier) altar-piece for S. Domenico, Fiesole, revealed that the present impression of equal penetration of space in all panels is due to a sixteenth-century restoration undertaken by Lorenzo di Credi (*ibid.*, p.189). Initially the pavement of the side panels extended to the upper edge of the dais, which was confined to the central panel: the green and vermilion colours of the pavement were clearly visible where losses had occurred in Credi's extension of that dais (in oil); above the pavement, in the side panels, was the gold ground, again visible through losses in the sixteenth-century surface.

47 To a certain extent Masaccio's S. Giovenale altar-piece is an exception to this rule. His use of one-point perspective marks a fundamental novelty, but the level of the pavement in the side panels is not continued into the centre one, and the figure scale changes dramatically.

48 The appearance of this altar-piece with its gables and colonettes is documented by an altar-piece in the Palazzo Pretorio, Prato, painted in 1413 for the convent of S. Matteo. This example also preserves the predella, which has structural parallels with that of Gentile. The present arrangement of the figures in Orcagna's altar-piece (Fig. 43) could have served as the

model for Gentile were it not for the fact that this arrangement is probably incorrect. Originally the St. Nicholas was in the position now occupied by St. Andrew (see R. Offner, *A Corpus of Florentine Painting*, J. J. Augustin, Glückstadt, Germany, 1962, IV, i, p.62, n.2).

49 For archaeological remains of the old church, see A. Alinari, *op. cit.* Gentile's church is, at the very least, Tuscan Romanesque.

Chapter IV, pp. 50–58

50 On the iconography and probable sequence of these works, see M. Meiss ('Some Remarkable Early Shadows in a Rare Type of Threnos', *Festschrift U. Middeldorf*, Walter de Gruyter & Co., Berlin, 1968, pp.112–17) who noted a similarity to Gentile's modes.

51 In 1425 Arcangelo dated an altar-piece, since destroyed, at Cessapalombo near Camerino. In 1427 he was debtor to an artisan in Florence. Relevant documents are gathered together by G. Sacconi (*Pittura marchigiana: la scuola camerinese*, La Editoriale Libraria, Trieste, 1968, pp.79ff.) but this author's attributions and critical interpretations are extremely dubious. The most up to date and convincing interpretation of Arcangelo's surviving works is that of F. Zeri ('Opere maggiori di Arcangelo di Cola', *Antichità Viva*, VI, 1969, pp.5–15).

52 P. Scapecchi (*La Pala dell'Arte della Lana del Sassetta*, Monte dei Paschi di Siena, 1979, pp.19ff.) argues – primarily on the basis of a new interpretation of the recorded inscription on the work – that the altar-piece was completed by March 1424. This would leave only eight months for its execution. The documents published by G. de Nicola ('Sassetta between 1423 and 1433', *Burlington*, XXIII, 1913, p.214) which relate to the funding of the altar-piece, still seem to me the most compelling evidence.

53 I am inclined to accept the hypothesis of F. Zeri ('Ricerche sul Sassetta: La pala dell'Arte della Lana, 1423–26', *Quaderni di Emblema II*, Emblema Editrice, Bergamo, 1973, pp.28–33) that these two landscapes once formed part of the continuous landscape at the base of the central panel of Sassetta's Arte della Lana altar-piece described by Abbot Carli in the eighteenth century (see J. Pope-Hennessy, *Sassetta*, Chatto & Windus, London, 1939, pp.6–7). Zeri reproduced photographs of the backs of each panel proving that they were originally bound together horizontally by a common batten. Exam-

ination reveals, however, that both panels have fragments of their original 'beard' on the bottom edge, indicating that nothing has been cut from the lower painted surface. Traces of gold are present at the upper edge of the city view (though this gold does not continue beneath the rest of the pigment and there is no sign of a beard), while the greyish colour behind the cropped hills of the other panel probably belonged to a further range rather than a distant sea. If one assumes that the city view was to the left of the landscape view, the point of land in the upper right-hand area of the former could, appropriately, link with the land mass surrounding the bay of the other panel. Above the sea, then, began the golden sky – as in the left-hand lunette of Gentile's *Adoration*. A small form obtruding over the water of the city view appears, upon comparison with Pietro di Giovanni Ambrosi's *Assumption* at Budapest – which Zeri argues derives from Sassetta's altar-piece – to have been the toe of one of the flying angels referred to by Carli. The vista was therefore less deep than Zeri assumed and the indications for a reconstruction more precise. The technical analysis undertaken by P. Torriti (*La Pinacoteca Nazionale di Siena,* Sagep, Genoa, 1977, pp.115–16) seems to me demonstrably false in its attempt to prove that the panels have been cropped only on the left-hand side; it also neglects the traces of the common batten.

54 On the importance of semi-circular compositions in early fifteenth-century art, see M. Meiss, 'Masaccio and the Early Renaissance: the circular plan', *Acts of the 20th International Congress of the History of Art,* Princeton, 1963, pp.123ff.

55 The major argument for early contact with Masaccio is that of F. Zeri, especially *op. cit.,* pp.22ff. I am inclined to view such contact as doubtful, given the very short overlap in time between the completion of Sassetta's work and the beginnings of Masaccio's. Moreover, what Zeri sees as ideas descending from Masolino I see as a combination of influences stemming from the Lorenzetti and Gentile.

56 There is little agreement as to the date of Masaccio's *Trinity* (see L. Berti, *L'Opera Completa di Masaccio,* Rizzoli Editore, Milan, 1968, pp.97–99, for a summary of often conflicting evidence). It seems to me to fall between the upper tier of the Brancacci Chapel, completed before Masolino's departure for Hungary in September 1425 (he painted Christ's head in the *Tribute Money*), and the Pisa altar, begun February 1426. Condition prohibits close compari-

son, but the lighting seems more generalized than in the latter work, and Donatello's influence is just beginning to be shown. Gentile's fresco seems to me the most persuasive evidence for dating the *Trinity* before 1426, about contemporary with the *Expulsion of Adam and Eve* (which I consider the latest of the upper tier frescoes in the Brancacci Chapel).

57 There is a certain amount of unnecessary confusion surrounding the years 1424–26. Gentile rented a house in Siena from 22 June to September 1425. He was in Orvieto at least in October. Prior to June he must have been in Florence, working for the Quaratesi family. At face value, then, Tommaso Fecini, in his chronicle of the late fifteenth century, would seem to err in mentioning the notaries' polyptych under the year 1424. In fact, Tizio, in the sixteenth century, was probably referring to this error when he wrote, under 1424, 'non hoc anno, ut fertur... sed sequenti perfecit'. Then, under 1426, Tizio states that Gentile returned to Siena to finish the painting, 'anno elapso incohatas...' (See Catalogue LVI.)

58 B. Fazio, *op. cit.,* p.105.

Chapter V, pp. 59–66

59 See above, note 18.

60 The Fano altar-piece is not documented but is generally considered an early work. In so far as the lateral saints seem to reflect such early works by Jacopo Bellini as the saints in the Berlin-Dahlem Museum (published by F. Zeri, 'Quattro tempere di Jacopo Bellini', *Quaderni di Emblema I,* Emblema Editrice, Bergamo, 1971, pp.42–49) a date around 1430 may be suggested.

61 For a summary and identifications of major manuscripts owned by Palla, as well as a bibliography on the subject, see A. Diller, 'The Greek Codices of Palla Strozzi and Guarino Veronese', *Journal of the Warburg and Courtauld Institutes,* XXIV, 1961, pp.313–17.

62 See above, note 27.

63 See above, p.25, and note 24.

64 The following section is heavily indebted to M. Baxandall, *op. cit.,* pp.78ff.; and *idem.,* 'Guarino, Pisanello and Manuel Chrysoloras', *Journal of the Warburg and Courtauld Institutes,* XXVIII, 1965, pp.183ff.

65 The translation is that of M. Baxandall, *op. cit.,* p.193.

66 *Ibid.,* p.198.

CATALOGUE OF PAINTINGS

THE CATALOGUE is arranged as follows:

1. Paintings whose design and/or execution I judge to be by Gentile. These are arranged chronologically, according to the text. Title of the work is followed by present location; the current inventory number; the support and dimensions; inscriptions with their respective sources, when traceable; a detailed condition report based upon first-hand examination; provenance; a discussion of past opinions; a critical analysis. In the case of large altar-pieces this order has been altered where necessary.

2. Paintings which have been attributed to Gentile after *c.* 1900 or which have a direct bearing on his activity.* These are arranged alphabetically according to location and follow the above format. A. Venturi (*Gentile da Fabriano e il Pisanello,* Florence, 1896, pp.25–27) gives a list of earlier, rejected attributions.

3. Works no longer traceable attributed to Gentile in literature or documents prior to the nineteenth century. The passage or description is reproduced.

4. Drawings attributed to Gentile. Except for the last group of ten drawings, which constitute one entry, these are arranged alphabetically according to location and follow the above format. Dimensions and technical description are by and large taken from B. Degenhart and A. Schmitt, *Corpus der Italienischen Zeichnungen, 1300–1450,* Berlin, 1968.

*An exception to this is a *Saint Anthony of Padua* in the magazine of the Vatican listed by Berenson (1932, p.222; 1968, p.165) as from the studio of Gentile. The only painting which would seem to answer this description is inv. no. 560, measuring 27.5 × 13 cm., but it is Florentine, close to Mariotto di Nardo.

ABBREVIATIONS

The following abbreviations are used throughout the catalogue:

Arslan E. Arslan, 'Gentile da Fabriano', *Encyclopedia of World Art,* McGraw-Hill, New York, 1962, VI, pp.108–112.

Bellosi L. Bellosi, *Gentile da Fabriano* (I Maestri del Colore, no. 159), Fratelli Fabbri, Milan, 1966.

Berenson, 1899 B. Berenson, *Central Italian Painters of the Renaissance,* G. Putnam's Sons, London, 1899.

Berenson, 1907 B. Berenson, *North Italian Painters of the Renaissance,* G. Putnam's Sons, London, 1907.

Berenson, 1932 B. Berenson, *Italian Pictures of the Renaissance,* Clarendon Press, Oxford, 1932.

Berenson, 1968 *Italian Pictures of the Renaissance, Central and North Italian Schools,* I, Phaidon, London, 1968.

Colasanti A. Colasanti, *Gentile da Fabriano,* Istituto Italiano d'Arti Grafiche, Bergamo, 1909.

Coletti L. Coletti, *Pittura Veneta del Quattrocento,* Istituto Geografico de Agostini, Novara, 1953.

Cavalcaselle J. Crowe and G. Cavalcaselle, *A New History of Painting in Italy,* John Murray, London, 1866, III.

Degenhart B. Degenhart and A. Schmitt, *Corpus der Italienischen Zeichnungen, 1300–1450,* Berlin, 1968.

Fazio B. Fazio, *De viris illustribus,* 'De pictore', as transcribed in M. Baxandall, *Giotto and the Orators,* Clarendon Press, Oxford, 1971, pp.163–168.

Grassi L. Grassi, *Tutta la pittura di Gentile da Fabriano,* Rizzoli, Milan, 1953.

Huter C. Huter, 'Gentile da Fabriano and the Madonna of Humility', *Arte Veneta,* XXIV, 1970, pp.26–34.

Longhi R. Longhi, 'Fatti di Masolino e di Masaccio', *Critica d'Arte,* V, 1940.

Magagnato L. Magagnato, *Da Altichiero a Pisanello,* Neri Pozza Ed., Venice, 1958.

Mayer A. L. Mayer, 'Zum Problem Gentile da Fabriano', *Pantheon,* XI, 1933, pp.41–46.

Micheletti B. Micheletti, *L'opera completa di Gentile da Fabriano*, Rizzoli, Milan, 1976.

Molajoli B. Molajoli, *Gentile da Fabriano*, Tip. Gentile, Fabriano, 1927.

Pallucchini R. Pallucchini, *La pittura veneta del Quattrocento*, Casa Editrice Prof. R. Patron, Bologna, 1956.

Ricci A. Ricci, *Memorie storiche delle arti e degli artisti della Marca di Ancona*, Macerata, 1834, I.

Rossi F. Rossi, 'Ipotesi per Gentile da Fabriano a Brescia', *Notizie da Palazzo Albani*, II, i 1973, pp.11–22.

Van Marle R. Van Marle, *The Development of the Italian Schools of Painting*, Martinus Nijhoff, The Hague, 1927, VIII (other volumes as cited by roman numeral).

Vasari G. Vasari, *Le vite de' piu eccellenti pittori, scultori ed architettori*, ed. G. Milanesi, Sansoni, Florence, 1906, III.

Venturi A. Venturi, *Storia dell'Arte Italiana*, U. Hoepli, Milan, 1911, VII, i.

Zampetti P. Zampetti, *La pittura marchigiana del '400*, Electa Editrice, Milan, 1969.

AUTOGRAPH AND DESIGNED WORKS

CAT. I (Plate 1)
MADONNA AND CHILD

Panel	Galleria Nazionale dell'Umbria, Perugia
96.8 × 59 cm.	(inv. no.129)

Inscriptions. On the halo of the Virgin: *ave maria gratia plena dominus tecum bened* [*icta*]; on the border of her robe: . . . *mather alma* . . . *dona nobis* . . . *solve* . . . *pro nobis;* on the scroll held by the angels: *regina celi leta*[*re alleluia, quia quem meruisti*]*portare alleluia*[,] *resurrexit sicut dixit allelu*[*ia, o*]*ra pro* [*nobis deum*] *allelu*[*ia*] (paschal antiphon of The Blessed Virgin).

The painting is in a poor state, the bottom third is particularly damaged. It has been cropped at the top; probably at the bottom as well. Two vertical cracks descend on either side of the Virgin's head. There is a large loss in the chest of Christ; three losses in the Virgin's robe, which is much darkened. The central, bottom angel is nearly effaced. Shadows now read with too great a prominence, while such details as the gold scallops on the Virgin's dress are largely lost. Restored in 1907 and again in 1949.

This is probably the painting cited by Vasari (p.7) as 'una tavola in San Domenico', Perugia. In 1861 Cavalcaselle described it ('Catalogo delle opere d'arte nelle Marche e nell'Umbria', *Le Gallerie Nazionale,* II, 1895, p.289) as in the Cappella del Noviziato of that church. In 1863 it passed to the Pinacoteca (see F. Santi, *Galleria Nazionale dell'Umbria,* Rome, 1969, pp.113–15). With the exception of Van Marle (p.22), the painting is universally accepted as a youthful work of Gentile, and generally placed later than those works once in Fabriano (the sepulchral monument in Berlin, the *Coronation of the Virgin* at Milan, and the processional standard *St. Francis* in a private collection). Colasanti (pp.58–59), Molajoli (p.38), Grassi (pp.15–17) and Micheletti (p.86) all compared it to the *Coronation,* which they date *c.*1400. L. Magagnato (p.76) suggested a date of *c.*1405 and followed Grassi's notion that a Lombard education preceded it. Longhi (p.190) doubted that the four paintings formed a coherent group. Bellosi (p.2) and M. Boskovits (*Pittura umbra e marchigiana fra Medioevo e Rinascimento,* Ed. Edam, Florence, 1973, pp.171–74) placed it after Gentile's Venetian experience, *c.*1410, and F. Rossi (p.19) also saw similarities with Venetian art, rightly comparing it to the ex-Paolini *Madonna and Saints* (Catalogue XLVI, Plate 105). C. Huter (p.28) has departed from past opinion by situating it between the Berlin sepulchral monument and the *Coronation.* He has suggested a date of *c.*1400.

The Perugia *Madonna and Child* is Gentile's earliest surviving painting. Among his works, it bears comparison only with the Berlin *Madonna and Saints,* but the

absence of a curvilinear compositional structure assures its precedence. The figure types derive from a group of works by Zanino di Pietro (a Crucifixion at Rieti, a saint at Gubbio, and the ex-Paolini *Madonna and Saints*) datable no earlier than *c.*1405 and no later than *c.*1410 (see note 13, p.68). It may therefore date between *c.*1406 and July 1408, when Gentile is first documented in Venice (see also p.5ff.). In 1428 the Perugian artist Pelegrino di Antonio (see F. Russell, 'Two Italian Madonnas', *Burlington,* CXX, 1978, p.55) freely copied the composition in a painting in the Victoria and Albert Museum, London, while Gentile repeated the motif of a pierced, Gothic throne overgrown with plants in the Metropolitan *Madonna and Child* (Cat. III). A possible precedent for this device occurs in a Madonna and Child related to the style of Jacopo di Paolo, a Bolognese artist, in the Dienst Verspreide Rijkscollecties, The Hague, reproduced by Van Marle (VII, fig. 150). The humility of the Virgin is expressed by her grassy seat, her glorification by the throne and incised crown held by angels. The shape of the original panel suggested by the present frame was questioned by Grassi (p.56); it is confirmed by the original border clearly visible on Pelegrino's copy. The frame of this copy, however, is not original as suggested by C. M. Kauffman (*Catalogue of Foreign Paintings, Victoria & Albert Museum,* Vol. I, 1973, pp.215–16).

CAT. II (Plate 2)
MADONNA AND CHILD WITH SS. NICHOLAS, CATHERINE OF ALEXANDRIA, AND A DONOR

Poplar panel

131 × 113 cm.

Gemäldegalerie, Berlin-Dahlem

(inv. no. 1130)

Originally signed on the frame: *gentilis de fabriano pinxit.* (The original frame, already encased in a modern one in the early years of this century, is now lost and, despite the efforts of the staff at the Staatliche Museen, Berlin, it remains untraceable. See *Beschreibendes Verzeichnis der Gemälde im Kaiser Friedrich-Museum,* Berlin, 1906, p.152.)

The angels play, clockwise, beginning at the bottom of the left tree: a harp, psaltry, fiddle, harp (?), mandora, lute, organetto; a shawm, shawm, bagpipe, shawm, nakers, shawm, and a wheel with jingles.

On the whole the condition is good. However, the background leaf has been renewed, partially hiding the clustered, incised rays around the saints' heads. Three vertical cracks, extending the height of the panel, pass through 1) St. Nicholas's head, 2) the left-hand tree and the Child's blessing arm, 3) the right edge of the right-hand tree. Other, less important ones pass through 1) St. Nicholas's shoulder and right hand, 2) the sixth, front podium arch (counting from the left), 3) St. Catherine's right shoulder and left hand, 4) her face, 5) the back of her head, and another skirts the right side of the Virgin's face, continuing through her torso. The three major cracks have been poorly inpainted, so that the new surface often extends over the old. In the case of the right-hand lily and the right edge of the throne a false impression results. The

craquelure has also been inpainted, as have the holes in the upper left corner of the panel and in the Madonna's right knee. The painting was cleaned and restored in 1837.

Ricci (pp.155, 169, n.31) states that the painting came from the church of S. Niccolò, Fabriano. From a manuscript at the house of a Leopardi Osimana he learnt that in 1660 it was in Osimo. Since S. Niccolò was rebuilt from 1630 (B. Molajoli, *Guida Artistica di Fabriano,* Rotary Club of Fabriano, 1968, p.148), the painting was probably removed at that time. A letter of 12 July 1828 further informed Ricci that it was in Matelica, but he saw it in Rome, in the collection of a Sig. Massani, in 1829. In 1837 it was placed in the Königliche Museen, Berlin as a loan, and in 1839 Friedrich Wilhelm III donated it.

Aside from Ricci (p.155) who, for reasons of local pride, dated all Gentile's works from Fabriano to a mythical, late phase, and Venturi (pp.193–94), scholars are agreed that this painting is an early work. Colasanti (p.55), Van Marle (pp.17–18), and Molajoli (pp.39–42) discuss it after the *Coronation of the Virgin* at Milan, while L. Grassi (pp.9–10, 53) described it as Gentile's earliest work. In it he saw evidence of contact with Lombard art, whether for its chromatic and technical qualities (its "puntinismo'), or the figural style, which he compared to miniatures close to Giovannino dei Grassi and Michelino da Besozzo. This notion, which traces its origin to suggestions of Longhi (pp.189–90), was accepted by Magagnato (p.74), Arslan (p.108), Bellosi (p.2), and Micheletti (pp.6, 85). However, Zampetti (pp.10–12, 32) returned to the earlier ideas of a local education, stressing contacts with Siena (see Cavalcaselle, p.97; Colasanti, pp.22ff.; Molajoli, pp.22ff.; Serra, pp.60–63). In this he was followed by F. Rossi (p.11). C. Hunter (pp.28, 32) dated the Berlin painting at *c.*1400 and discerned a Venetian background, as had Pallucchini (pp.82–85).

The figural style does show knowledge of Lombard miniatures of the late fourteenth century, but this is also true of works by Ottaviano Nelli (his altar-piece of 1403 at Perugia) and Lorenzo Salimbeni (the triptych of 1400 at Sanseverino) and is not proof of a trip to Lombardy. Certainly knowledge of Michelino, as evidenced in the Milan *Coronation of the Virgin,* is not yet noticeable. A date after 1406, the earliest probable date of the Perugia altar, and before July 1408, when Gentile is documented in Venice, is likely (see also pp.9–10). This dating invalidates the attempt of R. Sassi ('Gentile nella vita fabrianese del suo tempo', *Boll. mensile per la celebrazione centenaria,* VI, 1928, p.13) to relate the picture to a Gugliemo di Pietro, who left money for an altar in S. Niccolò in 1361, or the *oratore* of S. Niccolò, who possessed an altar in 1387.

The arched form of the painting with saints, donor, and holy group gathered together in a single field, is unusual for an altar-piece, though either peculiarity may be found separately (see for example, a canvas painted for the Fraglia di S. Maria dei Servi, Padua, 1408, in the museum of that city, and the *Pala della Levata* by Giovanni Badile in the museum at Verona). The combination is common for an image adorning a sepulchral monument, whether executed in mosaic, fresco,

or on panel (Paolo Veneziano's painting for the tomb of Doge Francesco Dandolo in the Frari, Venice). A similar form and composition was evidently repeated by Gentile in S. Maria Nova, Rome (Catalogue LV), and may serve as confirmation of the original function of the Berlin painting.

CAT. III (Plates 3–4)
MADONNA AND CHILD

Cradled Panel The Metropolitan Museum of Art, New York
86 × 55.8 cm. (inv. no. 30.95.262)

Inscription on scroll: [R] egina celi letare alleluia [quia] quem meruist[i] portar[e a]ll[e]l-luya [r]esur[rexit] sicut[...] (from paschal antiphon of The Blessed Virgin).

The picture is in a ruinous state. The surface is badly abraded, the upper half of the background is modern, and half of the Virgin's face is destroyed. The foliage, however, is in fair condition. Cut on all sides.

The painting came to the Metropolitan Museum in 1915 by bequest of T. Davis of Newport, Rhode Island (B. Burroughs, *Bulletin of the Metropolitan Museum of Art*, XXVI, iii, p.14; H. Wehle, *A Catalogue of Italian, Spanish, and Byzantine Paintings*, New York, 1940, pp.103–4; F. Zeri and E. Gardner, *Italian Paintings, Sienese and Central Italian Schools*, New York, 1980, pp.16–17).

Universally accepted as by Gentile da Fabriano. J. Breck ('Dipinti italiani nella raccolta Davis', *Rassegna d'Arte*, II, 1911, p.115), L. Venturi (*Italian Paintings in America*, New York, 1933, pl.131) and Wehle (*op. cit.*) considered it an early work, similar to the *Coronation* in Milan and the Perugia *Madonna*. L. Coletti (p.ix) thought it contemporary with the Berlin and Tulsa (Catalogue XLI) paintings and that it was executed at Venice. A date *c.*1405 was suggested by Pallucchini (p.85), one after 1408 by Zeri (*op. cit.*), and of *c.*1410 by Huter (p.28). A contrary case, for dating the Metropolitan *Madonna c.*1420, was made by Grassi (pp.22,57). He detected Tuscan contact: an accord of volume and line parallel to Jacopo della Quercia and Nanni di Banco (see also Magagnato, p.70; Arslan, p.109; Bellosi, p.4; Micheletti, p.87, who follow Grassi).

Comparison is certainly with the *Coronation*, the colours of which parallel those of the New York painting. The angels in both works are similar, the foliage nearly identical in treatment. The fingers, however, recall the Berlin *Madonna* in their spininess, making this Gentile's earliest painting indebted to Michelino da Besozzo, whose *Madonna* at Siena offers a parallel for the frontal posture of the Virgin and her flowing drapery. A date *c.*1410, when both Gentile and Michelino were in Venice, is probable.

CAT. IV (Plates 5–15, colour plate A)
THE VALLE ROMITA ALTAR-PIECE

Nine panels Pinacoteca di Brera, Milan

Lower tier, left to right (inv. no. 497)

The gold in all cases has been extended in the arches. Measurements are taken from the catalogue of 1877 which seems more accurate than later ones.

ST. JEROME, 116 × 40 cm., halo inscribed *santus ieronim[us] docto[r]*. The surface is excellently preserved, with but minor retouching on the hat and cloak. The face and adjacent gold has been superficially cleaned.

ST. FRANCIS, 116 × 40 cm., halo inscribed *santus franciscus confessor*. Condition is generally good. Two vertical cracks pass through 1) the leafed area to the right, top to middle, 2) the face and hands to knee height. Smaller cracks pass through 1) the right foot to waist, 2) the plants and gold on the right side. Aside from the last, these have been filled and coarsely inpainted. There are also retouches on the face and habit. The surface is dirty.

CORONATION OF THE VIRGIN, 158 × 79 cm., signed *gentilis de fabriano pinxit*. The border of Christ's cloak is inscribed *Ego sum lux mundi qui sequitur me non ambulat...* (John 8:12); the Virgin's cloak, *Ave gemma pretiosa super solem speciosa / virginale gaudium* (hymn: see F. Mone, *Hymni Latini Medii Aevi*, Freiburg, 1853, II, p.318, no.531).

The angels play, left to right: a mandora, harp, lute (?), lira da braccio, organetto, rebec, psaltry, and a cittern.

Generally good condition, with one, large vertical crack passing through the gold sun and smaller ones in the lower right. These are coarsely inpainted. There are two holes (filled) on the left arm and left breast of God the Father and one in Christ's garment. Losses of leaf in God's and Christ's garments and of the glazes employed for God's robe as well as for the seraphim alter the original, brilliant impression. Christ's right hand and the dove (painted over gold) have suffered serious losses. Other damage and retouching is of a local character.

ST. DOMINIC, 116 × 41 cm., halo inscribed *santus dominicus confessor*. His book is opened to two verses, the first reading *Conservatas sine macula virginitatis lilium ardebam quasi facula prozelo pereuntium;* the second, *Mundum calcans sub pedibus manum misi ad fortia nudus occorrens hostibus christi suffultus gratia. Pugnans verbo miraculis missis per orbem fratribus crebros a [orationibus]*. From the hymn 'ad matutinum', according to G. Kaftal, *Iconography of the Saints in Central and South Italian Painting*, Sansoni, Florence, 1965, p.355).

Condition is good, with a loss in the chin and several in the gold background; dirty.

ST. MARY MAGDALENE, 116 × 41 cm., halo inscribed *santa maria magdalena*. The gold is thin in places and her dress shows some flaking, with small losses and retouching; otherwise in good condition.

Upper tier, left to right
(all these panels have been cropped at the top):

ST. JOHN THE BAPTIST IN THE WILDERNESS, *c.* 37 × 48 cm. Condition is fair. The surface suffers from a heavy craquelure, while a large, vertical crack runs through the centre of the panel. The gold shows numerous fills.

MURDER OF ST. PETER MARTYR, *c.* 37 × 48 cm. Condition is fair. The surface has a heavy craquelure. A large, vertical crack passes through the executioner's extended wrist. This has been filled and inpainted, as have the losses above St. Peter Martyr and below his right arm.

A FRANCISCAN READING, *c.* 37 × 48 cm. The building and habit are badly flaked; otherwise in fair condition

ST. FRANCIS RECEIVING THE STIGMATA, *c.* 37 × 48 cm. Condition is fair, but St. Francis's habit is badly flaked with retouching on the knee and sleeve. There are small losses on the edges of the hills. A full-length, vertical crack passes through the saint's body.

The present frame dates from 1925, at which time *c.* 10 cm. were added to the tops of the small panels. The present cusps of the large panels do not follow the old, visible indications; and the over-complicated, tri-arched peaks of the small ones extend too high. It is arguable on the grounds of style that the St. John and St. Francis in the upper panels should flank the missing centre panel. However, there is no foundation for believing that the small panels ever formed part of a predella (Colasanti, p.50). A Crucifixion (Catalogue LIII), recorded by Ricci (p.153), once crowned the centre in a fashion paralleled in numerous Venetian and Marchigian altar-pieces. Two saints, now in the Harvard Collection, Villa I Tatti, Florence, have incorrectly been suggested as parts of the altar (see Catalogue VI).

The Valle Romita Altar originates from S. Maria di Valdisasso, near Fabriano. Originally a Benedictine foundation, the convent was abandoned by the nuns for more secure quarters at S. Maria Maddalena *extra portam plani* before the end of the thirteenth century, and it became a refuge for Franciscans. In December 1405 Chiavello Chiavelli, lord of Fabriano, purchased the site, rebuilt the church for the Observant Franciscan followers of Paul of Trinci, and compensated the nuns with the church of S. Romualdo in Fabriano (O. Marcoaldi, *Guida e statistica della città e comune di Fabriano,* G. Crocetti, Fabriano, 1873, pp.169–70; R. Sassi, *Le chiese di Fabriano,* Arti Grafiche 'Gentile', Fabriano, 1961, pp.56–57, 160–61; and 'Monasteri Camaldolesi di Fabriano', *Rivista Camaldolese,* Vol. II, Nos. 1 and 2, p.5). L. Wadding (*Annales minorum,* Rome, Vol. IX, 1734, p.276) describes the events as follows:

Hoc anno [1405] die XXIII. Decembris Chiavellus de Chiavellis nobilis miles Fabrianensis, qui cum laude meruit sub Philippo Maria Vicecomite Duce Mediolanensi, & Republica Veneta, publico desuper confecto instrumento, quod asservatur penes Moniales sancti Romualdi, emit ab Abbatissa, & Sororibus Monasterii sanctae Mariae Vallis-Saxeae (ita cognominati a primo incolatu, sed tunc siti intra oppidum in platea, seu districtu sancti Joannis, quod postea unitum

est praedicto Monasterio sancti Romualdi) eremitorium Vallis-Saxeae, ob Fratrum recessum ad ipsas, propter pristinam possessionem devolutum, soluto pretio centum sexaginta duorum aureorum; & tradidit Fratribus Regularis Observantiae. Ita erga novae Congregationis professores afficiebatur, ut omnia necessaria subministraret, & quotiescumque liceret, cohabitaret, divinisque interesset officiis. Venetiis decedens ultimis tabulis curavit in templum istud corpus transferri, & contumulari praeclarae foeminae Luciae consorti.

Molajoli (p.111, n.1) first suggested that Gentile's altar-piece was moved to S. Maria di Valdisasso from another establishment (see also Grassi, p.12; Magagnato, p.75; Micheletti, p.85). The iconography of the altar-piece, which shows the founders of the two mendicant orders in places of honour flanked by two famous early Christian hermits and surmounted by scenes from the lives of mendicant friars and the first Christian hermit, John the Baptist, leaves no doubt that it was commissioned for this church, where Flavio Biondo recorded it: 'Seruaturque picta in eo tabula gentilis fabrianensis opus ceteris quas uiderimus preferenda' (*Italia illustrata libri VIII*, Regio quinta Picenum sive Machia Anconitana incipit, 1453). In 1810 the convent was suppressed and the panels of the lower tier were transferred to the Brera (24 September 1811: see *Catalogue, 1877*). The four small panels entered the collection of Carlo Rosei at Fabriano (Ricci, p.153; Marcoaldi, *op. cit.*, p.90) and were sold to the Brera 20 October 1901 (Museum catalogue).

Although there is no agreement as to the date of the altar-piece, it cannot have been commissioned before 1406, and the idea that it is Gentile's earliest surviving painting (Colasanti, p.52; Venturi, p.190; Van Marle, p.9; Molajoli, p.25) may be rejected, as the style is more unified, the curving rhythms more pervasive than in either the Perugia or Berlin works. Since Cavalcaselle (p.97) critics have persisted in noting the influence of Sienese art, especially of Taddeo di Bartolo, but Mayer (p.41) pointed to Venice and dated the altar-piece *c.*1410 or later. He was followed by Pallucchini (p.83), Huter (p.28), and Boskovits (*Pittura umbra e marchigiana fra medioevo e rinascimento,* Ed. Edam, Florence, 1973, p.24; see also Bellosi, p.2).

The use of an involuted curve as a basis of figural construction and the subordination of colour to a compositional scheme of interlocking forms associates this work with the style of Michelino da Besozzo as seen in his British Library manuscript of *c.*1414 (see also Grassi, pp.13–55). Such contact probably took place in Venice, where Michelino is documented in 1410 and where Gentile worked from late 1408. Some frescoes at the cathedral of Pordenone (Catalogue XXXVI, Plates 94–97) directly reflect the style of the *Coronation*. If Chiavello was the patron, as is reasonable to suppose, then the commission was no later than 1412, when he died in Venice. Conjunction of stylistic and historical evidence points to a date *c.*1410–12. Gentile completed the altar-piece before 1414, when he is documented in Brescia.

There is some confusion as to the identity of the friar shown reading outside his cell. Cavalcaselle (p.7, n.1) called him St. Dominic, but he wears a Franciscan, not a Dominican habit. For the same reason he cannot represent St. Thomas Aquinas, as Colasanti (p.49) first thought. The iconography is also unusual for St. Anthony of Padua (Venturi, p.191, n.1). Given the popularity of the Franciscan

movement throughout central Italy, and the cult of local saints and *beati* (i.e. Beato Ranieri of San Sepolcro, Beato Sante at Mombarroccio), the figure most likely represents a less well-known Franciscan. Despite the fact that he is shown with a halo rather than rays, a local figure like Beato Ranieri of Arezzo or Francesco Venimbeni, who was a bibliophile, may be intended.

Gentile's image of St. Mary Magdalene evidently enjoyed a local celebrity and is the subject of several sixteenth-century poems (R. Sassi, 'Sonetti di Poeti Fabrianesi in onore di Gentile da Fabriano', *Rassegna Marchigiana*, II, 1924, pp.173–82). Raphael is said to have visited the convent in order to study the altar-piece (Ricci, p.155).

CAT. V (Plate 16)
MADONNA AND CHILD

Panel Pinacoteca Nazionale, Ferrara
58 × 48 cm.
Halo inscribed *ave maria gratia plena dominus tecum*.

The painting is in a ruinous state and almost completely overpainted. An area encompassing the Virgin's left hand, Christ's right breast and right-hand fingers, as well as most of the Madonna's sleeve has been recreated with a false craquelure. The gold beyond the haloes is modern. However, the tooling is original, as is the raspberry-to-pink blanket of Christ and portions of the lining of the Virgin's veil.

From the Vendeghini Collection it passed to M. Baldi, who bequeathed it to Ferrara (museum folder by M. Pace Brugnoli, 1975).

Longhi's opinion that the painting was by Jacopo Bellini (*Viatico per cinque secoli di pittura veneziana*, Sansoni, Florence, 1946, p.52) was repeated by M. Rothlisberger ('Studi su Jacopo Bellini', *Saggi e Memorie di Storia dell'Arte*, II, 1958–59, p.78) and has been accepted by R. Pallucchini (Exhibition *Konstens Venedig*, 1962, p.55, No.47), who dates it about 1440, and L. Dussler ('Berichte: Stockholm', *Pantheon*, XXI, 1963, p.129). F. Heinemann ('Die Anstellung Venezianischer Kunst in Stockholm', *Kunstchronik*, XVI, 1963, p.63) proposed Michele Giambono as its author. A. Gonzalez-Palacios ('Un lasciato che fa onore a Ferrara', *Il Mondo*, 18 December 1975, p.99) first suggested Gentile's name, considering the panel part of a polyptych, and C. Volpe ('La donazione Vendeghini Baldi a Ferrara', *Paragone*, XXVIII, No. 329, 1977, pp.75ff.) has dated it in the second decade of the century.

Despite its terrible condition, there can be little doubt that Gentile is the author. The tooling is fully worthy of him; the figure types, the gold ornamentation on the hem of the Virgin's robe, the gold striations of Christ's blanket, and the halo designs are paralleled in the *Valle Romita Altar*. A similar date (*c.* 1410–14) is very probable, while Zanino di Pietro's *Madonna* on the iconostasis of the cathedral of Torcello probably reflects this or a very similar painting by Gentile executed in Venice.

CAT. VI (Plate 17)
SS. PETER AND PAUL

Panels Harvard University, Villa I Tatti, Florence
23.5 × 8.6; 23.1 × 8.7 cm. (painted surface, 22.4 × 6.4; 22.3 × 6.8 cm.)
respectively.

A strip of wood, 0.6 cm., has been added to the right side of the panel of St. Paul.
On the back of this panel is written, '*Gentile da Fabriano pinxit – fragmento che era nella
cappella overa . . . sepoltura di casa Sancti nelle (?) orofecerie Anno 1610*'; then, in another
hand, '*cioè dalle parti [dalla panca?]della palla (?) con certi intagli all'antica i quali erano
condotti per la longhezza del temp'* (see F. Russoli, *La Raccolta Berenson*, Officine
Grafiche Ricordi, Milan, 1962, p.xxi – whose measurements, however, should be
corrected – and C. Volpe, 'Due frammenti di Gentile da Fabriano', *Paragone*, IX, No.
101, 1958, pp.53–55 – who reads the handwriting differently).

Both panels are poorly preserved and show retouching in the gold and pig-
mented areas. St. Peter's right hand and his foot, excluding the toes, are new, as is the
glaze surrounding the gold backgrounds of the two paintings.

The provenance, aside from the above-cited indications, is unknown. Despite the
seventeenth-century attribution, Berenson thought them by Stefano da Verona (1907,
p.302; 1932, p.550). This was questioned by B. Degenhart ('Stefano da Verona',
Thieme-Becker Künstler Lexicon, Leipzig, XXI, 1937, p.529), who later associated
them with a St. Anthony Abbot at Pisa and suggested Pisanello as the author ('Di una
pubblicazione su Pisanello e di altri fatti, II', *Arte Veneta*, VIII, 1954, pp.116–17). The
St. Anthony is by a different hand, and has a companion St. Jerome in the Louvre
(Volpe, *op. cit.*, p.54, and F. Zeri, 'Qualche appunto su Alvaro Pirez', *Mitteilungen des
kunsthistorischen Institutes in Florenz*, XVII, 1973, pp.367–70). Volpe correctly attrib-
uted the I Tatti panel to Gentile and hypothesized that they once formed part of the
Milan *Coronation*. Berenson (1968, p.164) and R. Chiarelli, (*L'Opera completa del
Pisanello*, Rizzoli Ed., Milan, 1972, p.108) accepted the attribution while Micheletti
(p.88) has suggested collocation with a demonstrably mythical altar-piece. Rossi (p.19
and n.32) has questioned both the attribution and association with the *Coronation*.

There can be little doubt that the two panels are roughly contemporary with the
altar-piece at Milan. However, the seventeenth-century notice indicates, if any-
thing, that they are from another ensemble: it can in no way be construed to refer
to the nineteenth-century collection of Carlo Rosei, owner of the four upper
panels of the *Coronation* (Volpe, *op. cit.*, p. 54). Judging from the somewhat softer
modelling, a later date is probable: *c.*1414–18 (i.e. at Brescia).

CAT. VII (Plates 18–19)
MADONNA AND CHILD

Cradled panel National Gallery of Art, Washington, D.C.
95.9 × 56.5 cm. (inv. no. 366, K 472)

The Virgin's collar is inscribed MATER, her hem AVE MARIA GRATIA PLENA DOM[INUS] TECUM BEN[EDICTA].

On the whole, condition is very good. Aside from small damages and retouching, none important, the major impediment to proper appreciation is a heavy varnish and the much darkened glazes of the Virgin's dress and throne brocade (see F. Rusk Shapley, *Paintings from the S. H. Kress Collection*, Phaidon, London, 1966, I, p.76). The leaf has been unnecessarily extended at the sides and traces of the placement of the frame's capitals have been filled in. In fact, when first published in 1911 (Colasanti, 'Un quadro ignorato di Gentile da Fabriano', *Bollettino d'Arte*, V, 1911, pp.33–35) the painting was enclosed by a different frame which Colasanti believed to be original. Aside from the cusps, the design of which indicates a recent date, this seems possible. A coat of arms (or, band gules with fleur-de-lys or) ornamented the base.

From the Alexander Barker Collection, London (sold Christie's, London, 6 June 1874, no.45) the painting passed to E. J. Sartoris, Paris (exhibited: Royal Academy, London, 1876, no.195; Musée des Arts Decoratifs, Paris, 1911). It was sold by Nathan Wildenstein and René Gimpel prior to July 1918 to Henry Goldman, who sold it on 1 February 1937 to Duveen, from whom Kress purchased it on 9 March (E. Fahy, *Art Bull.*, LVI, 1974, p.283). Since 1941 it has been in the National Gallery of Art, Washington.

An ascription to Gentile da Fabriano has never been questioned, and, excepting Van Marle (pp.18–21), Venturi (pp.192–94) and Bellosi (p.3), a dating during Gentile's Florentine sojourn is universal. For Colasanti (*op. cit.*, p.35) and Shapley (*op. cit.*, p.76, and *Italian Paintings*, Washington, 1979, pp.195–96) a moment prior to the *Adoration of the Magi* seemed probable (*c.* 1422), while Molajoli (p.78), Huter (p.27), Micheletti (p.91) and Grassi (pp. 31–33) placed it between the *Adoration* and the *Quaratesi Altar* (*c.* 1424–25). The last compared it to the Getty *Coronation* and the fragmentary *Madonna* at Villa I Tatti, all of which seemed to him to reveal Sienese contact (see also L. Grassi, 'Considerazioni intorno al "Polittico Quaratesi'", *Paragone*, II, No. 15, 1951, pp.29–30).

Resemblance to the I Tatti *Madonna* is superficial, while even the figures of the Getty *Coronation,* almost certainly commissioned in 1420, are modelled more loosely and are more sculpturally conceived. The maroon glaze of the Virgin's tunic, the deep blue of Christ's robe, and the dark green (?) brocade covering the bench create an effect not readily paralleled in Gentile's work and recall French panel painting. Gentile may have seen such works at Brescia. In the absence of comparative material a date prior to 1420 cannot be excluded. However, the tooling is also unprecedented in Gentile's art. It stems from Tuscan, not French or north Italian art, and the type of capital letters of the inscriptions also points to Florentine contact. The frame published by Colasanti was of a distinctly Floren-

tine design. A date shortly after September 1419, when Gentile left Brescia to join Pope Martin V – then in Florence – seems likely.

In his left hand the Child holds a string to which a moth is attached. This is an allusion to the Resurrection.

CAT. VIII (Plates 20–21, colour plate B)

DOUBLE-SIDED PROCESSIONAL STANDARD

CORONATION OF THE VIRGIN, cradled panel, 87.5 × 64 cm., J. P. Getty Museum, Malibu Beach, California

Christ's halo inscribed: YHS/XPS / FIL[IUS]: scrolls inscribed: *Timete dominum et date illi hono[rem]* and *Dignus est agnus qui o[ccisus est]* (Revelations 5:12); hem of Virgin's robe inscribed: *Ave Maria g[ratia] plen[a] dominus tecum be[nedicta]*.

Cleaning in 1976 has revealed the painting to be in good condition. Losses are of a minor character; a vertical crack runs through the Virgin's jaw. The raised crown, brooch, and belt are modern, though already present in a watercolour reproduction of the 1830s (photograph on file at German Institute, Florence). The original gesso work may be reproduced in the copy at Vienna (see below). The most serious damage is the loss of much of the glazes used to model the areas below and behind the figures and the sleeve of Christ's garment. The lower *c*. 1 cm. of the panel has been renewed; a rectangular section at the bottom centre indicates where a support was attached (see below); and areas at either side mark where framing capitals were originally placed. The panel has been reduced, but the paint surface has not been cropped (contrary to Grassi, p.60).

ST. FRANCIS RECEIVING THE STIGMATA, cradled panel, *c*. 87 × 64 cm., private collection, Italy

Halo of St. Francis inscribed *franciscus*.

In very good condition. Only where pigment has been laid over gold (i.e. illuminated half of the hill, the Christ-seraph, the left hand of St. Francis) has some flaking occured. The original placement of the frame's capitals, in the roof of the chapel and on the opposite edge, have been inpainted, as has a loss in the main hill and a rectangular area in the centre bottom where a support was attached (see below). Heavily varnished.

The original form of these two paintings (once united to form a double-sided processional standard mounted on a pole and, like Figure 15, with a gable showing God the Father on the obverse) has not heretofore been recognized despite a concordance of style, size, such physical peculiarities as are mentioned above, and the documented form of a copy of equal dimensions executed in 1452 (Catalogue XLIV). Confusion with that copy and the differing provenances are largely to blame for this (see also K. Christiansen, 'The Coronation of the Virgin by Gentile da Fabriano', *The J. Paul Getty*

Museum Journal, 6–7, 1978–79, pp.1–12). The earliest notice of the two paintings catalogued here is in a manuscript of 1827 by Vicenzo Liberati (cited by Molajoli, p.112, n.2) which stated that: 'Due quadri da cavalletto esistono presso questo nostro V. Seminario, raffiguranti l'uno la Coronazione di M. V. e l'altro S. Francesco che riceve le stimate; questi sono in fondo d'oro d'un lavoro eccellente; tali quadri furono ceduti in dono dai PP. Francescani ai Filippini, ed ora, soppressi questi, sono passati in dominio de V. Seminario'; another hand adds, 'quindi venduti'. (S. Francesco was renewed 1781–88; destroyed 1864. The Congregation of the Fathers of the Oratory of S. Filippo Neri was instituted in Fabriano in 1628. In 1632 they were ceded the oratory of the Fraternità dei Disciplinati, later the Compagnia dei SS. Giuseppe e Francesco (See Molajoli, *Guida artistica di Fabriano*, Rotary Club, 1968, pp.52, 142).

Liberati also noted a copy of both paintings in the Casa Buffera, Fabriano, attributed to Antonio da Fabriano (Molajoli, p.118, n.4; R. Sassi, 'Arte e storia fra le rovine d'un antico tempio francescano', *Rassegna Marchigiana*, V, 1927, p.346). J. Passavant saw these at the Buffera house in 1835 and described them as forming a double-sided processional standard (*Raphael d'Urbin et son père Giovanni Santi*, Paris, 1860, I, p.389). By 1858 the front and back had been separated (Eastlake, *Notebook, II*, p.200), and they were in the Casa Morichi, Fabriano, where they passed after Buffera's death in 1853 (O. Marcoaldi, *Guida e statistica della città e commune di Fabriano*, G. Crocetti, Fabriano, 1873 p.239, n.181). Both Eastlake and Cavalcaselle (p.106) recorded an inscription on the *St. Francis* reading *Año dñi 1452, die 25 de Martio*: a period coinciding with Antonio da Fabriano's activity but post-dating Gentile's death by twenty-five years (a fact not known until 1887). Not more than two years after Liberati recorded the traditional attribution to Antonio, Ricci (*Elogio del pittore Gentile da Fabriano*, G. M. Cortesi, Macerata, 1829, p.18) named Gentile as their author. With the exception of Eastlake, who recorded the attribution to Antonio, this ascription continued through Van Marle (p.26). In fact, though O. Marcoaldi (*Sui quadri di pittori fabrianesi raccolti e posseduti dal Sig. Romualdo Fornari*, Tipographia G. Crocetti, Fabriano, 1867 – not 1897, as Molajoli and others print it – p.8 and n.A) knew both the Morichi paintings and Gentile's *St. Francis*, then in the Fornari Collection, Fabriano, he ascribed both versions to Gentile. By 1873 the 1452 version, along with its companion *Coronation*, had passed into the Casa Rotondi, Fabriano (O. Marcoaldi, *Guida e statistica. . .*, pp.89–90). In 1889 the *St. Francis* was described in the F. Pirri Collection, Rome (*Catalogo degli oggetti d'arte e curiosità del Sig. Filippo Pirri*, Tip. A. Befani, Rome, 1889, p.92, No.548), and in 1892 it was offered for sale to the British Museum by Ernesto Aurelio, Rome; its present location is unknown. What must be the companion *Coronation* was given by Prince Johann von Liechtenstein to the Akademie, Vienna in 1882 (M. Poch-Kalous, *Katalog der Gemälde Galerie*, Vienna, 1972, p.12).

Gentile's *Coronation* was purchased in Florence on 16 August 1835 by Rev. John Sanford, evidently from a Sig. Nocchi (*Account book/diary of Rev. Sanford*, Barber Institute, Birmingham). The fact that the catalogue of 1847 claims that the painting had belonged to Sig. R. Buffera (B. Nicolson, 'The Sanford Collection', *Burlington*, XCVII, 1955, p.210) may be attributed to the compiler's confusion with the painting mentioned by Ricci. At Sanford's death in 1855 the painting passed to Lord Methuen at Corsham Court (he had married Sanford's daughter), and thence to his son (G.

Waagen, *Galleries and Cabinets of Art in Great Britain,* John Murray, London, 1857, p.397). Sold in 1899 to Ch. Sedelmeyer (Christie's, 13 May 1899, No.81), it was bought by Henri Heugel, Paris in 1902. In 1976 it was purchased from the Heugel family by Agnew's, who sold it to the J. P. Getty Museum. Its companion *St. Francis* had, as already noted, passed into the Fornari Collection, Fabriano prior to 1858 (Eastlake, *op. cit.*) but was seen by neither Passavant nor Cavalcaselle. Colasanti ('Un quadro inedito di Gentile da Fabriano', *Bollettino d'Arte,* I, 1907, pp.19–22) published it along with a third, coarse copy also mentioned by Marcoaldi (see also F. M. Perkins, 'Note...', *Rassegna d'Arte,* VI, 1906, p.52, n.1). By 1923 it was in Rome, though still part of the Fornari Collection (R. Sassi, 'La famiglia di Gentile da Fabriano', *Rassegna Marchigiana,* II, 1923, p.9), and is said to have been owned by a banking firm before purchase by Sig. Carminati (Grassi, p.56), who also purchased other Fornari paintings; sold, 1978.

There can be no doubt that the Getty and ex-Carminati paintings are those referred to by Liberati as by Gentile, and in light of physical and comparative data, it is not legitimate to question their original form and function as two sides of a processional standard. Previous conjectures as to provenance and attribution must be largely discarded (Molajoli, pp.117–18; Van Marle, p.26; Grassi, p.56; Bellosi, p.3; Rossi, p.17, n.23; Micheletti, pp.87–88), and an attempt to reconstruct an altar-piece around the Getty *Coronation* is invalid (R. Longhi, 'Me pinxit. Un San Michele Arcangelo di Gentile da Fabriano', *Pinacotheca,* I, 1928, pp.71ff.; Micheletti, pp.87–88). Any notion that the *St. Francis* pre-dates the *Coronation* by as much as twenty years must be considered highly unlikely (Colasanti, pp.54–55; Molajoli, p.34; Grassi, pp.15, 56; Van Marle, p.14; M. Boskovits, *Pittura umbra e marchigiana fra medioevo e rinascimento,* Ed. Edam, Florence, 1973, pp.24, 43, n.134). On the one hand, the use of light in the *St. Francis* is comparable to no work prior to the *Adoration of the Magi* (Arslan, p.110; see text pp.22f.). On the other hand, there are close correspondences of figure style between the St. Francis and the Christ in the *Coronation,* whose features are more rigorously modelled and better articulated than the Christ of the *Valle Romita Altar* or the Madonna in Washington. Differences in treatment between the two sides are due, in the first place, to the contrasting nature of the subject-matter (similar differences in treatment are to be found between the central, hieratic gable of the *Adoration of the Magi* and the lateral gables) and, in the second place, to the intervention of an assistant in the *Coronation* – especially in the dove (compare to the *Valle Romita Altar*) and angels, but also in the figure of the Virgin. However, it is also possible that a short delay in fulfilling the commission separates the *Coronation* from the *St. Francis,* which seems the more advanced of the two. The iconography lends credence to the provenance from S. Francesco in Fabriano given by Liberati. Since Gentile was in contact with Fabriano in March–April 1420 (Document V), this may be considered the probable moment of the commission. The iconography of Christ simultaneously blessing and crowning the seated Virgin, however, is ex-

tremely rare outside Florence. This fact, as well as relations of style to Jacopo di Cione's altar-piece at the National Gallery, London, points to its execution in Florence, where Gentile is securely documented in the autumn of 1420 (Document VI) but where he may have arrived as early as late September 1419.

CAT. IX (Plates 22–38, colour plate C)
THE ADORATION OF THE MAGI

Four panels Uffizi, Florence
ensemble measures 300 × 282 cm. (inv. no. 1890)

Signed below the main scene OPUS GENTILIS DE FABRIANO / MCCCCXXIII MENSIS MAII. On either pilaster base is the Strozzi coat of arms (or, band gules with crescents), poorly preserved. The left-hand gable shows Gabriel holding a scroll inscribed AVE MARI[A GRATIA PLENA] DOMINUS TECUM BENEDI[C]TA (Luke 1:28). Below are Ezekiel and Micah with scrolls respectively inscribed ALTITUDI[NES SEMPITERNAE] INHEREDITA[TEM] DAT-[AE SUNT NOBIS] (Ezekiel 36:2) and ERIT MONS DOMUS (Micah 4:1). In the central gable Moses holds two tablets inscribed NON HABEBIS DEOS ALIENOS [CORAM ME]; NON [AS]SUMES NOMEN DOMINI D[EI TUI IN VANUM] (Exodus 20:3,7). David plays a harp. In the third gable the scrolls of Baruch and Isaiah are respectively inscribed [POST HAEC I]NTERRIS VISUS ES[T] (Baruch 3:38) and ECCE [VIRGO CONCIPIET E]T PARIE[T FILIUM] (Isaiah 7:14).

The frame is original with its gold largely intact, though in the joints of the pilasters, on the frame of the predella, and possibly on the foliated gables new leaf gives a harsher brilliance. The painting on the frame (i.e. prophets, flowers, etc.) is also in good condition, damage being confined to where pigment was laid over gold (the garment of Christ, the seraphim) or where glazes have darkened (much of the floral painting, David's cloak).

THE JOURNEY AND ADORATION OF THE MAGI, 173 × 223 cm.

On the whole the condition is remarkably good for a painting of this size. Most damages are concentrated in areas where pigment was laid over gold (the cave, the hair of the child, Joseph's cloak, overhang of the shed, etc.) or where oil glazes were used. In these places losses and abrasions have occurred. Especially the old magus's cloak has suffered as well as the sleeves of the young magus; also the blue brocade worn by the man holding a falcon. These areas originally gave a richer and more sculptural impression. Most other, small losses (i.e. on the Virgin's cloak) have been inpainted. The largest damage is between the legs of the youthful page, and there is a vertical crack in the left portion of the central lunette. Most of the raised ornament (*pastiglia*) has also been lost.

Predella scenes:

THE NATIVITY, 25 × 61.8 cm.

In very good condition. The major damage is loss of the pigment that overlaid the aureoles of Christ and the angel. However, losses have also occurred in the lower left-hand corner of the panel and in the hindquarters of the ox.

THE FLIGHT INTO EGYPT, 25.1 × 87.5 cm.

Because of the extensive use of gold leaf beneath the pigments, the left third of the panel especially has suffered disfiguring losses. The glazes of the left-hand, flowered patch as well as those on the left-hand maid have darkened and separated, impeding clear reading. The right two thirds of the painting is in excellent condition.

THE PRESENTATION IN THE TEMPLE, Louvre, Paris (inv. n. 295), 26 × 61 cm.

The painting has been cleaned and is in excellent condition. There is some flaking on the glazed, maroon dress of the maid.

Completed for the sacristy of S. Trinita in May 1423. Gentile received 150 gold florins on June 8 'per resto di paghamento di dipintura della tavola a fatto alla sagrestia di Santa Trinita' (Document VIII). Palla Strozzi had perhaps commissioned it by 1421, when the sacristy was dedicated, but the fact that in 1420 Gentile was renting a house from a member of the Strozzi family (Doc. VI) may indicate that he was engaged even earlier. It was first mentioned by Fazio, then Vasari (p.6) and G. Cinelli (*Le bellezze della città di Firenze,* Florence, 1677, p.192). D. Davisson ('The Iconology of the S. Trinita Sacristy, 1418–35: A Study of the Private and Public Functions of Religious Art in the Early Quattrocento', *Art Bulletin,* LVII, 1975, pp.315–35) has proposed that it was intended not for the main altar, which he argues was ornamented with an altar-piece by Lorenzo Monaco (on this, see text p.25 and note 24), but was placed in the adjacent chapel. This conjecture is without documentary foundation and contradicts all descriptions of the sacristy. The earliest of these is a history of S. Trinita written by B. Davanzati in 1740, still in the possession of the monastery, in which it is stated (ff.319–20):

> La prima volta esi Altare appogiava al muro e poi tirato in isola con dar luogo agli Armari con i mobili [these were added in 1698]. In detta Sagrestia dietro all'Altare vi è una bellissima tavola di mano di Gentile da Fabriano, fatte l'anno 1430 in circa, la quale rappresenta l'adorazione dei Magi.

A complete rearrangement occurred when Ghirlandaio's *Nativity* was removed from the Sassetti Chapel to make way for Vittorio Barbieri's marble Pietà (dated 1743). Ghirlandaio's painting was placed on the altar; Gentile's was hung on the wall above it (Richa, *Notizie delle chiese fiorentine,* Florence, 1755, III, pp.156–57). When the convent was suppressed in 1810, the altar-piece was transferred to the Accademia di Belle Arti, minus the *Presentation in the Temple,* which was transported to Paris (arrived August 1812; exhibited 1814, No.52). In 1919 the altar-piece passed to the Uffizi. A copy of the *Presentation,* by Prof. della Bruna, replaces the panel in the Louvre.

As one of Gentile's two most important commissions in Florence and his earliest dated work, the *Adoration of the Magi* has occasioned numerous comments on its peculiarities of style and iconography (see Ricci, pp.148–49; Cavalcaselle, p.202; Van Marle, pp.33–40; Venturi, pp.198–99; Grassi, pp.23–30; and P. Francastel, *La Figure et le lieu,* Gallimard, Paris, 1967, pp.108–33). Degenhart (I-1, pp.257–61, 239) has attempted to trace the foreground hound to a Tuscan pattern book (but see R. Scheller, *A Survey of Medieval Model Books,* Haarlem, 1963, pp.191ff.), and Colasanti (pp.68–70) first noted the iconographic precedence of Bartolo di Fredi's Siena *Adoration* and the probable influence of liturgical plays and *sacre rappresentazioni* for the

episodes of the voyage of the magi portrayed in the lunettes: sighting the star, journeying to Jerusalem and Bethlehem (see E. Mâle, 'Les rois mages et le drame liturgique', *Gazette des Beaux-Arts*, IV-4, 1910, pp.261–70). A fresco by Cenni di Francesco at S. Donato in Polverosa, Florence (1383) should be cited as a local precedent for the elaborate train and the presence of two maidservants (Fig. 31). The depiction of men fighting has been discussed by C. Sterling ('Fighting Animals in the Adoration of the Magi', *Bulletin of the Cleveland Museum of Art*, LXI, 1974, pp.350–59), while Davisson (*op. cit.*, pp.315–35) has attempted to relate the subject-matter to hypothetical functions of the chapel: his conclusions are highly suspect and founded upon incorrect information. Beyond the facts that special masses were said for the patrons – SS. Onuphrius and Nicholas – that stalls were built for the monks' use, and that the building was to serve as a tomb chapel for Onofrio's branch of the family, no extraordinary religious practices point to an unusual iconography (see G. Poggi, *La Cappella e la tomba di Onofrio Strozzi nella chiesa di S. Trinita*, Tip. Barbera, Florence, 1903). The inscriptions on the prophets' scrolls relate to prophecies of the coming of Christ and the restoration of the kingdom of David. Especially the chapters opened by the verses of Ezekiel and Micah are pertinent to the magi and the lush landscape. The plants of the pilasters have been identified and their symbolism studied by L. Behling ('Das Pflanzenbild um 1400 – zum Wesen des pflanzlichen Dekors auf dem Epiphaniasbild des Gentile da Fabriano', *Pantheon*, XXIV, 1966, pp.347–59).

The turbaned young man staring frontally out of the painting was engraved in the second edition of Vasari as a self-portrait, and Davisson (*op. cit.*, p.324) identified him as Palla Strozzi, with his father standing next to him. Though the two figures certainly are portraits, they appear to represent Lorenzo and Palla, aged respectively eighteen and fifty in 1422. A falcon, held by Palla, was the family emblem (G. B. Crollalanza, *Dizionario storico-blazonico*, Arnaldo Forni, Bologna, 1965, II, p.568). The identification of the old magus as Emperor Sigismund (G. Scaglia, 'An Allegorical Portrait of Emperor Sigismund by Mariano Taccola of Siena', *Journal of the Warburg and Courtauld Institutes*, XXXI, 1968, pp.431–32) is improbable.

R. Longhi ('Me pinxit: un S. Michele Arcangelo di Gentile da Fabriano' *Pinacotheca*, II, 1928, pp.71–75) first alluded to the fact that Gabriel is shown with three pairs of wings, though he does not properly belong to the rank of cherubim or seraphim. However, Jacopino so depicts him in an alter-piece of the Death of the Virgin at Bologna, and the Gabriel painted by Vitale for S. Apollonia a Mezzaratta, also in the Pinacoteca Nazionale, has at least two pairs of wings, as does Gabriel in A. Lorenzetti's *Annunciation* of 1344 (on their originality, see N. Muller, 'Ambrogio Lorenzetti's *Annunciation*: a Re-examination', *Mitteilungen des Kunsthistorischen Institutes in Florenz*, XXI, 1977, pp.1–11).

The frame is discussed by M. Cämmerer-George (*Die Rahmung der Toskanischen Altarbilder im Trecento*, P. H. Heitz, Strasbourg, 1966, pp.184–87).

Despite a remarkably uniform style, several heads seem to evidence the presence of an assistant who was also responsible for the execution of the St. George in the *Quaratesi Altar* (i.e. The man in a red turban next to the cave and those, but partially seen, in the back of the main train). There are, however, no grounds for the belief that Pisanello had a hand in the work, since his *Annunciation* at S. Fermo, Verona (c.1424–26) is conceived in a markedly different style. If he had

participated, it would be strange that his name did not occur in some of the documents (see B. Degenhart, 'Gentile da Fabriano und die Anfänge des Antikenstudiums', *Münchner Jahrbuch der Bildenden Kunst,* XI, 1960, p.71; and G. Paccagnini, *Pisanello e il ciclo cavalleresco di Mantova,* Electa Ed., Venice, 1973, p.146).

CAT. X (Plates 39–41)
MADONNA AND CHILD
Panel Museo Nazionale, Pisa

56 × 41 cm.

The damaged inscription on the border of the Virgin's cloak is only partly legible and seems to begin, [a]ve m[ate]r dicgna [d]ei. . . ; that on the Child's blanket is in garbled Arabic, *La Illahi Ila Allah* ('There is no god but God' – confirmed by Manuel Keene of the Metropolitan Museum).

The painting is in its original frame and is moderately well preserved. The maroon glaze of the cloth of honour and the patterned floor (painted over gold) have suffered most; the blue and green cloak of the Virgin has darkened; the flesh portions show some wear. The feigned marble reverse side is in very good condition, aside from some small losses. Restored 1958.

The panel passed from the Pia Casa della Misericordia, Pisa (Cavalcaselle, p.106) to its present location (A. Bellini, *Catalogo del Museo Civico,* Pisa, p.129).

The attribution of this panel has never been questioned, and the pseudo-cufic inscription of the Virgin's halo has been thought to camouflage a signature (E. Teza, 'Per una firma di Gentile', *Augusta Perusia,* II, 1907, p.145; W. Bombe, 'Le opere di Gentile da Fabriano alla mostra d'Arte Antica Umbra', *loc. cit.,* pp.113–14). However, scholars are divided between dating the painting during the Florentine period (Colasanti, p.60; Molajoli, p.78; Venturi, p.200; Huter, p.27) or somewhat earlier – perhaps while Gentile was at Brescia (Grassi pp.20, 56–7; Van Marle, p.22; Magagnato, p.78; Rossi, pp.11, 20ff.; Arslan, p.109; Bellosi, p.3; Micheletti, p.87; and E. Carli, *Il Museo di Pisa,* Pacini Ed., Pisa, 1974, pp.67–68).

Comparisons should be made with the *Adoration of the Magi* rather than the *Coronation of the Virgin* at Milan; and a Tuscan-Florentine provenance is proved by the iconography (both Huter, pp.29ff., and Rossi, pp.20ff., trace the origin of this particular type, but neither argument is completely convincing: for a general treatment of the *Madonna of Humility* see M. Meiss, *Painting in Florence and Siena after the Black Death,* Princeton University Press, 1951, pp.132ff.). While the curved floor and attitude of the Virgin in Gentile's image derive from Venetian models, where a curving meadow is the normal setting, they have been adapted to an interior with a cloth of honour more current in Florence. This conception, including the unusual, crossed arms of the Madonna, was repeated only once: in a *Madonna of Humility* from the workshop of Fra Angelico (Fig. 38) which obviously depends on the Pisa painting. A date *c.*1422 – later than the Washington *Madonna* but prior to the Frick altar – is most probable.

CAT. XI (Plates 42–43)
MADONNA AND CHILD WITH SS. JULIAN AND LAWRENCE

Cradled panel Frick Collection, New York
90.8 × 47 cm. (picture surface) (inv. no. 66.1.167)
On the frame is the signature *gentili*[s] *de . . .* and sc. LAURE[N]TIUS / SC. IULIANUS.

On the whole, condition is good, especially in the flesh areas. The most disfigur-ing damage is loss of the gold or pigment on Christ's blanket, gold on the Virgin's dress, and the deep red shadows and some of the yellow highlights on the throne cloth. In the last case, the intended three-dimensional effect is compromised. The green oil glaze of Julian's tunic is much darkened. Additionally, there are small losses in the Virgin's face and larger ones in the area of her right knee; both carefully inpainted. The background leaf beyond the haloes is new. The frame is original, but has been supplied with modern colonettes. Except on the base, its gold is new.

The painting was purchased in Italy, possibly Florence, by the Duc de Broglie in 1846. It was in that family's collection when C. Sterling first published it in 1958 ('Un tableau inédit de Gentile da Fabriano', *Paragone*, IX, No. 101, 1958, pp. 26–33). The Frick purchased it on 22 December 1966.

Sterling (*op. cit.,* pp. 28–31) detected Sienese influence in the iconography (the clothed Child) and style. He dated it *c.*1423–25 (contemporary with the *Quaratesi Altar*) or *c.*1426 (at Siena); Micheletti (p. 91) agreed. However, the case made by B. Davidson ('Gentile da Fabriano's *Madonna and Child with Saints*', *Art News*, LXVIII, 1969, No. 1, pp. 24–27, 57–60) for a date close to the Strozzi *Adoration of the Magi* is more convincing, and a date of *c.* 1423 may be considered nearly certain.

The probable date and the depiction of thistles on the frame, found also on that of the *Adoration,* have raised the possibility that the Strozzi were the patrons (D. Davisson, 'The Iconology of the S. Trinita Sacristy, 1418–35: A Study of the Private and Public Functions of Religious Art in the Early Quattrocento', *Art Bulletin,* LVII, 1975, p. 327: but the red and blue pigments on the frame, if they repeat the original colours, are commonly found on other contemporary altar-pieces and are thus unlikely to refer to the Strozzi, while the iconography of the altar would better refer to Palla's heir, Lorenzo, than to Bartolomeo). In fact, Julian and Lawrence are among the saints constantly invoked in the various ac-count books of Lorenzo Strozzi and Orsino Lanfredini (ASF, Carte Strozziane, Ser. III, 285, 286, 287), which, however, record no payments to Gentile beyond that for the *Adoration.* In the absence of any firm evidence, the patron and destina-tion of this altar-piece remain highly problematic.

CAT. XII (Plate 44)
MADONNA AND CHILD

Panel Harvard University, Villa I Tatti, Florence
24.8 × 19 cm.

The painting is a fragment, cut on all sides. At one time the area beyond the Virgin's veil was painted out with a deep blue pigment. The removal of this with a scalpel or knife has damaged the background, while some of that pigment still mars the Child's face. There are losses of the gessoed surface throughout. However, the Virgin's face is dirty but essentially well-preserved, and the Child's face retains details such as the highlights on his cheeks.

The fragment was purchased in Rome by B. Berenson early in the century (F. Russoli, *La Raccolta Berenson*, Officine Grafiche Ricordi, Milan, 1962, p.xxix).

Since its publication in 1907 (*Rassegna d'Arte*, VII, 1907, p.120) an attribution to Gentile has been universal. A date close to the *Quaratesi Altar* (Colasanti, p.60; Grassi, pp.31, 61; Arslan, p.111; Micheletti, p.92) has, without grounds, been questioned by M. Boskovits ('Una scheda e qualche suggerimento per un catalogo dei dipinti ai Tatti', *Antichità Viva*, XIV, 1975, No. 2, p.16), who places it close to the Milan *Coronation* (see also Van Marle, p.18). A more sculptural conception of the heads and stronger use of highlights distinguishes this work from the Washington *Madonna*, with which it is often compared, and places it between the Frick and Quaratesi altars: *c.* 1424. The supposed influence of Sienese art (Grassi) is superficial.

CAT. XIII (Plate 45)
MADONNA AND CHILD

Cradled panel Yale University Art Gallery, New Haven
91.4 × 62.9 cm. (inv. no. 1871.66)
Signed on the window casement, lower left, *gent[ilis de] fabriano.*

The condition is ruinous. The panel, cropped on all sides, was radically over-cleaned in 1950–52 (*Italian Primitives: the Case History of a Collection and its Conservation*, Yale University, 1972, pp.20–21). There is nothing left of the final layer of pigment. The deep green and maroon glazes on the gold pillow are almost completely lost, as is the modelling on the Child's pillow and Virgin's dress. There are several holes along the upper architectural moulding and in the signature.

In the collection of J. Jarvis at Florence prior to 1860 (*Descriptive Catalogue of 'Old Masters' collected by J. Jarvis. . .* , Cambridge, 1860, p.51; Cavalcaselle, p.103, n.1), the painting passed to Yale University in 1871.

Scholars have been unanimous in considering it close to those works done in Florence (Colasanti, pp.58–60; Arslan, p.109); most have placed it after the *Adoration of the Magi* (Van Marle, pp.26–30; Venturi, pp.194, 200; Molajoli, pp.76–77; O. Siren,

A Descriptive Catalogue of the Pictures in the Jarvis Collection, Yale University Press, New Haven, 1916, p.169; C. Seymour, *Early Italian Paintings in the Yale University Art Gallery,* Yale University Press, New Haven, 1970, pp.226–28; Bellosi, p.4) and Grassi (pp.42, 64) has thought it just after the *Quaratesi Altar: 1425* (see also R. Offner, *Italian Primitives at Yale University,* Yale University Press, New Haven, 1927, p.43; and Micheletti, p.92). At one time A. Venturi (*Gentile da Fabriano e il Pisanello,* Sansoni Editore, Florence, 1896, p.24) thought this panel constituted the centre of that altar-piece, whose style, in fact, it closely resembles.

Although condition prohibits a proper evaluation, the colour procedures of the painting mark a refinement over those of the Frick altar, making a date just prior to the *Quaratesi Altar-piece, c.* 1424, most probable. The roses, apples, and pomegranates are traditional references to the Virgin, the Fall of Man and his salvation, and the Resurrection.

CAT. XIV (Plates 46–59, colour plate D)
THE QUARATESI ALTAR-PIECE

Ten pieces located as indicated below.
Originally signed on the frame *Opus Gentilis de Fabriano MCCCCXXV mensis maii* (S. Roselli, *Sepoltuario Fiorentino,* 1657, I, f.193r., Bib. Naz., Florence, Ms. II-IV, 534; Richa, *Notizie delle chiese fiorentine,* Florence, 1762, X, p.270: both record the inscription with slight variations in spelling).
Main panels:

MADONNA AND CHILD WITH ANGELS and (in roundel) CHRIST BLESSING, H. M. the Queen, Hampton Court (on loan to the National Gallery, London)
Panel, total height with frame 222.7 cm.; painted area beneath the gable measures 139 × 83.0 cm. Virgin's halo inscribed AVE MARIA GRATIA PLENA; Child's halo reads YHS / XPS / FILII.

Cleaned in 1949, the painting is only in fair condition. Especially the darker part of the Virgin's dress has been reinforced, while the flesh areas have been abraded. Where pigment was laid over gold (the hair of the Child and angels, the Child's tunic) there are many losses, and the maroon glaze of the cloth of honour has both darkened and been retouched (perhaps partly in a sixteenth-century repainting, see below). Other losses are of a minor nature. The gold is substantially old, as is the main portion of the gable and the inner half of its moulding. The bottom border of the paint surface shows its original beard.

ST. MARY MAGDALENE and (in roundel) ANNUNCIATORY ANGEL, Uffizi, Florence (inv. no. 887)
Panel, total height with frame, about 200 cm.; painted area beneath gable measures 120 × 57.9 cm. Halo inscribed SANTO MARIA MAGDALENA.

Apart from the dirt, the painting is in very good condition. Most losses are

concentrated in the maroon glazed cloak, which has also darkened. The frame has been repaired and partly regilt. The seraph has flaked badly.

ST. NICHOLAS and (in roundel) ST. FRANCIS, Uffizi, Florence (inv. no. 887)
Panel, total height with frame about 200 cm.; painted area beneath gable measures 120 × 56.6 cm. Halo inscribed SANCTUS NICHOLAUS.

The painting is dirty, with scattered losses; otherwise in very good condition. The green glaze of Nicholas's cope has darkened. Losses in the background gold have been regilt. The frame has also been repaired and partly regilt.

ST. JOHN THE BAPTIST and (in roundel) ST. DOMINIC, Uffizi, Florence (inv. no. 887)
Panel, total height with frame, about 200 cm.; painted area beneath gable measures 120 × 56.3 cm. Halo inscribed SANCTUS IOHANNES BAPTIS.

In very good condition, but dirty. There are scattered losses, inpainted. The frame is repaired and partly regilt.

ST. GEORGE and (in roundel) VIRGIN ANNUNCIATE, Uffizi, Florence (inv. no. 887)
Panel, total height with frame, about 200 cm.; painted area beneath gable measures 120 × 58 cm. Halo inscribed SANCTUS GEORGIUS MARTIR.

The condition is good, but the flesh areas show considerable flaking and much silver leaf has been lost from the leg armour. The gable figures have flaked more than in the above three panels. The frame has been repaired and partly regilt.

Predella, in original order:

BIRTH OF ST. NICHOLAS, Pinacoteca, Vatican
Panel, 36 × 36 cm.

Badly damaged; the final layer of pigment is gone. Beside the two major losses, not inpainted, there are serious, but inpainted, losses in the servant women, the bed, the face of Nicholas's mother. The painted surface has been cut only at the top.

ST. NICHOLAS PROVIDES THE DOWRY FOR THREE POOR MAIDENS, Pinacoteca, Vatican, Panel, 36.5 × 36.5 cm.

Despite large losses, portions of the interior are in a fair state. Most losses have been left a neutral colour and are evident. Only the top edge of the paint surface has been cropped.

ST. NICHOLAS SAVES A SHIP IN DISTRESS, Pinacoteca, Vatican Panel, 39 × 62 cm.

In the ship, St. Nicholas, and the extreme foreground, the condition is fair; elsewhere the final layer of pigment is lost. Major losses, inpainted, occur on the left horizon, in the sea to the right of the ship, and in the ship's crew. The upper edge of the paint surface is intact; the other three sides are cropped.

ST. NICHOLAS RESUSCITATES THREE YOUTHS AT AN INN, Pinacoteca, Vatican
Panel, 36.5 × 36.5 cm.

The condition is poor, with no final layer of pigment preserved. Small, local losses have been inpainted. The paint surface is cropped at the top.

PILGRIMS AT THE TOMB OF ST. NICHOLAS, National Gallery, Washington, D.C. (inv. no. 379, K 486).
Panel, 36 × 35 cm.

Though somewhat abraded, this panel is in fair to good condition. There are numerous small losses and pitting throughout, but the only serious restoration occurs where the original arcuated form of the panel has been camouflaged, thereby compromising the spatial effect. Presumedly cut at the top and sides.

When together, the above pieces formed the high altar-piece for S. Niccolò sopr'Arno, where Lionardo Tanci, rector of the church, described it prior to the remodelling carried out by Vasari in 1561:

> La tavola di questo altare e all'antica ma ricca e bella di mano di Gentile da Fabriano come in essa e scritto, sta nel mezzo la vergine con figlio dal lato dell'evangelio S. Nicolo e Sta. M. Maddalena, della Epistola S. Giov. Battista e S. Giorgio. Era la Cappella Maggiore l'anno 1552 quando io Lionardo Tanci obtenni la Chiesa in questa forma, et l'altare haveva uno scaglione solo di pietra, stava la tavola posata su l'altare, senza grado o, altro, bassa strardinamente, e dietro s'andava con una scala a piuoli, infin sopra la tavola
> (Ms., f. 97v., preserved in the archive of S. Niccolò and transcribed, with minor errors, by I. Moretti, *La Chiesa di S. Niccolò Oltrarno,* Istituto Professionale Leonardo da Vinci, Florence, pp.71–72).

Vasari (pp.6–7) recounts that:

> per la famiglia de' Quaratesi fece la tavola dell'altar maggiore; che di quante cose ho veduto di mano di costui, a me senza dubbio pare la migliore: perchè oltre alla Nostra Donna e molti Santi che le sono intorno, tutti ben fatte; la predella di detta tavola, piena di storie della Vita di San Niccolò, di figure piccole, non puo essere più bella nè meglio fatta di quello che ell'è.

Tanci notes that Bernardo di Castello Quaratesi's patronage was transferred from the chapel of St. John the Baptist to the main one, which may have been dedicated in 1418 – the date appearing on a marble plaque bearing Bernardo's name that was found beneath the high altar (Moretti, *op. cit.,* p. 62). In 1421 he was called 'Restaurator, Innovator, et Benefactor Ecclesie' (Richa, *Notizie delle chiese fiorentine,* Florence, X, 1762, p.269). Since he died on 10 March 1422 (1423 modern reckoning) (Tanci, *op. cit.,* f. 266v), another member of the family may have commissioned the altar-piece from Gentile (see also W. Paatz, *Die Kirchen von Florenz,* Vittorio Klostermann, Frankfurt, 1952, IV, pp.358ff.). Confusion as to the patron already existed in the sixteenth century, when Tanci records (*op. cit.*):

> Di poi Andrea Quaratesi fece aggiungere oro al tabernacolo del Sagramento, levare la tavola dell'altare e redipigner le stelle quasi tutte, e il campo, ma tacitamente che non parve suo fatto fece due armicine nella tavola dell'altare, essendosi gia conteso se la tavola l'avessi fatta e Quaratesi o, altri. . .

The four main panels with saints remained in the chapel until 1879, when they were presented to the Uffizi by the Quaratesi family (*Catalogue de la R. Galerie de Florence,* Florence, 1882, p.126). The central image and predella were removed, probably, between 1824 and 1832 (H. Horne, 'The Quaratesi Altarpiece of Gentile da

Fabriano', *Burlington*, VI, 1904–06, p.474). Waagen (*Works of Art and Artists in England*, 1838, II, p.126) saw the Madonna and Child in the collection of Mr. Young Ottley in 1835. Prince Albert purchased it from Ottley's nephew in 1846 (*ibid.*; also L. Cust, *Notes on Pictures in the Royal Collections*, Chatto & Windus, London, 1911, pp.17–18). The predella scene portraying pilgrims at the tomb of St. Nicholas passed into the collection of Tommaso Puccini, Pistoia; thence to his nephew, Niccolò and then, by 1899, to the Marchese Tucci of Lucca (G. Vasari, *Le vite...* , Felice Le Monnier, Florence, 1848, IV, p.153, n.5; A. Chiapelli, 'Per la predella del Polittico Quaratesi di Gentile da Fabriano', *Bollettino mensile per la celebrazione centenaria*, II, 1928, pp.60–61). It entered the Contini Bonacossi Collection, and was purchased by Samuel Kress in 1937. It entered the National Gallery in 1941 (F. Rusk Shapley, *Paintings from the S. Kress Collection, Italian Schools*, Phaidon, London, 1966, I, p.77; *Italian Paintings*, Washington, 1979, pp.197–99). The four remaining scenes were in the Vatican prior to 1884 (A. Schmarsow, *Masaccio, Studien*, Fisher & Co., Kassel, 1895–99, IV, pp.82ff.).

Schmarsow considered the Vatican predella scenes to be by Masaccio (*op. cit.*; 'Frammenti di una predella di Masaccio nel Museo Cristiano', *L'Arte*, 1907, pp.209–17), but after O. Sirén ('Notizie critiche sui quadri sconosciuti nel Museo Cristiano Vaticano', *L'Arte*, V, 1906, pp.332–34; but see Venturi, p.196) recognised that they formed the predella to the *Quaratesi Altar-piece*, this attribution was abandoned.

The idea that they might be the work of a follower or assistant of Gentile (F. M. Perkins, 'Note su alcuni quadri del 'Museo Cristiano' nel Vaticano', *Rassegna d'Arte*, VI, 1906, p.122; G. Bernardini, 'La nuova Galleria Vaticana', *loc. cit.*, IX, 1909, p.117; Colasanti, p.74; Van Marle, pp.44–46; Molajoli, p.82) has been disproved by their radical restoration in 1970–71. Equally unfounded is the notion that Florentine influence in the gables and the angels is due to the 'intervento di un pittore della cerchia Bicci di Lorenzo – "Maestro del Bambino Vispo" ' (Grassi, pp.34–35, 62), though the same assistant responsible for various background figures in the *Adoration of the Magi* seems to have executed the St. George. Longhi (pp.190–91) first drew attention to the unique, genre-like qualities of the scene at Washington, while M. Salinger ('Notes and Correspondence', *Isis*, XXII, 1934–5, pp.226–28) has pointed to possible meanings of the symbols appearing on the inn in *St. Nicholas resuscitates three Youths*. (See also Ricci, p.150; Cavalcaselle, p.102; Arslan, p.111; Grassi, 'Considerazioni intorno al "Polittico Quaratesi" ', *Paragone*, II, No. 15, 1951, pp.23–30; Bellosi, p.4; Micheletti, pp.9, 91.)

CAT. XV (Plates 60–62)
DOSSAL

Presently on deposit, Pitti Palace, Florence.
From S. Niccolò sopr'Arno.
Painted on five panels which are joined to a single, horizontal one running the length of the pentaptych and reaching to the height of the rainbow in the central scene, showing left to right.

ST. LOUIS OF TOULOUSE (64.5 × 22 cm.)

RESURRECTION OF LAZARUS (69 × 45.5 cm.)

THE VIRGIN AND CHRIST INTERCEDING (80 × 56.5 cm.)

MEETING OF SS. COSMAS AND DAMIAN WITH JULIAN (?) (71 × 46 cm.)

ST. BERNARD OF CLAIRVAUX (66 × 22.5 cm.)

In its present state a full condition report is impossible. A fire in 1897 blackened the surface and caused blistering, especially at the sides of the two 'narrative' scenes and in that of St. Bernard. There are large, vertical cracks and losses throughout. The flood of 1966 and neglect since that time have caused further damage.

When first mentioned by Cavalcaselle (p. 102), the pentaptych was in the sacristy of S. Niccolò. However, like the high altar-piece, it was almost certainly commissioned to commemorate the death of Bernardo di Castello Quaratesi (died 1423: see Cat. XIV). The resurrection of Lazarus is an appropriate funerary image, as is the central scene of intercession by the Virgin and Christ. This latter takes up an iconography related to a text then attributed to St. Bernard and illustrated in an altar-piece from the cathedral of Florence, now in New York (M. Meiss, 'An Early Altarpiece from the Cathedral of Florence', *The Metropolitan Museum of Art Bulletin*, XII, 1953–54, pp. 302–17). But whereas in the cathedral altar-piece and subsequent large scale versions (*ibid.*), the setting is earthly, here Christ and Mary kneel on the rings of heaven, with the earth far below. Such a depiction more clearly relates to the dead than the living. The presence of St. Bernard almost certainly refers to Bernardo Quaratesi.

The notion of A. Conti ('Quadri alluvionati', *Paragone*, XIX, No. 215, 1968, p. 21, n. 53) that the peculiar form of the pentaptych – a low, multi-gabled dossal – indicates placement on an altar of the tramezzo, is without foundation.

A point of comparison for the combination of single saints and narrative scenes exists in fragments of a Duecento dossal by the Master of St. Francis (E. Garrison, *Italian Romanesque Panel Paintings*, L. Olschki, Florence, 1949, p. 171). This form was little used after the early fourteenth century and the reasons for commissioning such a dossal in the early fifteenth century are mysterious, especially since Gentile had already painted the high altar-piece for the Quaratesi chapel in S. Niccolò. There is a possibility that the dossal was intended not for the newly constructed church, but for its Romanesque predecessor, which was still standing in 1438. A dispute between the bishop of Florence and the monastery of San Miniato for jurisdiction of this church may have occasioned the new building, begun after 1390 at right angles to the old structure. Sandro di Simone Quaratesi had provided for a chapel in the old S. Niccolò in 1363, but the money had been diverted to San Miniato by his brother and heir, Vanni (A. Alinari, 'La chiesa antica di S. Niccolò Oltrarno di Firenze', *Rivista d'Arte*, XX, 1938, pp. 330–31; and

W. Paatz, *Die Kirchen von Florenz,* Vittorio Klosterman, Frankfurt, 1952, vol. IV, pp.358f., 375, n.8). For these reasons, the Quaratesi may have commissioned two altar-pieces from Gentile, one for the new church, the other for the old. Tanci does not mention the dossal in his chronicle (see Catalogue XIV), but the present framing suggests that at that time it was adapted to form a 'grado' for the high altar-piece, the absence of which he lamented. When the high altar-piece was dismantled in the early nineteenth century, the dossal would have been removed to the sacristy, but by 1908 it was (perhaps for the second time) in the choir (M. Crutwell, *A Guide to the Paintings in the Churches and Minor Museums of Florence,* 1908, p.212).

Cavalcaselle noted, prior to the fire damage, that 'it is more hasty than the Virgin of the Quaratesi' (p.103), and several scholars have found a direct attribution to Gentile difficult (M. Crutwell, *op. cit.;* Grassi, p.69, and 'Considerazioni intorno al "Polittico Quaratesi" ', *Paragone,* II, No. 15, 1951, p.29; Micheletti, p.93). Because the scene of the resurrection of Lazarus depends on Masaccio's *Baptism of the Neophytes,* L. Berti has considered a Florentine, Francesco di Antonio, its author ('Note brevi su inediti toscani', *Bollettino d'Arte,* XXXVII, 1952, pp.176–78).

There can be little doubt that the design is Gentile's (Longhi, p.190; A. Conti, *op. cit.,* p.14). Nonetheless, the predominating curvilinear rhythms of the figures and the flattened folds of their drapery clearly reveal execution by an assistant – probably trained under Gentile at an earlier date. Comparison of specific, as well as overall, traits with paintings of SS. John the Evangelist and Peter at Berlin suggests a common author. F. Zeri ('Quattro tempere di Jacopo Bellini', *Quaderni di Emblema I,* Emblema Editrice, Bergamo, 1971, pp.42–49) argues convincingly that the latter are by Jacopo Bellini (their strict dependence upon Gentile and their relation to presumedly early works by Giambono, such as his altar-piece at Fano, make a date close to 1430 probable). That Jacopo was Gentile's pupil there can be no doubt, and that he is identical with the 'Jacopo di Piero' present in Florence in 1423 and again in 1425 (Document IX) is probable. The most recent discussion of the relevant documents is by C. Joost-Gaugier, 'Considerations regarding Jacopo Bellini's Place in the Venetian Renaissance', *Arte Veneta,* XXVIII, 1974, pp.21ff.) The latter date coincides with the probable one of the pentaptych.

CAT. XVI (Plate 63)
STONING OF ST. STEPHEN

Cradled panel — Kunsthistorisches Museum, Vienna
16.5 × 27 cm. — (inv. no. 5977)

Condition is poor. The badly abraded surface has been almost completely repainted and the gold and tooling is also new. Only the rectangular ornament at the bottom of Stephen's dalmatic, the area around his hands, and an area in the upper right-hand

corner, with remnants of a robe and cruciform halo (the seraphim are modern), preserve the original gold, while the best preserved figure is that closest to St. Stephen. There are losses throughout the landscape and in Saul's robe. A horizontal crack runs the height of the knees of the executioners, with another a bit higher. The top has been cropped.

The painting was a gift of Karl and Rosalie Goldschmidt in 1903. Though at one time attributed to Gentile, in the Museum it was tentatively catalogued as early Florentine (*Die Gemäldegalerie,* Vienna, 1907, No. 92a) and then ascribed to a follower of Gentile, *c.*1430–35 (*Katalog der Gemäldegalerie,* Vienna, 1965, I, pp.57–58). Berenson (1907, p.303) attributed it to Stefano da Verona; A. Colasanti ('Un quadro ignorato di Gentile da Fabriano', *Bollettino d'Arte,* V, 1911, p.35, n.1) thought it a fake. C. Ragghianti ('Postillina gentilesca', *Critica d'Arte,* I, 1954, p.585) has re-ascribed it to Gentile.

The St. Stephen especially has a monumental bearing that relates him to the *Quaratesi Altar* and the fresco at Orvieto. The composition is Early Christian in origin (see the seventeenth-century drawing in the Biblioteca Apostolica Vaticana (Cod. Barb. lat. 4406, f.89r.) copied from the destroyed fifth-century frescoes in S. Paolo fuori le Mura in Rome), but Gentile's painting derives from a much repeated model by Bernardo Daddi (e.g. his predella scene in the Vatican). Gentile has made the composition more compact and added a group of bystanders, only one of whom is now legible. In effect this grouping recalls the semicircular compositions by Masaccio in the Brancacci Chapel. Although this predella scene cannot be linked with any known altar-piece by Gentile, it post-dates the *Quaratesi Altar* and was therefore probably executed either in Siena or Rome. Giovanni Pecci (*Relazione delle cose più notablili della città di Siena,* Siena, 1752, p.109) noted that 'una tavola di Gentile da Fabriano' adorned an altar in S. Cristofano, while at least two works other than the frescoes in S. Giovanni Laterano were done in Rome.

CAT. XVII (Plates 64–69)
MADONNA AND CHILD
Mural Cathedral, Orvieto
225 × 125 cm
Virgin's halo inscribed AVE MARIA GRATIA PLENA.

 The mural suffers not only from a reduced picture field (see below), but from the addition of the figure of St. Catherine, which covers much of the original design. The present blue-green of the Virgin's cloak is modern; other areas are heavily retouched. Much appears to have been done *a secco,* resulting in serious flaking. Losses occur throughout, but especially disfiguring are those in the hair of Christ, and the scarf and neck of the Madonna. The gold background, throne brocade, dress and ornament on

the Virgin were tooled and have flaked badly. The present pseudo-mosaic frame is modern.

The mural was executed for the *Opera* of the Cathedral sometime after August 1425, when Gentile was still renting a house in Siena. On 16 October eighteen gold florins were agreed upon as payment, and four days later the sum was paid to Gentile (Document XI). The fresco was probably finished by this date; it is so described in a proceeding of 9 December, concerning a disagreement over the presence of a coat of arms beneath the image:

> Cum per egregium magistrum, magistrum Gentilem de Fabriano pictorem facta fuerit immago et picta majestas Beate Virginis Marie tam subtiliter et decore pulcritudinis in dicta Ecclesia Sancte Marie post fontem Batismatis in pariete et muro dicte Ecclesie expensis et sumptibus dicte operis et fabrice, et ibidem subtus dictam picturam ad presens pingantur arma Albericorum de Urbeveteri, quia dicitur quod ibi erat pictura et erant arma prefata ubi hodie picta est dicta pulcerrima maestas dicte sancte matris Virginis Marie, que arma ut dicitur antequam dicta figura fieret per dictum magistrum Gentilem. . .
>
> (the full transcription is given in A. Venturi, *Gentile da Fabriano e il Pisanello*, G. Sansoni, Florence, 1896, pp.16–17).

Destruction of the mural during the sixteenth-century remodelling of the cathedral was averted when new designs by Ippolito Scalza provided for a frame around it, reducing the picture field, but leaving the figures intact (L. Fumi, *Il Duomo di Orvieto*, Rome, 1891, pp.414–15, doc. CXCI; p.354, docs. XX–XXII). This decoration was removed between 1877 and 1891 (*ibid.*, pp.345–47), but the figure of St. Catherine remained. A reconstruction of the original appearance is given in the Appendix, page 174.

Critics are agreed that Gentile alone is responsible for the execution (see: Ricci, p.148; Cavalcaselle, p.104; Colasanti, p.61; Molajoli, pp.87–89; Van Marle, p.46; Venturi, p.200; Grassi, pp.43, 65; Arslan, p.111; Micheletti, p.92).

CAT. XVIII (Plates 70–71)
MADONNA AND CHILD

Cradled panel Museo Capitolare, Velletri

110.4 (to top of pinnacle) × 66.3 cm.; 79.8 cm. at side.

Virgin's halo inscribed AVE MARIA GRATIA; on hem of dress AVE GRATI[A]; on the lower border of the picture, nearly effaced, [TOTA P]ULCHRA [ES] AMIC[A MEA] (Song of Songs 4:7).

Restored in 1912 (A. Gabrielli, 'Una Madonna col Bambino in Velletri attribuita a G. d. F.', *Arte Cristiana*, I, 1913, pp.156–58) and again recently, the painting is in generally poor condition, but with areas fairly preserved. Besides the huge loss, comprising half the torso of the Virgin and the whole of the Child's, two vertical cracks run, full length, either side of the figures; these have been filled in. There are

numerous other losses. All final detailing and almost all glazing are gone. The flesh portions are best preserved.

The painting was originally in SS. Cosma e Damiano, Rome, but was transferred to S. Apollonia, Velletri by Ludovico Ciotti da S. Paolo, Father General of the Franciscan third order, in 1633 (B. Theuli, *Theatro Historico di Velletri,* Velletri, 1644, p.344). In 1913 it was moved to the Sala del Capitolo of the cathedral and thence to the museum (L. Venturi, 'Un quadro inedito di Gentile da Fabriano a Velletri', *Bollettino d'Arte,* VII, 1913, pp.73–75; L. Mortari, *Il Museo Capitolare della Cattedrale di Velletri,* Di Luca Ed., Rome, 1959, pp.23–25).

An inscription once on the back of the panel bore a reference to Pope Felix IV (526–30) and the date 526 or 525 (B. Theuli, *op. cit.;* A. Borgia, *Istoria della Chiesa e città di Velletri,* Nocera, 1723, p.482). This was later superimposed over the inscription on the front (probably when the painting was reinforced in 1769, but it is now effaced) and read ANNO DOMINI CCCCCXVII P. FEL (L. Venturi, *op. cit.,* p.75). The date was assumed to be that of the painting, but since 1910 the whole inscription has been thought posterior – perhaps the work of Ciotti in 1633 (A. Tersenghi, *Velletri e la sua contrada,* Velletri, 1910, p.224; L. Venturi, *op. cit.,* p.75). Felix IV dedicated SS. Cosma e Damiano so that it seems plausible that Gentile was commissioned to paint this Madonna and Child on the nine hundredth anniversary of the church. The inscription would allude to that occasion. Moreover, among those elevated to the College of Cardinals on 24 May 1426, was Ardicino della Porta, Bishop of Novara. Since his titular church was SS. Cosma e Damiano, he was probably the patron (see L. Pastor, *History of the Popes,* Butler & Tanner, London, 1923, I, p.262; *Encyclopédie Théologique,* J. P. Migne, Paris, 1857, XXXI, pp.1421, 1739). Gentile is only documented in Rome from 28 January 1427 to 2 August. Prior to October 1426, he was probably in Siena (see Catalogue LVI). Since he died before 14 October 1427, the painting would seem to date from a period between late 1426 and October 1427. Style supports such a date (but see Van Marle, p.22).

The composition of the Madonna seated on the floor with an intarsiated bench behind presupposes familiarity with Sienese painting, while even in its present condition the figures are the most sculpturally conceived of all Gentile's creations. Use of a neutral brown bench as a backdrop with a high value orange pavement in front further develops a use of colour first seen in the Yale *Madonna and Child.* However, though critics have unanimously accepted this work as Gentile's (L. Venturi, *op. cit.;* Molajoli, p.97; Van Marle, p.22; Berenson, 1968, p.165; Grassi, pp.46–47, 65; Huter, p.26; Micheletti, p.92), there is reason to suspect partial execution by another hand. The painting and tooling are coarser than usual, the recession of the floor uncontrolled by incisions. These features are partly explained by the pressure under which Gentile must have worked at this time. If the flesh areas of the Madonna and Child are of high quality, at least the left-hand angel is the work of an assistant.

CAT. XIX (Plates 72–74)
HEAD OF DAVID (?)

Fresco fragment Museo Cristiano, Vatican
59 × 47 cm.

Although all *a secco* and gold leafed portions have been lost (the arched background and figure's garment; the crown and halo), the face is in fair condition. Recently cleaned.

Evidently offered to Benedict XIV (1740–58) by clergy of the Congregation of Theatines and held to represent Charlemagne, nothing is known of its provenance. According to one tradition it once hung in the Villa Medici or another villa on the Pincio (G. Tambroni, 'Osservazioni sulla immagine dell'imperatore Carlo Magno che trovasi nel Museo Cristiano della Biblioteca Vaticana', *Dissertazioni dell'Accademia Romana di Archeologia*, I, pt.II, 1823, p.249; Grassi, p.68). It is said to have come from S. Giovanni Laterano (Berenson, 1899, p.146; Van Marle, p.48, n.2); F. Volbach found confirmation of this provenance, but his source is no longer traceable (Grassi, p.68; written communication from Volbach). Attribution is equally uncertain. Berenson (1899, p.146; 1932, p.222; 1968, p.165) and E. Sindona (*Pisanello*, Harry Abrams, New York, 1961, p.127) thought Gentile its author, while Grassi (p.68) considered the style closer to Pisanello (especially to the figure on the *stemma* of the fresco of *St. George* at S. Anastasia, Verona: see also Arslan, p.112; Micheletti, p.94; R. Chiarelli, *L'opera completa del Pisanello*, Rizzoli Ed., Milan, 1972, p.90). Others have thought it of the school of Gentile (A. Callosso, 'Le origini della pittura del Quattrocento attorno a Roma', *Bollettino d'Arte*, XIV, 1920, p.207; Van Marle, pp.48, n.2; 436). Venturi (p.201, n.1) called it 'trecentesca'.

Though not autograph, the manner in which volume is suggested by loosely applied brushstrokes is characteristic of Gentile, as are the pale flesh tones. Nowhere is the incisive outline employed by Pisanello evident. The features relate to those of the Velletri *Madonna and Child*. Of Gentile's known commissions in Rome, only that at S. Giovanni Laterano could have provided the setting. In the *Historici liber de vita Christi ac omnium ponificium* Platina recounts that:

> Martinus autem ab externo hoste quietus, ad exornandum patriam basilicasque romanas animum adiiciens, porticum Sancti Petri iam collabentem restituit; et pavimentum lateranensis basilicae opere vermiculato perfecit; et testudinem ligneam eidem templo superduxit, picturamque Gentilis, opus pictoris egregii, incohavit

(L. A. Muratori, *Rerum Italicarum Scriptores*, Città di Castello, III, i, p.312). Provisions for repair of the pavement were made on 1 July 1425 (see P. Lauer, *Le Palais de Latran*, E. Leroux, Paris, 1911, p.274) and on 17 September 1426 a priest, Antonio di Giovanni, was reimbursed twenty-five florins 'per eum fiendarum in pavimentis et picturis' (A. M. Corbo, *Artisti e artigiani in Roma al tempo di Martino V e di Eugenio IV*, De Luca Ed., Rome, 1969, p.44). Gentile received a monthly salary of twenty-five florins from 28 January to August, 1427. In his life of Gentile, Fazio states:

Eiusdem est opus Romae in Iohannis Laterani templo, Iohannis ipsius historia, ac supra eam historiam Prophetae quinque ['quatuor' deleted] ita expressi, ut non picti, sed e marmore ficti esse videantur. Quo in opere, quasi mortem praesagiret, se ipse superasse putatus est. Quaedam etiam in eo opere adumbrata modo atque imperfecta morte praeventus reliquit.

Vasari (p.6) adds only, 'ed in fra l'altre figure di terretta, tra le finestre, in chiaro e scuro, alcuni profeti, che sono tenuti le migliori pitture di tutta quell'opera'. Pisanello continued the storiated portion under Eugenius IV from April 1431 to 28 February 1432.

Pinxit et Romae in Iohannis laterani templo quae Gentilis divi Iohannis Baptistae historia inchoata reliquerat, quod tamen opus postea, quantum ex eo audivi, parietis humectatione pene obliteratum est (Fazio, p.166).

O. Panvinio (died 1558) attributed the entire cycle to Pisanello:

Sinistram porro magnae parietis partem, quae porticum et calcidicam quam tribunam vocant respicit. Martinus Papa V elegantibus figuris Petri Pisani eo tempore celeberrimi pictoris opera ornare inchoaverat, et Eugenius IV qui Martino successit perficere statuerat. In tumultu populi Urbe pulsus opus imperfectum reliquisset, octo inter columnarum spatio Sancti Johannis Bapt. acta quaedam prophetae, aliquot apostoli, Evangelistae et doctores optimis et exquisitissimis coloribus expressis ceruleo praesertim picti super sunt.
(De sacro sancta basilica, baptisterio et patriarchio lateranensi, cap. I, viii; reprinted in R. de Fleury, Le Latran au moyen age, A. Morel, Paris, 1877, p.510, Colasanti, pp.79–80, and P. Lauer, op. cit., p.434).

Portions of the narrative scenes and 'alcuni Profeti, Apostoli, Evangelisti e dottori della Chiesa' were noted in the seventeenth century prior to their destruction when Borromini remodelled the basilica beginning in 1647 (P. Lauer, op. cit., p.585, transcribed the Relatione from the Arch. Lateranense FF. XXIII. 12; reprinted by K. Cassirer, 'Zu Borominis umbau der Laterans-basilika', Jahrbuch der Preussischen Kunstsammlungen, XLII, 1921, pp.62ff.). A drawing from Borromini's circle records their features (Plates 73–74). The existing fragment accords with the position of the half-length prophets viewed through an arched balcony, and would presumedly show David rather than Charlemagne, as often asserted. This is the only fragment whose association with that cycle may be, in part, verified, though Degenhart ('Pisanello in Mantua', Pantheon, XXXI, 1973, pp.401, 410 n.92) has suggested that a female head in the Palazzo Venezia is a remnant of Pisanello's work (see also G. Paccagnini, 'Il ciclo cavalleresco del Pisanello alla corte dei Gonzaga', Studies in Honor of Millard Meiss, New York University Press, 1977, p.209 n.13). Several drawings from a notebook from Pisanello's workshop have also been connected with the frescoes, but the studies of individual figures have little to do with Gentile, and those with scenes from the life of the Baptist reveal principles of figure construction and composition that are closer to Pisanello. The two most important of these show the Baptism of Christ (Louvre, No. 420r.) and the Arrest of the Baptist (British Museum, No. 1947-10-

11-20). Since Gentile can only have begun the narrative cycle during his six month employment at the Lateran, neither of these scenes is likely to have been painted by him, while the indications for the *Visitation* (Louvre, No. 421r.) – the second scene according to the Borromini workshop drawing – are inconclusive, and the identification of Milan, Ambrosiana, fol. no. 10 as *Zaccharias in the Temple* is not convincing (see, most recently, B. Degenhart, *Pisanello,* Verlag A. Schroll, Vienna, 1941, p. 31; *Disegni del Pisanello e di maestri del suo tempo,* Neri Pozzo Ed., Vicenza, 1966, pp. 13ff.; B. Degenhart & A. Schmitt, 'Gentile da Fabriano in Rom und die Anfänge des Antikenstudiums', *Münchner Jahrbuch der bildenden Kunst,* XI, 1960, pp. 59ff.; M. Fossi-Todorow, 'Un taccuino di viaggio del Pisanello e della sua bottega', *Scritti in onore di M. Salmi,* De Luca Ed., Rome, 1962, II, pp. 133ff.; *I Disegni del Pisanello e della sua cerchia,* L. Olschki, Florence, 1966, pp. 121ff.; also the discussion for Document XVII).

ATTRIBUTED AND RELATED WORKS

CAT XX (Plate 75)
MADONNA AND CHILD WITH ANGELS

Panel National Gallery, Athens

50 × 49 cm.

Virgin's halo inscribed: *santa maria mater dei;* Child's: *jesus naçarenum rex judeorum.*

The panel, cut at the bottom and sides, was originally framed to form an arch. The surface is badly abraded.

The provenance of this Madonna of Humility is unknown. It was first published and attributed to Gentile by C. Brandi ('A Gentile da Fabriano at Athens', *Burlington,* CXX, 1978, pp.385–86), who compared the figures and tooling to Gentile's Perugia *Madonna and Child* and suggested a date about 1418 – 'after the frescoes in Brescia'.

Although generic similarities between the Athens and Perugia paintings exist, the true comparison is with figures in a Crucifixion once in the Chillingworth Collection and almost certainly by Zanino di Pietro (see note 13, p.68) to whom the Athens painting may be attributed. Together with a group of works that includes Catalogue numbers XLII and XLVI, the Athens painting pre-dates Zanino's contact with Michelino da Besozzo, who was documented in Venice in 1410. Brandi notes the peculiarity of the inscription in the Child's halo, and he mistakenly maintains that the absence of a cruciform halo on the Christ Child is normal in Gentile's paintings. With the exception of the Berlin *Madonna and Child,* the opposite is true.

CAT. XXI (Plate 76)
MADONNA AND CHILD

Panel Accademia Carrara, Bergamo

63 × 53 cm.

Cleaning prior to 1957 revealed the background to be modern and the painting to be in poor condition.

In the Lochis Collection prior to 1859, the painting was listed as by Gentile in the catalogue of 1881 (p.95, No.230). This attribution was repeated by Van Marle (pp.30–32). However, as early as 1904 G. Cagnola ('Intorno a Jacopo Bellini', *Rassegna d'Arte,* IV, 1904, p.42) suggested that Jacopo Bellini was its author. This idea was accepted by Frizzoni (*Le Gallerie dell'Accademia Carrara,* Bergamo, 1907, p.43) and most subsequent critics.

CAT. XXII (Plate 77)
ST. MICHAEL

Panel Museum of Fine Arts, Boston

99.6 × 37.4 cm.

Suffering from a heavy craquelure and loss of the silver leafed portion of Michael's armour, the painting is in poor condition. There is a large loss in the lower left corner, smaller ones throughout. Nevertheless, the face is fairly well preserved.

In the d'Hendecourt Collection, Paris (1914), prior to 1924 it passed to the Stoclet Collection, Brussels. Sold in 1965 (Sotheby's, 30 June 1965, No.19, as Andrea di Bartolo), to Agnew's, it was purchased by the Boston Museum in 1968.

The painting was first published by F. M. Perkins ('Dipinti senesi sconosciuti o inediti', *Rassegna d'Arte,* XIV, 1914, p.100) as a probable work by Andrea di Bartolo. Most subsequent critics have tended to agree only in considering it Sienese. (Van Marle, II, p.574, as Andrea di Bartolo; IX, pp.332–33, as Sassetta. Berenson, 'Lost Sienese Trecento Paintings, pt. IV', *International Studio,* XCVIII, i, 1931, pp.29–35; 1932, p.9; 1968, p.6, as Andrea di Bartolo. J. Pope-Hennessy, *Sassetta,* Chatto & Windus, London, 1939, pp.182–83, not Sassetta; 'The Development of Realistic Painting in Siena', *Burlington,* LXXXIV, 1944, p.119, as Domenico di Bartolo under Gentile. Grassi, p.69, 'verso Gualtieri di Giovanni'.) Longhi ('Me Pinxit: un San Michele Arcangelo di Gentile da Fabriano', *Pinacoteca,* I, 1928, pp.71–75) first suggested the attribution to Gentile, noting similarities with the young magus of the *Adoration of the Magi* and the iconographic peculiarity, shared with the Gabriel of that altar-piece, of showing an archangel with three pairs of wings. While his suggestion has, on occasion, been followed (Micheletti, p.88; S. L. Faison, 'Early Spanish and Italian Paintings', *Apollo,* XCI, 1970, pp.28–31; 'Centennial Acquisitions', *Museum of Fine Arts Bulletin,* No.351–2, LXVIII, 1970, p.55), C. Brandi pointed instead to Antonio Alberti of Ferrara (*Quattrocentisti Senesi,* Milan, 1949, pp.208–9, n.71), and recently names as far afield as the Lombard artist, Bonifacio Bembo (B. Witthoft, 'A Saint Michael by Bonifacio Bembo', *Arte Lombarda,* XLI, 1974, pp.43–50), and Jacopo Bellini (C. Huter, 'Early Works by Jacopo Bellini', *Arte Veneta,* XXVIII, 1974, pp.18–20) have been suggested. The attribution to Bembo is based upon an incorrect analysis of the armour and that to Bellini must be considered groundless. Longhi further suggested that the *St. Michael* was part of a polyptych, with the Getty Museum *Coronation* as the centre, but this is demonstrably false, since that panel was part of a processional standard. His observation that the representation of an archangel with three pairs of wings is peculiar to Gentile is also false. This iconography is found in an altar-piece by Jacopino and a fresco by Vitale, both in the Pinacoteca Nazionale, Bologna. However, if the similarities with Gentile's young magus are superficial, a general influence by Gentile is not to be excluded. The attribution to Domenico di Bartolo under Gentile is suggestive, but in his earliest work, a Madonna and Child with Saints Peter and Paul at Washington (*c.*1430), he is a follower of Masaccio, and his *Madonna of Humility* at Siena (1433) shows a careful attention to plant life not paralleled in the stylized flowers of the St. Michael. Giovanni di Paolo's paintings of 1426–7 prove that much of Gentile's impact on

Sienese art was in such naturalistic details. It is in Umbrian painting that the closest parallel to the *St. Michael* may be found. A *Madonna and Child* in the Victoria and Albert Museum, London, signed *Peregrinus* and dated 1428, shows a similar derivation from a painting by Gentile. Features are described by a regular, but fluid line and evenly modelled – much as in the St. Michael. The plants are identically treated and the halo tooling is close. Peregrinus seems the most probable author of the Boston painting. Once confused with the Sienese artist, Pellegrino di Mariano (J. Pope-Hennessy, *Sassetta*, 1939, p.173, and 'Panels by Pellegrino di Mariano', *Burlington*, LXXIV, 1939, pp.216 ff.). he has been identified by A. Parronchi ('Peregrinus Pinsit', *Commentari*, XXVI, 1975, p.3) and F. Russell ('Two Italian Madonnas', *Burlington*, CXX, 1978, p.155) with the Perugian painter Pelegrino di Antonio, who is first mentioned in 1425 and died in 1437 (see K. Christiansen, ' "Peregrinus" and Perugian Painting in the XVth Century', *Burlington*, CXXIII, 1981, pp.353–55).

CAT. XXIII (Plate 78)
MADONNA OF HUMILITY WITH A DONOR

Poplar panel Isabella Stewart Gardner Museum, Boston
100 × 58 cm.

Virgin's halo inscribed *ave maria [gratia] plena domin[us]*; hem similarly inscribed.
Condition is poor: the entire paint surface is badly worn. Cleaned 1981.

The painting was purchased after 1909 from J. L. Smith (P. Hendy, *Catalogue*, Boston, 1931, pp.151–62; 1974, p.96). Van Marle (pp.23–24) considered it possibly by Gentile da Fabriano and placed it with an amorphous group of works which he considered to date between the Milan *Coronation* and the *Adoration of the Magi*. Hendy (*op. cit.*, 1931 and 1974) has correctly observed the stylistic affinity to the Milan *Coronation*, though he considered the quality too low to be by an assistant of Gentile. Drapery fall, facial type and tooling accord in dating this work close to the *Coronation*, though it is probably by a Paduan-Veronese rather than Venetian or Marchigian follower. (See also F. Zeri, B. Fredericksen, *Census of Pre-nineteenth Century Italian Paintings in North American public collections*, Harvard University Press, Cambridge, Mass., 1972, p.79).

CAT. XXIV (Plates 79–80)
SS. MARY MAGDALENE, FRANCIS, VENANZIO (JULIAN?), JOHN THE BAPTIST

Fresco area adjacent to the old chapel of S. Lorenzo to the
 right of the present presbytery of the cathedral, Fabriano
The frescoes are fragmentary and poorly preserved.

The attribution of these mediocre frescoes to Gentile is due to L. Venturi ('A traverso le marche', *l'Arte*, XVIII, 1915, p.18). Van Marle (pp.299, 306) incomprehensively divides them between two hands, one influenced by Gentile, the other not. They date from the second quarter of the fifteenth century and relate to the works of a local artist generally known as the Staffolo Master (see F. Zeri, 'Giovanni Antonio da Pesaro', *Proporzioni*, II, 1948, p.166, n.2; and Zampetti, pp.34–35).

CAT. XXV (Plate 81)
ST. FRANCIS

Panel Harvard University, Villa I Tatti, Florence
94 × 44 cm.
Badly damaged and much repainted.

Berenson (1909, p.174) at first considered this painting an early work by Gentile, but later (*Italian Pictures of the Renaissance, Venetian School,* Phaidon, 1957, p.93) hesitantly assigned it to Jacobello del Fiore. E. Hutton (in Crowe and Cavalcaselle, 1909, III, p.149, n.5) agreed with the attribution to Gentile and M. Muraro (*Paolo da Venezia,* Pennsylvania State University Press, 1970, p.159) calls it central Italian. As indicated by F. Russoli (*La Raccolta Berenson,* Officine Grafiche, Milan, 1962, p. XXV), the painting is mid-fourteenth-century Venetian, though not by Paolo Veneziano (E. Sandberg-Vavalà, in M. Muraro, *op. cit.,* p.97; and M. Boskovits, 'Una scheda e qualche suggerimento per un catalogo dei dipinti ai Tatti', *Antichità Viva,* XIV, 1975, No.2, p.16).

CAT. XXVI (Plate 83)
ST. ANSANUS

Detached fresco S. Niccolò sopr'Arno, Florence
227 × 142 cm.
The fresco was detached in 1965, at which time the *sinopia* was uncovered. It is in only a fair state.

Shortly after this fresco was uncovered in 1925, K. Suter and H. Beenken ('Ein unbekanntes Fresco des Gentile da Fabriano', *Zeitschrift für bildende Kunst,* 1927, pp.84ff.) attributed it to Gentile, comparing it with the young king in the *Adoration of the Magi.* This attribution was rejected by Molajoli (p.120, n.19), and corrected by Berenson (*Pitture italiane del Rinascimento,* U. Hoepli, Milan, 1936, p.34) to Francesco di Antonio (see also Longhi, p.186, n.24, L. Berti, 'Note brevi su inediti toscani', *Bollettino d'Arte,* XXXVII, 1952, p.178; F. Zeri, *Due dipinti, la filologia e un nome,* G. Einaudi, 1961, p.62; and P. dal Pogetto, in *The Great Age of Fresco,* Metropolitan Museum of Art, 1968, p.122). M. Salmi (*Masaccio,* U. Hoepli, Milan, 2nd. ed., 1948, pp.218–19) wrongly attributed it to the Marchigian painter Giovanni Boccati.

CAT. XXVII (Plate 82)
DECORATION OF LILIES

Detached frescoes Sacristy, S. Trinita, Florence
Condition is poor; there is much loss of colour.

The frescoes decorate the underside of a double-sided arch containing the tomb of Onofrio Strozzi (died 1418). W. Paatz (*Die Kirchen von Florenz*, Frankfurt, 1953, V, p.293) first suggested comparison with the pilaster decoration of Gentile's *Adoration of the Magi*. M. Gosebruch ('Florentinische Kapitelle von Brunelleschi bis zum Tempio Malatestiano und der Eigenstil der Frührenaissance', *Römisches Jahrbuch für Kunstgeschichte*, VIII, 1958, pp.134f.) attributed them to Gentile, followed by L. Berti ('Donatello e Masaccio', *Antichità Viva*, V, 1966, No.3, p.8) and Micheletti (p.90; see also the exhibition catalogue *Mostra di affreschi staccati*, Forte del Belvedere, 1966). However, the arch they decorate has been dated as late as *c.*1440 (U. Middeldorf, 'Additions to Lorenzo Ghiberti's Work', *Burlington*, CXIII, 1971, p.76; H. Caplow, *Michelozzo*, Garland Publishing, New York, 1977, p.83, n.60; and G. Goldner, *Niccolò and Piero Lamberti*, Garland Publishing, New York, 1978, pp.95–100) on the assumption that the Strozzi only gained patronage to the small chapel, which one side of the tomb complex faces, in the 1430s. Since documents recording Strozzi building activity specifically mention this chapel, the observation is not valid (a payment in 1423 is recorded for 'un muro della sagresstia minore dalla logia...': ASF, Carte Strozziane, ser.IV, 343, f.275r.). A payment was made 4 August 1418 to 'M° Pietro di Niccolò che fa il cassone di marmo per defunto Messer Onofrio' (G. Milanesi, *Miscellanee*, Ms. Vol. XV, 44, III, P, Biblioteca Comunale, Siena, f.51: no traceable source is indicated). There is no reason for doubting that the arch, and thus the fresco, is contemporary with the sarcophagus. Although Gosebruch has attempted to attribute the arch of the tomb to Michelozzo in the 1420s, the most persuasive attribution for the design is to Donatello (M. Lisner, 'Zur frühen Bildhauerarchitektur Donatellos', *Münchner Jahrbuch der bildenden Kunst*, IX/X, 1958–9, pp.94ff; and L. Berti, *op. cit.*). He is not likely to have had a part in the execution, but affinities with his work have been generally acknowledged. Similarly, the closest parallel for the lilies in vases is found in Donatello's stuccoes in the Old Sacristy of S. Lorenzo (M. Lisner, *op. cit.*, n.178). They are dissociated from Gentile's works by their decorative disposition and lack of attention to botanic details, justifying Bellosi's opinion that Gentile was not their author ('La mostra di affreschi staccati al Forte Belvedere', *Paragone*, XVII, No.201, 1966, p.79). Probably the same artist who coloured the coats of arms was responsible for the execution (in 1423 Ventura di Moro was paid for 'dipintura d'armi a fatto nella sagrestia': ASF, Carte Strozziane, ser.III, 286, f.44v.). See also p.25 above and notes 26 and 27.

CAT. XXVIII (Plates 84–87)
MIRACLES OF ST. BENEDICT
locations as follows:

1. ST. BENEDICT REPAIRS A BROKEN SIEVE, Uffizi, Florence, 108 × 62.5 cm.;

2. ST. BENEDICT TORTURED BY A BLACKBIRD AND ABOUT TO CAST HIMSELF ON THORNS, Poldi-Pezzoli Museum, Milan (inv. no. 519), 110 × 65 cm.;

3. THE MONKS ATTEMPT TO POISON ST. BENEDICT, Uffizi, 108 × 63.5 cm.;

4. ST. BENEDICT EXORCISES A MONK, Uffizi, 110 × 66 cm.

All panels are abraded. Cleaning of those in the Uffizi has revealed substantial losses throughout.

Although the original destination is unknown, two of the paintings (Nos. 3 and 4) came from the Palazzo Portalupi, Verona. Another (No. 1) was bought in Mantua by R. Sessa of Milan. These were purchased by Cannon (J. P. Richter, *A Descriptive Catalogue of Old Masters of the Italian School*, B. Seeber, Florence, 1907, pp.16–25), and ultimately came to the Uffizi. The fourth panel (No. 2) was purchased in Milan by A. Cantoni in 1893 and eventually passed to the Poldi-Pezzoli. The subject-matter of this last painting and the diverse provenances of the others, however, remained unknown to scholars, resulting in their separate consideration.

Sometimes identified as a hermit, sometimes as St. John, the Poldi-Pezzoli Saint was attributed by Berenson (1907, p.302) to Stefano da Verona. While his suggestion was followed by Van Marle (VII, p.292, n.1), E. Sandberg-Vavalà (*La pittura veronese del trecento e del primo quattrocento*, Verona, 1926, pp.324–25) thought it closer to the school of Jacopo Bellini. Later, Berenson attributed the panel to Gentile (1932, p.221), followed by Morassi and Wittgens (*Il Museo Poldi-Pezzoli in Milano*, 1936 and 1937 respectively). G. M. Richter ('Pisanello again', *Burlington*, LVIII, 1931, pp.235–40) first suggested an attribution to Pisanello, dating the work after the S. Anastasia *St. George* (*c.*1440). He was followed by B. Degenhart (*Pisanello*, Verlag Schroll & Co., Vienna, 1941, p.30) who considered it early, and Coletti ('Pittura veneta dal tre al quattrocento, pt. II', *Arte Veneta*, I, 1947, pp.251–62), who compared the figure to a fresco in the cathedral at Pordenone (Catalogue XXXVI) as well as to some in S. Caterina, Treviso (Catalogue XXXIX – XL). Both authors stressed the Gentilesque quality of the scene. In 1949 Degenhart convincingly showed that the Poldi-Pezzoli painting represented St. Benedict and that its measurements coincided with the (now) Uffizi panels ('Le quattro tavole della leggenda di S. Benedetto', *Arte Veneta*, III, 1949, pp.7–22). Arguing that Pisanello was Gentile's pupil, and emphasizing supposed relations between the series and drawings attributed to the former, he attributed all four to Pisanello. In his little noted catalogue J. P. Richter (*op. cit.*) had reached the same conclusion as to the unity of the series, but had attributed them to the artist responsible for the Serego Monument frescoes in S. Anastasia, Verona (1432).

The Uffizi panels have passed under a variety of names. Longhi (p.190) at first hesitated between Gentile and Niccolò di Pietro, but decided upon the latter (*Viatico per cinque secoli di pittura veneziana*, Sansoni, Florence, 1952, pp.48–49). Coletti considered them the works of another frescoist active in Treviso – though he went on to relate some near certain works of Niccolò di Pietro to that artist ('Il Maestro degli Innocenti', *Arte Veneta*, II, 1948, pp.30–40). Even after Degenhart's revelation that the four paintings formed one series, Coletti continued to believe in a collaborative effort of more than one artist (pp.XVI–XVII), a position maintained by others (R. Brenzoni, *Pisanello*, Leo Olschki, Florence, 1952, pp.196–205, and *idem, L'Arte pittorica di Pisanello,* Leo Olschki, Florence, 1955, pp.17–42 – questioning whether the panels really form a unit; M. Fossi-Todorow, 'The Exhibition "da Altichiero a Pisanello" in Verona', *Burlington*, CI, 1959, p.13; *idem, I Disegni del Pisanello e della sua cerchia,* L. Olschki, Florence, 1966, p.4, n.1; and C. Huter, 'Jacobello del Fiore, Giambono and the St. Benedict Panels, *Arte Veneta*, XXXII, 1978, pp.31–38 – suggesting that the Milan panel is by Giambono, the others by Jacobello del Fiore). Most critics, however, have accepted one author for all panels, though attributions have varied from Pisanello (Coletti, 'La mostra da Altichiero a Pisanello', *Arte Veneta,* XII, 1955, p.247; R. Longhi, 'Sul catalogo della mostra di Verona', *Paragone,* IX, No. 107, 1958, p.75; G. Paccagnini, *Pisanello e il ciclo cavalleresco di Mantova,* Electa Editrice, 1973, pp.124–40; R. Pallucchini, 'Nuove proposte per Niccolò di Pietro', *Arte Veneta,* X, 1956, p.54 – with reservation), to Niccolò di Pietro (O. Ferrari, 'Un opera di Niccolò di Pietro', *Commentari,* IV, 1953, pp.228–30; Grassi, p.68; Micheletti, p.93; F. Bologna, 'Contributi allo studio della pittura veneziana del trecento', *Arte Veneta,* VI, 1952, p.11), and to such non-Italians as 'Maestro Venceslao' (G. Fiocco, 'Niccolò di Pietro, Pisanello, Venceslao', *Bollettino d'Arte,* XXXVII, 1952, pp.13–20) or Teodorico d'Ivano d'Alemagna (N. Rasmo, 'Il Pisanello e il ritratto dell'imperatore Sigismondo a Vienna', *Cultura Atesina,* IX, 1955, p.13, n.3). Since 'Maestro Venceslao' is but another name for the frescoist of the Serego Monument, and Teodorico for the artist whose works at Treviso Coletti studied – works also attributed to Niccolò di Pietro – the last two names do not alter previous opinions. Recently A. Parronchi ('Peregrinus Pinsit', *Commentari,* XXVI, 1975, pp.3–13) has advanced the improbable solution that the four panels originally flanked the Madonna and Child signed *Peregrinus* in the Victoria and Albert Museum, London, but otherwise accepted the earliest grouping of Coletti.

The single constant factor in the attributional history of these panels is the notion of Gentile's influence (Berenson, 1968, p.301; F. Russoli, *La Pinacoteca Poldi-Pezzoli,* Milan, 1955). However, unlike the Treviso and Pordenone frescoes, there is no direct relation to the figure style of the Milan *Coronation*. The curving rhythm of the figures is unconnected to structural function; the caricatured faces and planar patterns relate neither to Gentile nor to Pisanello. The obvious difficulty encountered in foreshortening architectural elements points to a Venetian rather than Veronese or Paduan artist as the author. The closest parallels for the angular drawing and the facial types are in the work of Niccolò di Pietro, where a parallel for the halo tooling and use of raised, circular ornament may also be found. Further suggestive comparisons are found in the works of Giambono, to whom Volpe attributed the series ('Donato Brigadin

ultimo gotico', *Arte Veneta*, IX, 1955, p.20, n.4; 'Da Altichiero a Pisanello', *Arte Antica e Moderna*, 1958, p.412; also F. d'Arcais, 'Le tavole con le "Storie di San Benedetto": un problema ancora aperto', *Arte Veneta*, 1976, XXX, pp.30–40). Especially significant in this regard is his *Death of the Virgin* at Verona. He is, moreover, certainly the author of the Serego Monument frescoes, where the same assistant employed for the upper tier of saints in his altar-piece at Fano executed part of the feigned hanging. As Volpe has pointed out, Giambono's cultural position is that of a native Venetian – perhaps Niccolò di Pietro's pupil – influenced by Gentile and active at Verona; coinciding precisely with the attributional history of the panels. If, given the present state of knowledge, a direct ascription to either Giambono or Niccolò di Pietro is not yet possible, there is, nonetheless no reason to confuse the generic relation they bear to Gentile with the specific one evidenced in the Pordenone frescoes. Nor can an attribution to Pisanello be maintained when these works are compared to his *Annunciation* at Verona, indebted to the local art of Stefano and Altichiero and without any reflection of contemporary Venetian art (Magagnato, pp.81–82).

CAT. XXIX (Plate 88)
MADONNA AND CHILD

Panel Museum of Fine Arts, Houston
48.9 × 34 cm.
Inscribed on neckline of the Virgin: *ave maria.*

The painting is in a ruinous condition and the gold background is modern. The Child's face is still largely repainted.

In the Palumbo Collection in 1916 (photograph at I Tatti, Florence), where A. Venturi had attributed it to Gentile (Sotheby's, London, 9 June 1955, No. 78), the painting was purchased by the Museum of Fine Arts in 1957 (*Art Quarterly*, XXIII, 1960, p.92). At I Tatti the painting is listed with Stefano da Verona, while Zeri attributes it to an artist close to or influenced by Gentile (F. Zeri, B. Fredericksen, *Census of Pre-Nineteenth Century Italian Paintings in North American Public Collections,* Harvard University Press, Cambridge, Mass., 1972, p.79).

The recent cleaning reveals that any superficial resemblances to works by Gentile were the result of a restorer. The inorganic construction of the Child, the drooping pattern of the drapery, and the choice of colours (the translucent red robe of the Virgin with a lining tending to turquoise) are paralleled only in Bohemian art of the last decades of the fourteenth century (see especially the Třeboň Altar in Prague).

CAT. XXX (Plate 89)
MADONNA OF HUMILITY WITH FOUR ANGELS

Panel Hermitage, Leningrad
80 × 51 cm.
From photographs the painting appears somewhat abraded but in fair to good condition; cropped at the top.

In the Stroganov Collection, St. Petersburg, prior to 1898, it came to the Hermitage in 1922. A. Venturi ('Quadri di Gentile da Fabriano a Milano e a Pietroburgo', *l'Arte,* I, 1898, pp.495–97) published this painting as by Gentile, but Colasanti (p.62) recognised it as a work of a follower. Since 1921 opinions have vacillated between Arcangelo di Cola (Colasanti, 'Nuovi dipinti di Arcangelo di Cola da Camerino', *Bollettino d'Arte,* I, 1921–2, p.544; Van Marle, pp.251–52; G. Vitalini-Sacconi, *Pittura Marchigiana, la scuola camerinese,* La Editoriale Libreria, Trieste, 1968, pp.87–88, 95) and Angelico, influenced by Gentile (R. Longhi, p.174; 'Un dipinto dell'Angelico a Livorno', *Pinacoteca,* I, 1928–9, p.154; M. Salmi, 'Problemi dell'Angelico', *Commentari,* I, 1950, p.78; *Il Beato Angelico,* Valori Plastici, 1958, pp.8–9, 95; L. Ragghianti-Collobi, 'Studi Angelichiani', *Critica d'Arte,* II, 1955, pp.37–38; M. Boskovits, *Un'Adorazione dei magi e gli inizi dell'Angelico,* Abegg-Stiftung, Bern, 1976, pp.35–38; and, with reservations: F. Zeri, 'Opere maggiori di Arcangelo di Cola', *Antichità Viva,* VIII, 1969, No.4, p.15, n.9; U. Baldini, *L'Opera completa dell'Angelico,* Rizzoli, Milan 1970, p.86). The attribution to Arcangelo rests upon superficial similarities to a *Madonna and Child with two Angels* in Rotterdam, correctly recognized by Zeri (*op. cit.,* pp.13–15) as a Florentine work; that to Angelico is based upon comparison with the altar-piece at S. Domenico, Fiesole. Though the Child depends upon Gentile's *Madonna and Child* at Pisa, the style is more clearly related to Angelico. Despite this, an attribution to the latter is unlikely (L. Berti, 'Miniature dell'Angelico, II', *Acropoli,* III, 1963, p.15; Pope-Hennessy, *Fra Angelico,* Phaidon, London, 1952, p.200 and 1974, p.227), and a follower working *c.* 1430 seems the most probable solution.

CAT. XXXI (Plate 90)
NATIVITY

Panel J. P. Getty Museum, Malibu Beach, California
72 × 43 cm. (painted surface *c.* 2.5 cm. smaller on all sides).
Cloak of Virgin inscribed at the top, *ave / mater / digna / dei . . .* ; at the left, *salve / regina / mate[r] / mis[eric]ordia* (Salve Regina); at the right, *ave / maris / stel[la] / dei / mater. . .* (Stella Maris); at the bottom, *Ave / maria / g[ratia] / plena. . .* (Ave Maria).

There are traces of the original beard on all sides except the bottom, the lower limits of which have been reconstructed. The landscape and gold background are well preserved, but the figures have suffered from abrasion. This is especially true of the Child, whose halo has also lost much of its gold. In addition to small losses that occur throughout, there are serious ones along the left vertical edge.

Prior to its sale in 1977, the painting was owned for an indeterminate period by the Sorgo family, who come from Yugoslavia. It was first published by Huter (pp.26ff.) as a work by Gentile close in date to the Pisa *Madonna* and just prior to the *Adoration of the Magi.* Though this attribution and dating have been accepted by E. Carli (*Il Museo di Pisa,* Pacini Ed., Pisa, 1974, p.67) and C. Volpe ('La donazione Vendeghini Baldi a Ferrara', *Paragone,* XXVIII, No.329, 1977, p.76), Rossi (p.14) has rightly questioned its authorship.

The technique is of the highest quality and the detail of the annunciation to the shepherds, taken by iself, is worthy of Gentile. However, the inarticulate composition is the result of isolated motifs taken from the *Adoration*. A comparison of the Child with that at Pisa or in the *Adoration* predella leaves little doubt that in design as well as execution the Getty painting is the product of an assistant of Gentile. It cannot be much later than 1423–24. Huter (pp.29ff).) points out that in combining a prominent Madonna of Humility with the accessories of a Nativity what had become an isolated iconographic type has returned to its original context (see M. Meiss, *Painting in Florence and Siena after the Black Death*, Princeton University Press, 1951, pp.132ff.).

CAT. XXXII (Plate 91)
MADONNA AND CHILD

Panel Private collection, Milan

53 × 37 cm.

Judging from photographs, the painting is heavily abraded and much repainted, especially in the faces.

Once in the Shearman Collection, Venice. When published by Grassi (p.67) it was in Milan with an attribution to Gentile. The suggestion (repeated by Micheletti, p.93) that this mediocre painting is by a direct pupil of Gentile – probably Marchigian – is without basis. The iconography depends not upon Gentile's Pisa *Madonna of Humility*, but upon a type popular in the Veneto. It probably dates from the third decade.

CAT. XXXIII (Plate 92)
MADONNA OF HUMILITY

Panel Museo Poldi-Pezzoli, Milan

47 × 25 cm. (inv. no. 586)

Heavily abraded, the painting is only in fair condition.

It was purchased in 1896 and attributed by the director, Bertini, to Gentile. A. Venturi ('Quadri di Gentile da Fabriano a Milano e a Pietroburgo', *l'Arte*, I, 1898, pp.495–97) accepted this attribution when he first published the painting. Berenson (1907, p.302) gave it to Stefano da Verona (Van Marle, p.48, n.2; and VII, p.292, n.1), but later agreed with Venturi (1932, p.221 – likewise G. Cagnola, 'Intorno a Jacopo Bellini', *Rassegna d'Arte*, IV, 1904, p.43). For Colasanti (p.62) it seemed Veronese, close to Giovanni Badile, and a Veronese localization has been taken up by the various catalogues of the museum and Magagnato (pp.79–80; also Berenson, 1968, p.301). E. Sandberg-Vavalà (*La pittura veronese del trecento e del primo quattrocento*, Verona, 1926, pp.335–37) first noted similarities to the work of Jacopo Bellini and Giambono; R. Longhi has concurred in this ('Sul catalogo della mostra di Verona', *Paragone*, IX, No. 107, 1958, p.75). Though the representation of foliage depends upon Gentile's treatment in the Milan *Coronation*, the facial types and drapery have little to do with

his work and are unlikely to precede *c.*1430; reflecting, then, such Gentile followers as Jacopo and Giambono.

ST. BENEDICT TORTURED BY A BLACKBIRD AND ABOUT TO CAST HIMSELF ON THORNS

Poldi-Pezzoli Museum, Milan

see Catalogue XXVIII

CAT. XXXIV
MADONNA OF HUMILITY

Panel Church of the Servi, Padua

65 × 35 cm.

Evidently both dirty and repainted, it awaits cleaning (L. Grossato, *Da Giotto al Mantegna,* Electa Editrice, Milan, 1974, cat.65).

Originally in the Scuola di S. Rocco, the painting passed to S. Canziano after the suppression of the confraternity. It was in the Servi by 1936 (W. Arslan, *Inventario degli oggetti d'arte d'Italia, VII, Provincia di Padova, Comune di Padova,* Rome, 1936, p.154). Arslan (*ibid.*) considered it Bolognese, close to Michele di Matteo, but this is certainly incorrect. Equally unfounded was Huter's attribution to Gentile (pp.26ff.), between the Berlin and Brera paintings, *c.*1405 (see also E. Carli, *Il Museo di Pisa,* Pacini, Ed. Pisa, 1974, p.67). It seems rather to be related to various Venetian paintings, all of very low quality, sometimes given to Jacobello del Fiore. The closest comparison is with a series of saints in S. Giovanni in Bragora, Venice (see Coletti, *Pittura veneta del quattrocento,* Istituto Geografico de Agostini, Novara, 1953, pl.22), which seem to date from the fourth decade of the century. An attempt to re-christen the Padua painting, the S. Giovanni series, and others as the work of a single master remains unsuccessful (C. Huter, 'The Ceneda Master', *Arte Veneta,* XXVII, 1973, pp.25–37).

CAT. XXXV (Plate 93)
MADONNA AND CHILD WITH SS. FRANCIS AND CLARA

Cradled panel Pinacoteca Civica, Pavia

56 × 42 cm.

Inscribed: S FRANCISCUS; S CLARA

The painting is in ruinous condition. Despite cleaning it still suffers from disfiguring overpaint. The frame is original.

G. Bernardini ('I dipinti nel Museo Civico in Pavia', *Rassegna d'Arte,* I, 1901, p.151) first drew attention to this work, noting its affinities with Gentile. To Colasanti

(p.41), Toesca (*La Pittura e la Miniatura nella Lombardia,* U. Hoepli, Milan, 1912, pp.473 n.1, 557) and others it seemed Lombard (M. Salmi, 'La pittura e la miniatura gotiche', *Storia di Milano,* Fondazione Treccani degli Alfieri, 1955, VI, pp.774–75; *Arte Lombarda dai Visconti agli Sforza,* Silvana, Milan, 1958, p.62; U. Bicchi, *La Pinacoteca Civica di Pavia,* Alfieri and Lacroix, Milan, 1965, p.20; Micheletti, pp.93–94). Recently it has again been brought into relation with Gentile (Magagnato, p.80; Berenson, 1968, p.301, ill.534; Longhi, 'Sul catalogo della mostra di Verona', *Paragone* IX, No.107, 1958, p.75). Comparison with the *Madonna and Child with Saints and Donor* at Raleigh (Kress 22) clearly distinguishes the figure types and drapery from that of Giovannino and his circle, while the tooled Annunciation group in the upper corners has exact parallels in Gentile's Perugia altar. A date close to 1410–14 is suggested by its dependence upon the style of the *Madonna and Child* at New York. For the iconography, see M. Meiss (*Painting in Florence and Siena after the Black Death,* Princeton University Press, 1951, p.139).

CAT. XXXVI (Plates 94–97)
FRESCOES

Chapel of SS. Peter and Paul, Cathedral, Pordenone

The quadripartite vault has a symbol of an evangelist at each peak, and saints in the lower corners:

THE BULL OF ST. LUKE WITH A SAINT (BENEDICT?) READING;

THE ANGEL OF ST. MATTHEW;

NAKED YOUTH (JOHN THE BAPTIST?) COVERED BY AN ANGEL AND ST. MARY MAGDALENE;

THE LION OF ST. MARK, ST. FRANCIS RECEIVING THE STIGMATA;

THE EAGLE OF ST. JOHN, TWO ADORING ANGELS.

The lunettes show 1) a landscape view and 2) remains of buildings – probably the setting of an Annunciation.

Uncovered in 1938, the frescoes are in very poor, often fragmentary, condition.

The series was first studied by L. Coletti ('Pittura veneta dal tre al quattrocento, pt. II', *Arte Veneta,* I, 1947, pp.251–62). Rightly emphasising their strong connection with Gentile, he went on to group them with some frescoes at Treviso: a *Madonna and Child* from S. Margherita (Catalogue XL), a lunette in the baptistry, a *Madonna and Child with St. John and a Miracle of St. Eligius* from S. Caterina (Catalogue XXXIX). Noting an expressive intensity uncharacteristic of Gentile, and remarking upon supposed resemblances between a drawing, generally given to Pisanello, and the St.

Eligius, he concluded that the latter was by Pisanello and that the other frescoes were from his circle. Later he attributed the S. Margherita and Pordenone frescoes to Pisanello as well (pp.XVI–XVII; 'La mostra da Altichiero a Pisanello', *Arte Veneta*, XII, 1958, p.247; *Guida del Museo Civico di Treviso*, Longo e Zoppelli, Treviso, 1959, p.17). Other critics focused attention on the St. Eligius fresco, largely ignoring those at Pordenone, though R. Brenzoni (*Pisanello*, Leo Olschki, Florence, 1952, pp.204–5) thought the same artist responsible for the panel of St. Benedict in the Poldi-Pezzoli Museum, Milan (see also A. Parronchi, 'Peregrinus Pinsit', *Commentari*, XXVI, 1975, pp.3–13). That panel shows a tendency to flat, linear patterning not found in the Pordenone series, and the three companion-pieces in the Uffizi are still farther removed in style (Catalogue XXVIII). Berenson (1968, pp.301–02, ills.539–40) rightly maintained a relation to Gentile. The drapery rhythms and facial structure of the *Angel of St. Matthew* depend upon a prototype close to the Magdalene of the Milan *Coronation* or the *Madonna* at New York. The shallow, rocky setting of the saints reflects that found in the upper scenes of the *Coronation*. Although related to the Treviso group by compositional motifs, this is probably due to a common source in Gentile. A preference for linear description, and a subordination of individual, physiognomical features to an overall pattern distinguish the Treviso from the Pordenone frescoes and underline the very direct relation of the latter to Gentile. If both series were conceived by a single artist, the lapse of time separating them is substantial.

Coletti erred in identifying the naked youth and Magdalene as Adam and Eve.

CAT. XXXVII
CRUCIFIX

Detached fresco Cappella dei Conversi, S. Paolo Fuori le Mura, Rome.
In ruinous condition, the lower half is modern, the rest much retouched.

The fresco was discovered during restorations at the Benedictine convent in 1908, where it evidently adorned the end wall of the old refectory. The fresco (including the *intonaco*) was removed in pieces and re-composed in its present locale. E. Lavagnino published it as a work of Gentile ('Un affresco di Gentile da Fabriano a Roma', *Arti Figurative*, I, 1940, pp.4off.). His argument rests on the facts that from 24 January 1426 the abbot of the convent of S. Giustina, Padua, Lodovico Barbo, was installed at S. Paolo to undertake reforms and rebuilding; a seventeenth-century index to the convent's archive cites a debt of twenty-five lire owed by Gentile to the monastery ('Gentilis de Fabriano – Debiti confessio di Gentilis ad favore Monasteri – lib. 25'. *Ibid.*, p.48); and on supposed resemblances between the fresco and works by Gentile (especially with figures of the *Quaratesi Altar-piece*). Neither the weak physiognomical construction nor such details as the uncial letters of the scroll or the tooling of the halo are comparable to Gentile's Orvieto fresco. Though condition does not permit proper analysis (Grassi, p.69; Micheletti, p.94), it is probably the product of a local artist, possibly somewhat later in the century.

CAT. XXXVIII
SCENES FROM THE LIFE OF JOB
Fresco (destroyed) Ospedale di S. Giovanni Laterano, Rome

These scenes and a cycle devoted to the story of Tobias decorated the exterior of the façade of the hospital of S. Giovanni Laterano. The compositions are known through drawings done at the time of their destruction in 1636 (R. de Fleury, *Le Latran au moyen-age,* A. Morel, Paris, 1877, pp.299–301). Largely on the basis of the figure style in these drawings H. Gollob (*Gentiles da Fabriano und Pisanellos Fresken am Hospitale von St. Giovanni in Laterano zu Rom,* J. H. Heitz, Strasbourg, 1927; also 'Pisanellos Fresken im Lateran und der Codex Vallardi', *Studi in onore di Giusta Nicco Fasola, Arte Lombarda,* X, 1965, pp.51–60) has attributed the Job cycle to Gentile and the Tobias cycle to Pisanello. There is no basis for either attribution.

The earliest reference to the frescoes is by G. Mancini around 1620 (*Considerazioni sulla pittura* and *Viaggio per Roma,* ed. A. Maruchi, 1956) who attributed the Job cycle to Simone Martini and dated both to 1363:

> Di questi medessimi tempi credo che siano le pitture di S. Rosa di Viterbo, et in Siena molti altari in S. Domenico, di Gioanni di Paolo, come se vede dalle lettere ivi scritte, et d'altri mastri suoi coetanei, et di Gentil da Fabriano, del quale si vede in Siena la Madonna di Banchetti.
>
> Et qui in Roma li pareti di S. Gio. Laterano, fatte in compagnia di Vittor Pisano veronese nel 419 incirca; quelle dell'Hospedale di S. Gio. Laterano. (p.72)

> L'historia de Iobbe a chiaro scuro nella facciata sotto l'orlogio dello spedale di S. Giovanni Laterano forse sono di questo Simone [Martini], perchè vi sono queste lettere: 'Simon de – pinxit', che quello scasso ci dà questa difficultà. Che del resto, quanto a' tempi nei quali furon fatte et la maniera convengono assai con il nostro Simone Ma. (p.174)

> E quelle pitture dell'Hospidale di S. Gio. Laterano del tempo del Ripanda (1363). (p.274)

R. de Fleury (*op. cit.*) recorded a dedication on the tympanum of the hospital door reading: 'Hoc opus inchoatum fuit tempore guardianatus Francisci Vecchi et Francisci Rosana priorum sub anno Domini MCCCXLVIII indictione secunda mense sept.' He dated the frescoes *c.* 1450 while S. Waetzoldt (*Die Kopien des 17. Jahrhunderts nach Mosaiken und Wandmalereien in Rom,* Schroll-Verlag, 1964, pp.42–43) suggests the second half of the fourteenth century (see also P. Lauer, *Le palais de Lateran,* E. Leroux, Paris, 1911, pp.327–29).

Neither Gentile nor Pisanello is documented for any work at S. Giovanni Laterano besides the fresco cycle inside the basilica depicting scenes from the life of St. John the Baptist (see Catalogue XIX). The compositional and architectural elements of the Job cycle indicate that, with the exception of the last two scenes, it was painted by a fourteenth-century Tuscan artist. The two remaining scenes and all of the Tobias cycle have many affinities in treatment of landscape, architecture, and figure disposition with Masolino's frescoes at S. Clemente, Rome.

CAT. XXXIX (Plate 98)
MIRACLE OF ST. ELIGIUS

Fresco Nave of S. Caterina, Treviso
315 × 136 cm.
Fragmentary and in poor condition.

L. Coletti published this fresco along with one showing the Madonna and Child with
St. John also at S. Caterina, a *Madonna and Child* from S. Margherita (Catalogue XL),
a lunette from the baptistry, and a series in the cathedral at Pordenone (Catalogue
XXXVI) ('Pittura veneta dal tre al quattrocento, pt.II', *Arte Veneta*, I, 1947, pp.251–
62; see also A. Parronchi, 'Peregrinus Pinsit', *Commentari*, XXVI, 1975, pp.3–13).
Though in all he found affinities with works by Gentile, the intense expressions in the
St. Eligius episode and supposed relations of its protagonist to a drawing, generally
given to Pisanello, led him to single out that fresco as a youthful work by the latter
artist. This idea was taken up by B. Degenhart ('Le quattro tavole della leggenda di S.
Benedetto', *Arte Veneta*, III, 1949, pp.7–22), who also attributed the series of panels
depicting miracles of St. Benedict (Catalogue XXVIII), three of which are at the Uffizi
and one in the Museo Poldi-Pezzoli, Milan, to Pisanello. A few critics have accepted
both attributions (L. Coletti, 'La mostra da Altichiero a Pisanello', *Arte Veneta*, XII,
1958, p.247; R. Chiarelli, *L'Opera completa del Pisanello*, Rizzoli, Milan, 1972, pp.87–
88; G. Paccagnini, *Pisanello e il ciclo cavalleresco di Mantova*, Electa Editrice, 1973,
pp.123–36), but most have either questioned or rejected that of the *St. Eligius* (E.
Sindona, *Pisanello*, Harry Abrams, New York, 1961, p.128; N. Rasmo, 'Note sui
rapporti fra Verona e l'Alto Adige nella pittura del tardo trecento', *Cultura Atesina*,
VI, 1952, p.76; 'Il Pisanello e il ritratto dell' imperatore Sigismondo a Vienna', *loc.
cit.*, IX, 1955, p.13, n.3; R. Brenzoni, *Pisanello*, Leo Olschki, Florence, 1952,
pp.205–8; M. Muraro, *Pitture murali nel veneto e tecnica dell'affresco*, Neri Pozzo Ed.,
Venice, 1960, p.69; M. Fossi-Todorow, *I disegni del Pisanello e della sua cerchia*, Leo
Olschki, Florence, 1966, p.4, n.1). As Coletti first noted, the style of the *St. Eligius* is
related to Gentile. The attribution to Pisanello therefore implies that he was Gentile's
pupil. There is little support for such a notion. Fazio, who knew Pisanello personally,
never hinted at such a relationship, and when the two artists worked on the same
commissions, at Venice and Rome, biographical and documentary evidence implies
that Pisanello was employed after Gentile had left (there is virtually no evidence that
Gentile continued to visit Venice after 1414, as Degenhart, *op. cit.*, p.22, supposes). In
Pisanello's earliest certain work, the *Annunciation* at S. Fermo, Verona, the influence
of Gentile is less prominent than a graphic style learned from Stefano and an architec-
tural setting derived from Altichiero. The influence of these Veronese artists is not
perceptible in the *St. Eligius*. While the facial types recall those in a work like Gentile's
Milan *Coronation*, there is a love of surface pattern and angular rhythms that make the
relationship less close than is the case with the Pordenone frescoes, which this scene
certainly postdates. The brilliant colouring of both figure and architecture, the fused
modelling, the architectural setting, and the emotional intensity relate to the local
tradition established by Tommaso da Modena. The same master is responsible for the
Madonna and Child from S. Margherita and at least the design of the *Madonna and*

128

Child with St. John. His identification with the master of the Pordenone frescoes remains hypothetical.

CAT. XL (Plate 99)
MADONNA AND CHILD WITH ST. MARGARET

Detached fresco fragment Museo Civico, Treviso
201.5 × 99.5 cm.
The fresco is in a ruinous condition, with many losses; restored 1958.

From S. Margherita, Treviso (1883). Coletti (*Treviso,* Italiano d'Arti Grafiche, Bergamo, 1926, pp.90–91) records that the fresco recalled Pisanello and seemed to be by the same artist as a lunette in the baptistry. Since Giambono worked in the Cathedral in 1431, Coletti suggested him as the author. With discovery of some related frescoes in S. Caterina (Catalogue XXXIX), however, he changed this attribution first for one to the circle of Pisanello ('Pittura Veneta dal tre al quattrocento, pt.II', *Arte Veneta,* I, 1947, pp.251–62), then directly to Pisanello (pp.XVI–XVII; 'La mostra da Altichiero a Pisanello', *Arte Veneta,* XII, 1958, p.247; *Guida del Museo Civico di Treviso,* Longo and Zoppelli, Treviso, 1959, p.17). This idea was rightly rejected by Brenzoni (*Pisanello,* Leo Olschki, Florence, 1952, pp.206–8), and then by Magagnato (pp.78–79). The former linked the *Madonna* to one of the S. Caterina frescoes published by Coletti, showing a miracle of St. Eligius, as well as to a series of frescoes in an adjacent chapel by a master Coletti called 'of the Innocents' ('Il Maestro degli Innocenti', *Arte Veneta,* II, 1948, pp.30–40). These latter frescoes are by a separate hand who has been identified as Teodorico d'Ivano (N. Rasmo, 'Il Pisanello e il ritratto dell'imperatore Sigismondo a Vienna', *Cultura Atesina,* IX, 1955, p.13, n.3) or Niccolò di Pietro (R. Pallucchini, 'Nuove proposte per Niccolò di Pietro', *Arte Veneta,* X, 1956, pp.37–55). That the *Madonna* and the St. Eligius frescoes are by the same artist, however, cannot be doubted. As Magagnato pointed out, their style owes much to Gentile. Both L. Menegazzi (*Il Museo Civico di Treviso,* Neri Pozza Ed., Venice, 1964, pp.100–4) and Huter (p.28) have attributed the *Madonna and Child* to Gentile, on account of resemblances to the Perugia and New York paintings. Such affinities as exist, however, are too superficial to support their attribution. The colours and architectural setting point to a local artist, influenced by the types in Gentile's Milan *Coronation,* but trained in the tradition of Tommaso da Modena. The fact that other related frescoes are in Treviso is indicative, and the anonymous authorship favoured by Berenson (1968, p.302) is to be preferred.

CAT. XLI (Plate 100)
MADONNA AND CHILD WITH TWO ANGELS

Panel Philbrook Art Center, Tulsa
58.7 × 42.9 cm. (inv. no. 3358, K 535)
Virgin's halo inscribed *ave maria gracia plena;* hem reads *ave maria gratia [plena] dominus*
. . .

The painting is in poor condition, being heavily abraded. Losses are minor but the sides have been extended by *c.* 0.5 cm. The upper arch and two roundels are original, the latter contain the nearly effaced, tooled figures of Gabriel and the Virgin. Cleaned 1953.

Prior to its purchase by Samuel Kress in 1938 it was in the Contini-Bonacossi Collection, Florence. From 1941–52 it was in the National Gallery, Washington, and since 1953 it has been at Tulsa (F. Rusk Shapley, *Paintings from the S. H. Kress Collection,* Phaidon, London, 1966, I, p.76). A direct attribution to Gentile (Longhi, p.191; *Preliminary Catalogue of Paintings and Sculpture,* Washington, 1941, p.75; W. Suida, *Paintings and Sculpture of the S. H. Kress Collection,* Tulsa, 1953, p.20; Coletti, p.IX; Grassi, pp.19, 56; Pallucchini, p.84; Rossi, p.14; Micheletti, p.87; Shapley, *op. cit.*) was questioned by Berenson (1968, p.165; and see *Preliminary Catalogue, op. cit.*), while Zeri (Shapley, *op. cit.*) has suggested identity with a "Virgin and Child between two angels, an injured piece with embossed ornament, of the school of Gentile da Fabriano', seen by Cavalcaselle in the Casa Persicini, Belluno (*History of Painting in North Italy,* Scribner's, New York, 1912, II, p.116, n.4). A date at *c.*1410, when Gentile was in Venice, is universally accepted.

A direct ascription to Gentile cannot be sustained: both in conception and execution quality is inferior to any autograph work. The style of the Tulsa painting forms a mid-way point between the more abstract figures of the Milan *Coronation* and the softer forms of the *Madonna and Child* at Washington. It may well reflect a lost work by Gentile either at Venice or Brescia. The posture of the Child relates to a series of devotional statuettes (U. Schlegel, 'The Christchild as Devotional Image in Medieval Italian Sculpture: A Contribution to Ambrogio Lorenzetti Studies', *Art Bulletin,* LII, 1970, pp.1–10) found also in Paduan painting (e.g., Giusto de'Menabuoi's *Madonna and Child* in the Padua Cathedral: see L. Grossato, *Da Giotto al Mantegna,* Electa Editrice, Milan, 1974, cat. nos.2, 51).

CAT. XLII (Plate 101)
MADONNA AND CHILD WITH ST. DOROTHY
Panel Galleria Nazionale delle Marche, Urbino
77 × 52 cm.
Cleaning has revealed the painting to be in ruinous condition (*Mostra di opere d'arte restaurate,* Urbino, 1969, pp.38–43).

Originally in the collection of a Sig. Grimaldi, Genoa, the painting was purchased from the dealer G. Grassi in 1915. F. M. Perkins ('Un dipinto inedito di Gentile da Fabriano', *l'Arte,* XVIII, 1915, p.232) published it as an early work by Gentile, close in date to the Brera *Coronation*. His opinion has been frequently repeated (G. Cantalamessa, 'Un dipinto sconosciuto di Gentile da Fabriano', *Bollettino d'Arte,* IX, 1915, pp.257–61; L. Serra, *Il Palazzo Ducale di Urbino e la Galleria Nazionale delle Marche,* Rome, 1918, pp.39–41; Van Marle, p.18; Molajoli, p.37; Huter, p.28). Doubts expressed before its cleaning (Grassi, p.67, as follower; Micheletti, p.94, who

repeats Grassi), however, have been substantiated. At the *Mostra* (*op. cit.*) a Venetian artist named, by Coletti (p.XV), the 'Maestro del bocolo' – an artist of Giambono's generation – was suggested (G. Vitalini Sacconi, *Pittura marchigiana: la scuola camerinese*, Trieste, 1968, p.91, wrongly attributed one of his paintings to Arcangelo di Cola), while more recently M. Lucco ('Di un affresco padovano del "Maestro di Roncaiette"', *Arte Veneta*, XXXI, 1977, p.173) has suggested another anonymous master. S. Padovani ('Materiale per la storia della pittura ferrarese nel primo quattrocento', *Antichità Viva*, XIII, No.5, 1974, p.10) placed it with a group of works generally given to Zanino di Pietro, thereby pointing the way to a correct attribution. The author is identical to the painter of the Valcarrecce Altar-piece, for a time displayed at Urbino (now at Camerino). When freed of the majority of works attributed to him by Padovani, the probable identity of this artist remains Zanino di Pietro rather than Giovanni di Francia (her suggestion: see especially R. Longhi, *Viatico per cinque secoli di pittura veneziana*, Florence, 1952, p.49; and F. Zeri 'Aggiunte a Zanino di Pietro', *Paragone*, XIII, No.153, 1962, pp.56–60). A date close to 1410 is suggested by comparison to Zanino's other works (see note 13, p.68). The saint has been referred to as Rosa (of Viterbo?), but Kaftal more plausibly calls her Dorothy (*Iconography of the Saints in Central and South Italian Schools of Painting*, Sansoni, Florence, 1965, p.370).

CAT. XLIII (Plate 102)
ANNUNCIATION

Panel Pinacoteca, Vatican

41 × 49 cm.

Open book inscribed *Ecce ancil*[*l*]*a domini* / *fiat michi secundum* [*verbum tuum*] (Luke 1:38).

 Cleaned in 1960, the painting is in fair condition. There are major losses along a vertical axis to the left of the curtain. Those areas painted over gold (Gabriel's cloak, the tree) have flaked badly.

Longhi (p.191) first attributed the painting to Gentile, dating it in his Florentine period. This attribution has not been contested (Grassi, pp.41, 64; Bellosi, p.4; Micheletti, p.92), though Berenson (1968) does not list it. While cleaning has confirmed a technical dependence on Gentile, it has revealed a work of low quality which cannot be reconciled with any of his autograph paintings. The composition derives from the much copied fresco at SS. Annunziata, Florence (see W. Paatz, *Die Kirchen von Florenz*, Frankfurt, 1955, I, pp.98–99, 157, n.23).

CAT. XLIV (Plate 103)
CORONATION OF THE VIRGIN

Panel Gemäldegalerie der Akademie, Vienna

88 × 63.5 cm. (inv. no. 1097)

Christ's halo inscribed YHS / XPS / FIL[IUS]; scrolls inscribed *Timete dominum et date illi hono*[*rem*] / *Dignus est agn*[*u*]*s* (Revelations 5:12).

Despite the opinion expressed by M. Poch-Kalous (*Katalog der Gemälde Galerie,* Vienna, 1972, p.13), the painting is, on the whole, in good condition. Most damages are confined to the glazed cloak of Christ, which has serious losses and is much repainted. The pastiglia work is original. Up to at least 1835 this painting was part of a double-sided processional standard with a *St. Francis receiving the Stigmata,* now lost, on the reverse. The saw marks visible on the back resulted when the two sides were separated from each other; the gable has also been removed.

For the history of this painting see Catalogue VIII. Although a copy of Gentile's *Coronation of the Virgin* in the J. P. Getty Museum at Malibu Beach, California, this is a characteristic work by Antonio da Fabriano, as an early tradition maintained. The companion *St. Francis* was inscribed with the date 1452.

CAT. XLV (Plate 104)
DEATH OF ST. PETER MARTYR
Cradled panel Dumbarton Oaks, Washington, D.C.
56.8 × 46.8 cm. (Acc. no. 22.1)
On the whole condition is fair, with some portions well preserved; cleaned, 1951–2

Published by W. Suida ('Two unpublished paintings by Gentile da Fabriano', *Art Quarterly,* III, 1940, p.348) as a work by Gentile close in time to the Berlin *Madonna and Child with Saints* and the Milan *Coronation of the Virgin,* it has correctly been recognised as a characteristic work by Jacobello del Fiore. The closest comparisons are with his *Madonna of Mercy* in the Accademia, Venice, for which a date about 1415–20 seems probable.

CAT. XLVI (Plate 105)
MADONNA AND CHILD WITH SS. JEROME, FRANCIS, JULIAN OR VENANZIO
Panel whereabouts unknown
68.6 × 57.2 cm.
From old photographs the painting appears somewhat overpainted, especially in the Virgin's face.

Originally in the Herbert Collection, London, then that of P. Paolini, Rome. It was purchased in 1924 by Robert Thalman (American Art Galleries, New York, 11 December 1924, No.107). Van Marle (p.22) attributed it to Gentile and correctly associated it with the Perugia *Madonna and Child.* Molajoli ('Un nuovo quadro di Gentile da Fabriano', *Gentile da Fabriano, Bollettino mensile per la celebrazione centenaria,* II, 1928, vi, pp.39–41) considered it Gentile's earliest painting, while Grassi (p.69) judged it the product of a 'mediocre, anche se no disprezzabile, seguace di Gentile'. Rossi (p.19) has recently again compared it with the Perugia altar.

An intimate connection between the Perugia and Paolini paintings seems certain,

but a comparison of the saints of the latter with the bystanders of a crucifixion at Rieti, signed by Zanino di Pietro, points to that artist as its author. A similar date, *c.*1405–10, is very likely (see note 13, p.68). The young 'knight' is difficult to identify. Zanino worked near Fabriano and Camerino, where Venanzio is the patron saint. He, as well as Julian, is represented in a fashion that accords with the figure in question (see G. Kaftal, *Iconography of the Saints in Central and South Italian Schools of Painting,* Sansoni, Florence, 1965, p.118).

CAT. XLVII (Plate 106)
FEMALE SAINT

<div align="right">whereabouts unknown</div>

Inscription on reverse side: *Per il Sig. Gaetano Ciccorini-Gubbio.*

Bought in 1888 by Ludovic de Spiridon, Rome, from the sculptor-painter, Dies, the painting was sold in 1928 (*Collection Spiridon de Rome, Vente Publique,* 19 June 1928, Frederik Muller & Co., Amsterdam). Van Marle published it as by Gentile (pp.13–14; 'Quattro dipinti marchigiani del principio del Quattrocento', *Rassegna Marchigiana,* IV, 1925–6, p.225), but Molajoli (p.113, n.6) rejected that attribution. It appears to be Marchigian, first half of the fifteenth century, and has recently been associated with a group of anonymous works (see A. Rossi, *I Salimbeni,* Electa Ed., Milan, 1977, p.209, n.48).

CAT. XLVIII (Plate 107)
BUST OF A BEARDED HERMIT
28.3 × 21 cm.

<div align="right">whereabouts unknown</div>

From the collection of C. Loeser, the picture was sold as by Gentile (Sotheby's, London, 9 December 1959, lot 19) and is so listed by Berenson (1968, p.164). This attribution implies an early date, but a satisfactory opinion cannot be reached on the basis of existing photographs, which indicate heavy restoration.

LOST WORKS

CAT. XLIX
CRUCIFIX

San Agostino, Bari

Ed in Sant'Agostino di Bari, un Crucifisso dintornato nel legno con tre mezze figure bellissime, che sono sopra la porta del coro (Vasari, pp.7–8).

Ricci (pp.152, 168, n.19) was unable to locate this crucifix. H. W. Schulz (*Denkmäler der Kunst des Mittelalters in Unteritalien,* Dresden, 1860, I, pp.334–35) describes it thus: 'Ueber der Thür von S. Agostino zu Bari befand sich ein von Francesco Gentile da Fabriano gemalter Crucifixus'. Thereafter references to the Crucifix cease.

CAT. L
FRESCO CYCLE

chapel of the Broletto, Brescia

Gentile is documented at Brescia from January 1414, to September 1419, during which time he was involved in decorating a chapel for Pandolfo Malatesta. Most information concerning these frescoes has been gathered by G. Panazza ('La pittura nella prima metà del Quattrocento', *Storia di Brescia,* Morcelliana Ed., Brescia, 1961, II, pt.VII, i, p.891ff.). The chapel is mentioned by Fazio (p.164), but the only description of them occurs in the *De laudibus Brixiae oratio* of Umbertino Posculo, 1458:

Nullo tamen opere plus gloriatur quam sacello illo famosissimo; in quo sicut Athensin in arce Minervae Phydia cum vivebat ebur, it hoc viventem beati Georgii Christi Dei militis et martyris imaginem, micantia Draconis lumina, trementemque puelam, equum hinnientem naribus afflantem ostendit. Quae imagines tanta pictoris nostri Gentilis arte effictae sunt, quanta Fydias, aut Policletus in marmore aut ebore, vel Apelles pictor vix affingere potuisset.

They are last mentioned in the early sixteenth century by E. Capriolo (*Delle historie bresciane,* Brescia, *c.* 1505, ed. 1630, p. 129):

... con tutto che Gentil Pittor Fiorentino dipingesse politamente una Capella a Pandolfo all'hora Prencipe, chiamata sin hoggi la Capella di Pandolpho.

In a poem of *c.* 1675 Francesco Paglia (*Il Giardino della Pittura,* edited by C. Boselli, Tipolito Fratelli Geroldi, Brescia, 1967, pp.34–35) describes the chapel decorations more thoroughly, but attributes the paintings to Calisto da Lodi, who worked in Brescia in 1521, by which date, therefore, Gentile's cycle had been replaced:

Ma già che siamo vicini alla Chiesoletta, avanziamo quatro / passi e vedremo in essa S. Giorgio, che libera d'affanno / la Donzella smarita, et similmente tutta la

cupoletta / intorno dipinta della Vita e Passione del Nostro Salvatore, / e della Beat.ma Vergine in più luoghi compartita, con / grand.ma quantita di figure, et ornamenti, fatta con tanta / delicatezza, che fan stupire. et sono della mano / di Calisto da Lodi. che merita molte lodi.

A painting in the Pinacoteca Tosio Martinengo, Brescia, possibly by Paolo Caylina of Brescia and dating from about 1450–70, may reflect the principal group of Gentile's scene of St. George. Not only does it fit Posculo's description, but the narrow foreground space marked off by a hedge, the type of horse, and the lavish use of raised ornament have parallels in the Uffizi *Adoration of the Magi*. The stiff, mannered princess and distant landscape, however, are characteristic of Paolo, not Gentile. (For other attributions of this painting, see *Arte Lombarda dai Visconti agli Sforza,* Silvana, Milan, 1958, p.94, No.292).

CAT. LI
PANEL PAINTING FOR CARLO MALATESTA

Brescia

20 December 1417 and 31 January and/or 30 June 1418 Gentile is paid for 'una tavoletta da fare una anchona', 'per cornixe e altri lavori dintalio per la tavola del signore Carlo'. (see Document III: cod. 52, ff.2v., 11v.; cod. 55, ff.101, 108v)

CAT. LII
PANEL PAINTING FOR POPE MARTIN V

Brescia

8 November 1418 Giovanni da Prato is paid for 'una ancona' that Gentile paints to give to Martin V. (see Document III: cod. 52, f.16; cod. 55, f.120v.)

CAT. LIII
CRUCIFIXION

Convent of S. Maria di Valdisasso, Fabriano

The central, crowning panel to the *Coronation of the Virgin* now in the Brera, Milan; described by Ricci (p.153): '... il quinto (de quadretti) in che era dipinto Cristo in Croce fu venduto ad un orientale che il condusse fuori della nostra penisola'.

CAT. LIV
PORTRAIT OF MARTIN V AND TEN CARDINALS
S. Giovanni Laterano, Rome

Eiusdem est altera tabula in qua Martinus Pontifex Maximus et cardinales decem ita expressi ut naturam ipsam aequare et nulla re viventibus dissimiles videantur (Fazio, p.165).

On 24 May 1426 Martin V created ten new cardinals. The painting probably commemorated this event. B. Degenhart's suggestion ('Gentile da Fabriano in Rom und die Anfänge des Antikenstudiums', *Münchner Jahrbuch der Bildenden Kunst*, XI, 1960, pp.59–62) that this portrait may have resembled Simone Martini's *St. Louis of Toulouse* at Naples or a *Bicherna* cover of 1460 at Siena must be discarded. The first is an altar-piece dedicated to a saint. The second is a small-scale work destined for secular use celebrating the accession to the papacy of a member of a local family. The format is more likely to have been a series of profile and/or three-quarter view, bust-length figures – like that depicting the founders of the Florentine Renaissance, often attributed to Uccello, or J. van Scorel's *Twelve Jerusalem Pilgrims* at Haarlem. The fact that two later portraits of Martin depend upon such a bust-length, profile portrait may serve to confirm this conjecture (see L. Venturi, 'Due ritratti smarriti di Pisanello', *Arte Veneta*, VIII, 1954, pp.93–94; and Degenhart, *op. cit.*).

CAT. LV
MADONNA AND CHILD WITH SS. BENEDICT AND JOSEPH
S. Maria Nova (S. Francesca Romana), Rome

Dipinse in Roma, in Santa Maria Nuova, sopra la sepoltura del cardinal Adimari, fiorentino ed arcivescovo di Pisa; la quale e allato a quella di papa Gregorio IX; in un archetto la Nostra Donna col Figliuolo in collo, in mezzo a San Benedetto e San Giuseppo: la qual opera era tenuta in pregio dal divino Michelagnolo... (Vasari, p.7).

This painting was not necessarily a fresco; its format may have resembled Gentile's painting at Berlin. Cardinal Adimari died on 17 November 1422. The notion that the work was not associated with his tomb, but was over the entrance door to the church (P. Lugano, 'Gentile da Fabriano e l'ordine de Montoliveto', *Rivista Storica Benedettina*, XVI, 1925, p.311) contradicts Vasari's description. B. Degenhart (I, i. p.251, cat. 142) has associated a drawing, which he incorrectly attributes to Arcangelo di Cola, with this composition. However, the identification of Benedict in that drawing is questionable and the style is unrelated to Gentile.

CAT. LVI
MADONNA AND CHILD WITH SS. JOHN THE BAPTIST, PETER, PAUL, CHRISTOPHER

Palazzo dei Notai, Siena

> Eius est opus Senis in foro eadem Maria Mater Christum itidem puerum gremio tenens, tenui linteo illum velare cupienti adsimilis, Iohannes baptista Petrus ac Paulus Apostoli, et Christoforus Christum humero sustinens, mirabili arte, ita ut ipsos quoque corporis motus ac gestus representare videatur. (Fazio, p. 164)

To this description Tizio adds:

> Gentiles Fabrianensis pictor eximius Virginis imaginem ceterorumque sanctorum non hoc anno [1424], ut fertur, pro foro publico apud Tabelliones depinxit, sed sequenti perfecit. In imis vero sub Virginis circulus est, in quo Iesu Christi in sepulcro mortui consistentis, quam Pietatem christiani vocant, a dextris ac sinistris angeli duo sunt aereo colore tam tenue picti, tamque exili lineatura in tufeo lapide, ut nisi quis etiam ostensis acutissimum figat intuitum, conspicere non valeat.
> (S. Titii, *Historiarum Senensium*, Tom. IV, Ms. B. III 9, Biblioteca Comunale, Siena, ff. 220–1).

G. Mancini (*Considerazioni sulla pittura*, ed. A. Maruchi, 1956, p. 181) referred to it about 1620. The painting hung outside the palace, beneath an overhang visible in an engraving of G. A. Pecci's *Relazione delle cose più notabili della città di Siena*, 1752. It may still have been *in situ* at that date, since he describes it:

> Sotto la sudetta [Palazzo d'Elci] tengono Residenza i Notai, e la Curia del Giudice Ordinario, e sopra la Porta si sostiene, con catene di ferro una volta, che in un angolo non ha posamento, disegno, e invenzione – benchè alcuni dichino di Baldassare – di maestro Guirrino dal Borgo San Sepolcro, Muratore, che serve di baldacchino ad un'Immagine di Maria Santissima, ivi dipinta nel 1425 da Gentile da Fabriano. (p. 64).

An arrangement similar to that described by Pecci is depicted in Domenico di Bartolo's fresco of *The Distribution of Alms* in the Spedale della Scala, Siena. Gentile is documented in Siena from 22 June to September, 1425. By October he was in Orvieto, and in Rome from January 1427. The painting was thus begun in 1425, and not 1424 as Tommaso Fecini states in *Cronaca Senese*, Pt. II (Ms. A-VI-9, Bib. Communale, Siena, f. 350v. It is to this fifteenth-century chronicler that Tizio addresses himself in the above passage). It was evidently finished by October 1426:

> Diebus tamen paucis elapsis [i.e. October 1426] Gentiles Fabrianensis pictor Marie Virginis ceterorumque Sanctorum super Tabellionum sedilia in Publico foro ad Casati fauces pictas Imagines, iam perfectas annotato Augusti mense, Populo prebuit conspiciendas: tametsi anno elapso incohatas et non plene absolutas notaverimus. (Tizio, *op. cit.*, f. 205).

It is possible that the central image resembled in format the *Madonna and Child* at Velletri, since the iconographic elements of that painting depend upon earlier Sienese examples. However, Degenhart's notion ('Gentile da Fabriano in Rom und die Anfänge des Antikenstudiums', *Münchner Jahrbuch der bildenden Kunst*, XI, 1960, pp. 71f.) that the other figures may be reflected in drawings he attributes to Pisanello is without basis, as is his suggestion that this work was a fresco.

CAT. LVII
ALTAR-PIECE

S. Cristofano, Siena

Ed in essa si osservano nell'Altare, dove era una tavola di Gentile da Fabriano, una tela di Francesco Franci...

(G. A. Pecci, *Relazione delle cose più notabili della città di Siena*, 1752, p. 109).

CAT. LVIII
FRESCO DECORATION OF A NAVAL BATTLE

Sala del Maggior Consiglio, Palazzo Ducale, Venice

Pinxit et Venetiis in palatio terrestre proelium contra Federici Imperatoris filium a venetis pro summo Pontifice susceptum gestumque. quod tamen parietis vitio pene totum excidit.

(Fazio, p. 164, M. Baxandall, p. 105, incorrectly referred 'terrestre' to 'proelium' rather than 'palatio'.)

and:

Il quadro del conflitto nauale, fu ricoperto da Gentile da Fabriano Pittore di tanta riputatione, che hauendo di prouisione un ducato il giorno, vestiua a maniche aperte.

(F. Sansovino, *Venetia, città nobilissima et singolare*, Venice, 1581, p. 124a.)

Though Sansovino wrongly dated Gentile's activity to a still later redecoration of the room, beginning in 1474, he corrected his error, naming Giovanni Bellini as the author of the new scene (p. 129a). A record of the original inscriptions accompanying the frescoes is transcribed by G. Lorenzi (*Monumenti per servire alla storia del Palazzo Ducale di Venezia*, Venice, 1868, p. 63). The scene painted by Gentile was on the court side and bore the following inscription:

Pugnant viriliter partes, tandem clarissimus Dux et probissimi Veneti, Deo assistente, obtinent victoriam et triunphum, capto Ottone filio Imperatoris, et omnibus galeis Imperialibus devictis et positis in conflictum, de quibus LX capte fuerunt reliquis consumptis unda vel igne, exceptis pauces que rapuerunt fugam.

Lorenzi also reproduces some miniatures illustrating the story, but A. Venturi (*Gentile da Fabriano e il Pisanello*, G. Sansoni, Florence, 1896, p. 6) correctly notes that these cannot copy the lost frescoes.

No documents prior to 1474 naming the artist who painted this cycle dedicated to the popular narrative of the role of the Venetian Republic in the struggle between Frederick Barbarossa and Pope Alexander III survive. The Sala del Maggior Consiglio was, for the most part, constructed between 1340 and 1348 (Lorenzi, *op. cit.*, docs. 79, 80, 94), though in 1362 it was still not complete (*ibid.*, doc. 103; see now, E. Arslan, *Gothic Architecture in Venice*, Phaidon, London, 1971, pp. 141–54). Between 1366, when he is documented in Venice, and 1367, when he was again in Padua, Guariento frescoed the end wall with a *Paradise*, the forerunner of Tintoretto's painting (San-

sovino, *op. cit.*, p.123b, gives the year as 1365 and says that Guariento also painted 'alcuni altri quadri', among which the battle at Spoleto). In 1382 a custodian for the pictures was appointed (Lorenzi, *op cit.*, doc. 107). Then on 25 May 1409 measures were taken to 're-adapt' the pictures of the room:

> *Capta.* Quia Sala nostri Maioris Consillij superior multum destruitur in picturis: Vadit pars, quod committatur viris nobilibus Officialibus nostris super Sale et Rivoalto quod dictas picturas faciant reaptari de denariis nostri comunis cum quam minori sumptu fieri poterit non transuendo sumam ducatorum ducentorum (*ibid.*, doc. 137).

On 19 April 1411 further funds were provided:

> *Capta.* Cum alias captum fuerit quod Officiales nostri super Sale et Rivoalto pro faciendo reparare et aptari picturas Sale nove possent expendere libras viginti grossorum, et dicti denarij non fuerint sufficientes ad complementum operis: Vadit pars, quod committatur dictis officialibus super Sale et Rivoalto quod pro complendo laboreria necessaria possint expendere alias libras viginti grossorum de pecunia nostri comunis et ab inde infra sicut facere poterunt. (*ibid.*, doc. 140).

By 1415 the room was referred to in terms that imply completion of the pictorial decoration, and a new access was decided upon (*ibid.*, doc. 145). On 30 July 1419 the Maggior Consiglio convened in the room (*ibid.*, p.57, n.a), and in 1422 provision was made for a permanent surveyor of the pictures: 'pro faciendo reaptari et teneri continue in bono et debito ordine picturas...' (*ibid.*, doc. 148); Sansovino (*op. cit.*) recorded that the room was completed in 1423. Gentile's activity is therefore likely to date sometime between 1409 and 1414. He is listed in Venice by July 1408 (Document I) and was working for Pandolfo Malatesta in Brescia in January 1414 (Document III). F. Wickhoff ('Der Saal des grossen Rathes zu Venedig in seinem alten Schmucke', *Repertorium für Kunstwissenschaft*, VI, 1883, p.20) suggested that Gentile's and Pisanello's work in the palace dates from 1422, but this idea results from a misreading of the documents and is disproved by Gentile's presence in Florence that same year. As mentioned above, the entire cycle was redone beginning in 1474 and again following the fire of 1577 (Lorenzi, *op. cit.*, docs. 188, 842). The present, corresponding scene is by Domenico Tintoretto.

CAT. LIX
A PAINTING OF SS. PAUL AND ANTHONY ABBOT

San Felice, Venice

Fece in oltre vna tauola in San Felice de' Santi Paolo, & Antonio Eremiti....
(C. Ridolfi, *Le Maraviglie dell'arte,* Venice, 1648, p.23.)

CAT. LX
A PAINTING OF ST. PAUL THE HERMIT

San Giuliano, Venice

... dipinse in San Giuliano la tauola di San Paolo primo Eremita, che fu poi redipinta dal Palma giouane. (*ibid.*)

CAT. LXI
AN ALTAR-PIECE OF SS. PAUL AND ANTHONY ABBOT

S. Sofia, Venice

Vi dipinse la palla di San Paolo primo heremita, e di Santo Antonio, Gentile da Fabriano, che fu maestro nella pittura de i Bellini.

(F. Sansovino, *Venetia città nobilissima, et singolare,* Altobello Salicato, Venice, 1581, p.54b)

Ridolfi does not mention the altar-piece in S. Sofia, nor Sansovino that in S. Felice. Since the two churches are very near each other, and the subjects of both paintings identical, it does not seem impossible that the alter-piece was removed from S. Sofia to S. Felice prior to publication of the *Meraviglie.* In the Scuola di S. Cristoforo dei Mercanti Gentile is listed as living in the parish of S. Sofia (Document II).

CAT. LXII
A SEA STORM

Venice

Pinxit item in eadem urbe turbinem arbores caeteraque id genus radicitus evertentem, cuius est ea facies, ut vel prospicientibus horrorem ac metum incutiat. (Fazio, pp.164–65).

Neither the subject nor the precise location of this scene is known, but it has been presumed identical with the fresco in the Doge's Palace (B. Degenhart, *Pisanello,* Tip. Bona, Turin, 1945, p.26) and to have influenced Uccello's fresco of *The Flood* (J. Pope-Hennessy, *Paolo Uccello,* Phaidon, London, 1969, p.2).

CAT. LXIII
TWO PORTRAITS

once in Fabriano, then Venice

Noted in the house of M. Antonio Pasqualino in 1532 by Marcantonio Michiel (*Der Anonimo Morelliano,* ed. T. Frimmel, Vienna, 1888, p.78):

La testa per al naturale ritratta da un huomo grosso cun un capuzzo in capo et mantello nero, in profilo, cun una corda de 7 paternostri in mano, grossi, negri, delli quali el più basso et più grande è di stucho dorato rileuato, fu de man de Gentil da Fabriano, portata ad esso M. Antonio Pasqualino da Fabriano insieme cun la infrascritta testa; zoè un ritratto d'uno giouine in habito da chierico cun li capelli corti sopra le orechie, cun el busto fin al cinto, uestito di vesta chiusa, poco faldata, di color quasi biggio, cun un panno a uso di stola negra, frappata sopra el collo, che descende giuso, cun le maniche larghissime alle spalle et strettissime alle mani, di mano dell'instesso Gentile. Ambedoi questi ritratti hanno il campi neri, et sono in profilo et si giudicano padre et figlio, et si guardano l'un contra laltro, ma in due però tauole, perchè par che si simiglijno in le tinte delle carni. Ma al mio giudicio questa conuenienza delle tinte prouiene dalla maniera del maestro che facea tutte le carni simili tra loro et che tirauano al color pallido. Sono però ditti ritratti molto viuaci, et sopra tutto finiti et hanno un lustro come se fussino a oglio, et sono opere lodevoli.

ATTRIBUTED DRAWINGS

CAT. LXIV (Plates 108–109)
SEATED WOMAN (recto) and ST. PAUL (verso)
Pen-and-ink on parchment Kupferstichkabinett, Staatliche
 Museen, Berlin-Dahlem
17.8 × 11.0 cm. (Kd. Z. 5164)

Purchased by the Berlin Museum in 1910 from A. von Beckerath. Previously it was in
the Murray Collection (*Zeichnungen alter Meister im Kupferstichkabinett der K. Museen
zu Berlin,* G. Grote'sche Verlagsbuchhandlung, Berlin, 1910, I, p.xi, No. 39 a-b).

A. Venturi (*Gentile da Fabriano e il Pisanello,* G. Sansoni, Florence, 1896, pp.x–xi)
first suggested the attribution to Gentile; Molajoli (p.122) concurred (both describe it
as two drawings). Although Van Marle (p.52) considered it the work of a follower,
the contrary case has been maintained by L. Grassi (*Il Disegno Italiano,* Sudalizio del
Libro Venice, 1961, p.143) and M. Fossi-Todorow (*I disegni dei maestri: l'Italia dalle
origini a Pisanello,* Fratelli Fabbri Ed., Milan, 1970, p.85). Recently Degenhart (I-1,
cat. 75, pp.142–44) rejected the attribution to Gentile and proposed that both the sheet
at Berlin and what appears to be a companion sheet at Edinburgh (D. 2259; see
following entry) are Umbrian, dating from the third quarter of the fourteenth cen-
tury. This notion he bases on two observations: 1) the fine, short pen strokes used to
model the figures are comparable to works done on gilded glass that pre-date Gen-
tile's activity; 2) those drawings he would attribute to Gentile do not reveal this
technique. The technical relation of these two drawings to gilded glass-work is super-
ficial and, attribution aside, a study like that of the seated woman can hardly pre-date
the last decade of the fourteenth century. Nor is the comparison with later drawings
by Gentile pertinent since, on the one hand, his early drawings may be presumed to
differ as greatly from the late ones as do the paintings and, on the other hand, the
attribution of those drawings is extremely hypothetical (see Catalogue LXVII). A
drawing at the Ashmolean Museum, Oxford (No. 43), generally attributed to
Lorenzo or Jacopo Salimbeni, presents close affinities in graphic style. It confirms that
the Berlin drawing is also Marchigian and probably of the early fifteenth century (see
Degenhart, I-1, cat. 123, pp.231–33), as recognised by R. Salvini (review of De-
genhart, *Commentari,* IV, 1972, p.346).

As noted by Grassi and J. van Regteren Altena (review of Degenhart, *Master
Drawings,* VIII, 1970, p.397), the seated woman is in every respect comparable to the
crowning scenes of the *Coronation of the Virgin* at Milan. Not only do drapery fall, and
facial and hand structure relate, but the graphic technique perfectly translates the soft
modelling of the painting. No other drawing presents such close parallels with a work

142

from Gentile's painted *oeuvre*. It follows that no other drawing has better claim to be considered as autograph. The same cannot be maintained for the figure of St. Paul on the verso. He is harsher in execution and morphologically different from the figure on the recto; nor is there a parallel for his stance in any of Gentile's paintings. C. Dodgson (*The Vasari Society,* ser. I, p.viii, 1911–12, n.7) first suggested that he is by the same hand as the Edinburgh sheet. A comparison of technique and particulars of drapery seem to confirm this notion, though in the Edinburgh drawing a copy from a prototype by Gentile seems to be at issue. If, then, the seated woman may tentatively be attributed to Gentile and, upon comparison with the *Coronation,* dated *c.*1410–14, the verso necessarily remains the work of an anonymous follower. The alternative solution is that the seated woman, like the figures at Edinburgh, is a copy of an original by Gentile.

CAT. LXV (Plate 110)
TWO APOSTLES (?) (recto) and A DRAPERY STUDY (verso)
Pen-and-ink on parchment National Gallery of Scotland, Edinburgh
18.2 × 12.9 cm (D. 2259)
Inscribed on verso *Lorenzo Ghiberti.*

Evidently purchased by William Roscoe from W. Y. Ottley and sold at Liverpool on 23 September 1816 (No. 18) to Ford, Manchester; according to pencilled initials on the verso it was owned by W. B. Johnson; then W. F. Watson, who bequeathed the drawing to the National Gallery of Scotland in 1881 (K. Andrews, *Catalogue of Italian Drawings,* Cambridge University Press, 1968, I, p.55).

An initial attribution to Ghiberti (by Roscoe) was accepted by Watson, who is responsible for inscribing that name on the verso. In the catalogue of 1946 (p.392) the drawing is listed as by Pisanello (?), but C. Dodgson (*The Vasari Society,* ser. I, pt. VII, 1911–12, n.7) had already suggested Gentile's name and pointed out the close affinity with a figure of St. Peter at Berlin (Kd. Z. 5164). This attribution was accepted by Van Marle (p.16) and K. Andrews (*Old Master Drawings, A Loan Exhibition from the National Gallery of Scotland,* Colnaghi's, 1966, I; and *op. cit.*). B. Degenhart (I-1, cat. 76, pp.142–44) classified the drawing as Umbrian, third quarter of the fourteenth century, but he is almost certainly incorrect in divorcing it from Gentile's *oeuvre* (see Catalogue LXIV).

Comparison of the Edinburgh drawing with the painting of the *Coronation of the Virgin* at Milan reveals a general affinity with Gentile's style at that moment (*c.*1410–14). However, such features as the harsh, profile view of one figure, the finely curled beard of the other, and a tendency to flatness distinguish the drawing from that painting and from the drawing of a seated woman at Berlin (the extent to which this impression is due to later reinforcement remains problematic; see Dodgson). The latter drawing is the only one for which a direct attribution to Gentile is plausible. If, as Dodgson suggested, the artist of the Edinburgh drawing executed the verso of that at Berlin, then a model by Gentile must be hypothesized for the former. This would clarify its function as part of a pattern book, from which the Berlin sheet may also

originate. The identification of the two figures as Christ and Peter (Dodgson followed by Andrews) seems difficult to sustain. Representations of a pair of apostles are, on the other hand, traditional.

CAT. LXVI
MAIDEN

Water-colour and gouache on parchment
24.8 × 17.4 cm.
Scroll held by maiden inscribed *ven. got. vil.*

Louvre, Paris
(inv. no. 20693)

From the collections of the Marquis de Lagoy (1764–1829) and Revoil (?) (*Notice des dessins du Musée du Louvre,* Charles de Mourgues Frères, Paris, 1866, p.340, No. 634).

Originally classified as Flemish fifteenth century (*ibid.*) and then as French (*Portraits et Figures de Femmes,* Musée de l'Orangerie, Paris, 1935, p.17, No. 55), B. Degenhart ('Gentile da Fabriano in Rom und die Anfänge des Antikenstudiums', *Münchner Jahrbuch der Bildenden Kunst,* XI, 1960, pp.76–77; I-i, cat. 125, pp.234–35) first attributed this 'drawing' to Gentile (his opinion was followed in the exhibition *Europäische Kunst um 1400,* Kunsthistorisches Museum, Vienna, 1962, cat. 258, p.254). Stating that the face was overpainted in the sixteenth or seventeenth century, he compared the figure style and technique to Gentile's paintings at Berlin and Milan, noting that the German devise is rendered phonetically: his arguments are not convincing.

The gently curving posture, flowing drapery, and delicate, pointed fingers of the Louvre figure have little in common with the more angular drapery and ill-articulated features of Gentile's *St. Catherine* at Berlin. The Magdalene at Milan is equally removed by her monumental bearing and different morphology. When the Louvre sheet is compared to those at Edinburgh and Berlin, whose relation with Gentile is supported by precise parallels with the *Coronation of the Virgin* at Milan, there can be no doubt that the former has little to do with him. If Italian rather than German, the closest parallels are to be found in north Italy. In fact, an unstated assumption that Gentile was trained in Lombardy lies behind Degenhart's proposal. This idea, first proposed by Grassi (pp.7–8), is without documentary support.

An old pagination (14) indicates that the Louvre sheet was at one time united with two 'fashion studies' by Pisanello at Oxford and Chantilly (Degenhart, *op. cit.*).

CAT. LXVII

COPIES FROM THE ANTIQUE
Pen-and-ink, silverpoint on parchment Uffizi, Florence
18.9 × 25.8 cm. (no. 3 S)
Inscribed at bottom *Buonamico Buffalmacco.*

MADONNA AND CHILD WITH SAINT
Pen-and-ink on red-tinted paper Ambrosiana, Milan
19.6 × 24.9 cm. (Ms. 214 F, f.7)
From the collection of Padre S. Resta (1635–1714) (F. Lugt, *Les marques de collection de dessins et d'estampes,* Vereenigde Drukkerijen, Amsterdam, 1921, No. 2981).

TWO MADONNAS WITH CHILD
Pen-and-ink on red-tinted paper Ambrosiana, Milan
19.9 × 26 cm. (Ms. 214 F, f.8)
From collection of Padre S. Resta (*ibid.*).

COPIES FROM ANCIENT SARCOPHAGI (recto);
COPY FROM DONATELLO'S PULPIT AT PRATO (verso)
Pen-and-ink, silverpoint on parchment Ambrosiana, Milan
19.3 × 27.3 cm. (Ms 214 F, f.13)
From collection of Padre S. Resta (*ibid.*).

COPIES FROM AN ANCIENT SARCOPHAGUS (recto);
ANNUNCIATION (verso)
Pen-and-ink, silverpoint on parchment Ambrosiana, Milan
19.3 × 27.1 cm. (Ms. 214 F, f.15)
From collection of Padre S. Resta (*ibid.*).

TWO STANDING FIGURES, RICHLY DRESSED, AND HEAD OF A WOMAN (recto);
COPIES FROM AN ANCIENT SARCOPHAGUS (verso)
Pen-and-ink with water-colour (recto); Ashmolean Museum, Oxford
pen-and-ink, silverpoint (verso) on parchment (No. 41)
18.6 × 24.1 cm.)
In the collection of the Marquis de Lagoy (1764–1829) and then that of F. Douce; bequeathed 1834 (K. Parker, *Catalogue of the Collection of Drawings in the Ashmolean Museum,* Clarendon Press, Oxford, 1956, II, p.26).

STUDY OF RAM'S HEAD AND RAM (recto);
COPIES FROM ANCIENT SARCOPHAGI (verso)

Pen-and-ink, traces of silverpoint (verso) on parchment Louvre, Paris
19.4 × 27.3 cm. (inv. no. 2397)
From the Vallardi Collection (*Disegni di Leonardo da Vinci posseduti da G. Vallardi,*
Milan, 1855, p.42, No. 194).

COPY FROM A ROMAN RELIEF

Silverpoint on grey ground École des Beaux-Arts, Paris
16.2 × 24.2 cm. (no. 2342)
From the J. Masson Collection (*Art Italien des XV^e et XVI^e siècles,* École Nationale
Supérieure des Beaux-Arts, Paris, 1935, p.19, No. 65).

COPIES FROM ANCIENT SARCOPHAGI (recto-verso)

Pen-and-ink, silverpoint on parchment Museum Boymans-van
21.1 × 15.4 cm. Beuningen, Rotterdam
Inscribed on verso *Arnolfo di Lapo.* (no. I. 523)
From the collections of M. von Fries (1777–1826), Marquis de Lagoy (1764–1829) (F.
Lugt, *op. cit.,* Nos. 2903, 1710), F. Koenigs (†1941) (*Exposition de l'oeuvre de
Pisanello,* Bibliothèque Nationale, 1932, p.45, No. 88).

COPIES FROM ANCIENT MONUMENTS (recto);
HORSE SEEN FROM THE BACK (verso)

Pen-and-ink on parchment whereabouts unknown
18.6 × 24.7 cm.
Inscribed in lower right *Nicolaus Pisanus.*
From the collection of M. von Fries, Marquis de Lagoy (F. Lugt, *op. cit.,* Nos. 2903,
1710), F. Koenigs (†1941), Haarlem (No. I. 524) (*Exposition de l'oeuvre de Pisanello,*
Bibliothèque Nationale, 1932, p.45, No. 91).

The attribution of this group of drawings to Gentile (minus Ambrosiana 214 F.,
ff.13v., 15v.; Ashmolean 41r.; Louvre 2397r.) is due to B. Degenhart who, in 1949
('Le quattro tavole della leggenda di S. Benedetto, opere giovanili del Pisanello', *Arte
Veneta,* III, 1949, p.7), expressed the opinion that those at Milan, Haarlem and Rot-
terdam might as easily be by Gentile as the young Pisanello, to whom he had earlier
ascribed them (*Pisanello,* Tip. Vincenzo Bona, Turin, 1945, pp.23–25). Adding the
drawing at Oxford to that nucleus, he first attributed the group to Gentile in 1954 ('Di
una pubblicazione su Pisanello e di altri fatti', II, *Arte Veneta,* VIII, 1954, p.112, n.5),
noting that it formed part of a large complex of drawings, mostly by the young
Pisanello. Six years later he elaborated the principles for reconstructing this pattern
book on the basis of collector's marks, format and subject-matter, and reviewed the
evidence for an attribution of the above sheets to Gentile ('Gentile da Fabriano in Rom

und die Anfänge des Antikenstudiums', *Münchner Jahrbuch der Bildenden Kunst,* XI, 1960, pp.59ff.). The drawings of the Madonnas, he claimed, revealed close similarities with Gentile's late works (the fresco at Orvieto and the painting at Velletri); and the same hand was responsible for the drawings after ancient sarcophagi. Since, with one exception, these sarcophagi were located in Rome (the prototype for École des Beaux-Arts, No. 2342 is in Ravenna), he concluded that the drawings must have been done in that city during Gentile's presence (1426–27). The fact that these drawings were bound with others by Pisanello he explained by assuming a close collaboration between the two artists on the Lateran frescoes, interpreting Document XVII as proof of this collaboration and of the probable occasion when Gentile's drawings passed to Pisanello. Confirmation of this hypothesis was found in the fact that 1) certain sheets represented episodes from the life of St. John the Baptist and might therefore actually be copies from this lost cycle (Catalogue XIX), and 2) other drawings seemed attributable to Arcangelo di Cola and an anonymous Sienese, whom he considered assistants of Gentile (an unverifiable and unlikely conjecture). Almost contemporaneously M. Fossi-Todorow ('Un taccuino di viaggio del Pisanello e della sua bottega', *Scritti in onore di Mario Salmi,* II, De Luca Ed., Rome, 1962, pp.133ff.) reached similar conclusions as to the composition of the pattern (or note) book, but referred the drawings in question and the vast majority of others to Pisanello's circle rather than to Gentile or Pisanello. She later reiterated this view (*I Disegni del Pisanello e della sua cerchia,* L. Olschki, Florence, 1966, pp.47–48, 124ff.), adding that some of the sheets (including Ambrosiana 214 F., ff.7, 8), by virtue of the red-tinted paper, should be separated from the larger complex assembled by Degenhart. As early as 1909 K. Zoege von Manteuffel (*Die Gemälde und Zeichnungen des Antonio Pisano,* Halle a. S., 1909, pp.155, 172) had considered some of the above drawings too low in quality to be by Pisanello, and only the Louvre and Oxford sheets have consistently appeared as his work (see Fossi-Todorow, *op. cit.,* cat. 190, p. 131; cat. 195, p.133). Since 1960, however, Degenhart's attributions to Gentile have been widely accepted, either in part (E. Sindona, *Pisanello,* H. Abrams, New York, 1961, p.113, n.102) or in whole (R. Scheller, *A Survey of Medieval Model Books,* De. Erven Bohn, Haarlem, 1963, pp.171–75; *Europäische Kunst um 1400,* Kunsthistorisches Museum, Vienna, 1962, cat. 259, p.255; G. Paccagnini, *Pisanello e il ciclo cavalleresco di Mantova,* Electa Ed., Venice, 1973, p.150. See also B. Degenhart, I-1, pp.235–45; and *Disegni del Pisanello e di maestri del suo tempo,* Neri Pozza Ed., Vicenza, 1966, pp.12ff.). Nevertheless, Gentile's authorship of these drawings can be sustained neither on the basis of style nor of documents.

The flattened features and angularity of the Madonnas have little in common with the fuller, supple figures found in Gentile's works from the *Quaratesi Altar* on. When compared to the angels in the panel at Velletri, the closest approximations to drawings from Gentile's hand at this moment, neither technical nor morphological parallels are to be found; they have more in common with Pisanello's pilgrim and St. George from S. Anastasia, Verona. The same is true of the drawings after the Antique, not all of which, however, are by a single hand (see Fossi-Todorow, *op. cit.,* cat. 204, p.138; F. Lugt, *Le dessin italien dans les collections hollandaises,* Institut Néerlandais, Paris, 1962, p.21, n.9). Indeed, there is no basis for believing that Gentile was

interested in ancient art; nor do documents support the assumption of a collaboration between the two artists, explaining how Gentile's hypothetical drawings passed to Pisanello. When, from 1426–27, Gentile was in Rome, Pisanello was almost certainly in Verona (the most probable date for the Brenzoni monument at S. Fermo appears to be between 1424 and 1426; see W. Wolters, *La scultura veneziana gotica 1300/1460*, Alfieri, Venice, 1976, cat. 220, for a summary of the relevant material). Payments to Pisanello at the Lateran begin only on 18 April 1431 – four years after Gentile had died without a will ('intestato'; see Documents XIV–XVI). Despite Vasari's marked confusion, Fazio clearly states that Pisanello painted what Gentile left unfinished.

Questions of authorship aside, a drawing like Ambrosiana 214 F, f.13 can hardly pre-date 1438, since Donatello's pulpit at Prato, on which the verso is based, was only installed in that year. Other drawings in the complex copy figures from Filippo Lippi's *Barbadori Altar* (*c.* 1437–8). Because of such derivations, both Degenhart and Fossi-Todorow have assumed disparities of date, sometimes for individual motifs on a single page. Yet, the manner in which a partly hidden face, taken from Lippi, is combined with a figure derived from Michelino da Besozzo (Bacri Collection, Paris; Albertina No. 4834r.) strongly argues the procedures of pattern book making, in which various, individual studies have been re-copied to form pleasing compositions. Such is certainly the case with Ambrosiana 214 F, f.13r., where the two sarcophagi that served as models were located some distance from each other. The careful overlapping of figures proves that the drawing was not carried from site to site but unites two preexistent studies. The pattern book could well date from a relatively short span of time late in Pisanello's career. Indeed, the few drawings from the complex that seem actually to be by Pisanello are not necessarily as early as is generally thought; even the autograph sheet depicting nude women (Mu. Boymans no. I 520) bears but superficial resemblance to an early drawing like the *Luxury* at Vienna (Albertina no. 24018r.). The suggestion of a ground plane, the free movement in space and the open pen work, are comparable to the London painting of SS. Anthony and George or passages from the Mantua frescoes. Moreover, the interest in ancient art, foreign to Gentile's and Pisanello's paintings, stems from contact with a humanist environment such as Pisanello encountered at Ferrara and Mantua in the 1430s. Both the perspective study (Louvre no. 2520) and that of Giotto's *Navicella* (Ambrosiana 214 F, f.10r.) allude to an Albertian background and thus underline the improbability of a date prior to 1435, the date of *De Pictura* (see S. Edgerton, 'Alberti's Perspective, a New Discovery and a New Evaluation', *Art Bulletin*, XLVIII, 1966, pp. 375–77).

THE PLATES

1 *Madonna and Child* (Cat. I)
Galleria Nazionale dell'Umbria, Perugia

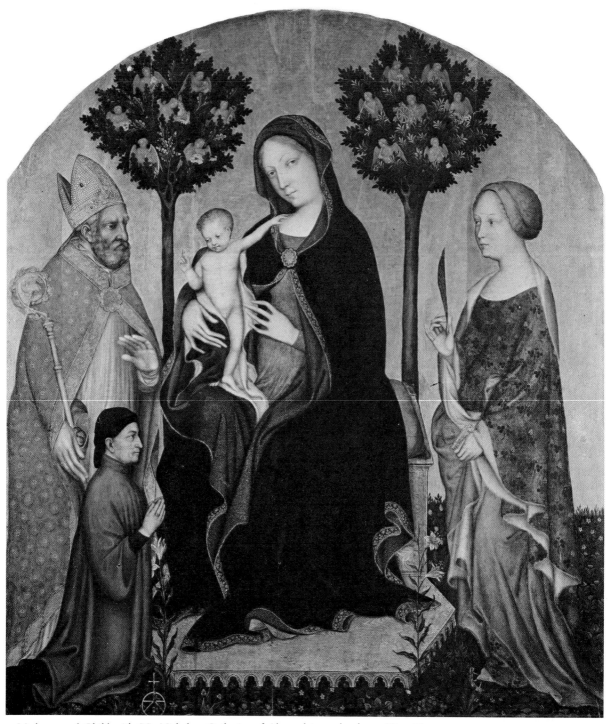

2 *Madonna and Child with SS. Nicholas, Catherine of Alexandria, and a donor* (Cat. II) Gemäldegalerie, Berlin–Dahlem

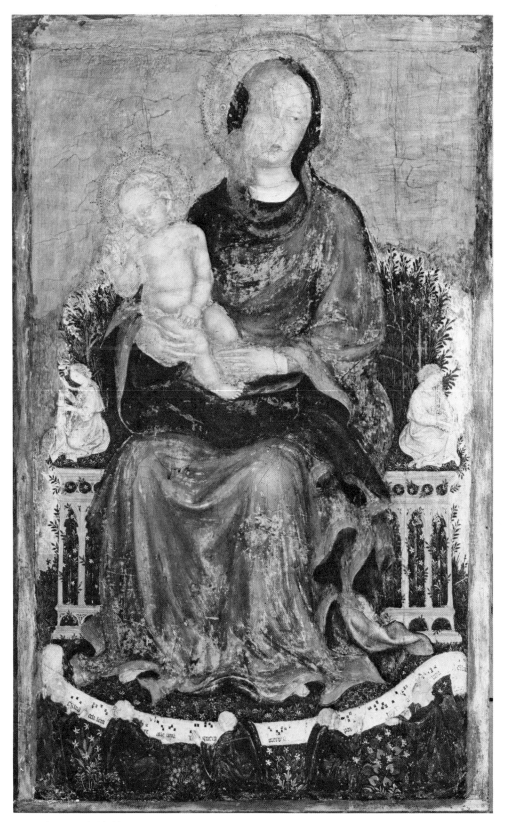

3. *Madonna and Child* (Cat. III)
The Metropolitan Museum of Art, New York

4 *Angel playing portative organ* (detail of Pl. 3)

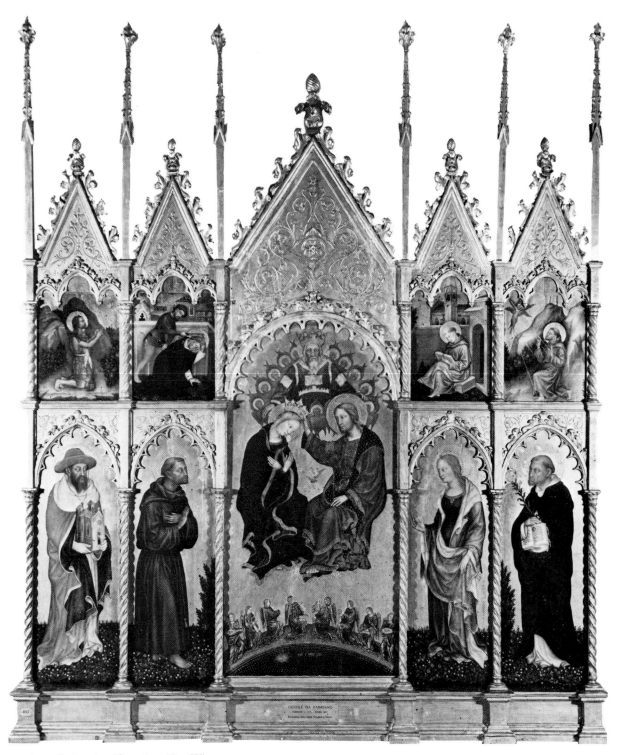

5 *The Valle Romita Altar-piece* (Cat.IV)
Pinacoteca di Brera, Milan
(see colour plate A)

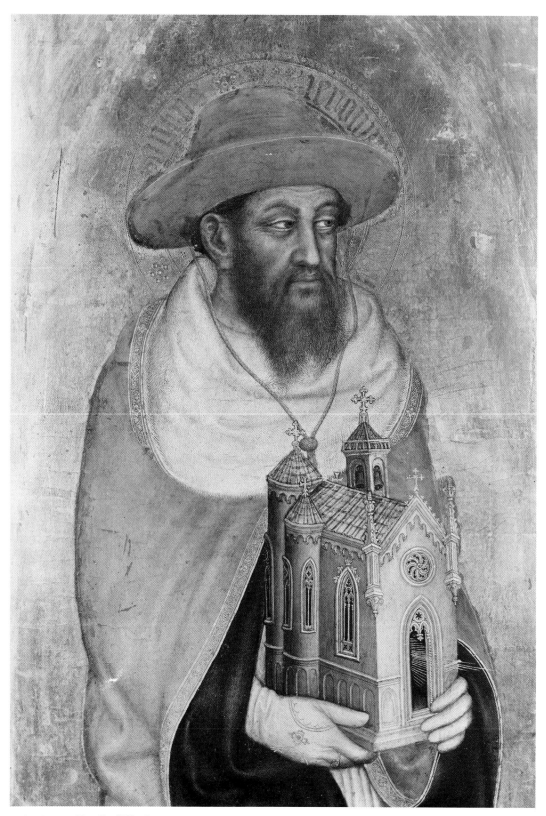

6 *St. Jerome* (detail of Pl. 5)

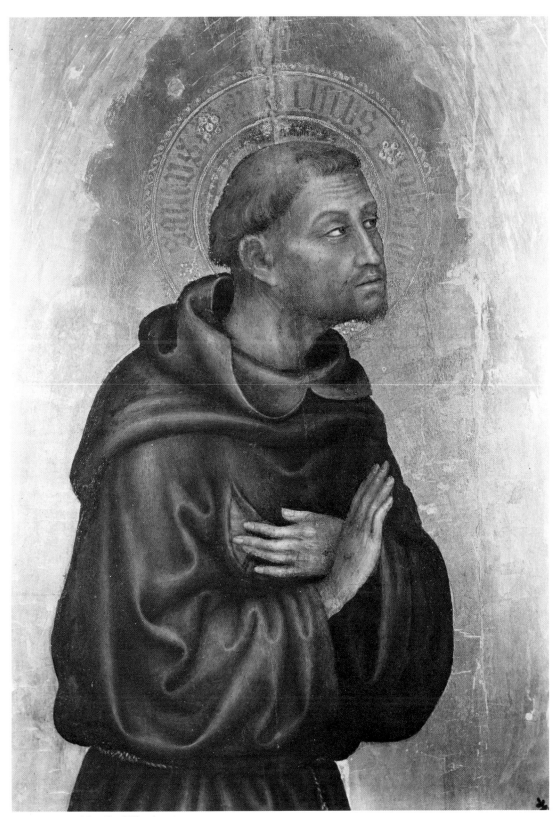

7 *St. Francis* (detail of Pl. 5)

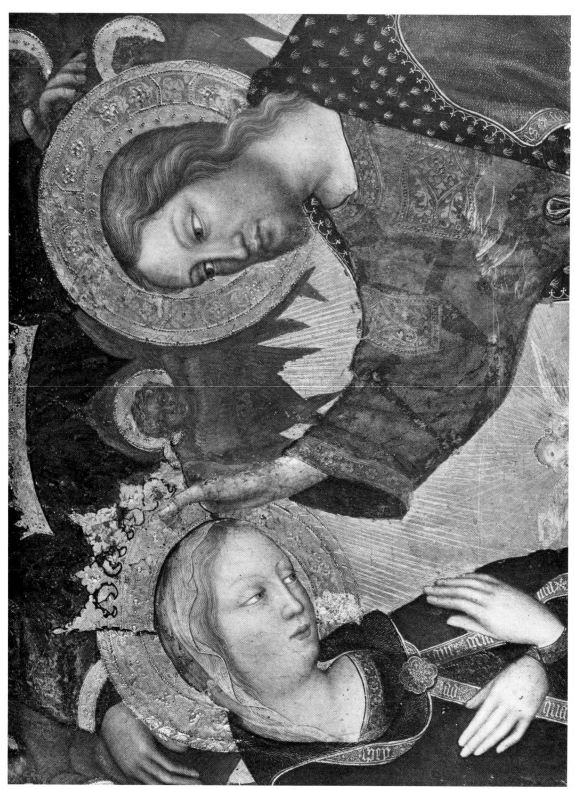

8 *Coronation of the Virgin* (detail of Pl. 5)

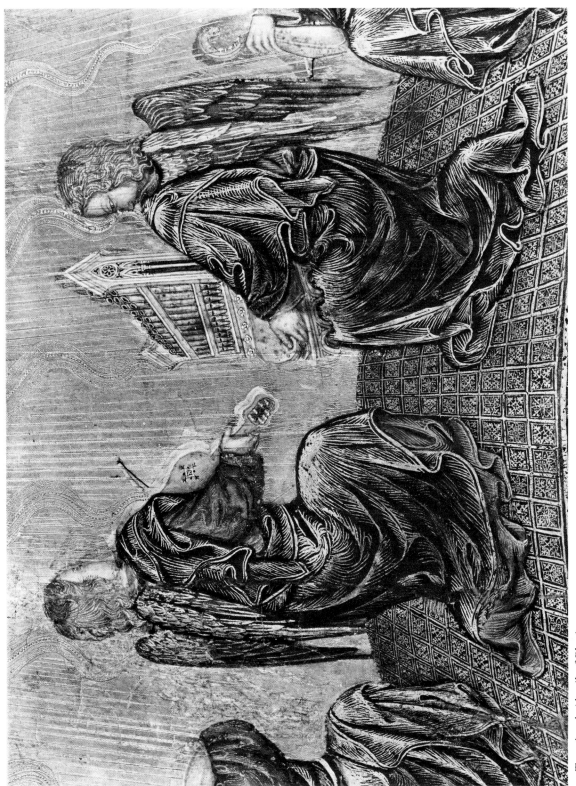

9 *Two Angels* (detail of Pl. 5)

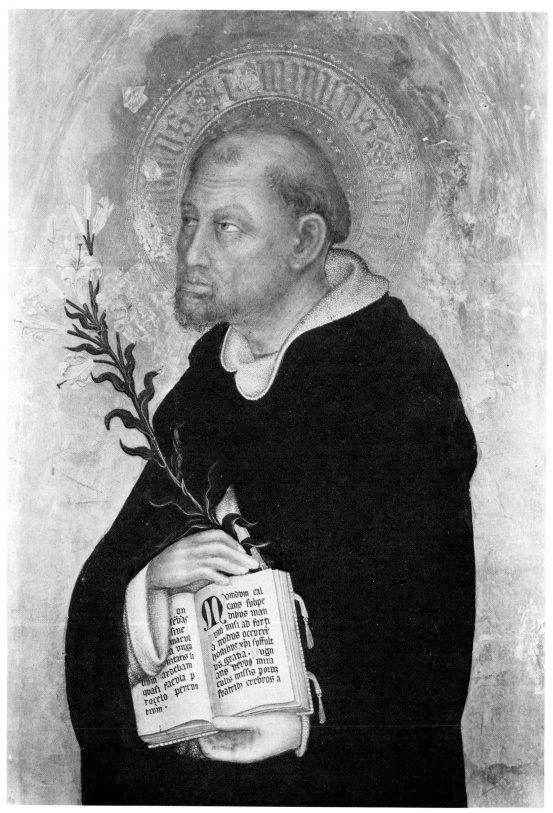

10 *St. Dominic* (detail of Pl. 5)

11 *St. Mary Magdalene* (detail of Pl. 5)

12 *St. John the Baptist in the wilderness* (detail of Pl. 5)

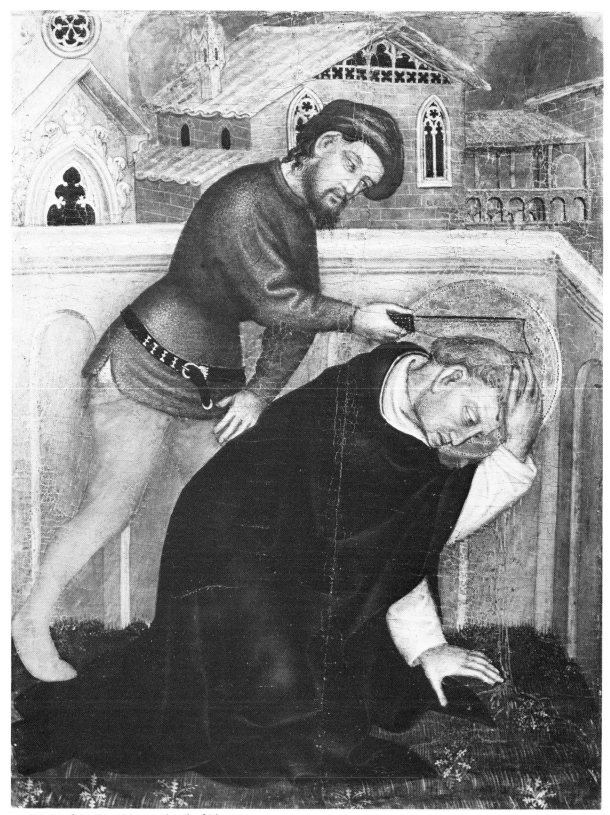

13 *Murder of St. Peter Martyr* (detail of Pl. 5)

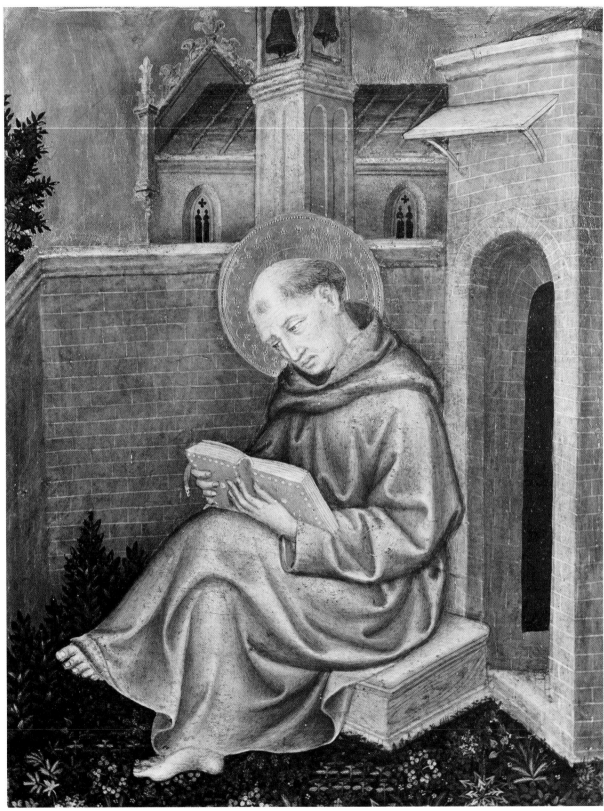

14 *A Franciscan reading* (detail of Pl. 5)

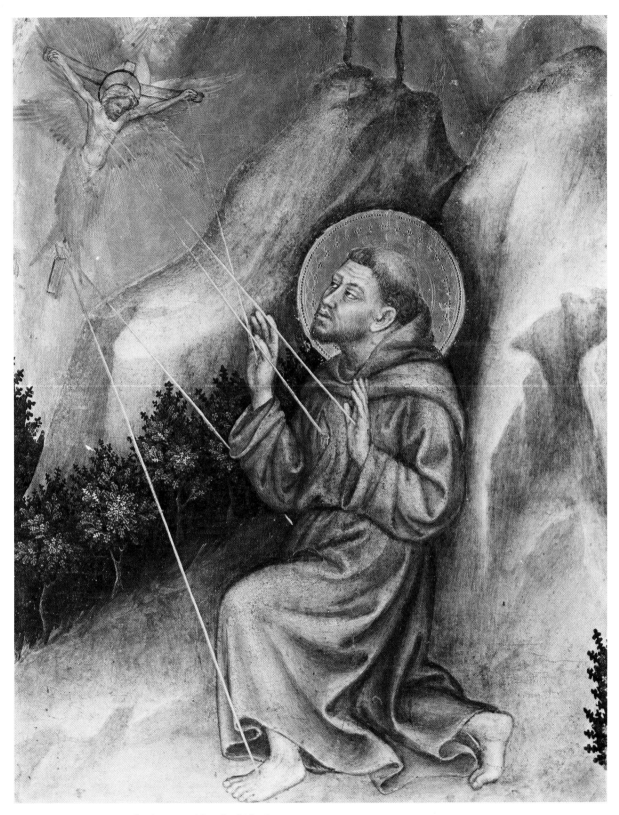

15 *St. Francis receiving the Stigmata* (detail of Pl. 5)

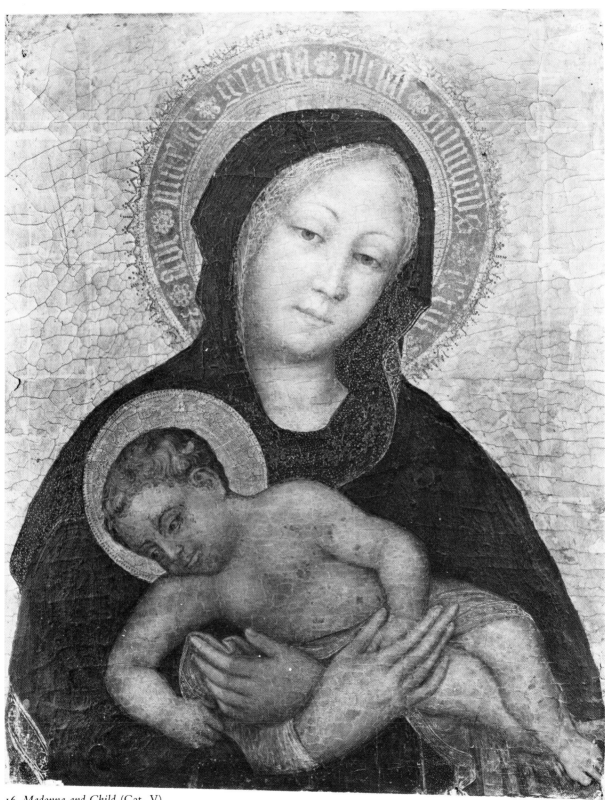

16 *Madonna and Child* (Cat. V)
Pinacoteca Nazionale, Ferrara

17 *SS. Peter and Paul* (Cat. VI)
Harvard University, Villa I Tatti, Florence

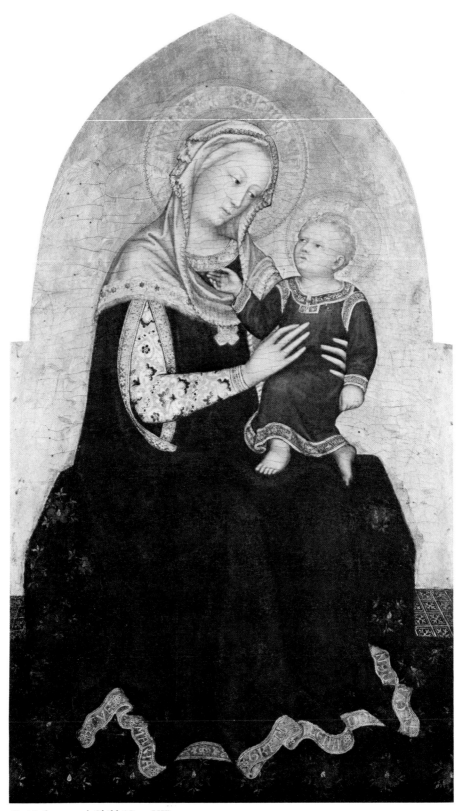

18 *Madonna and Child* (Cat. VII)
National Gallery of Art, Washington DC

19 Detail of Pl. 18

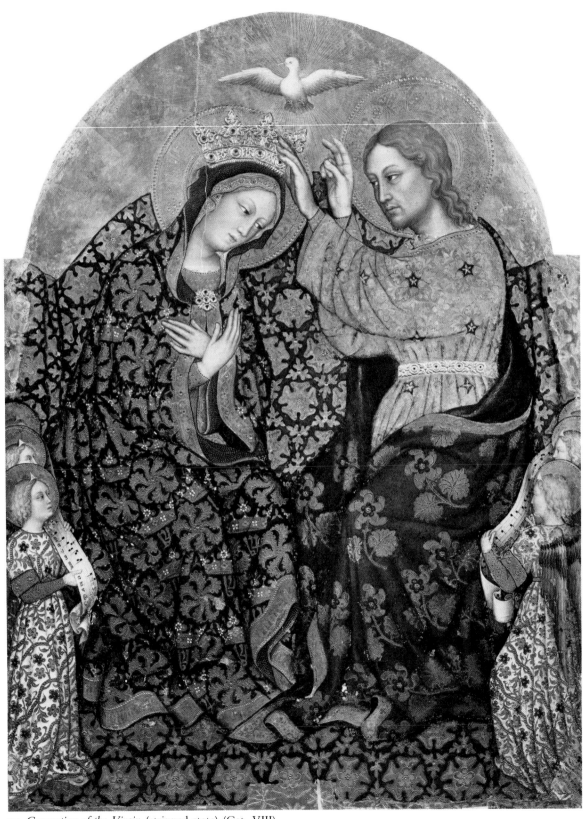

20 *Coronation of the Virgin* (stripped state) (Cat. VIII)
J. P. Getty Museum, Malibu Beach, California

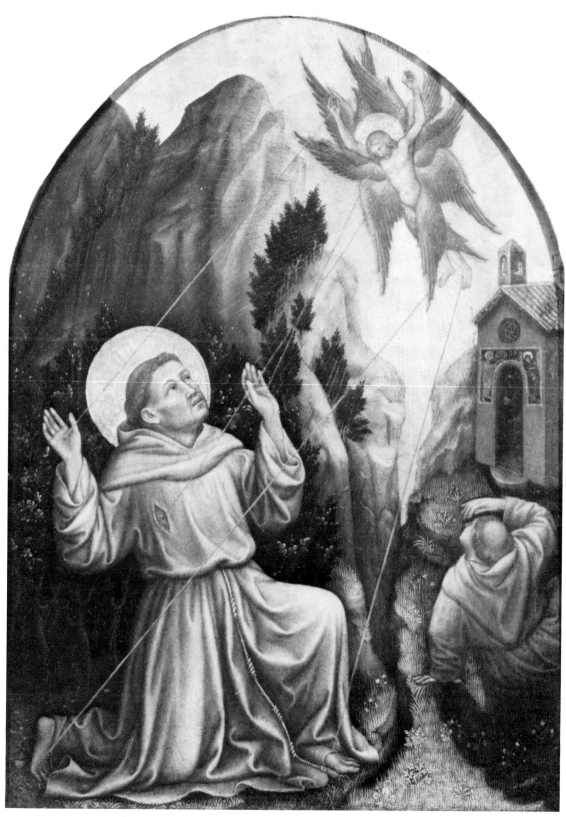

21 *St. Francis receiving the Stigmata* (Cat. VIII)
Private collection, Italy
(see colour plate B)

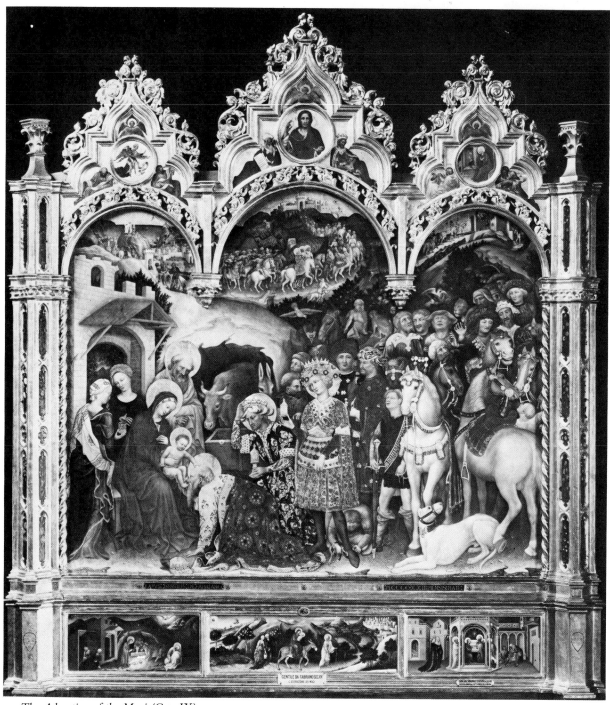

22 *The Adoration of the Magi* (Cat. IX)
Uffizi, Florence

23 *Morning-glories, crocuses and cornflowers* (detail of Pl. 22)

24 *Signature* (detail of Pl. 22)

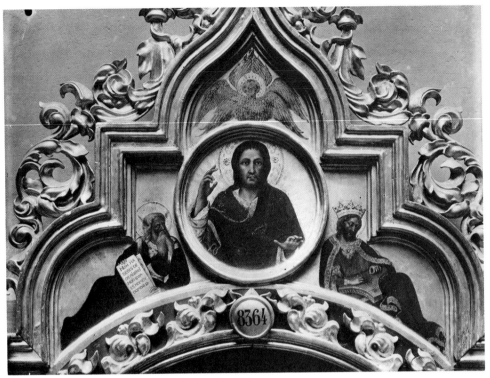

25 *Moses, Christ Blessing, and David* (detail of Pl. 22)

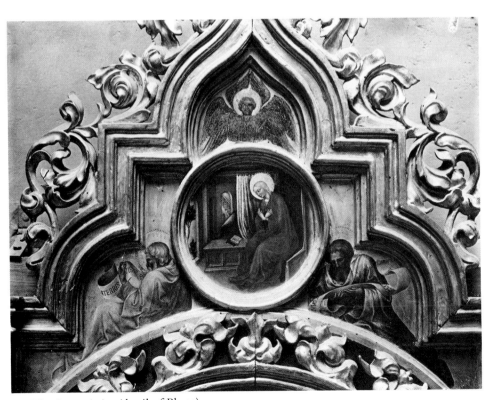

26 *The Annunciation* (detail of Pl. 22)

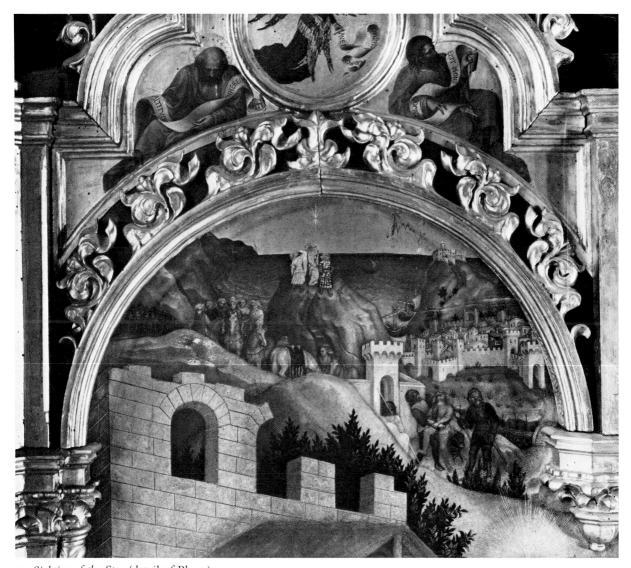

27 *Sighting of the Star* (detail of Pl. 22)

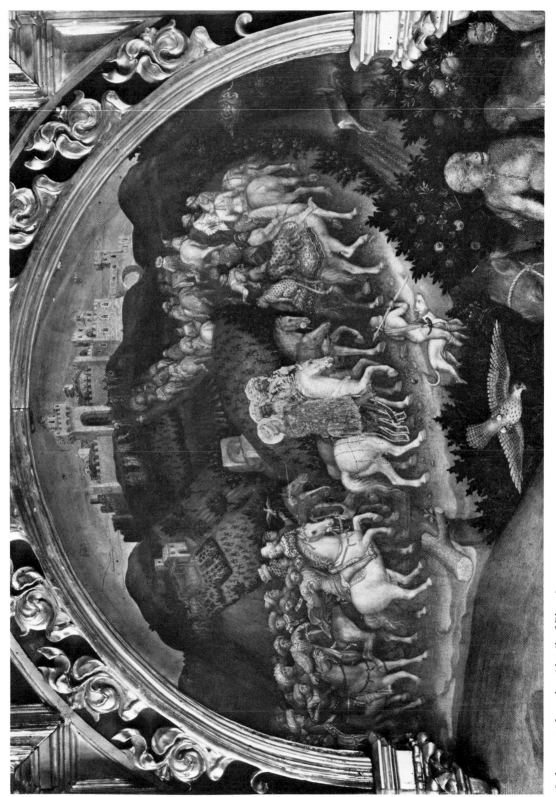

28 *Journey to Jerusalem* (detail of Pl. 22)
(see colour plate C)

29 *Entry into Bethlehem* (detail of Pl. 22)

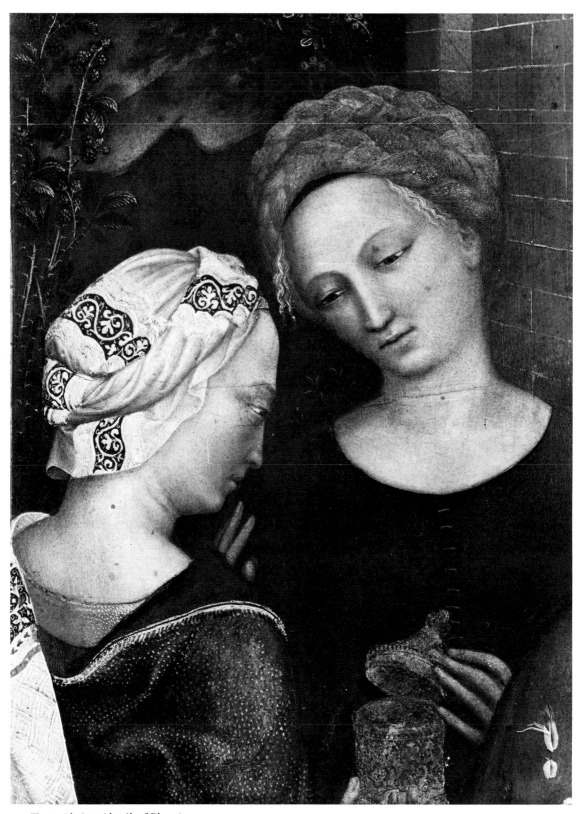

30 *Two midwives* (detail of Pl. 22)

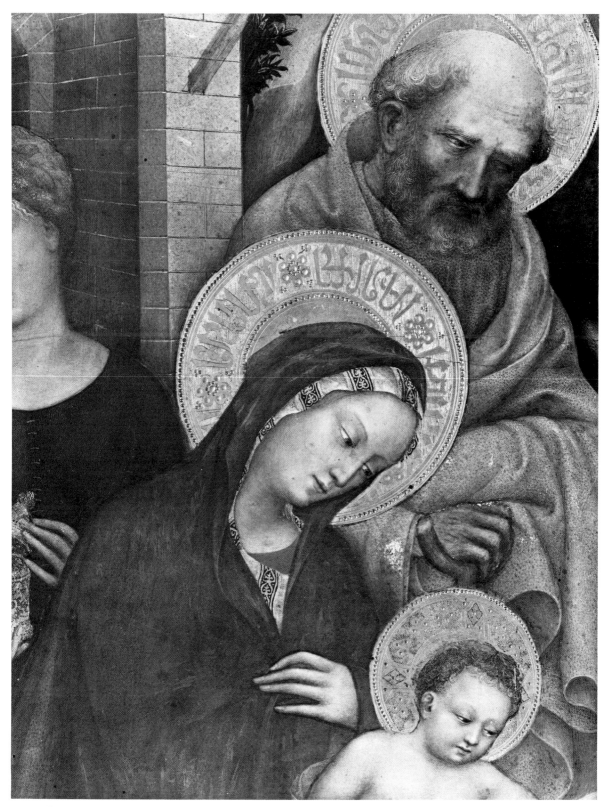

31 *Madonna and Child* (detail of Pl. 22)

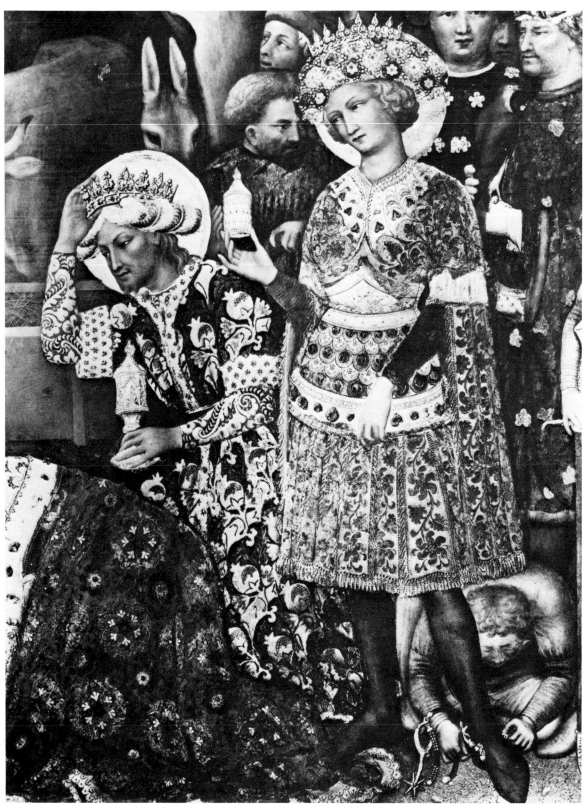

32 *Two Magi* (detail of Pl. 22)

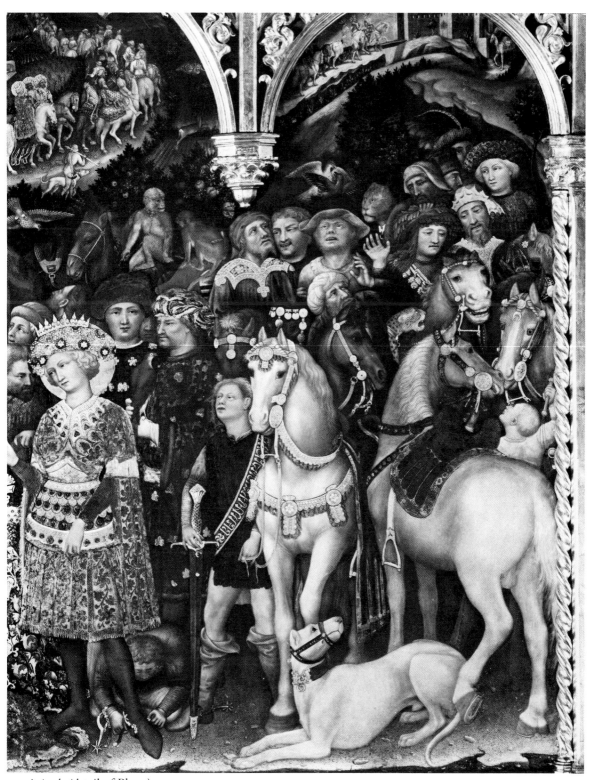

33 *Animals* (detail of Pl. 22)

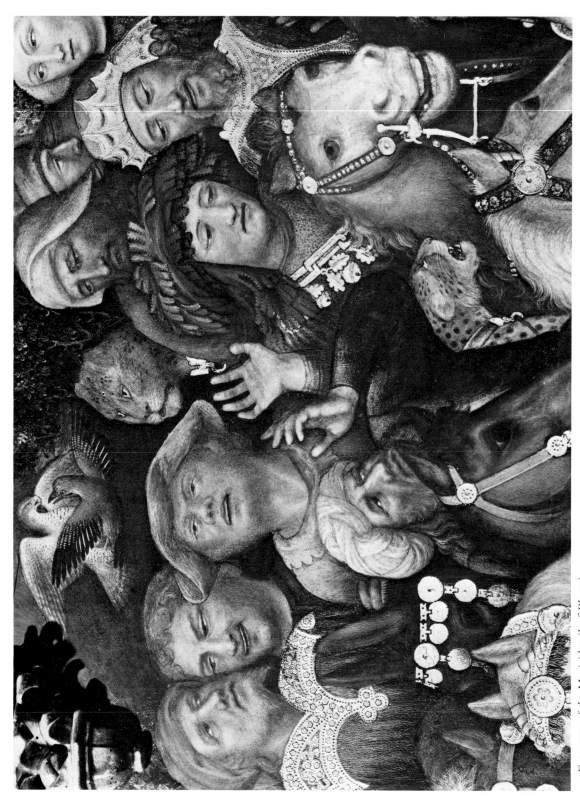

34 *Entourage of the Magi* (detail of Pl. 22)

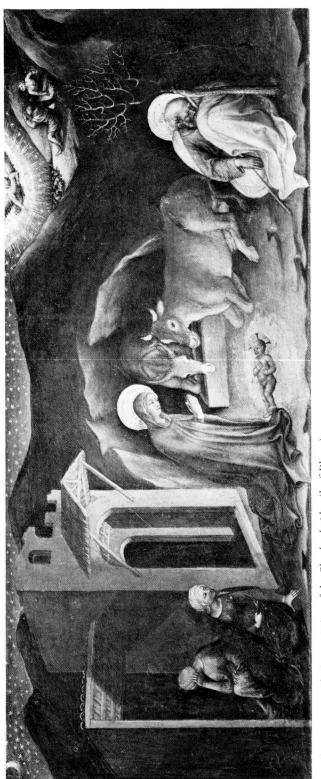

35 *The Nativity with Annunciation of the Shepherds* (detail of Pl. 22)

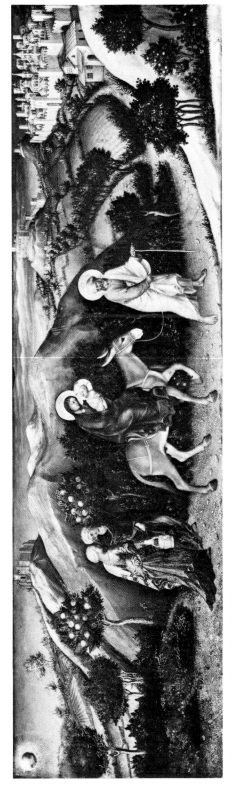

36 *The Flight into Egypt* (detail of Pl. 22)

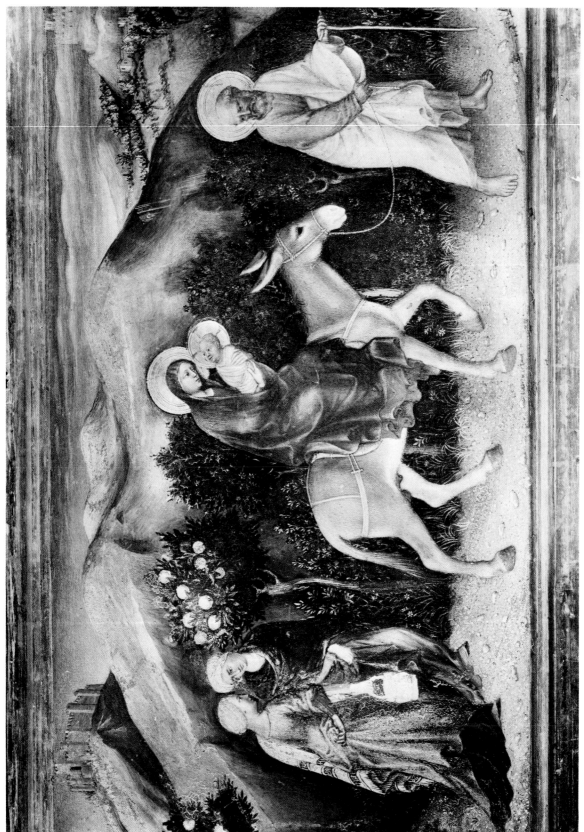

37 Detail of Pl. 36

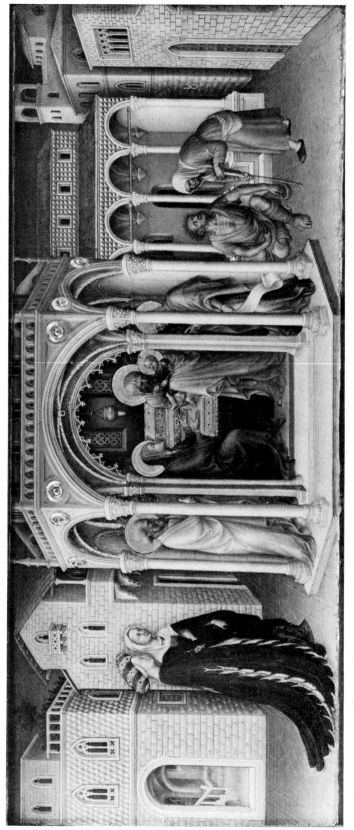

38 *The Presentation in the Temple* (detail of Pl. 22)

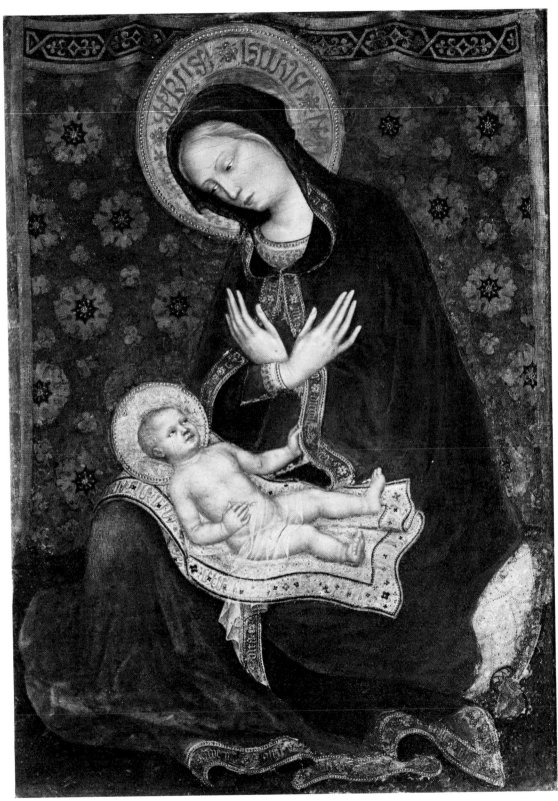

39 *Madonna and Child* (Cat. X)
Museo Nazionale, Pisa

40 *The Christ Child* (detail of Pl. 39)

41 Reverse of Pl. 39

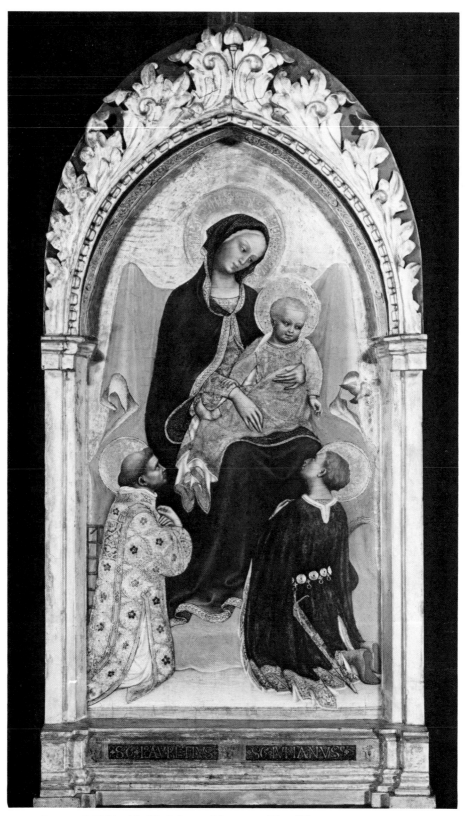

42 *Madonna and Child with SS. Julian and Lawrence* (Cat. XI)
Frick Collection, New York

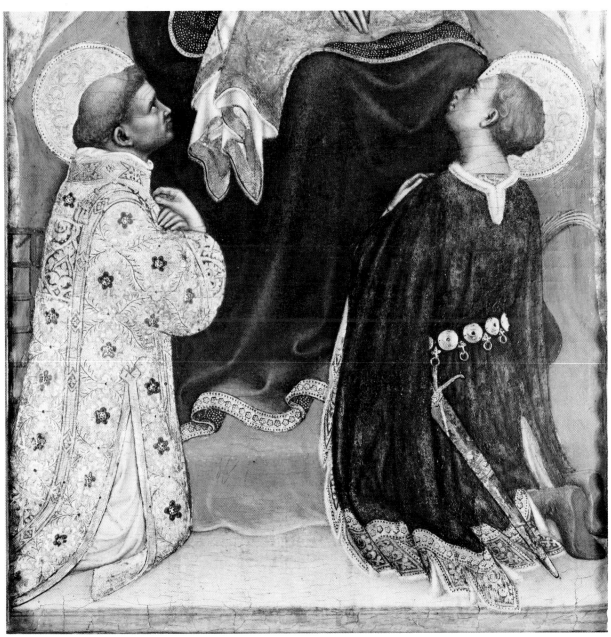

43 *SS. Julian and Lawrence* (detail of Pl. 42)

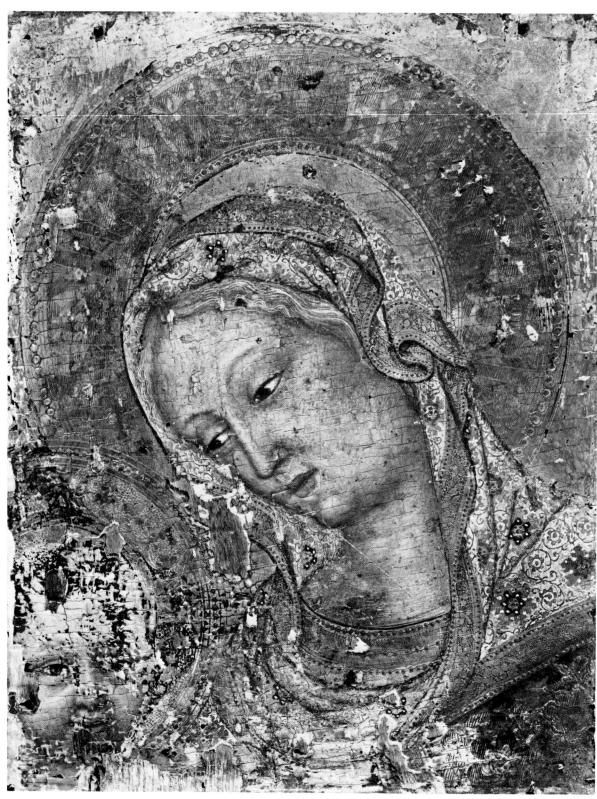

44 *Madonna and Child* (Cat. XII)
Harvard University, Villa I Tatti, Florence

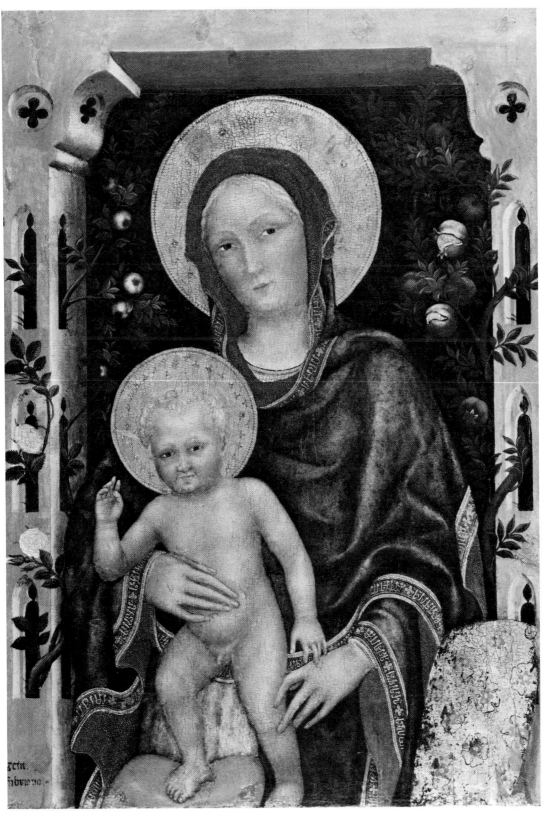

45 *Madonna and Child* (Cat. XIII)
Yale University Art Gallery, New Haven

46 *The Quaratesi Altar-piece* (Cat. XIV)
(Scale reconstruction)

47 *Roundel with Christ Blessing* (detail of Pl. 48) (Cat. XIV)

48 *Madonna and Child with Angels and
(in roundel) Christ Blessing* (Cat. XIV)
H.M. The Queen, Hampton Court
(see colour plate D)

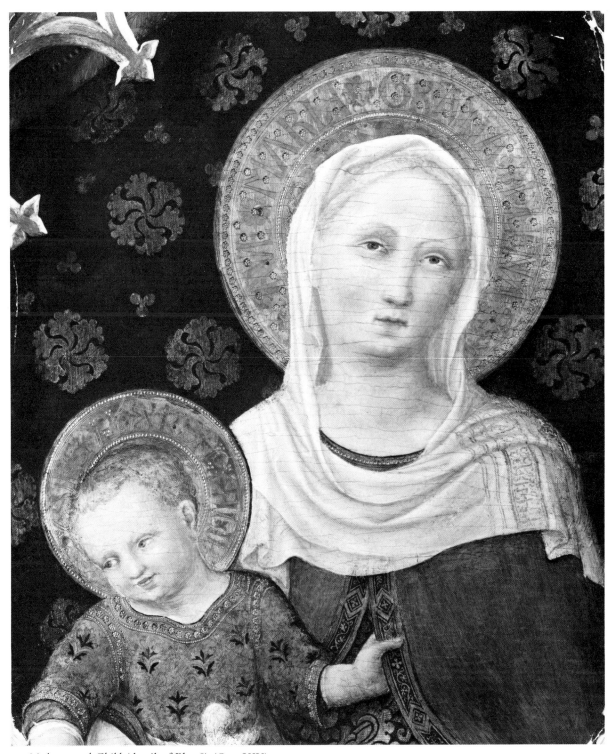

49 *Madonna and Child* (detail of Pl. 48) (Cat. XIV)

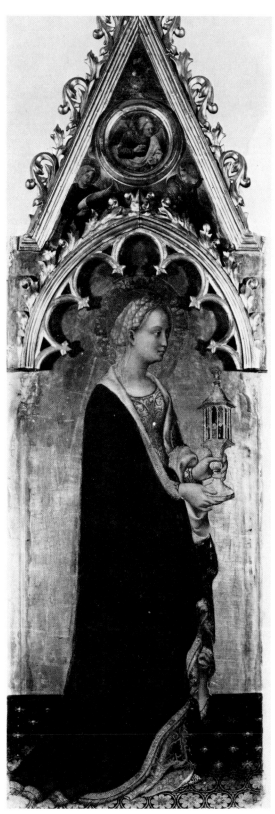

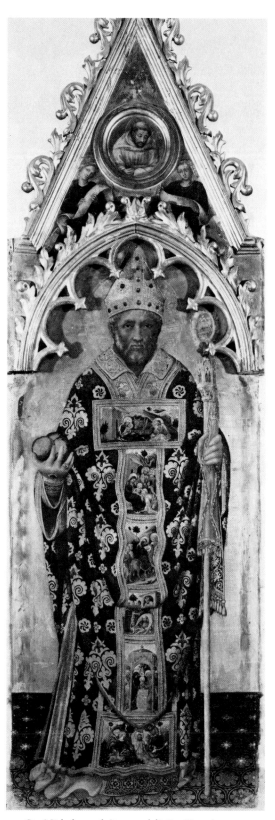

50 *St. Mary Magadalene and (in roundel)*
Annunciatory angel (Cat. XIV)
Uffizi, Florence

51 *St. Nicholas and (in roundel) St. Francis*
(Cat. XIV)
Uffizi, Florence

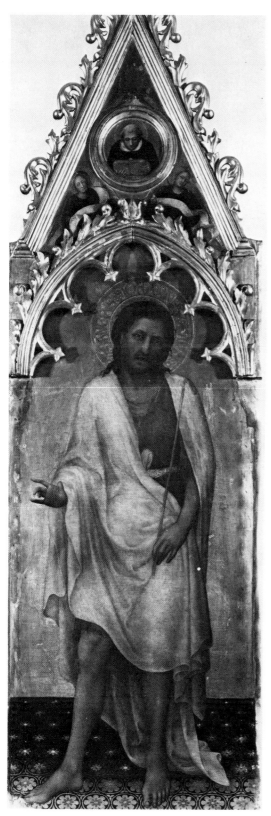

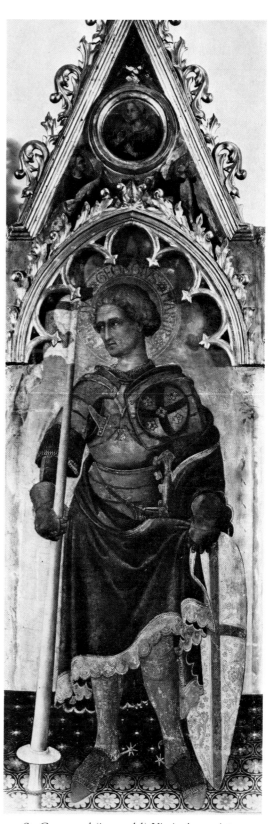

52 *St. John the Baptist and (in roundel)*
St. Dominic (Cat. XIV)
Uffizi, Florence

53 *St. George and (in roundel) Virgin Annunciate*
(Cat. XIV)
Uffizi, Florence

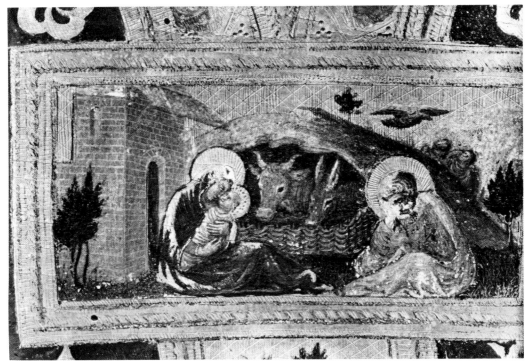

54 *Nativity* (detail of Pl. 51) (Cat. XIV)

55 *St. Nicholas saves a ship in distress* (Cat. XIV)
Pinacoteca, Vatican

56 *Birth of St. Nicholas* (Cat. XIV)
Pinacoteca, Vatican

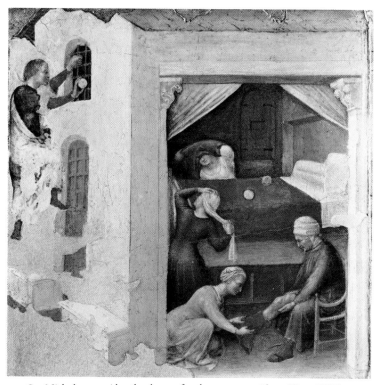

57 *St. Nicholas provides the dowry for three poor maidens* (Cat. XIV)
Pinacoteca, Vatican

59 *Pilgrims at the tomb of St. Nicholas* (Cat. XIV)
National Gallery, Washington DC

58 *St. Nicholas resuscitates three youths at an inn* (Cat. XIV)
Pinacoteca, Vatican

60 *St. Louis of Toulouse, the Resurrection of Lazarus, the Virgin and Christ interceding, Meeting of SS. Cosmas and Damian with Julian, and St. Bernard of Clairvaux* (Cat. XV)
S. Niccolò Sopr' Arno, on deposit at Pitti Palace, Florence

61 *St. Louis of Toulouse and the Resurrection of Lazarus* (detail of Pl. 60)

62 *Meeting of SS. Cosmas and Damian with Julian and St. Bernard of Clairvaux* (detail of Pl. 60)

63 *Stoning of St. Stephen* (Cat. XVI)
Kunsthistorisches Museum, Vienna

64 *Madonna and Child* (Cat. XVII)
Cathedral, Orvieto

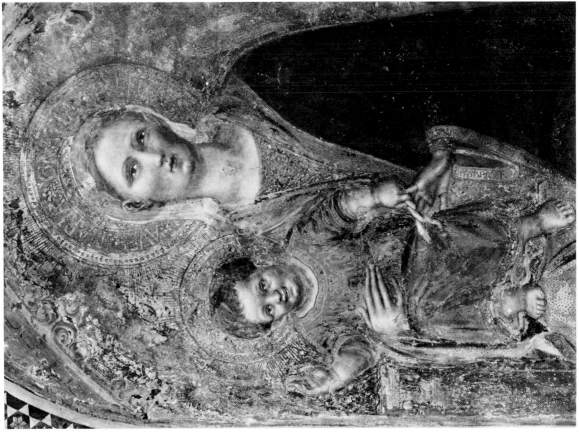

66 *Madonna and Child* (detail of Pl. 64)

65 *Madonna and Child* (before removal of sixteenth-century frame)

67 *Dais* (detail of Pl. 64)

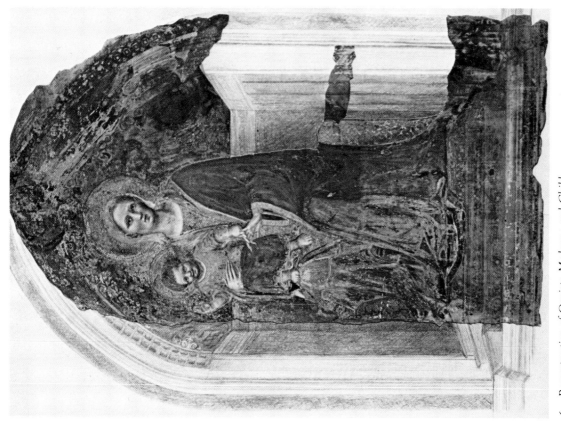

69 *Reconstruction of Orvieto Madonna and Child* (See Appendix)

68 *Coffering* (detail of Pl. 64)

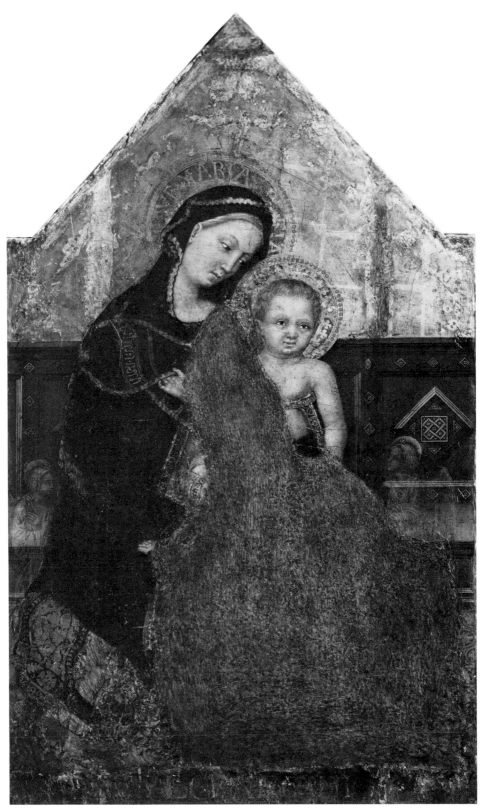

70 *Madonna and Child* (Cat. XVIII)
Museo Capitolare, Velletri

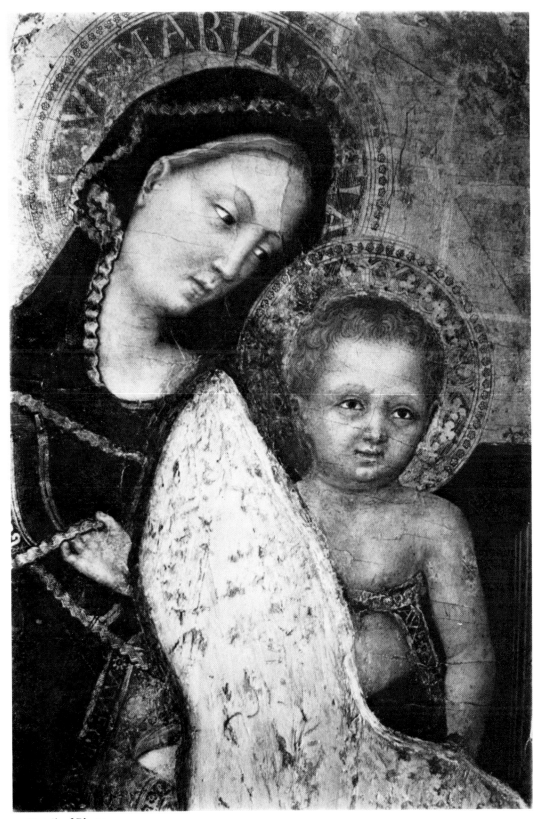

71 Detail of Pl. 70

72 *Head of David* (Cat. XIX)
Museo Cristiano, Vatican

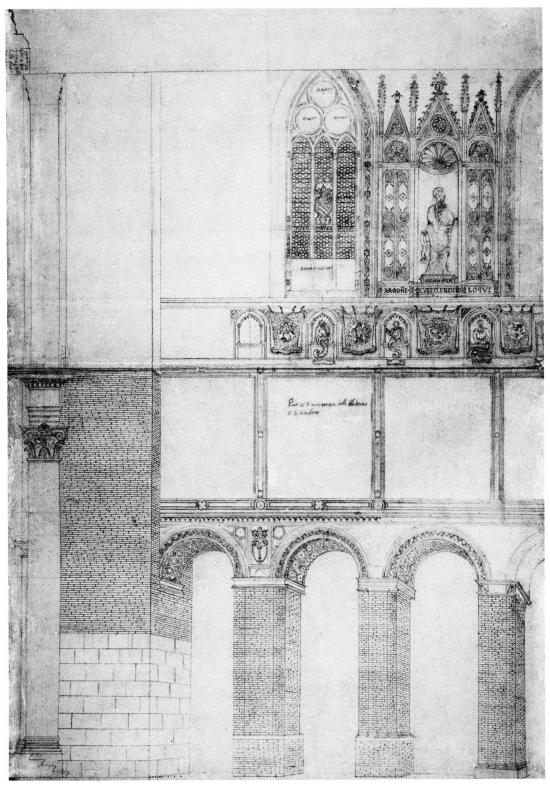

73 Follower of Borromini *Drawing of fresco cycle at S. Giovanni Laterano prior to 1647*
Kunstbibliothek, Berlin

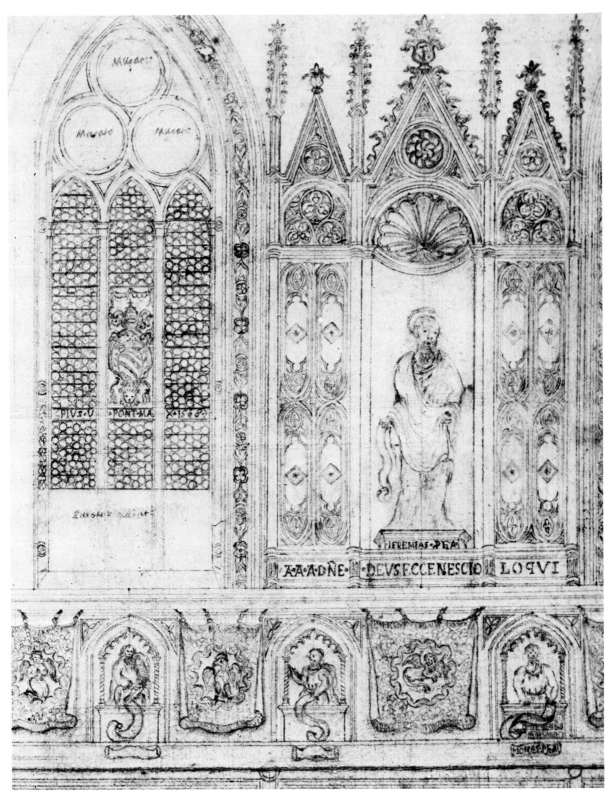

74 Follower of Borromini *Jeremiah, Jonah, unidentified prophet, and symbols of the Evangelists* (detail of Pl. 73)

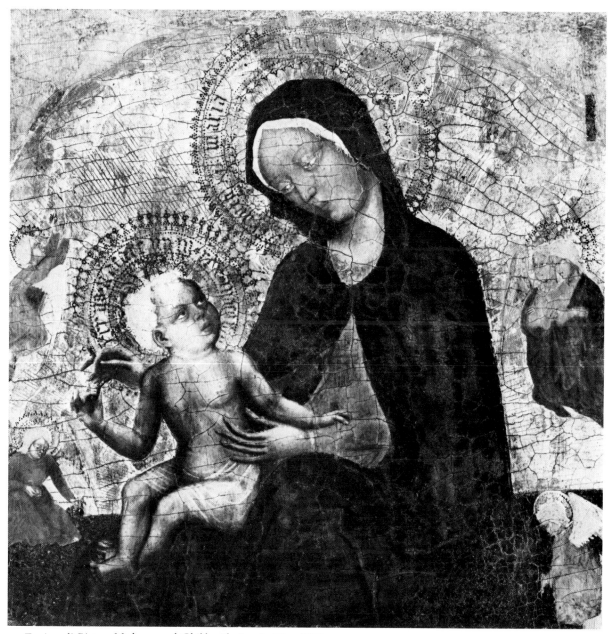

75 Zanino di Pietro *Madonna and Child with Angels* (Cat. XX)
National Gallery, Athens

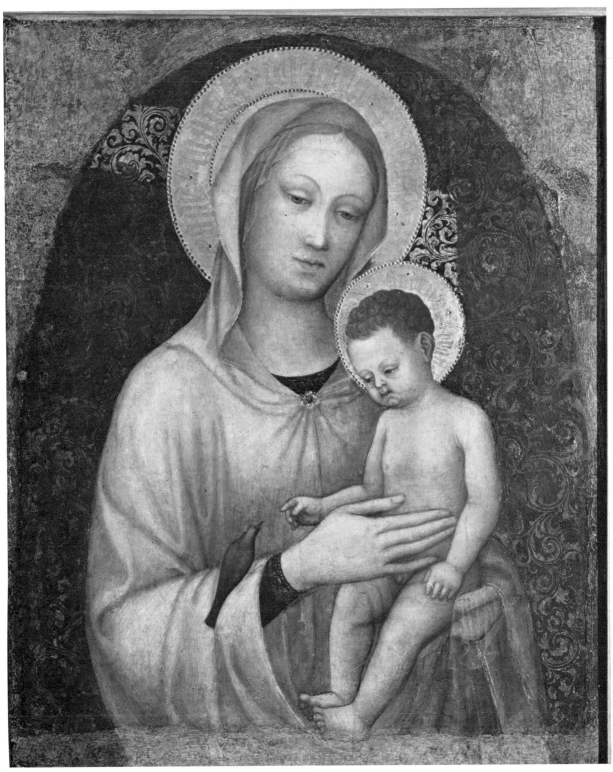

76 Jacopo Bellini *Madonna and Child* (Cat. XXI)
Accademia Carrara, Bergamo

77 Pelegrino di Antonio *St. Michael* (Cat. XXII)
Museum of Fine Arts, Boston

78 Follower of Gentile *Madonna of Humility with a donor* (Cat. XXIII)
Isabella Stewart Gardner Museum, Boston

79 The Staffolo Master *St. Mary Magdalene* (Cat. XXIV)
Cathedral, Fabriano

80 The Staffolo Master *St. Venanzio* (?) (Cat. XXIV)
Cathedral, Fabriano

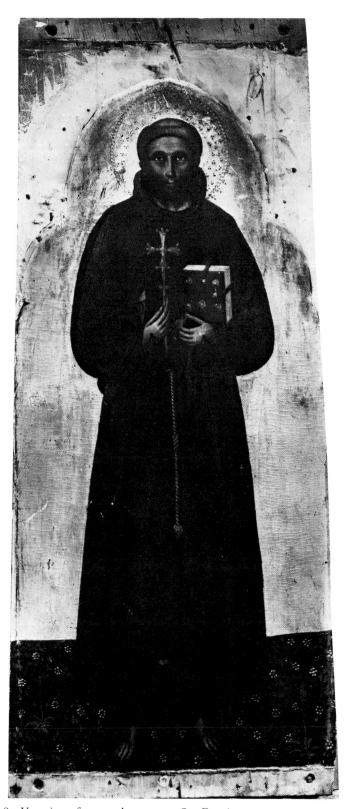

81 Venetian, fourteenth century *St. Francis*
(Cat. XXV)
Harvard University, Villa I Tatti, Florence

82 Ventura di Moro (?) *Decoration of lilies*
(Cat. XXVII)
S. Trinita, Florence

83 Francesco di Antonio *St. Ansanus* (Cat. XXVI)
S. Niccolò sopr' Arno, Florence

85 Giambono or Niccolò di Pietro (?)
St. Benedict tortured by a blackbird and about to cast himself on thorns (Cat. XXVIII)
Museo Poldi-Pezzoli, Milan

84 Giambono or Niccolò di Pietro (?)
St. Benedict repairs a broken sieve (Cat. XXVIII)
Uffizi, Florence

87 Giambono or Niccolò di Pietro (?)
St. Benedict exorcises a monk (Cat. XXVIII)
Uffizi, Florence

86 Giambono or Niccolò di Pietro (?) *The monks attempt to poison St. Benedict* (Cat. XXVIII)
Uffizi, Florence

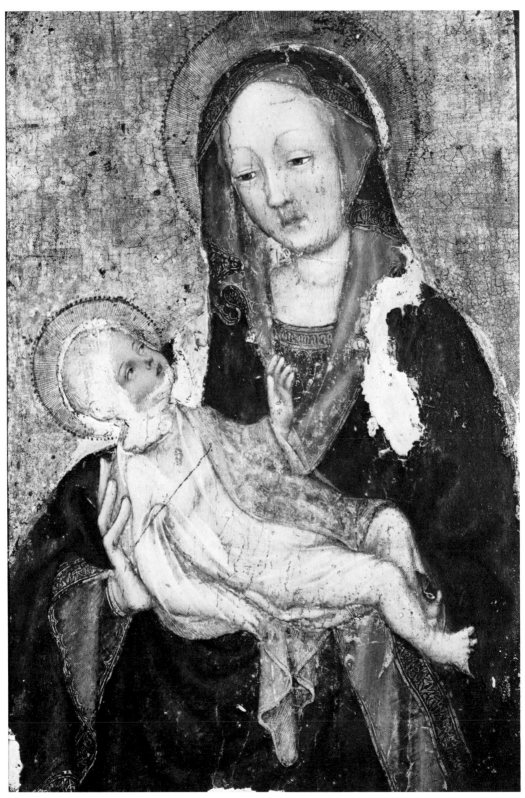

88 Bohemian, *c.* 1380–90 *Madonna and Child* (Cat. XXIX)
Museum of Fine Arts, Houston

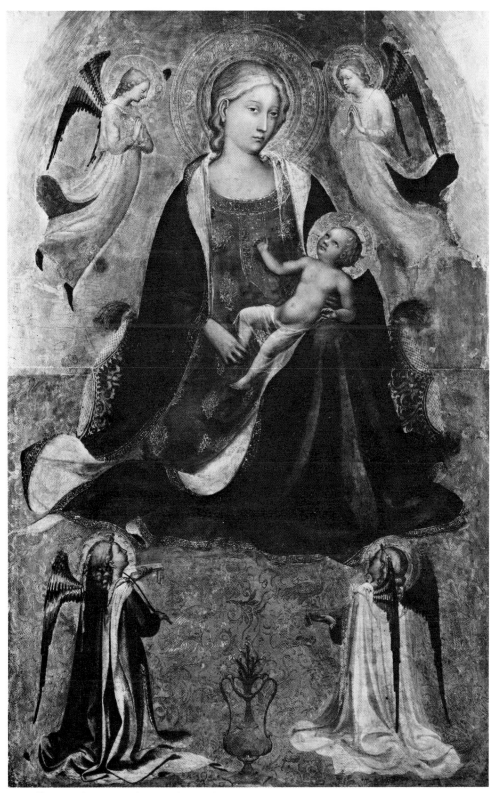

89 Follower of Fra Angelico *Madonna of Humility with four angels* (Cat. XXX)
Hermitage, Leningrad

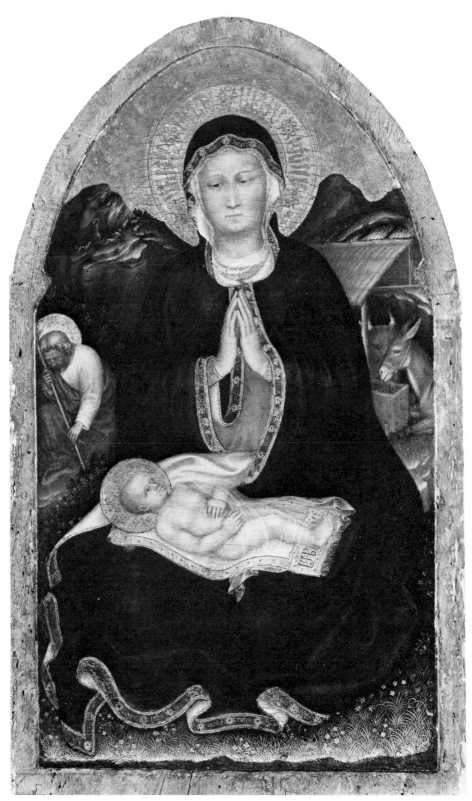

90 Follower of Gentile *Nativity* (Cat. XXXI)
J. P. Getty Museum, Malibu Beach, California

91 Venetian, early fifteenth century *Madonna and Child* (Cat. XXXII)
Private collection, Milan

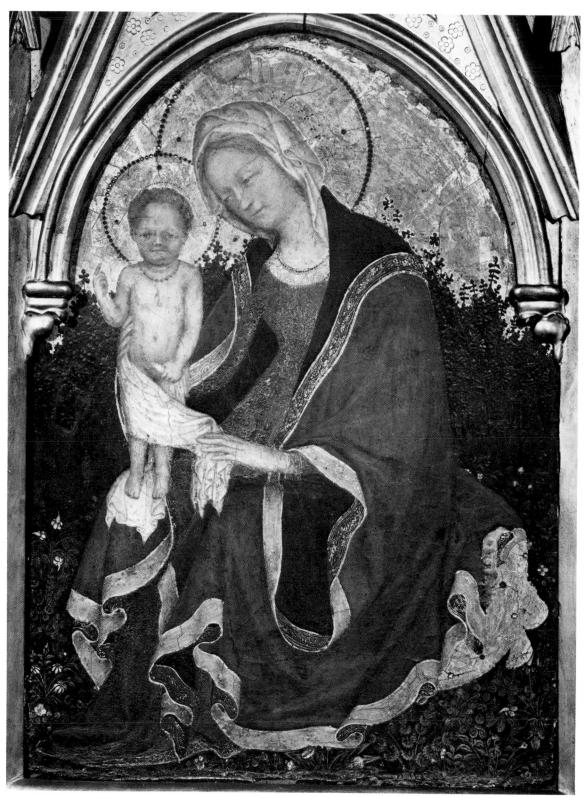

92 Venetian, *c.* 1430–40 *Madonna of Humility* (Cat. XXXIII)
Museo Poldi-Pezzoli, Milan

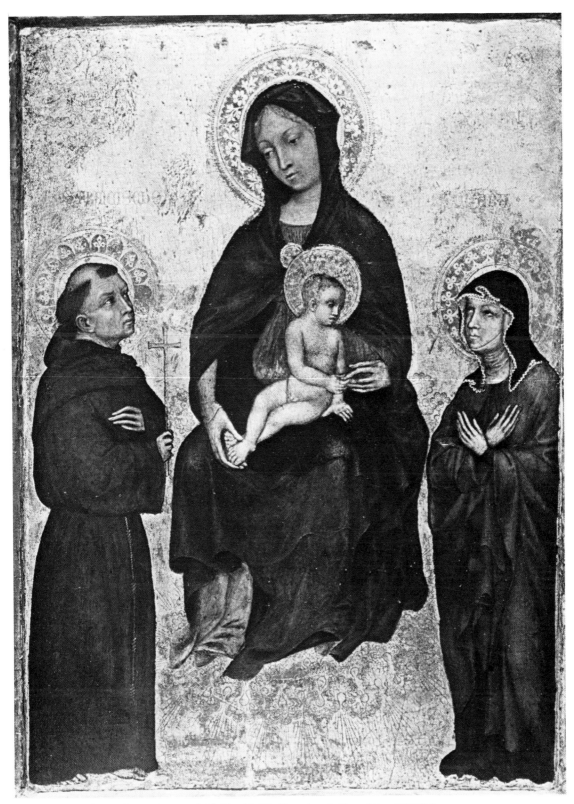

93 Follower of Gentile *Madonna and Child with SS. Francis and Clara* (Cat. XXXV)
Pinacoteca Civica, Pavia

94 Follower of Gentile *Naked youth (St. John the Baptist?) covered by an angel (Cat. XXXVI)*
Cathedral, Pordenone

95 Follower of Gentile *The Angel of St. Matthew* (Cat. XXXVI)
Cathedral, Pordenone

96 Follower of Gentile *St. Mary Magdalene* (Cat. XXXVI)
Cathedral, Pordenone

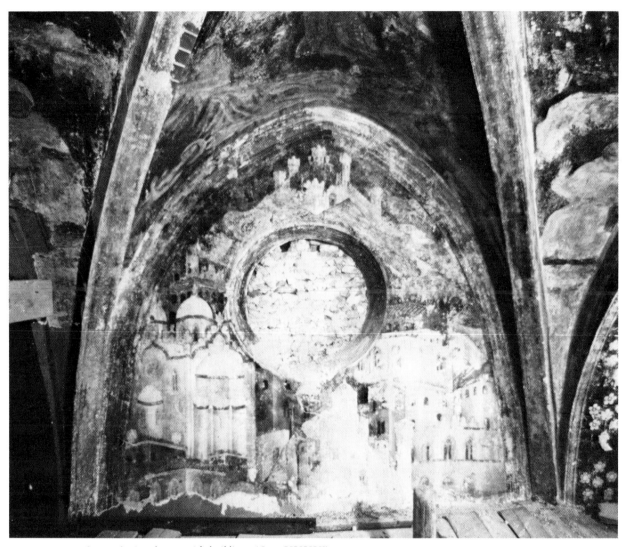

97 Follower of Gentile *Landscape with buildings* (Cat. XXXVI)
Cathedral, Pordenone

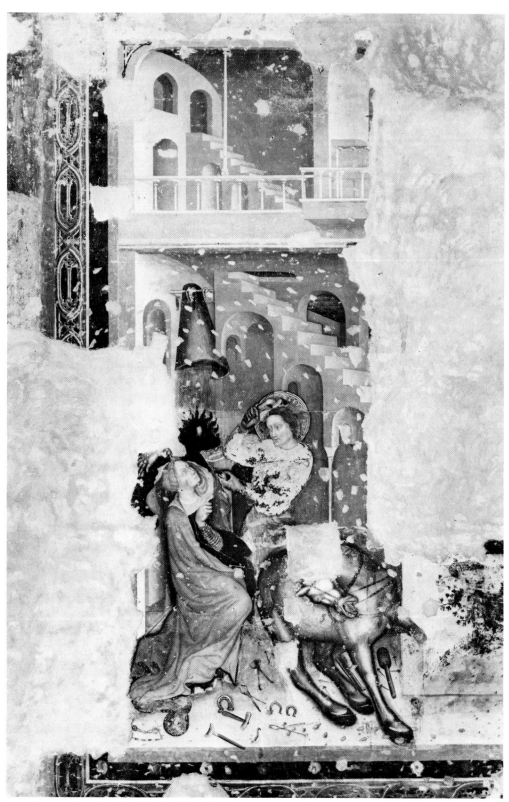

98 Influenced by Gentile *Miracle of St. Eligius* (Cat. XXXIX)
S. Caterina, Treviso

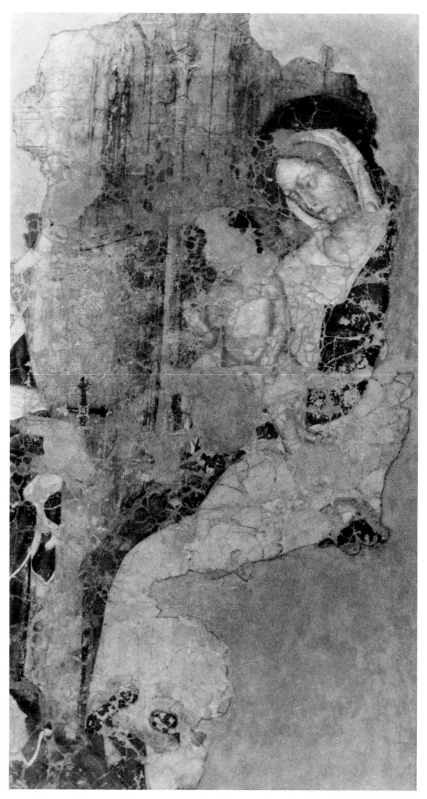

99 Influenced by Gentile *Madonna and Child with St. Margaret* (Cat. XL)
Museo Civico, Treviso

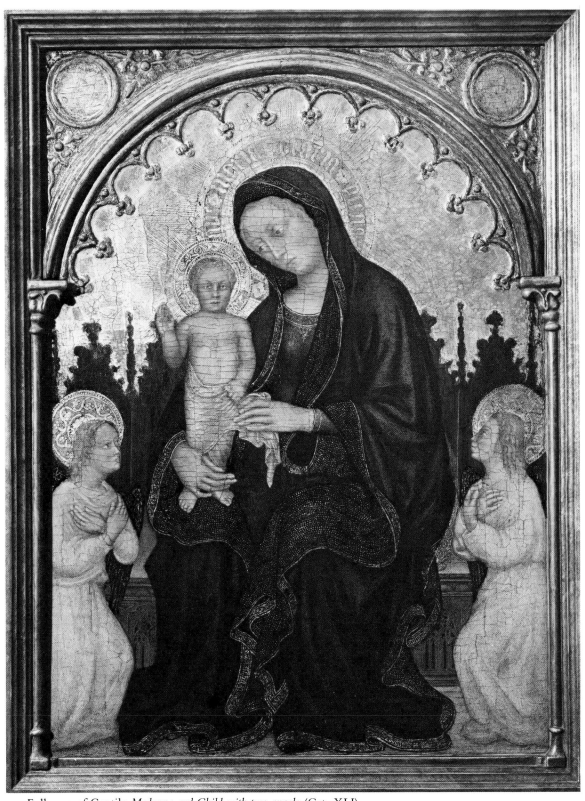

100 Follower of Gentile *Madonna and Child with two angels* (Cat. XLI)
Philbrook Art Center, Tulsa

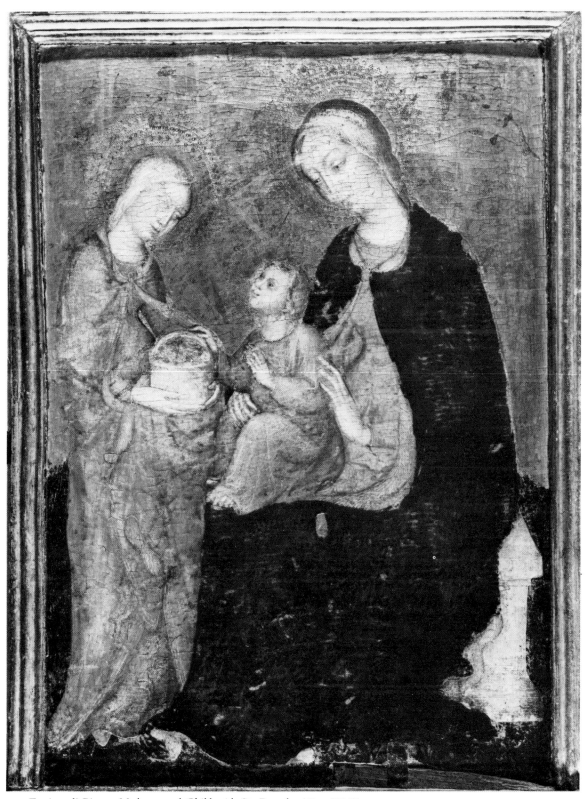

101 Zanino di Pietro *Madonna and Child with St. Dorothy* (Cat. XLII)
Galleria Nazionale delle Marche, Urbino

102 Follower of Gentile *Annunciation* (Cat. XLIII)
Pinacoteca, Vatican

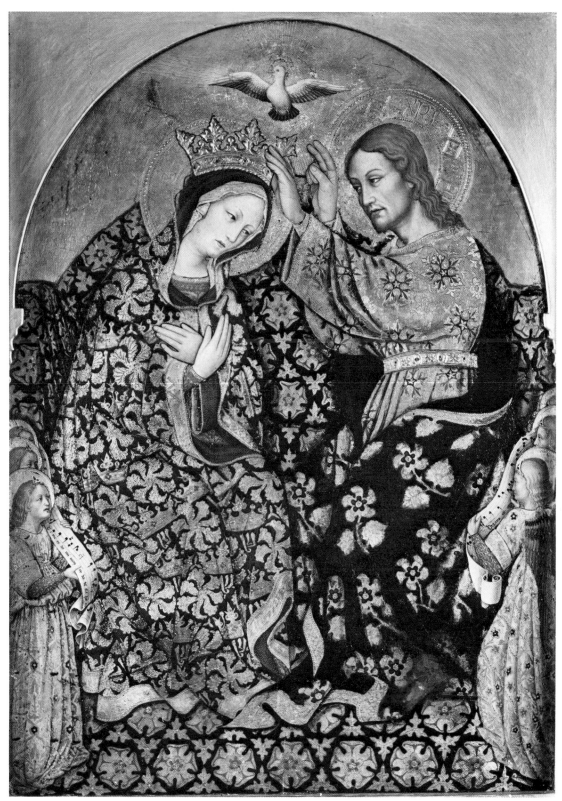

103 Antonio da Fabriano *Coronation of the Virgin* (Cat. XLIV)
Gemäldegalerie der Akademie, Vienna

104 Jacobello del Fiore *Death of St. Peter Martyr* (Cat. XLV)
Dumbarton Oaks, Washington

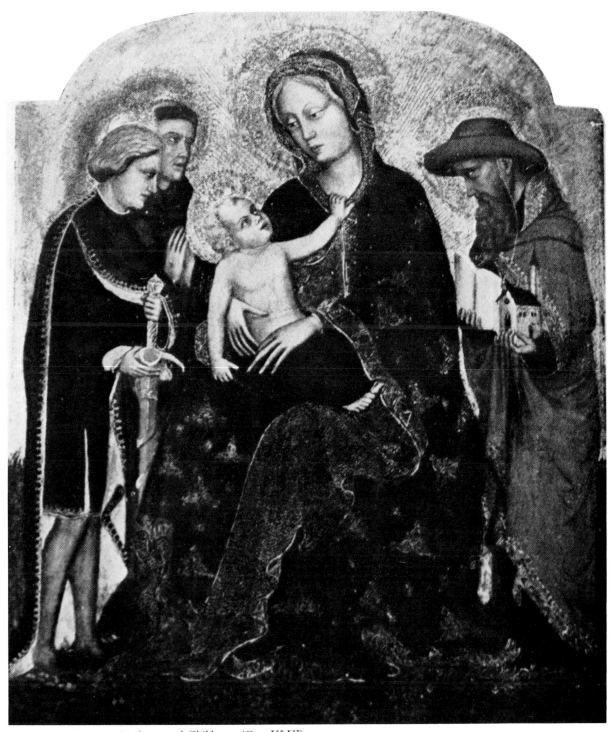

105 Zanino di Pietro *Madonna and Child, etc.* (Cat. XLVI)
Whereabouts unknown

106 Marchigian *Female saint* (Cat. XLVII)
Whereabouts unknown

107 Gentile da Fabriano (?) *Bust of a bearded hermit* (Cat. XLVIII)
Whereabouts unknown

108 Gentile da Fabriano (?) *Seated woman* (Cat. LXIV)
Kupferstichkabinett, Staatliche Museen, Berlin-Dahlem

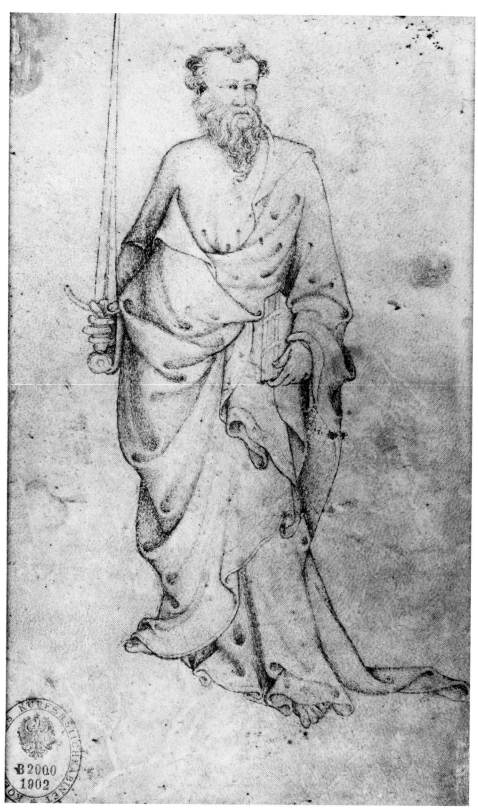

109 Follower of Gentile *St. Paul* (Cat. LXIV)
Kupferstichkabinett, Staatliche Museen, Berlin-Dahlem

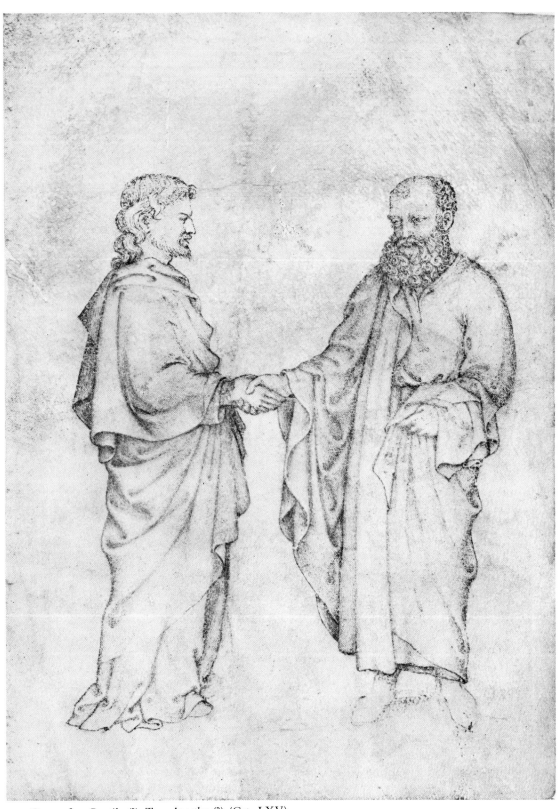

110 Copy after Gentile (?) *Two Apostles* (?) (Cat. LXV)
National Gallery of Scotland, Edinburgh

DOCUMENTS
CONCERNING GENTILE

The documents are arranged chronologically. The date and general content are listed at the head, followed by the location of the document and the source for the transcription when the actual document has not been consulted; then follows the transcription, the principal sources against which the printed transcription may be compared and a discussion of interpretations of that document, when pertinent.

DOC. I 27 July, 1408
Gentile to paint a panel for Francesco Amadi in Venice.

> Museo Civico, Venice, Raccolta Gradenigo, cod. No. 56, *Memorie lasciate da Francesco Amadi della sua famiglia*. The transcription is that of P. Paoletti (*l'Architettura e la scultura in Venezia*, Ongania, Venice, 1893, I, p.205, n.8).

I Maistri Intagliadori, et Depentori de Santi de dar adì 5 Giugno gli mandai per el suo Garzon ducati 2: val £9.10 et die dar adì 27 Luglio contadi in piu fiate ducati 11 d'oro... Item i ditti deno haver per una Ancona de depenzer Maistro Nicolò in Calle al Canton £14.15; et per una Ancona de depenzer Maistro Zentil £27.10, et per altri lavorieri a una vista £19.

> This passage comes from a manuscript composed by Angelo Amadi (b. 1425) that concerns the building of S. Maria dei Miracoli. In order to prove that the miraculous image painted by Niccolò di Pietro belonged to him, he cited from his grandfather's *Quadernetto delle spese delle case da S. Marina fatte per me Francesco Amadi, da dì 23 Guigno in qua* (i.e. up to 26 January, 1408–1409 modern reckoning). This is the earliest reference to Gentile (see also Boni, *Santa Maria dei Miracoli*, Venice, 1887, pp.8–11).

DOC. II
Gentile registered in the Scuola di S. Cristoforo dei Mercanti, Venice.

> A. S., Venice, *S. Maria e S. Cristoforo dei Mercanti, Scuola alla Madonna del Orto*, Busta No. 406, f.75r.

Maestro Zentil da Fabriano S. Sofia

> First published by E. Cicogna (*Delle Iscrizioni veneziane*, Venice, 1853, VI, pp.870–71). Colasanti (p.10) falsely asserted that the handwriting dated this reference before 1410. The *mariegola* is arranged alphabetically and covers a period from 1377 into 1545 (1546 modern reckoning): there is no way of ascertaining a date for Gentile's inscription. His residence in the parish of S. Sofia is of interest in so far as he may have executed a painting for that church (see Cat. LXI).

DOC. III January 1414-August 1419

Gentile is employed at Brescia by Pandolfo Malatesta to decorate a chapel. During the same period he executes two panel paintings (see Cats. LI, LII). In June 1416 his daughter is baptized.

A.S., Fano. Published in part by A. Zonghi (*Repertorio dell'antico Archivio Comunale di Fano*, Fano, 1888, pp. 81ff.) and by R. Mariotti ('Nuovi documenti di Gentile da Fabriano sui freschi della Cappella Malatestiana a Brescia', *Nuova Rivista Misena*, V, i. 1892, pp. 3–4). The transcriptions are those of I. Chiappini di Sorio ('Documenti bresciani per Gentile da Fabriano', *Notizie da Palazzo Albani*, II, ii, 1973, pp. 19–26).

CODEX 47, 1414:

f.42v. De avrer adì XVII de aprile versati a magistro Gientille da Fabriano, pintore a lui, folio 98, libre CCXLV.

f.43. Gientille da Fabriano de dare adì XVII de aprile versati a lui per Giovanni da Castiglone a lui in conto, folio 97, libre CCXLV. [in margin:] MCCCCXIIII de avere adì ultimo de aprile, uscita giallo.

f.64. Adì detto [1 giugno] versati in Venexia alla stazone d'Armanino da Nola per libre 2, onz 6 d'azurro oltramarino per la capela ducati 45, et per setole et chode da fare penelli ducati 1 soldi 12 et per duemila pezi d'oro batutto ducati 20, in tutto ducati 66 soldi 12 in debitto al giornal da parte a foglio 123 libre CLXII, soldi XVIII [*cf.* f.68v.].

f.68v. Conto della capella.

Magnifico et excellentissimo domino, domino Pandulfo de Mallatestis Brixie ac Pergami ect. de dare...

— Adì detto [1 giugno] versati in Venexia per lo dito Giovachino a la staccione d'Armanino da Nola spezier in Venexia per libre 2, onze 6 d'azurro oltramarino ducati 45, et setole et chode da fare penelly ducati 1 soldi 12 e per pezzi 2000 d'oro batutto ducati 20, in tutto ducati 66 soldi 12, monta in creditto a Giovachin folio 123 [*cf.* f.64], libre CLXII, soldi XVIII.

— A dì XI de luglo versati a magistro Gientille per ciera nuova et raxa, tolta per la capella appare al giornale folio 48 libre, soldi XV denari VIII.

— A dì XXVIIII d'agosto versati a magistro Gientille per onze 12 de ciera, libre 10 de raxa, libra 1 de cinabrio et dozine IIII de stagnolo biancho in tutto appare al giornale foglio 58, libre VII, soldi 1.

— Et in sino adì III d'agosto per libre V d'azurro oltramarino comprato Giovachino in Venexia et dati qui a magistro Gientille per la capella del Signore, a giornal foglio 142, libre CCXXXII, soldi XV.

— Et per dozine VIII de stagnolo fino per la soprascritta capella portò Giovanni Lambertengo da Venegia in giornale jallum folio 145, libre II, soldi XV.

— Et per datio de pezzi duemila d'oro battuto et de soprascritto stagnolo pagò in Vinegia, Ferara, Mantova et contado a Giovanni folio 145, libre III, soldi VII bolognini VI.

- Et dì II d'ottobre versati a Giovanni da Verona spiziale per libre XIII de ciera per la capella al giornal folio 66, libre III, soldi XVIII.
- Et dì X d'ottobre versati a magistro Gientile per libre II, de vernici . . . liquida et dozine II de stagnolo biancho al giornal folio 63, libre I soldi XVI.
- Adì ultimo d'ottobre versati a magistro Gientile per onze 1 de lacha fatta venire da Firenze al giornal al foglio 73, libre, soldi XII.
- Adì XXII de dicembre versati a Giovanni da Verona spiziale per onze 8 de bia[n]cha et onze 4 de vernicie liquida data a magistro Gientile per la capela a giornal folio 92, libre II, soldi XII.

 [total:] [libre] 685, [soldi] 15, [denari] 2.

- f. 87. Adì detto [3 agosto] per onze V d'azzurro oltramarino comperate da Armanino da Nola per la capella ducati 95, al giornal folio 123 [i.e. f.68v.], libre CCXXXII, soldi XV.

CODEX 48, 1415:

- f.102. Maestro Gentile depintore die dare adì VI de febraro ducati cento d'oro per la sua provisione per tuto el mese de genaro mandati per Mariano da Siena per lu in credito in libro verde folio 78. a libro verde ff.78. libre CCXLVII, soldi VI.

CODEX 49, 1415:

- f.70. Adì VI sup[r]ascritto [febbraio], per ducati 100 d'oro versati a maestro Gentile depintore a lui folio 78 libre CCXLVII, soldi X.
- f.78. Maestro Gientile da Fabriano depintore de dare adì VI de febraro ducati 100 d'oro versati a lui per Mariano dassiena per la sua provixion per tuto gienaro, in creditto a Mariano infolio 70 libre CCXLVII, soldi X.
- Adì XXVII de luglio versata a lui contanti ducati cento d'oro, apar al giornal folio 31 libre CCXLV soldi-.

 [total:] [libre] 492, [soldi] 10.

- Die aver adì ultimo de luglio messi a uscitta giornal foglio 49 libre CCCCLXXXXII, soldi X.

CODEX 50, 1416:

- f.103v. Maestro Gientile da Fabriano de dare adì VIII de magio versati a lui de commandamento del Signore al giornal verde folio 38, libre CCL, soldi-.
- Adì XXV de settembrio versati allui contanti, apare al giornal verde folio 86, libre L, soldi-.
- Adì XIII de ottobre versati allui contanti Giohachino a giornal verde folio 39, libre X, soldi-.
- Adì XVIII de ottobre versati allui per Giohanni de Borghino a giornal foglio 91, libre LXV, soldi-.

 [total:] [libre] 375.

– De aver adì ultimo de ottobre a ussita folio 100, libre CCCLXXV. [*cf.* Cod. 58, f.230]

f.104. [19 maggio] Et per dozine due de stagnuolo mandate a maestro Gientile per la capela al giornal folio 11, libre-, soldi XIIII [*cf.* Cod. 55, f.74]

f.157v. Maestro Gientile da Fabriano de dare adì XIII de novembris quali li assignamo da Filippino de Civini per parte de l'imbotate de vinno del comun da Ghiruola et Pudano a lui a libro verde a folio 172, libre LXXV, soldi-.

– E fatti buoni a lui Giovanni da Castrislone per la provixione de uno mense a lui in credito folio 162 libre L, soldi-,

– De aver adì ultimo de decembrio messi a uscita segnata a lui folio 126, libre CXXV, soldi-. [*cf.* Cod. 58, f.230].

CODEX 51, 1417:

f.3. Edì deto [20 febbraio] al deto [Pietro da Bergamo corriero] che portò certe cose de maestro Gientile a Venexia, a giornale folio 6, libre III [*cf.* Cod. 55, f.88v.]

f.3v. E dì deto [9 marzo] versati al Bolognino da Milano per sachi che mancorono a portare le... a Venezia e per vetri contrafatti dati a maestro Gientile per la capella, appare a giornale nero a folio 11, libre I, soldi IIII. [*cf.* Cod. 55, f.89]

f.4. [30 marzo] E per pezi mille d'oro batuto e mille de arzento batuto e dozine III de stagnoli date a maestro Gientile per la capella in credito a Giohachino, a folio 90, lire XXX e soldi X. [*cf.* Cod. 55, f.89v.]

f.97. Gientile da Fabriano de dare adì XXVII di magio versati per lui Giovanni di Borchino a Lafranco per oro auto da lui in conto a Giovanni folio 96, libre LVIIII, soldi XV.

– Adì XXVIII de magio versati a lui contanti per resto de la provixon del mese presente apar al giornal folio 21 libre II, soldi XV.

– Adì VI de luglo versati a lui contanti per la provixon de giugno a giornal folio 28, libre LXII, soldi X.

– Adì versati a lui contanti per la provixon de luglo Giovanni de Borgino per parte de li carris de larese de luglo, al libre de dari folio 15, libre LXII, soldi X.

– Adì VII de settembrio versati a lui contanti in casa de Filippo al giornal folio 40, libre LXII, soldi X.

– Adì [blank] de ottobre versati a luj per Giovanni da Castrislone a lui in credito folio 120, libre LXII soldi X.

– Adì de novembrio versati a luj per lo soprascritto Giovanni a lui in creditto a folio 122, libre LXII soldi X.

– Adì de decembrio versati a lui contanti per Giovanni soprascritto a lui folio 129, libre LXII, soldi X.

– Adì ultimo de decembrio versati a lui contanti per Giovanni soprascritto a lui folio 135, libre LXII, soldi X.

– De avere adì ultimo d'achosto messi a ussita gialla folio 154 libre CCL, soldi- [*cf.* Cod. 58, f.230].

– De avere adì ultimo de decembrio messi a ussita gialla folio 163, libre CCL, soldi-.

CODEX 52, 1418:

f.2v. E dì ultimo de gienaro versate a maestro Gientile per cornixe e altri lavori dintalio per la tavola del signore Carlo e altri lavori torniti per la capela et uno caro de legne per ardere per la capela al giornale al folio 9 libre 3 soldi XII. [*cf.* Cod. 55, f. 108v.]

[24 gennaio] A Jacomino de Panizaldi adì deto, per oro e colori dati a magistro Gentile per la capella libre 3 soldi XIIII. [*cf.* Cod. 55, f.105]

f. 5v. El prefato Signor nostro deve dare.

– E dì deto [15 Marzo] per peze seicento doro et duecento d'argento batuto e otto duzene de stagnoli, L petre contrafate, libre 5 de giesso fino comprati a maestro Gentile a caxone de la capela a Gioacchino.

folio 72 libre XX. soldi XIV.

f.6. E dì deto versati al deto [Jacomino] per oro battuto, cera bianca dati da XXXI di gienaro in sino a questo dì, al giornal folio 28, libre-, soldi XVII, denari III.

soldi XIII, denari VI.

f.6v El prefato Signore nostro de dare a caxon de le spexe del mese de aprille antedetto. .

– E dì deto [30 aprile] a Maestro Gientille per colla, biacca et altre cosse per la capela. al giornale foglio 32 libre II, soldi III [*cf.* Cod. 55, f.110].

f.9v. E dì XII [d'ottobre], versati a Jachomino Panizaldi per oro fine batuto, stagnolo, cenabrio, cera et altre chose date a mestro Gientile per la capella a giornale folio 46, libre VII, soldi XII, denari VI [*cf.* Cod. 55, f.99, from which the date appears to be 1417, not 1418].

f.10. El nostro magnifico Signore antedetto de dare per la spexa consumada del mese de lulio fatta come apare di soto.

– E dì VI de luglio a Rafaino orefice per 34 legature di smalti dati a maestro Gientile per la capella.

Al giornale a folio 43 libre II, soldi I, denari I [*cf.* Cod. 55, f.115v.]

– E dì deto versati a Rafayno orifice per VIIII smalti fati a maestro Gientile per la capela, al giornal a folio 46, libre-, soldi XIII, denari VI [*cf.* Cod. 55, f.116]

f.11v. A dì XX del deto [dicembre] versati a maestro Gientile per duo centenara d'oro e stagnuolo per la capela e per una tavoletta da fare una anchona per il signor Carlo, a giornale folio 58, libre VIIII, soldi VIII [*cf.* Cod. 55, f. 101, from which it results that the year in question is 1417, not 1418]

f.12. El prefato nostro magnifico et excelso Signore de dare per caxone dele spese consumate del mese di septembre come appare di soto.

– E dì deto [15 settembre] versati a Maestro Gentile per minio, colla e ova per la capella al giornale a folio 72 libre-, soldi 15. [*cf.* Cod. 55, f.117v.]

f.13. E dì XXVII de septembre a Iacomo di Panizaldi spiziaro, per cera, raxa, bia[n]ca e minio date a Maestro Gentile per la capella in sino adì 7 de luglio, al giornale a folio 74 libre 1, soldi 14 [*cf.* Cod. 55, f.118v.]

f.14. El prefato nostro magnifico Signore messer Pandolfo de dare per a caxone de la spese consumade del mese de octobre come apare qui de soto.

– E dì deto [11 ottobre] versati a Maestro Gentile per stagnoli et colore rosso per la capella, al giornale, folio 79, libre 1, soldi- [*cf.* Cod. 55, f.119].

f.16. El prefato nostro magnifico et excelso Signore de dare per a caxon de le spexe consumate del mese de novembrio come di soto appare.

– E dì VIII di novembrio versate a maestro Gioane de Prata carpentaro per una ancona fata che se penze per Maestro Gentile per donare al Papa, al giornale a f. 86 libre 1, soldi 12 [*cf.* Cod. 55, f.120].

f.45. Maestro Gentile da Fabriano de dare a dì XXVI de gienaio versate a lui contanti per la provisione del deto mese, al giornale a folio 8, libre LXII, soldi 10.

– A dì XXII de febraro li portò Maestro Nicholò da Fabriano per la provisione de febraro al giornale a folio 13, libre LXII, soldi 10.

– A dì XXIIII de marzo portò per Zilio suo cugnato per la provisione de marzo al giornale folio 20, libre LXII, soldi 10.

– A dì ultimo de aprille per la provisione de aprille al giornale folio 32, libre LXII, soldi 10.

– E dì XXVIII di magio al giornale folio 37, libre II, soldi 10.

– E dì VIIII di giugno per resto de la provisione de magio al giornale folio 43, libre LXII, soldi 10.

– E dì XV de giugno li quali hassignamo da Maffiolo Avogadro per parte del pagamento del dazo della macina del mese de luyo a lui in credito a libro C, a folio 12, libre LXII, soldi 10.

– Dal deto per lo deto dazo del settembre, libre LXII, soldi 10.

– Dal deto per lo deto dazo di ottobre, libre LXII, soldi 10.

– Dal deto per lo deto dazo di novembre, libre LXII, soldi 10.

– Dal deto per lo deto dazo di decembre, libre LXII, soldi 10.

– Da Lorenzo da Como per parte del dazo del prestino del mese di agosto a lui in credito al libro C, a folio 13, libre LXII, soldi 10.

– E dì XXIII di giugno, versate a lui per provisione del detto mese al giornale folio 50, libre LXII, soldi 10.

– De avere a dì ultimo de aprile a ussita bianca giornale folio 3, libre CCL.

– E de avere a dì ultimo de agosto per la signazione che li era fata del mese presente scossa per Lanfranco a lui in debito a 312.10, folio 110, libre LXII, soldi 10.

– E de avere a dì in debito a dì ultimo del desembre messi a uscita bianca a folio 19, libre CCCXXXVII, soldi 10.

f.65. Maestro Gientile da Fabriano pintore de dare in sino adì XXVIIII de gie-
naro versati a lui contanti, al giornal nero folio 4, libre LXII, soldi X.

– Adì XXIII de febraro versati a lui contante, appare al giornal nero a folio 7, libre
LXII, soldi X.

– Adì XXX de marzo versati a lui contante, apare a giornal nero folio 14, libre
LXII, soldi X.

– Adì XXV d'aprile versati a lui contante Giovanni da Broghino a lui, foglio 93,
libre XLII, soldi X.

– De avere adì ultimo d'aprile messi a uscitta, a giornal folio 131, libre CCL.

CODEX 53, 1419:

f.38v. Maestro Gentile de dare adì XXVII de giennario per la provixion del
mese presente, al giornale a folio 9, libre LXII, soldi X.

– E dì XXI de febraro per la provixion del deto mese a lui contanti e Opizo per lui
ducati 12, al giornal folio 10, libre LXII, soldi X.

– E dì XXIII de marzo per la provixion del deto mese al giornal folio 16, libre
LXII, soldi X.

– E dì XIIII de aprille al giornal a folio 20, libre II, soldi X.

– E dì XXI de aprille per lo resto d'aprille al giornal foglio 23, libre LX, soldi-.

– E dì XXIII de magio al giornal a folio 33, libre LXII, soldi X.

– E dì XXVIIII de agosto a lui per Velardo da Ghedi de i dinari del Comun da
Vixano al giornal a folio 59, libre LXX, soldi-.

– E dì... XXX d'agosto al giornal a folio 61, libre XL.

– E de dare i quali li versò Bartolomeo de Guaynari adì XXVII de geniaro messi in
credito a Bartolomeo a folio 133 libre LXII, soldi X.

– De avere adì ultimo de agosto messi a ussita biancha a folio 36, libre
CCCCXXII, soldi X.

– E de avere adì ultimo de decembrio messi a ussita bianca a folio 50 libre LXII,
soldi X [cf. Cod. 58, f. 230].

CODEX 55: (This codex more or less summarizes the various payments made over the
span of time covered in the above-cited codices.)

In Christi nomine. Hic est liber super quo scripte sunt expense consumpte facte
pro Magnifico et excelso Domino nostro per personas inter scriptas inceptus
in Kalendis January MCCCCXIIII.

1414

f.3v. Magistri Gentili pro emendo Dominis nostris duecentum decem stagni
batuti per capella Domini X ianuari, libre VI, soldi-.

f.5. Maestro Gentili pictori die XV marcij per libre IIII vernicis liquide pro
capela Domini, libre I, soldi IIII.

f.5v. [martij] Magistro Gentili pictori per libre VI bia[n]che, libre I minii, libre I
licargeri et per uno libro magno ab auro et argento, per I colla et ovis per
distemperando colores, in Registro libre III, soldi-.

f.12v. [maij] Magistro Gentili pictori per rebus acceperatis ab Antonio de la palata, speciario, per capella Domini, libre III, soldi III.

1415

f.35v. Die XXVI Januario versate Johanni de Roado speciario, per bia[n]cha data Magistro Gentili usque die XI decembris proximo preteriti pro duobus doplerys datis pro Johani . . . ambasciatoribus venetorum, libre II, soldi I, denari III.

f.48. Die dito [13 iulij] versati magistro Gentili pro cera rubea, alba et vernice per capella Domini libre I, soldi XVIIII.

f.53v. Oprando de Crete pro oleo lino se dato per cappella Domini die X augusti magistro Gentili prescripto suprascripto libre II, soldi-.

f.54. Jacomello speciario per libre X cere, libre 400 rasa, libre VIII bia[n]che, et libre VI vernicis liquide datis. Magistri Gientili per capella libre VIII; per scripture detto die ultimo augusti libre VII, soldi XV.

f.57. Magistro Gentili de Fabriano pro emey aurum per capella Domini, de XIII octobre per scripti Lodovici, die suprascripto libre XV.

f.61. Ser Johani Zanino per auro e stagnolo empto in Venecia per Domino usque de mensis iully pro parti misso Magistro Gentili de Fabriano per dominum Matheum de Fano pro ducati 30 per scriptum nomine Magistro Gentili libre LXXIII, soldi X.

– Pro stagnolis emptis in Venecia dati Magistro Gentili suprascripto de mense novembris libre II, soldi III.

1416

f.65. Suprascripto [Joachino] per peciis II mila auri batuti datis magistro Genutili pro capella Domini prescripta libre L, soldi VIIII, nomine magistro Gentili in nigro curit forza.

f.68v. [Martius] Magistro Gentili pro emendo duo centenara auri battuti per capella Domini prescripta libre VI, soldi-.

f.69v. [Maius] Magistro Gentili per cera pro capella die suprascripti, libre I, soldi XI.

f.71. [4 aprilis] Magistro Gentili pictori pro scinaprio, calcina, tela, brochetis. tela, cera et stagno pro capella Domini die suprascripto libre I, soldi XII.

f.74. Pro duabus duodems stagnoli empti per magistro Gentili libre-, soldi XIIII [cf. Cod. 50, f.104].

– Per peziis 600 auri sotilis empti pro capella Domini libre XV, soldi-.

– Per peziis 600 auri grossi empti pro Domino ad compto duchati V pro centenaro per duchati XIIII, libre LXXV, soldi-

f.74v. [Iunius] Domino Archipresbitero mayori Brixie qui babtizavit unam filiam magistri Gentilis, ser Donatus per dictum die dicto libre II, soldi X.

f.76. Magistro Gentili per auro batuto pro capella Domine die dicto [16 iulij], libre III, soldi X.

f.81v. Domine Cateline de la palata pro uno centenario aura et cera data magistro Gentili die dicto [27 settembre] libre III, soldi XV.

f.85. Magistro Gentili pro 1 centenario auri batuti empti pro capella Domini die XVII decembri prescripti libre II, soldi XIIII.

– Jacobinus de Panizaldis spiciaro pro auro, cera rasia, sinaprio et vernice dati dicto magistro Gentili, die XXIIII decembre per capella Domini suprascripta perscriptum libre VIII, soldi X.

1417

f.88v. [20 februarij] Suprascripto [Petro de Pergamo] qui tulit certas res magistri Gientili a Brexia, Venezias libre III, soldi- [*cf.* Cod. 51, f.3].

f.89. Bolognino mezadro pro sachis deficientibus ad portans monetas Veneciam datis per ipsum et pro ditus contrafacto datis magistro Gentili pro capella Domini die dicto [9 marzo], libre I, soldi IIII [*cf.* Cod. 51, f.3v.].

f.89v. [Aprilis] Pro pecys mille auri et mille argenti batuti et duo deugens tribus stagnolorum dati magistro Gentili pro capella Domini, libre XXX, soldi X [*cf.* Cod. 51, f.4].

f.90. Magistro Gentili pro cira, bia[n]cha et alijs necessarijs per capella, die XVIIII de aprilis, libre II, soldi VIII.

f.92. [31 maij] Per canelis vayri, stagnolis et smaltis portati magistro Gentili per capella Domini prescripto seu mandato suprascriptum libre II, soldi X.

f.94. [Iuleus] Magistro Gentili pictori pro oncia vernice et colla pro capella prescripta, libre I, soldi XII.

f.98. [24 septembris] Jacobino de Panisaldo per cera raxa et alijs rebus datis magistro Gentili pro capella die suprascripto, libre-, soldi XIII, denari VI.

f.99. Jacobino Panisaldo die XII octobre pro auro fino batuto et stagno, scinaprio, cera et alijs datis magistro Gentile pro capela, libre VII, soldi XII, denari VI [*cf.* Cod. 52, f.9v.].

f.101v. Maestro Gentili pinctori die XX decembri pro centenarii II auri batuti et stagni pro capella et pro una tabuleta pro faciendo unam anchonam per magnifici domini Karulo, libre VIIII, soldi VIII [*cf.* Cod. 52, f.11v.].

1418

f.105. Jacobino de Panizaldis pro auro et coloribus datis magistro Gentili pro capella die suprascripto [25 gennaio], libre III, soldi XIIII [*cf.* Cod. 52, f.2v.].

f.108. Magistro Gentili pictori pro peciis decem auri, ducentis argenti batuti et pro octo et mezo donzenis stagnolorum, quinquaginta lapidibus contrafactis, pro libris V zessi fini empti Venecia pro capella die soprascripti [15 martij], libre XX, soldi XIIII.

f.108v. Magistro Gentili pro cornice et aliis laboreriis intalii pro tabula domini Karuli et aliis laboreriis tornitis pro capella et uno perho lignorum pro archipresbitero die ultimo junio, libre III, soldi XII [*cf.* Cod. 52, f.2v., where the date appears as 31 January].

157

f.109v. Per suprascripto Jacobino pro auro mezo batuto et cera alba dati in quisque die XXXI ianuari usque in diem hodiernum [21 aprilis] pro capella Domini libre-, soldi XVII, denari III.

f.110. Magistro Gentili pictori pro colla alba et alijs rebus pro capella Domini, die ultimo [aprilis], libre II, soldi III [*cf.* Cod. 52, f.6v.].

f.115v. Raffayno fabro die VII iully pro ligamentas XXXIIII smaltorum datis magistro Zentili pro capela, libre II, soldi XI [*cf.* Cod. 52, f.10.].

f.116. Rafayno aurifice die suprascripto [21 iulij] pro smaltos VIIII dati magistro Zentili pro capella, libre-, soldi XIII, denari VI [*cf.* Cod. 52, f.10.].

f.117v. Maestro Gentili pinctori die suprascripto [15 septembris] pro colla et etiam alijs pro capela, libre-, soldi XV [*cf.* Cod. 52, f.12.].

f.118v. Jacobino de Panizaldi usque XXVII septembre per cera, raxa biancha continuo date maestro Gentili pro capella, libre I, soldi XIIII [*cf.* Cod. 52, f.13.].

f.119. Maestro Gentili die suprascripto [11 octobris] pro stagnolo et colore rubeo pro capella, libre I, soldi- [*cf.* Cod. 52, f.14.].

f.120v. Magistro Johannj de parto, die VIII [novembris] pro factura unam anchonete pincte per magistrum Gentillem pro Sancto Patre Papa, libre I, soldi XII [*cf.* Cod. 52, f.16].

1419

f.133. Johanni de Roado speciario pro auro et argento batuto mezo, senaprio, bia[n]cha et colla dati magistro Gentili pro capella Domini die VIII febrary, libre VIII, soldi XV, denari VI.

f.136. [8 maij] Johannj de Roado spiziaro pro cera, bia[n]cha et raxa dati magistro Gentili pro capela, libre I, soldi XII, denari VI.

f.137v. Jacobo de Panizaldis per auro et coloribus datis magistro Zentili pro capella Domini, die dito [16 iunij], libre I, soldi III.

f.138. Magistro Gentili pro ligatura L lapidum et pro carta pro furnimento colam et pro scudelinis, die XXII juni, libre III, soldi V.

f.140v. Magistro Gentili pro cera, raxa et calzina pro capela die XII [augusti], libre I, soldi V.

f.141. Magistro Zentili pinctori per una douzena stagnolorum die suprascripto [29 augusti], libre-, soldi XII.

CODEX 58:

f.230. MCCCCXV

Magistro Gentilis de Fabriano pictor capelle magnifici et excellentissimi domini, Domini nostri, debet dare numerare suprascriptis diebus, sexto februari et 27 jully 1415, ducatos CC aurj scriptos in credito Joachino Malegonelle de Florencia texoriero Domini prefati. In libro rubeo dati et scripti in folio

CXLVII recto in ratione primorum VII mensis 1415,

<p style="text-align:center">libre CCCCLXXXXII, soldi X.</p>

Item numerati suprascripto die primo decembris annj suprascipti per ser Ludovicum canzelarium Dominy et scripti sibi in credito in isto in folio CXLIII a tergo per ducatos C a soldi 40, pro ducato, libre CCXLV, soldi-.

Item pro auro et stagnolo empti in Venezia de mense jully per ser Joanne Panizum ducati XXX quos Yoachinum texorierum posuit ad expensas consumptas in fine 1415 in signato G in folio LXI libre LXXIII, soldi X.

Item pro pezi II auri batuti per Joachinum suprascriptum positi ad expensam Januarii 1416 in signato G suprascripto in folio LXV libre 50, soldi VIIII.

Item quos recepit de mensis madii septembris octobris annj MCCCCXVI scriptos in credito texoriero suprascripto in folio XVIII in nomine Alzalenum, aprilis usque per totum octobre MCCCCXVI,

<p style="text-align:center">libre CCCLXXV, soldi- [cf. Cod. 50, f.103v.].</p>

Item scriptum in credito texoriero suprascrito veteris, in folio XLV pro eius provixione mensium novembris et decembris pro ducatos LII auro, in Giallo, libre CXXV [cf. Cod. 50, f.157v.].

<p style="text-align:center">MCCCCXVII</p>

Item debet dare suprascripto [Gentile da Fabriano] versati pro eius provixione mensis january february, marty et aprilis suprascripti annj 1417 scripti in credito texoriero suprascripto veteris in folio L a tergo,

<p style="text-align:center">libre CCL, soldi-.</p>

Item numerati suprascripto pro eius provixione madij, julii et augusto MCCCCXVII et scriptos in credito Yoachino tesoriero soprascripto in libros viridi suprascripto in folio LXXIII a tergo, libre CCL, soldi- [cf. Cod. 51, f.97v.].

Item numerati suprascrito de mensibus octobris novembris et decembris anni suprascripti pro eius provixione mensium quatuor pro ducati C scripti in credito dicto texauriero in libro suprascripto in folio LXXXII, libre CCL, soldi- [cf. Cod. 51, f.97].

Item numerati suprascrito, die VIII augusti 1416 ser Ludovichum de Canziis canzelarium Domini scripti eidem in credito in isto in folio CXLIIII pro ducati C, libre CCL, soldi-.

Item suprascripto solutos per Joachinum texauriero de anno 1419 scriptos dicto texauriero in credito in libro viride dati et scripti in folio CXXV libre LXII, soldi X [cf. Cod. 53, f.38v.].

Although Sorio gives no indication, the format of Codex 55 suggests that the last six payments were made in 1419 rather than 1418. In any case, Gentile was in Brescia until mid-September 1419 (see Doc. IV). The one outstanding payment after that date (for December 1419: Cod. 53, f.38v.) was cancelled (Cod. 58, f.230).

DOC. IV 18 September, 1419:
Gentile requests a letter of safe conduct for eight people and eight horses in order
to join Pope Martin V. It is to begin 22 September and last at least fifteen days.
 A.S., Fano, Codice Malatestiano, 113, anno 1419.

Strenue vir Maior honorande

Strenue vir Maior honorande. Quando El papa fo in questa terra volse la sua
Sanctitade che Io glie promettesse andar daluy finita questa capella che haveva
comenzata al Signor messer pandolfo. Et perche al presente la ho finita et altra non
ho da fare ve prego quanto so et posso che ve piaccia esser cum lo Conte Carme-
gnola et pregarlo che glie piaccia concederme un Salvoconducto per octo persone
et octo cavalli che dure almanco xv dì et comenzi venardi xxij de questo mese et
pregove che mel facciate far pieno quanto se po a cio che io possa andar Siguro.
Mando da voy Anzelino todescho mio famiglio per questa caxion piacciave de
farlo Spacciare piu presto che voy possete. Aracomandome a voy et se Io posso o
poro may fare cosa che ve piaccia so sempre apparecchiato. dat brixie xviij Sep-
tembre

 El vostro Zentile da fabriano pentore.

 The letter was first published by A. Zonghi (*op. cit.*) and, most recently, by I.
 Chiappini di Sorio (*op. cit.*, p.26). Carmagnola (Francesco Bussone), Filppo Maria
 Visconti's captain, had launched a campaign to recapture Pandolfo's territory. Ber-
 gamo fell to him that July: any safe conduct necessitated his seal as well as Pandolfo's.

DOC. V 23 March and 6 April, 1420:
Gentile requests exemption from taxes and debts in Fabriano, having decided to
live and practice his art there.
 A. S., Fabriano, No. 693, *Libor alphabetico ordine discriptus, in quo omnes gratiae et
 compositiones factae per D. Thomassam de Clavellis Fabriani pro S. R. C. Vicarium de anno
 1418.*

MCCCCXX die xxiii martis
Magister Gentilis nicolaij Johannis maxij supplicavit eo quare est dispositus vivere
et mori et artem suam facere in terra fabrianj sub umbra de vestre dominatoris,
petit gratiam de omnibus honeribus civis tam realibus quam persunalibus. Et
signatum fuit sic. Ne propter dictas solutiones possint ejus commendabilia exer-
citia impedirj, facimus sibi gratiam de omnibus honeribus realibus et personalibus
presentibus et futuris. Ita quod predictis non possit in posterum nec debeat ab
aliquo molestarj.
di[e] vj aprilis
Magister Gentilis predictus resupplicavit in carta membrana et petjt per mag-
nificum dominum Tomassium fieri liberam gratiam de infrascriptis videlicet ab

honeribus comunis Fabrianj in omnibus realibus et personalibus angarijs et pro angarijs cujuscumque modi et solutionibus pretaxatis, siquid superesset ad solvendum presentibus et futuris ex nunc exemtum facere. Et signatum fuit sic. Ne proper dictas solutiones possi[n]t ei commendabilia exercitia impedirj facimus sibi gratiam de omnibus supradictis honeribus presentibus et futuris. Ita quod per predicta non possint imposterum nec debeat ab aliquo molestarj.

> These notices were first published by A. Zonghi ('Gentile a Fabriano nel 1420', *Le Marche,* VII, 1908, pp.137–38). Zonghi and subsequent critics have considered these as proof that Gentile was in Fabriano in 1420. The wording of the first petition does imply this. However, the second petition reveals that Gentile was not requesting a favoured status, but was responding to specific obligations, possibly longstanding, that were only cancelled by making another, more detailed, supplication. The intent behind the phrase 'to live and die and practice his art in Fabriano' cannot be taken at face value. It is clear from Doc. IV that six months previously Gentile had set out to meet Martin V, then in Florence, while Doc. VI shows that by autumn 1420 he was in that city. As Colasanti (p.12) suggests, it is most probable that the trip to Fabriano represented a brief interlude, occasioned by specific circumstances, in a Florentine sojourn (see also text, pp.18, and Cat. VIII).

DOC. VI 1420–1422:

Gentile pays rent for a house in the quarter of S. Maria Ughi (S. Trinita) in Florence.

> A.S.F., Carte Strozziane, ser. IV, 341.

> The transcription is that of D. Davisson ('New documents on Gentile da Fabriano's Residence in Florence, 1420–22', Burlington, CXXII, 1980, pp.759–63).

f.38r. MCCCCXX [between 6 August and 24 October]
> Maestro Gientile da Fabriano dipintore de'dare fiorini XX d'oro per pigione d'una chasa postalo di Santa Maria a Ughi – f. XX
> Anne dato fiorini -XX d'oro a Palla di messer Palla – f. XX

f.43r. MCCCCXXI [between 24 August and 2 October]
> Maestro Gientile da Fabriano dipintore de'dare fiorini X d'oro, per pigione d'una chasa posta nel popolo di Santa Maria via Ughi – f. X
> Anne dato X fiorini d'oro a Palla di messer Palla – f. X

f.46v. MCCCCXXII
> Maestro Gientile da Fabriano dipintore de'dare fiorini X d'oro, per pigione di mesi sei d'una chasa posta nel popolo di Santa Maria Ughi f. X
> Anne dato a dì X di novembre fiorini X d'oro – f. X

> An annual rent of 20 florins is established by the payment of November 1422, and this fact, in turn, suggests that the documents are incomplete. Davisson assumes that the

rent was paid for the upcoming term of lease, but this is by no means certain. As often as not rent was paid at the end of a term of lease, as, for example, Gentile did in Siena. If this was the case, then Gentile's arrival in Florence in late September or early October 1419 would be proved.

Palla di Palla Strozzi (Il Novello) was a second cousin to Palla di Nofri, but what bearing this may have on the commissioning of the *Adoration of the Magi* is not clear.

DOC. VII 21 November 1422:
Gentile inscribed in the *Arte de'Medici e Speziali,* Florence.

A.S., Florence, Medici e Speziali, n.21, *libro nero delle matricole 1408 gia segnato G,* f.145v.

Magister Gentilis Nicolai Johannis Massi de Fabriano pictor, habitator Florentie in populo Sancte Triniiatis. Volens venire ad magistratu[m] dicte artis et poni e[t] describi in matricula dicte artis inter alios ibidem matriculatos tamquam eius juravit et eius promisit e[t] eius debet solvere dicte arti florentis duo deci.aurum.

First referred to by D. Moreni (*Illustrazione storica critica della medaglia rappresentante Bindo Altoviti opera del Buonarroti,* Florence, 1824, pp.xlv–xlix). Ricci (p.165, n.3) confused both the date and the source, stating that Gentile's name appears in the *Ruolo della Compagnia di S. Luca* (A.S., Florence, Accademia del Disegno, No. 1). As G. Poggi (*La cappella e la tomba di Onofrio Strozzi nella chiesa di S. Trinita, Florence,* Tipografia Barbera, 1903, p.18, n.2) noted, this is not true. The error was repeated by A. Venturi (*Gentile da Fabriano e il Pisanello,* G. Sansoni, Florence, 1896, p.8).

DOC. VIII 8 June 1423:
Gentile receives 150 gold florins as payment for the *Adoration of the Magi* and subsequently pays his debts.

A.S., Florence, Carte Strozziane.

SERIES III, No. 286, 1423 (*Quaderno di Cassa segnato C di Lorenzo di Messr. Palla Strozzi e Orsini Lanfredino*):

f.XLIIIIv. E de' dare a dì VIII di giungno fiorini ciento cinquanta d'oro per lui [Palla Strozzi] a maestro Gientile da Fabriano maestro di depintura posto debbi avere, in questo a carta 49, disse gli ricievea per resto di paghamento di depintura della tavola a fatto alla sagrestia di Santa Trinita. fiorini CL soldi- [*cf.* f.XLVIIIIr.]

f.XLVIIIv. Maestro Gientile da Fabriano depintore de' dare a dì VIII de Giungno fiorini sesantuno soldi XVI denari VI piccioli per lui a Chosimo e Lorenzo de Medici e compagni, portò Dante di Bernardo contanti in suggello nuovi. fiorini LXI soldi VI denari-

– E de' dare a dì VIIII di Giungno lire trentuno piccioli per lui ad Andrea di Lodovicho e compagni Becchai, portò Niccholo di Giovanni contanti in

fiorini nuovi fuor di borsa, sono per resto di più charne avuto dalloro per infino a questo dì. fiorini VII soldi XXIII denari III

– E de' dare a dì detto fiorini dodici d'oro portò e' detto contanti in grossi, disse per dare a Giovanni da Imola. fiorini XII soldi-

– E de' dare a dì detto lire cinquantatre soldi XVIIII denari VIII piccioli per lui a Bastiano di di [sic.] Giovanni battiloro, portò e' detto contanti in fiorini nuovi fuor di borsa, sono per resto di più oro battuto avuto dallui. fiorini XIII soldi XVII denari IIII

– E de' dare a dì detto fiorini venzetti d'oro per lui a Isau d'Angniolo Martellini compagnia portò Bernaba di Giovanni contanti in sugello nuovi. fiorini XXVII soldi-

– E de' dare a dì detto lire diciotto piccioli per lui a Lorenzo di Messer Palla degli Strozi proprio posto debbi avere in questo a carta 50. fiorini IIII soldi XV denari IIII [cf. f.L]

– E de' dare a dì X di Giugno fiorini cinque d'oro. portò e' detto contanti in grossi, disse per dare fiorini tre d'oro a Michele di Ungheria sta collui per suo salaro. fiorini V soldi-

– E de' dare a dì detto fiorini tre soldi XX a fiorino per lui a Matteo Rondinelli e compagnia intagliatori, porto Amideo di Filippo contanti in grossi per resto di resto [sic.] per insino a questo dì. fiorini III soldi XX denari-

– E a dì fiorini quindici soldi V dinari I a fiorino, posto debbi avere in questo a carta 50. fiorini XV soldi V denari I [cf. f.Lr.]

f.XLVIIIIr. Maestro Gientile da Fabriano depintore de' avere a dì VIII de Giungno fiorini ciento cinquanta d'oro per lui da Messer Palla di Nofri degli Strozzi, posto debbi dare in questo a carta 45. fiorini CL soldi- [cf. f.XLIIIIv.]

f.XLVIIIIv. Maestro Gientile da Fabriano depintore de' dare a dì X di Giugno fiorini quattro d'oro lire sei soldi IIII piccioli per lui a Jacopo di Rustighini da Frigholi portò e' detto contanti in grossi, sono per resto di suo salaro e per denari gli prestò. fiorini V soldi XVI denari VI

– E de' dare a dì XII di Giungno fiorini uno d'oro portò Michele di Ungheria sta chollui contanti in grossi. fiorini I soldi-

– E de' dare a dì XVI di Giungno fiorini uno d'oro, portò e' detto contanti in grossi. fiorini I soldi-

– E de' dare a dì detto fiorini sette soldi XVII denari VII a fiorino, messe dallui a entrata segnata C a carta II. fiorini VII soldi XVII denari VII [cf. Ser. III, No. 287, f. Iv.]

f.Lr. Lorenzo di Messer Palla degli Strozzi proprio de' avere a dì VIIII di Giungno lire diciotto piccioli per lui da Maestro Gientile da Fabriano depintore, posto debbi dare in questo a carta 49. fiorini IIII soldi XV denari IIII [cf. f. XLVIIIv.]

– Ricordo Maestro Gientile da Fabriano depintore de' avere a dì fiorini quindici soldi V denari I a fiorino, posto debbi dare in questo a carta 49. fiorini XV soldi V denari I [cf. f.XLVIIIv.]

SERIES III, No. 287, 1423 (*Libro di debitori e creditori di Lorenzo e Bartolomeo di Messr. Palla di Nofri degli Strozzi . . . e di Orsino di Lanfredini . . .*):

f.Iv. E a dì detto [21 giugno] fiorini sete soldi XVII denari VII a fiorino per lei [company of Lorenzo Strozzi and Orsino Lanfredini] a maestro Gientile da Fabriano dipintore, portò e' detto contanti in grossi a uscita segnato A 122. fiorini VII soldi XVII denari VII [*cf*. Ser. III, No. 286, f.XLVIIIIv.]

SERIES IV, No. 363, 1423 (*Quaderno di spoglio del quaderno di cassa segnato B . . . di Lorenzo di Messr. Palla e Orsino Lanfredino*):

f. XXXVr. A dì 8 detto [di giugno] fiorini ciento cinquanta d'oro dieron per me a maestro Gientile da Fabriano dipintore per resto di paghamento della tavola della sagrestia. fiorini CL soldi- [*cf*. Ser. III, No. 286, f.XLIIIIv. and XLVIIIIr.]

> The payment of 150 florins was known through the copy of the original MSS. made by Carlo Strozzi (Ser. III, No. 100). A. Venturi (*op. cit.*, p.9) published the original source, but Poggi (*op. cit.*, pp.19–20) first brought all the various payments together. The Michele d'Ungheria mentioned as an assistant of Gentile's has sometimes been identified with 'Mechile Ongaro dipintore', who is documented in Ferrara from 1446, was dead by 1464, and signed the painting of the muse Thalia now in Budapest (*ibid.*, pp.20–21; and, most recently, M. Boskovits, 'Ferrarese Painting about 1450', *Burlington*, CXX, 1978, p.381).

DOC. IX

From a proceeding of 1425 it transpires that in 1423 Jacopo di Piero was a pupil and servant of Gentile, who was then living in the quarter of S. Maria degli Ughi, near S. Trinita.

> This and a related document, less specific and erroneous in the date of the event referred to (A. S., Florence, Diplomatico, Camera fiscale, 28 November 1424), were first noted by Milanesi (pp.20 and 149 n.1). A. Venturi (*op. cit.*, pp. 10–14), to whom the transcription is due, published them in full.

Reverenter exponitur vobis magnificis et potentibus dominis dominis prioribus artium et vexillifero iustitie populi et comunis Florentie pro parte Iacobi Pieri pictoris de Venetiis, quod ipse sub descriptione Iacobi de Venetiis famuli et discipuli magistri Gentilini pictoris de Fabbriano habitatoris in populo Sancte Marie Ugonis de Florentia in domo et habitatione dicti magistri Gentilini die secundo mensis settembris anni millesimi quadrigentesimi vigesimi tertii fuit condempnatus per Romanum de Benvedutis de Eugubio tunc executorem ordinamentorum iustitie populi et comunis Florentie in libris quadringentis quinquaginta flor. parv. dandis et solvendis generali camerario camere comunis Florentie pro eodem comuni recipienti et in quarto pluris, si non solverit infra mensem a die dicte late sententie computandum. Et hoc ex eo processit, prout est in condempnatione narratum, quia dictus Iacobus intentione infrascriptum mal-

leficium commictendi armatus quodam bastone ligneo, re acta ad infrascripta maleficia commictendum dolose et appensate assalivit Bernardum ser Silvestri ser Tommasii notarii et civis florentini et de populo Sancte Trinitatis de Florentia et cum dicto bastone pluribus vicibus admenando percussit una percussione ipsum Bernardum in brachio sinistro sine sanguinis effuxione contra voluntatem dicti Bernardi, prout predicta in effectu et alia plura in dicta condempnatione dicto die lata et scripta per ser Antonium Francisci de Eugubio notarium publicum et tunc notarium maleficiorum prefati d. Executoris latius constant et apparent. Et quod quicquid in condempnatione narretur veritas sic se habuit quod proiciendo prefatus Bernardus cum certis aliis lapides in quamdam curiam ipsius magistri Gentilini, ubi erant certa scultitia et picture maxime importantie, prescriptus Iacobus de precepto dicti magistri Gentilini redarguit ipsum Bernardum dicendo: Tu fai una grande villania a gittare, essendo oggimai grande come uno huomo. Quibus equidem verbis iratus dictus Bernardus multa verba iniuriosa et derisoria protulit contra eum, invitans ipsum ad facendum secum ad pusillos. Qui Iacobus tante iniurie impatiens respondit quod sic et ita vicissim ad pugnos bellarunt manibus vacuis nullaque alia interveniente percussione. Et quod ipse Iacobus credens de narratis commissis per eum nullam fiendam esse condempnationem super vestris galeis ad servitia vestre comunitatis accessit. Et quod supradictus ser Silvester videns quod prefatus Iacobus erat absens ipsum notificari fecit in condempnatione narrata commisisse prelibato executori, qui erat valde ipsius ser Silvestri familiaris et quod ipse executor leviter se habens fidem prestavit dicto ser Silvestro et ipsum Iacobum ignorantem inquisitionem et ad sui defensionem venire penitus non valentem contra omnem iustitiam condempnavit. Et quod post modum reductis ad portum vestrum ipsis galeis, de condempnatione predicta quicquid adhuc nesciens, hanc vestram felicissimam civitatem libere rediit. Et quod ipse paucis diebus elapsis a die huiusmodi reditus captus fuit. Et demum die vigesimo quarto mensis octobris anni millesimi quadringentesimi vigesimi quarti fuit ex parte tunc d. potestatis civitatis Florentie recommendatus in carceribus Stincarum Vestri Comunis per ser Pasqualem eiusdem potestatis militem socium et familiam pro una condempnatione librarum quadringentarum quinquaginta flor. parv. cum quarto pluris. Item recommendatus fuit per ipsum ser Pasqualem dicta die pro dirictura dicti d. potestatis videlicet lib. viginti quinque f. p. Et quod ipse Iacobus die vigesimo octavo mensis novembris anno millesimo quadringentesimo vigesimo quarto pacem habuit de predictis a supradicto Bernardo, ut constat per instrumentum inde confectum per ser Bartholomeum Iohannis Dini de Laterino not. publicum florentinum. Et quod pauperrimus est et non videt modum a tanta miseria liberari nisi interveniat suffragium vestre benigne dominationis: quapropter confisus tam in ipsius dominationis clementia et misericordia quam in levitate negocii et sua paupertate decrevit ad eamdem recurrere et pro elimosina infrascriptam gratiam postulare. Quare vobis dominis supradictis pro ipsius parte devotissime supplicatur et petitur quatenus vobis eisdem placeat et dignemini oportune providere – quod – ipse Iacobus in die pascatis resurrectionis domini nostri

Iesu Christi, quod celebrabitur die octavo presentis mensis aprilis anni millesimi quadringentesimi vigesimi quinti possit et debeat offerri ad ecclesiam Sancti Iohannis Baptiste civitatis Florentie – et more solito duci capite discoperto cum torchietto in manibus et horis consuetis et cum tubis precedentibus – et sic per viam oblationis – absolutionem et liberationem plenissimam et a dictis carceribus – relaxationem consequi et habere .

Super qua quidem petitione – dicti domini priores et vexillifer habita – una cum officiis gonfaloneriorum sotietatum populi et duodecim bonorum virorum dicti communis deliberatione solempni, et – premisso, facto et celebrato solempni et secreto scruptinio et obtempto partito ad fabas nigras et albas – eorum proprio motu – providerunt, ordinaverunt et deliberaverunt die secundo mensis Aprilis anno Domini millesimo quadringentesimo vigesimo quinto, indictione tertia quod dicta petitio et omnia et singula in ea contenta procedant, firmentur et fiant et firma et stabilita esse intelligantur et sint et observentur et observari et executioni mandari possint et debeant in omnibus et per omnia secundum petitionis eiusdem continentiam et tenorem.

Qua provisione lecta et recitata, ut supra dictum est, dictus dominus prepositus – proposuit inter dictos consiliarios supradictam provisionem et contenta in ea, super qua petiit sibi per omnia ut supra pro dicto Comuni et sub dicta forma bonum et utile consilium impertiri, postque illico dicto et proclamato in dicto consilio per precones comunis eiusdem, ut moris est, quod quilibet volens vadat ad consulendum super provisione et proposita supradicta et nemine eunte et ipso proposito – proponente et partitum facente inter consiliarios dicti consilii numero CCVII presentium in dicto consilio, quod cui videtur et placet dictam provisionem – admictendam esse et admicti fieri, observari et executioni mandari posse et debere – det fabam nigram pro sic et quod cui contrarium vel aliud videretur det fabam albam pro non. Et ipsis fabis datis etc. – repertum fuit CCII ex ipsis consiliariis dedisse fabas nigras pro sic: et sic secundum formam dicte provisionis obtemptum, firmatum et reformatum fuit, non obstantibus reliquis v. ex ipsis consiliariis repertis dedisse fabas albas pro non.

Milanesi identified Jacopo di Piero veneto with Jacopo Bellini, who is known to have signed two works, now lost, as Gentile's pupil. His name, however, occurs in Venetian documents as Jacopo di Niccolò, and there is no compelling explanation why he should be referred to as Jacopo di Piero (see A. Venturi, 'Gentile da Fabriano und Vittore Pisanello', *Jahrbuch der Königlich Preussischen Kunstsammlungen,* XVI, 1895, p.69). The fact that a work designed by Gentile seems to have been executed by Bellini lends weight to the identification (see Cat. XV). The passage is equally interesting for the mention of 'certa scultitia' in the courtyard of Gentile's house. The use or nature of this sculpture remains obscure.

DOC. X 22 June to September 1425:
Gentile rents a house in Siena.
A.S., Siena, Patrimonio dei Resti, No. 2344, f.159.

anno 1425
lonardo di Betto d'angnioluccio die' avere dodici livre e' quagli o autj per lui a dì xviij d'aghosto da maiestro gientile di ... da ... dipentore e so'per pigione dela chasa di lonardo la quale gli aloghai a dì 22 di giungio ora passati per ifino a tuto aghosto per prezo di dodici livre – Fiorini 0 Livre XII soldi 0 denari 0

The reference is noted by Milanesi (p.17 n.6) and published by A. Venturi (*op. cit.*, p.14). During this time Gentile worked on the lost *Madonna de' Notai* (see Cat. LVI).

DOC. XI October 1425:
Gentile is paid for a fresco of the Madonna in the cathedral at Orvieto.
Archivio dell'Opera del duomo, Orvieto: *Liber di Riform. 1421–26*, f.CLXXXXVII; *Camerale 1423–29*, respectively. The transcriptions are those of A. Venturi (*op. cit.*, p.16).

Die xvj octubris
Magnifici viri Nicolaus Nerii de Mealla, ser Franciscus Pippi, Jacobus Verii et Jacobus Jacobutii Teste conservatores pacis Urbevetano populo presidentes, et providus vir Monaldus Iohannis domini Nicole, Iacobutius Venture, Montanutius Pini [?] et Cola Cecharellii Cartarii superstites dictorum operis et fabrice convenientes in unum una cum provido Oriante Bartholomei Henrici de Urbeveteri camerario dicte fabrice, deliberaverunt et declaraverunt, quod pro factura et pittura Virginis gloriose in Ecclesia predicta per m. Gentilem de Fabriano, quod ipse m. Gentile habeat et habere debeat et teneatur tanquam bene merito decem et octo flor. auri et de auro, et quod dominus camerarius possit et debeat expensis dicte fabrice dictos decem et octo florenos a [*sic.*] dicto m. Gentili integraliter solvere expensis dicte fabrice.
[20 ottobre, 1425]
M. Gentili de Fabriano pro pictura unius Gloriose Virginis Marie per dictum laborata et secundum declarationem factam per dominos Conservatores et Superstites florenos auri et de auro currentes in toto capientes summam lib. centum sex et solidos quatuor – lib. cvj sol. iv.

A third document (*Lib. di Rif. 1421–26*, f.CCIV), relating to a debate on 9 December, was first noted by G. della Valle (*Storia del duomo d'Orvieto*, Rome, 1791, p.123), while that of 20 October was referred to by L. Luzi (*Il duomo d'Orvieto descritto ed illustrato*, Le Monnier, Florence, 1866, p.407). They were reprinted by L. Fumi (*Il duomo di Orvieto*, Rome, 1891, pp. 392–93), while the agreement of 16 October was first published by A. Rossi ('Spogli Vaticani' *Giornale di erudizione artistica*, VI, 1877, pp.149–50). For their relation to Gentile's fresco, see Cat. XVII.

DOC. XII 28 January to 2 August, 1427:

Gentile is paid for work at S. Giovanni Laterano, Rome.

A.S., Rome, *Mandati dal 1426–30*, reg. 825. Aside from ff. 25r. and 34r., which were taken from A. Corbo (*Artisti e artigiani in Roma al tempo di Martino V e di Eugenio IV*, De Luca Ed., Rome, 1969, pp.44–45), the transcriptions are those of A. Rossi (*op. cit.*, pp.150–51).

f.25r. Benedictus etc. ut supra [sent directly to Oddone Varri, treasurer], solvatis etc. magistro Gentili de Fabriano, egregio pictori, pro salario suo unius mensis incepti die vigesimooctavo mensis januarij proxime preteriti et finiti die ultimo presentis mensis februarij florenos auri de Camera vigintiquinque, quos etc.

Datum, ut supra [Rome, apud Sanctos Apostolos], die ultimo mensis februarij, indictione quinta, pontificatus etc. anno decimo.

Ita est. Benedictus de Guidalottis, locumtenens predictus.

f.29v. ... egregio pictori magistro Gentili de Fabriano pro salario suo mensis martij proxime preteriti florenos auri de camera vigintiquinque... [dated die primo mensis aprilis]

f.34f. Benedictus etc. solvatis etc. egregio pictori magistro Gentili de Fabriano pro suo salario mensis aprilis proxime preteriti florenos auri de Camera vigintiquinque, quos etc.

Datum Rome, ut supra [apud Sanctos Apostolos], die primo mensis maij, indictione quinta, pontificatus etc. anno decimo.

f.37v. ... egregio pictori magistro Gentili de Fabriano pro salario suo mensis maij proxime preteriti florenos auri de camera vigintiquinque... [dated die primo mensis junij]

f.43r. ... egregio pictori magistro Gentili de Fabriano pro salario suo mensis junij proxime preteriti florenos auri de camera vigintiquinque...
[dated die VII mensis iulij]

f.46r. ... egregio pictori magistro Gentili de Fabriano pro suo salario mensis julij proxime preteriti florenos auri de camera vigintiquinque... [dated die primo mensis augusti]

These references were first noted, before transfer to the state archives, by G. Amati ('Notizie di alcuni manoscritti nell'Archivio Segreto Vaticano', *Archivio Storico Italiano*, ser. 3, III, 1866, p.194), and then were reprinted, in part, by E. Müntz (*Les Arts à la cour des Papes*, Bibliothèque des Écoles Françaises d'Athènes et de Rome, E. Thorin, Paris, 1878, IV, p.16). Below are the actual payments to Gentile by the treasurer. Archivio Segreto Vaticano, *Introitus et exitus*, reg. 386. The transcriptions are due to A. Corbo (*op. cit.*, pp.44–46).

f. 12r. Die dicta [28 februarij], ut supra, solvi fecit magistro Gentili de Fabriano, pictori, pro suo salario unius mensis incepti die XXVIII proxime preteriti et

finiti die ultima presentis mensis, florenos auri de Camera vigintiquinque: fl. XXV de Camera.

f. 17r. Die prima dicti mensis [aprilis] prefatus dominus Oddo, thesaurarius, de mandato sibi a supra dicto domino Benedicto locumtenente facto, per eius bullectam et per manus dicti Johannis de Astallis solvi fecit magistro Gentili de Fabriano, pictori in ecclesia Lateranensi, pro eius salario mensis martij proxime preteriti, florenos auri de Camera vigintiquinque: fl. XXV de Camera.

f. 20r. Die secunda, dicti mensis [maij], prefatus dominus Oddo, thesaurarius, de mandato sibi a supradicto domino Benedicto locumtenente facto, per eius bullectam et per manus dicti Johannis de Astallis, thesaurarij, solvi fecit magistro Gentili de Fabriano, pictori in ecclesia Lateranensi, pro eius salario mensis aprilis proxime preteriti, florenos auri de Camera vigintiquinque: fl. XXV de Camera.

f. 22r. Die primo, dicti mensis [iunij], prefatus dominus Oddo, thesaurarius, de mandato sibi a supradicto domino Benedicto locumtenente facto, per eius bullectam et per manus dicti Johannis de Astallis, thesaurarij, solvi fecit magistro Gentili de Fabriano, pictori in ecclesia Lateranensi, pro eius salario mensis maii proxime preteriti, florenos auri de Camera vigintiquinque: fl. XXV . . .

f. 25v. Die VIIII, dicti mensis [iulij], prefatus dominus Oddo, thesaurarius, de mandato sibi a supradicto domino Benedicto locumtenente facto, per eius bullectam et per manus dicti Johannis de Astallis thesaurarij, solvi fecit magistro Gentili de Fabriano, pictori in ecclesia Lateranensi, pro eius salario mensis iunij, proxime preteriti, florenos auri de Camera vigintiquinque: fl. XXV . . .

f. 27v. Die secunda, dicti mensis [augusti], prefatus dominus Oddo, thesaurarius, de mandato sibi a supradicto domino Benedicto locumtenente facto, per eius bullectam et per manus dicti Johannis de Astallis, thesaurarij, solvi fecit magistro Gentili de Fabriano, pictori in ecclesia Lateranensi, pro suo salario mensis iulij, proxime preteriti, florenos auri de Camera vigintiquinque: fl. XXV . . .

Previously only f.17r. had been published by E. Müntz ('Les arts à la cour des Papes, nouvelles recherches . . .', *Mélanges d'Archéologie et d'Histoire*, IV, 1884, p.285). The Lateran fresco cycle is discussed in Cat XIX.

DOC. XIII Gentile owes money to the monastery of S. Paolo fuori le Mura, Rome.

Archive of S. Paolo fuori le Mura, Rome, seventeenth-century index compiled by Don Comerio Margarini, Vol. V, f.62. The transcription is by E. Lavagnino ('Un affresco di Gentile da Fabriano a Roma), *Arti Figurative*, I, 1940, p.48).

Gentilis de Fabriano – Debiti confessio di. Gentilis ad favore Monasteri – lib. 25

Lavagnino associated the debt with a ruined fresco still in the convent; but that work is not by Gentile (see Cat. XXXVII.). There is no indication of a date, but the reference must refer to 1426–27, when Gentile was in Rome.

DOC. XIV 14 October 1427:

Gentile is referred to as dead; the prior of S. Maria Nova acts as his executor.
Archivio Capitolino-Archivio Urbano, Rome, Rogiti originali, Vol. 785 bis, fasc. 11, f. 139, B. 'Atti del nataio Nardo di Puccio de Vinectini'. The transcription is due to Colasanti (p. 18 n. 1)

Eodem anno [1427], die XIV mensis octobris.

In presentia mei notari, etc. Heunufrius Johannis Masci de Fabriano patruus q. magistri Gentilis Nicolai Johanis Masci de Fabriano pictoris sponte nunc manualiter et presentialiter habuit et recepit a religioso viro fr. Johanne q. Bartholomei de Padua, priore venerabilis monasterii S. Marie nove de Urbe, clandestino executore alicuius quantitatis pecunie ad manus sue obvente de bonis dicti magistri Gentilis iuxta voluntatem et mandatum eiusdem magistri Gentilis, videlicet ducatos auri in auro viginti sex et ducatos grossorum pro auro vigintiquatuor, de quibus sebene quietum vocavit et renunciavit exceptioni non habite et solute et non numerate etc. et generaliter etc. asserens idem prior habuisse in commissione et mandato dicti magistri Gentilis ut disponeret et sibi Heunufrio solveret, de quibus L ducatis et ipsorum occasione dictus Heunufrius liberavit et absolvit ipsum dominum priorem etc. volens quod de predictis hanc conficerem scripturam. Actum in camera domorum habitationis mei notarii, presentibus et intervenientibus his etc. videlicet Bartholomeo Petri Johannis Macticoli della Corte, de regione Montium et Johanne Sancti Antonii Maxecti de Aquila in quarto S. Joannis ad hoc vocatis et rogatis.

Colasanti considered the sum an outstanding payment for a painting in that church by Gentile, described by Vasari (see Cat. LV). There is no evidence for such an interpretation. The fact that the prior of S. Maria Nova (S. Francesca Romana) acted as executor seems to confirm a source cited by Ricci (p. 162), which stated that Gentile was buried in that church. G. de Rossi ('Raccolta di iscrizioni romane relative ad artisti ed alle loro opere nel medio evo compilata alla fine del XVI', *Bullettino di Archeologia Christiana*, ser. v, II, 1891, pp. 88–89) published an inscription from the pavement of S. Maria Nova reading . . . T MAGISTER / . . . ABRIANO PICTOR (codex in the Biblioteca Angelica, seg. 1729). The same inscription was reproduced, in a more fragmentary form, by V. Forcella (*Iscrizioni delle chiese e d'altri edifici di Roma*, Bencini, Rome, 1873, II, p. 12, No. 36), taken from a copy of a manuscript of Cassiano dal Pozzo (codice visconteo). As noted by A. Venturi (*op. cit.*, p. 21), this certainly referred to Gentile and may, as suggested by P. Lugano ('Gentile da Fabriano e

l'ordine di Montoliveto', *Rivista Storica Benedettina,* XVI, 1925, p.312), be recon-
structed as: [HIC REQUIESCI]T or [HIC IACE]T MAGISTER / [GENTILIS DE F]ABRIANO PICTOR.
What P. d'Ancona ('Intorno alla iscrizione oggi perduta della tomba di Gentile da
Fabriano', *l'Arte,* XI, 1908, pp.51–52; also Grassi, p.49, and Micheletti, p.84) thought
to be the full epitaph seems rather to record a commemorative inscription (Colasanti,
pp.19–21), since the above-cited words are not repeated. Supposedly copied from S.
Maria in Trastevere, on the first page of a *Decretum Gratiani* (Bib. Laurenziana,
Florence, Edili, No.96), it is only one of three such verses known (see A. Venturi,
op.cit., p.20, and A. Mancini, 'Ancora sull'iscrizione sepolcrale di Gentile da Fab-
riano', *Rivista d'Arte,* XXIII, 1941, pp.258–63).

DOC. XV
Gentile is listed as a creditor in Giovanni de'Medici's tax return.
>Portata al Catasto, 1427 of Giovanni di Averardo de'Medici, Quartiere di S.
>Giovanni, Gonfalone Leon d'Oro. A.S., Florence, num. verde 51, f.1195 (see G.
>Poggi, *op. cit.,* p.19, n.3).

M. Gentile da Fabriano 103 fiorini

DOC. XVI 22 November 1428:
Gentile's niece inherits his goods.
>Archivio Comunale, Fabriano, armario XX, busta 1311. The transcription is due to
>A. Zonghi ('L'anno della morte di Gentile da Fabriano', *Nuova Rivista Misena,* I,
>1888, pp.9–10).

Acceptatio Hereditatis Magistri Gentilis per dominam Madalenam filiam ser
Egidi.
 In Dei Nomine amen. Anno dnj MILLIO QUATRIGENTESIMO
VIGESIMO OPTAVO Indictione sexta tempore domini Martini pape quinte die
lune XXII mensis novembris, Actum fabriani in domo Ser Egidii bartholomei
mactei de fabriano posita in quarterio santi blaxij juxta viam pubblicam, gabriel-
lum tomassutij, lippum bernardi et alia latera, presentibus Ser raynaldo Ser fran-
cisci Nicolutij, Nicolao Antonij Vannis, et meo Johannis alias de ribeccha de
fabriano et ser dominico Andree de Arimino testibus vocatis et rogatis. Constituta
dna. Madalena adulta major duodecim et minor viginti quinque Annorum filia
Ser egilii bartolomei de bizochis de fabriano coram Nobili et egregio legum
doctore dno bartolomeo de bonictis de fano hon. vicario et judice comunis decte
terre fabrianj pro tribunalj sedente in loco supra dicto in quadam sedia, quem
locum per infra scripta omnia et singula pro suo tribunalj et juridico elegit et
deputavit, cum presentia consensu et Auctoritate dicti ser Egidij sui patris, Sciens
hereditatem quondam MAGRI. GENTILIS NICOLAI JOHANNIS MASSIJ DE
FABRIANO quondam Avuncoli dicte domine Madalene fuisse et esse devolutam

ab intestato ad ipsam dominam Madalenam Neptam dicti magrj Gentilis prox-
imori in gradu eidem magri Gentili [sic.]. Et quod nuperrime ad notitiam ipsius
domine madalene pervenit de obbitu dicti magri Gentilis ab intestato defunti in
urbe, Credens et appinans hereditatem dictj magrj Gentilis fore et esse lucrosam et
non dampnosam, Id circho presente et Autorante dicto Ser Egidio suo patre,
ipsam hereditatem cum benefitio legis et inventarij adivit et adceptavit et dixit et
declaravit presente et consensiente et Auctorante dicto suo patre, se velle esse
heredem dicti magri. Gentilis, ut premictitur, ab intestato defunti cum benefitio
legis et inventarij omnj modo via jure et forma quibus magis melius potuit et
debuit, Rogans me notarium quod de predictis publicum conficere instrumen-
tum. Quibus omnibus et singulis supra dictis, supra dictus dominus Vicarius et
Iudex sedens ut supra suam et comunis fabriani Auctoritatem interposuit et de-
cretum et predicta insinuarj Mandavit hic per me notarium infrascriptum.

 Et ego JOHANNES SER FEDERICI notarius rogatus.

Aside from testifying that Gentile did not die penniless, this document indicates that
his daughter, baptized at Brescia (Doc. III), had apparently died before 1428 – or was
illegitimate, since no mention is made of the mother either.

DOC. XVII May 1433:
Tools or supplies left by Gentile at S. Giovanni Laterano and used by Pisanello are
sold.
 Archivio lateranense, *Liber Intr. et Ex. ab anno 1432 per totum annum 1442*. The tran-
scription is Colasanti's (p.18, n.2).

[1443 mensis maij]
Recepimus pro suppellictilibus emptis tunc per capitulum Magistro Gentili q.
postea remanserunt Magistro pisano pictori venditis demum per dictum
capitulum, presbitero henrico sacriste nostre ecclesiae lateranensis ducatos auri
decem qui sunt flor. currentes decem et octo S. trigintanovem . . . fl. xviii et . . . S
xxxix

B. Degenhart (*Pisanello*, Tip. V. Bona, Turin, 1945, p.30) first supposed this docu-
ment evidence of a collaboration between Gentile and Pisanello. Later ('Gentile da
Fabriano in Rom und die Anfänge des Antikenstudiums', *Münchner Jahrbuch der bil-
denden Kunst*, XI, 1960, p.71) he hypothesized that among the tools 'inherited' by
Pisanello were drawings by Gentile and his assistants. Even disregarding his attribu-
tions, none of which are tenable on grounds of style, the conjecture has no documen-
tary foundation. Pisanello was paid for work at S. Giovanni from 18 April 1431 to
28 February 1432. There is no reason to believe these documents incomplete. Fazio's
report supports the documentary evidence. He says: '[Pisanus] pinxit et Romae in
Iohannis Laterani templo quae Gentilis divi Iohannis Baptistae historia inchoata re-
liquerat...' (p.166). The obvious interpretation is that those tools purchased for

Gentile were retained for Pisanello and, upon completion of the frescoes, were sold for the profit of the church. The fact that Fazio, who knew Pisanello personally, never hints at any partnership between Pisanello and Gentile, let alone the relation of teacher and pupil, necessarily overrides all later conjectures to the contrary.

APPENDIX
RECONSTRUCTION OF THE ORVIETO FRESCO
(Pls. LXIV–LXIX)

Before the sixteenth-century alterations to the cathedral of Orvieto and the consequent disfiguring of Gentile's fresco (Pl. LXIV), this work presented itself in a form that fully justified Fazio's praise (Pl. LXV). Appreciation is presently hampered by the poor condition of the remaining portion as well as the figure of St. Catherine, added to balance the asymmetrical picture field which resulted from the sixteenth-century alignment with the window above. She almost completely obliterates what remains of the architectural setting. However, enough remains where paint has flaked from her dress (or was removed in the nineteenth-century restoration) and where the original incisions show through to enable a reconstruction (Pl. LXIX).

Even photographs give an overall impression: the intricate tracery of the *sotto-in-sù* throne, base, and frame; the small coffering and floral decorations that cut off one incixed angel more than the other; the moulding and feigned mosaic that extended beyond the coffering; the junction of a wall element with the frame. Examination revealed that what appeared to be an intarsiated throne was, in fact, a sort of wainscoting behind a backless throne; the incision between its upper edge and the leafed background clearly turns upward at precisely the point where St. Catherine's right arm crosses the horizontal. Measurements confirmed that the whole composition was purposely off-centre. A plumb dropped from the peak of the arch passes through the Virgin's left wrist, thereby placing most of the figural composition well to the spectator's left. The fact that the left angel is more cropped than the right one proves that figure and frame were not axially aligned. The throne base and throne are displaced about 5 cm. from the central axis. The centres for the arch of the frame are likewise displaced about 5 cm. to the left. This means, of course, that in order to make the two arcs meet at the present point, the last portion of one arc had to be determined from yet a third centre, or freely drawn in; this appears to be the case with the left arc. Following these hints, one may assume that while the missing left portion of the architectural frame will mirror the right in its features, it will not be symmetrical. Those 5 cm. have been consistently incorporated into the reconstruction so that the projection point for the wainscoting was moved 5 cm. to the left. The steps recede following the indications of the existing portions.

No trace of the floral ornament of the arches was found on the inner, vertical portion of the frame; nor any coffering. The assumption is that there were none, but only the removal of the St. Catherine will clarify this. The manner in which the wainscoting meets the frame, again, remains a bit hypothetical. Even cleaning

of the fresco will not reveal how the frame connected with its base: were there applied colonettes, as in the frescoes at S. Giovanni Laterano? Some sort of moulding continued above the mosaic. When the fresco is at last cleaned, these uncertainties will in large part be answered and the visitor to Orvieto will be able to glimpse once again the beauty of this painting, meant to be seen from below just as one enters the cathedral and glances to the left, beyond the baptismal font.

BIBLIOGRAPHY

What follows is a selected bibliography of the most important literature relating to Gentile da Fabriano and to the various issues of this study. Other references will be found in the relevant catalogue entries. A complete bibliography for Gentile, up to 1929, may be found in B. Molajoli, *Istituto d'archeologia e storia dell'arte,* III, 1929, pp. 102–07.

L. B. Alberti, *De Pictura,* ed. C. Grayson, Phaidon, London, 1972

P. d'Ancona, 'Intorno alla iscrizione oggi perduta della tomba di Gentile da Fabriano', *l'Arte,* XI, 1908, pp.51–52

F. Antal, *Florentine Painting and its Social Background,* Kegan Paul, London, 1948

F. d'Arcais, 'Le tavole con le "Storie di San Benedetto": un problema ancora aperto', *Arte Veneta,* 1976, XXX, pp.30–40

E. Arslan, 'Gentile da Fabriano', *Encyclopedia of World Art,* McGraw-Hill, New York, 1962, VI, pp.108–12

Arte lombarda dai Visconti agli Sforza, Silvana, Milan, 1958

M. Baxandall, 'Bartholomaeus Facius on Painting', *Journal of the Warburg and Courtauld Institutes,* XXVII, 1964, pp.90–97

———, 'A dialogue on art from the court of Lionello d'Este', *ibid.,* XXVI, 1963, pp.304ff.

———, *Giotto and the Orators,* Clarendon Press, Oxford, 1971

———, 'Guarino, Pisanello, and Manuel Chrysoloras', *Journal of the Warburg and Courtauld Institutes,* XXVIII, 1965, pp.183ff.

———, *Painting and Experience in Fifteenth Century Italy,* Oxford University Press, 1972

L. Behling, 'Das italienische Pflanzenbild um 1400 – zum Wesen des pflanzlichen Dekors auf dem Epiphaniasbild des Gentile da Fabriano', *Pantheon,* XXIV, 1966, pp.347–59

L. Bellosi, *Gentile da Fabriano* (I Maestri del Colore, No. 159), Fratelli Fabbri, Milan, 1966

L. Berti, *Masaccio,* Pennsylvania State University Press, University Park, 1967

C. Brandi, *Giovanni di Paolo,* Le Monnier, Florence, 1947

———, *Quattrocentisti senesi,* U. Hoepli, Milan, 1949

———, 'A Gentile da Fabriano at Athens', *Burlington,* CXX, 1978, pp. 385–86

R. Brenzoni, *Pisanello,* L. Olschki, Florence, 1952

M. Cämmerer-George, *Die Rahmung der toskanischen Altarbilder im Trecento,* P. H. Heitz, Strasbourg, 1966 (esp. pp.184ff.)

K. Cassirer, 'Zu Borrominis Umbau der Lateransbasilika', *Jahrbuch der preussischen Kunstsammlungen,* XLII, 1921, pp.62ff.

L. Castelfranchi-Vegas, *International Gothic Art in Italy,* Leipzig, 1966

———, 'Il libro d'ore Bodmer di Michelino da Besozzo . . .', *Études d'art français offertes à C. Sterling,* Presses Universitaires de France, Paris, 1975, pp.91–103

K. Christiansen, 'The Coronation of the Virgin by Gentile da Fabriano', *The J. Paul Getty Museum Journal,* 6–7 1978–79, pp.1–12

A. Christie, 'The Development of Ornament from Arabic Script', *Burlington,* XL, 1922, pp.287–92; *ibid.,* XLI, pp.34–41

K. Clark, 'Architectural Backgrounds in Fifteenth Century Italian Painting', *The Arts,* I, 1946, pp.13ff.; *ibid.,* II, 1947, pp.33ff.

———, *Landscape into Art,* John Murray, London, 1949; Harper & Row, New York, 1976 (esp. the first chapters)

A. Colasanti, *Gentile da Fabriano,* Istituto Italiano d'Arti Grafiche, Bergamo, 1909

———, *La pittura del quattrocento nelle marche,* Pantheon, Milan, 1932

———, 'Un quadro inedito di Gentile da Fabriano', *Bollettino d'Arte,* I, 1907, pp.19–22

L. Coletti, 'Il Maestro degli Innocenti', *Arte Veneta*, II, 1948, pp.30–40

―――, 'Pittura veneta dal tre al quattrocentto, pt. II', *ibid.*, I, 1947, pp.251–62

―――, *Pittura veneta del quattrocento*, Istituto geografico de Agostini, Novara, 1953

H. Cornell, *The Icon of the Nativity of Christ*, Uppsala, 1924

D. Covi, 'Lettering in Fifteenth Century Florentine Painting', *Art Bulletin*, XLV, 1963, pp.1–18

J. Crowe and G. Cavalcaselle, *A New History of Painting in Italy*, John Murray, London, 1866

B. Davidson, 'Gentile da Fabriano's Madonna and Child with Saints', *Art News*, LXVIII, 1969, No. 1, pp.24–27 and 57–60

―――, 'Tradition and Innovation: Gentile da Fabriano and Hans Memling', *Apollo*, XCIII, 1971, pp.378ff.

D. Davisson, 'The Iconology of the S. Trinita Sacristy, 1418–35: a study of the private and public functions of religious art in the early Quattrocento', *Art Bulletin*, LVII, 1975, pp.315–35

―――, 'New documents on Gentile da Fabriano's residence in Florence, 1420–22', *Burlington*, CXXII, 1980, pp.759–63.

B. Degenhart, *Pisanello*, Tip. V. Bona, Turin, 1945

―――, *Disegni del Pisanello e di maestri del suo tempo*, Neri Pozzo Ed., Vicenza, 1966

B. Degenhart and A. Schmitt, *Corpus der Italienischen Zeichnungen, 1300–1450*, Berlin, 1968

―――, 'Gentile da Fabriano in Rom und die Anfänge des Antikenstudiums', *Münchner Jahrbuch der bildenden Kunst*, XI, 1960, pp.59ff.

Europäische Kunst um 1400 (catalogue), Kunsthistorisches Museum, Vienna, 1962

H. G. Fell, 'Gentile da Fabriano', *Connoisseur*, XCVI, 1935, pp.306–11

G. Fiocco, 'Niccolò di Pietro, Pisanello e Vencislao', *Bollettino d'Arte*, XXXVII, 1952, pp.13–20

M. Fossi-Todorow, *I disegni dei maestri, l'Italia dalle origini a Pisanello*, Fratelli Fabbri Editore, Milan, 1970

―――, 'Un taccuino di viaggio del Pisanello e della sua bottega', *Scritti in onore di Mario Salmi*, De Luca Ed., Rome, 1962, II, pp.133 ff.

―――, *I disegni del Pisanello e della sua cerchia*, L. Olschki, Florence, 1966

P. Francastel, *La Figure et le lieu*, Gallimard, Paris, 1967 (esp. pp.108ff.)

R. Freemantle, 'Some new Masolino Documents', *Burlington*, CXVII, 1975, pp.658–59

A. Gherardini, 'Lorenzo e Jacopo Salimbeni da Sanseverino', *l'Arte*, LVII, 1958, pp.3–11 and 121–62

C. Gilbert, 'The Archbishop on the Painters of Florence, 1450', *Art Bulletin*, XLI, 1959, pp.75–87

―――, 'Peintre et menuisier au début de la Renaissance en Italie', *Revue de l'Art*, XXXVII, 1977, pp.9–28

V. Golzio, *L'Arte in Roma nel secolo XV*, Licinio Cappelli Ed., Bologna, 1968, pt. II, pp.201–05

E. Gombrich, 'Light, Form and Texture in Fifteenth Century Painting', *Journal of the Royal Society of Arts*, CXII, 1963–64, pp.826–49 (reprinted in *The Heritage of Apelles*, Phaidon, Oxford, 1976)

L. Grassi, 'Considerazioni intorno al politico Quaratesi', *Paragone*, II, No. 15, 1951, pp.23–30

―――, *Tutta la pittura di Gentile da Fabriano*, Rizzoli, Milan, 1953

R. Hatfield, 'The Compagnia de' Magi', *Journal of the Warburg and Courtauld Institutes*, XXXIII, 1970, pp.107ff.

G. Hill, *Pisanello*, Duckworth & Co., London, 1905

H. Horne, 'The Quaratesi Altarpiece by Gentile da Fabriano', *Burlington*, VI, 1904–06, pp.470–74

C. Huter, 'Early Works by Jacopo Bellini', *Arte Veneta*, XXVIII, 1974, pp.18–20

―――, 'Gentile da Fabriano and the Madonna of Humility', *ibid.*, XXIV, 1970, pp.26ff.

―――, 'Jacobello del Fiore, Giambono and the St. Benedict Panels', *ibid.*, XXXII, 1978, pp.31–38.

―――, 'The Novella Master: A Paduan Illuminator around 1400', *ibid.*, XXV, 1971, pp.9–27

―――, 'Panel Paintings by Illuminators: remarks on a crisis of Venetian style', *ibid.*, XXVIII, 1974, pp.9–16

―――, *The Veneto and the Art of Gentile da Fabriano*, Thesis for the University of London (unpublished), 1966

H. Janson, 'The Pazzi Evangelists', *Festschrift Hans Swarzenski*, G. Mann Verlag, Berlin, 1973, pp.439ff.

P. J. Jones, *The Malatesta of Rimini and the Papal State,* Cambridge University Press, Cambridge, 1974

C. Joost-Gaugier, 'Considerations Regarding Jacopo Bellini's Place in the Venetian Renaissance', *Arte Veneta,* XXVIII, 1974, pp.21–38

R. Krautheimer, *Lorenzo Ghiberti,* Princeton University Press, 1956 and 1970

P. Kristeller, 'The Humanist Bartolomeo Facio and his Unknown Correspondence', *From the Renaissance to the Counter-Reformation: Essays in Honor of G. Mattingly,* ed. by C. Carter, Random House, New York, 1965; Cape, London, 1966, pp.56–74

H. Lavoix, 'De l'ornamentation arabe dans les oeuvres des maîtres italiens', *Gazette des Beaux-Arts,* XVI, 1877, pp.15–29

R. Longhi, 'Arcangelo di Cola', *Paragone,* I, No. 3, 1950, pp.49–50

———, 'Fatti di Masolino e di Masaccio', *Critica d'Arte,* V, 1940, pp.145ff.

———, 'Me pinxit: un S. Michele Arcangelo di Gentile da Fabriano', *Pinacotheca,* I, 1928, pp.71ff.

———, 'Recupero di un Masaccio', *Paragone,* I, No. 5, 1950, pp.3–5

———, 'Tracciato Orvietano', *ibid.,* XIII, No. 149, 1962, pp.3–14

———, *Viatico per cinque secoli di pittura veneziana,* Sansoni ed., Florence, 1946

P. Lugano, 'Gentile da Fabriano e l'ordine di Montoliveto', *Rivista Storica Benedettina,* XVI, 1925, pp.305–21

L. Magagnato, *Da Altichiero a Pisanello,* Neri Pozza Ed., Venice, 1958

H. Maginis, 'Cast Shadows in the Passion Cycle at S. Francesco, Assisi: a note', *Gazette des Beaux-Arts,* LXXVII, 1971, pp.63–64

A. de la Mare, *The Handwriting of Italian Humanists,* Oxford University Press, 1973

L. Martines, *The Social World of the Florentine Humanists 1390–1460,* Routledge & Kegan Paul, London, 1963

A. L. Mayer, 'Zum Problem Gentile da Fabriano', *Pantheon,* XI, 1933, pp.41–46

M. Meiss, *French Painting in the Time of Jean de Berry, the Boucicaut Master,* Phaidon, London, 1968

———, *French Painting . . . , the Limbourgs and their Contemporaries,* Thames & Hudson, London, 1972

———, *French Painting . . . , the late Fourteenth Century and the Patronage of the Duke,* Phaidon, London, 1967

———, 'Light as Form and Symbol in some Fifteenth Century Paintings' *Art Bulletin,* XXVII, 1945, pp.175–81 (reprinted in *The Painter's Choice* by M. Meiss, Harper & Row, New York, 1976)

———, 'Masaccio and the Early Renaissance: the circular plan', *Acts of the 20th International Congress of the History of Art,* Princeton, 1963, pp.123ff. (reprinted in *The Painter's Choice, op. cit.*)

———, Review of Antal, *Florentine Painting . . . , Art Bulletin,* XXXI, 1949, pp.143–50

———, 'Some Remarkable Early Shadows in a Rare Type of Threnos', *Festschrift U. Middeldorf,* W. de Gruyter & Co., Berlin, 1968, pp.112–17

———, 'Toward a More Comprehensive Renaissance Palaeography', *Art Bulletin,* XLII, 1960, pp.97–112 (reprinted in *The Painter's Choice, op. cit.*)

E. Micheletti, *l'Opera completa di Gentile da Fabriano,* Rizzoli, Milan, 1976

———, 'Qualche induzione sugli affreschi di Gentile da Fabriano a Venezia', *Rivista d'Arte,* XXVIII, iii, 1953, pp.115–20

B. Molajoli, *Gentile da Fabriano,* Edizione dello stabilmento Tip. 'Gentile', Fabriano, 1927

I. Moretti, *La chiesa di S. Niccolò Oltrarno,* Istituto Professionale Lionardo da Vinci, Florence (undated)

E. Müntz, *Les Arts à la cour des Papes,* E. Thorin, Paris, 1878

———, 'Les Arts à la cour des Papes', *Mélanges d'Archéologie et d'Histoire,* IV, 1884, pp.276ff.

R. Offner, 'Light on Masaccio's Classicism', *Studies in the History of Art presented to W. E. Suida,* Phaidon, London, 1959

W. Paatz, *Die Kirchen von Florenz,* Vittorio Klostermann, Frankfurt, 1952

O. Pächt, "Early Italian Nature Studies", *Journal of the Warburg and Courtauld Institutes,* XIII, 1950, pp.13–47

G. Paccagnini, *Pisanello e il ciclo cavalleresco di Mantova,* Electa Editrice, Venice, 1973

R. Pallucchini, *La pittura veneta del Quattrocento,* Casa Editrice Prof. R. Patron, Bologna, 1956

P. Partner, *The Papal State under Martin V,* British School at Rome, London, 1958

L. F. A. von Pastor, *History of the Popes,* Butler & Tanner, London, 1923, Vol. I

Platina, *Historici liber de vita Christi ac omnium*

pontificium, in L. A. Muratori, *Rerum Italicarum Scriptores*, Città di Castello, III, i

G. Poggi, *La cappella e la tomba di Onofrio Strozzi nella chiesa di S. Trinita (1419–23)*, Tip. Barbera, Florence, 1903

J. Pope-Hennessy, *Fra Angelico*, Phaidon, London, 1952 and 1974

———, *Giovanni di Paolo*, Chatto & Windus, London, 1937

———, *Sassetta*, Chatto & Windus, London, 1939

———, 'The development of Realistic Painting in Siena', *Burlington*, LXXXIV, 1944, pp.110ff. and 139ff.

———, 'The Interaction of Painting and Sculpture in Florence in the Fifteenth Century', *The Royal Society for the Encouragement of Arts, Manufactures and Commerce*, CXVII, 1969, pp.406–24

U. Procacci, 'Sulla cronologia delle opere di Masaccio e di Masolino tra il 1425 e il 1428', *Rivista d'Arte*, XXVIII, 1953, pp.3–55

C. Ragghianti, 'Incontri fatidici', *Critica d'Arte*, XLI, No. 145, 1976, pp.70–72

———, 'Postillina gentilesca', *ibid.*, I, 1954, p.583

M. Reymond, 'L'arc mixtiligne florentin', *Rivista d'Arte*, II, 1904, pp.245ff.

———, 'Les débuts de l'architecture de la Renaissance (1418–1440)', *Gazette des Beaux-Arts*, 1900, pp.89ff. and 425ff.

———, 'La porte de la Chapelle Strozzi', *Miscellanea d'Arte*, I, 1903, pp.4–11

———, 'La tomba di Onofrio Strozzi, *l'Arte*, VI, 1903, pp.7–14

A. Ricci, *Memorie storiche delle arti e degli artisti della Marca di Ancona*, Macerata, 1834, I, pp.145ff.

A. Rossi, *I Salimbeni*, Electa Editrice, Milan, 1976

F. Rossi, 'Ipotesi per Gentile da Fabriano a Brescia', *Notizie da Palazzo Albani*, II, i, 1973, pp.11–22

G. Sacconi, *Pittura marchigiana: la scuola camerinese*, La Editoriale Libraria, Trieste, 1968

R. Sassi, 'Altri appunti su la famiglia di Gentile da Fabriano', *Rassegna Marchigiana*, VI, 1928, pp.259–67

———, 'Arte e storia fra le rovine d'un antico tempio francescano', *ibid..* V, 1927, pp.331–51

———, 'La famiglia di Gentile da Fabriano', *ibid.*, II, 1923, pp.21–28

———, 'Gentile da Fabriano', *ibid.*, III, 1925, pp.247–51

———, 'Gentile nella vita fabrianese del suo tempo', *Gentile da Fabriano, Bollettino mensile per la celebrazione centenaria*, VI, 1928, pp.7–13 and 33–38

L. Serra, 'Le origini artistiche di Gentile da Fabriano', *Rassegna Marchigiana*, XI, 1933, pp.59ff.

G. Souliers, 'Les caractères coufiques dans la peinture toscane', *Gazette des Beaux-Arts*, V–IX, 1924, pp.347–58

J. Spencer, 'Ut rhetorica pictura: A Study in Quattrocento Theory of Painting', *Journal of the Warburg and Courtauld Institutes*, XX, 1957, pp.26–44

C. Sterling, 'Fighting Animals in the Adoration of the Magi', *Bulletin of the Cleveland Museum of Art*, LXI, x, 1974, pp.350–59

———, 'Un tableau inédit de Gentile da Fabriano', *Paragone*, IX, No. 101, 1958, pp.26ff.

Storia di Milano, Fondazione Treccani degli Alfieri, Milan, 1955, Vol. I

L. Testi, *Storia della pittura veneziana*, Istituto Italiano d'Arti Grafiche, Bergamo, 1909

E. Teza, 'Per una firma di Gentile', *Augusta Perusia*, II, 1907, p.145

D. Thomas, 'What is the origin of the Scrittura Umanistica?', *La Bibliofilia*, LIII, 1951, pp.1–10

P. Toesca, *La pittura e la miniatura nella Lombardia*, G. Einaudi, 1912 and 1966

R. van Marle, *The Development of the Italian Schools of Painting*, Martinus Nijhoff, The Hague, 1927, Vol. VIII

A. Venturi, *Gentile da Fabriano e il Pisanello*, Florence, 1896

———, 'Di Arcangelo di Cola da Camerino', *l'Arte*, XIII, 1910, pp.377–81

L. Venturi, 'Un quadro di Gentile da Fabriano a Velletri', *Bollettino d'Arte*, VII, 1913, pp.73–75

C. Volpe, 'Due frammenti di Gentile da Fabriano', *Paragone*, IX, No. 101, 1958, pp.53–55

G. Weise, 'Gli archi mistilinei di provenienza islamica nell'architettura gotica italiana e spagnola', *Rivista d'Arte*, XXIII, 1941, pp.1–18

J. White, *The Birth and Rebirth of Pictorial Space*, 2nd ed., Harper & Row, New York, 1967

P. Zampetti, *La pittura marchigiana del '400*, Electa Editrice, 1969

F. Zeri, 'Una precisazione su Bicci di Lorenzo', *Paragone*, IX, No. 105, 1958, pp.67–71

———, 'Ricerche sul Sassetta', *Quaderni di*

Emblema 2, Emblema Editrice, Bergamo, 1973, pp.22ff.

————, 'Towards a reconstruction of Sassetta's Arte della Lana Triptych (1423–26)', *Burlington,* XCVIII, 1956, pp.36ff.

A. Zonghi, 'Gentile a Fabriano nel 1420', *Le Marche,* VII, 1908, pp.137–38

LIST OF
ILLUSTRATIONS

All the illustrations are of works by or attributed to Gentile da Fabriano, unless otherwise stated.

The author and publishers would like to thank the museums, galleries, private collectors, publishers, photographers and photographic agencies who provided photographic material and kindly permitted its reproduction. Specific acknowledgement is made to photographers and photographic agencies, otherwise photographic material was provided by the owners of the original works.

COLOUR PLATES

MONOCHROME PLATES
Between pages 148 and 149

Uffizi, Florence (Photo Gab. Fotografico, Florence)

52 *St. John the Baptist and (in roundel) St. Dominic* (Cat. XIV)
Uffizi, Florence (Photo Gab. Fotografico, Florence)

53 *St. George and (in roundel) Virgin Annunciate* (Cat. XIV)
Uffizi, Florence (Photo Gab. Fotografico, Florence)

54 *Nativity* (detail of Pl. 51) (Cat. XIV)
(Photo Gab. Fotografico, Florence)

55 *St. Nicholas saves a ship in distress* (Cat. XIV)
Pinacoteca, Vatican

56 *Birth of St. Nicholas* (Cat. XIV)
Pinacoteca, Vatican

57 *St. Nicholas provides the dowry for three poor maidens* (Cat. XIV)
Pinacoteca. Vatican

58 *St. Nicholas resuscitates three youths at an inn* (Cat. XIV)
Pinacoteca, Vatican

59 *Pilgrims at the tomb of St. Nicholas* (Cat. XIV)
National Gallery, Washington DC

60 *St. Louis of Toulouse, the Resurrection of Lazarus, the Virgin and Christ interceding, Meeting of SS. Cosmas and Damian with Julian, St. Bernard of Clairvaux* (Cat. XV)
S. Niccolò Sopr' Arno, on deposit at Pitti Palace, Florence (Photo Gab. Fotografico, Florence)

61 *St. Louis of Toulouse and the Resurrection of Lazarus* (detail of Pl. 60)
(Photo Gab. Fotografico, Florence)

62 *Meeting of SS. Cosmas and Damian with Julian and St. Bernard of Clairvaux* (detail of Pl. 60)
(Photo Gab. Fotografico, Florence)

63 *Stoning of St. Stephen* (Cat. XVI)
Kunsthistorisches Museum, Vienna

64 *Madonna and Child* (Cat. XVII)
Cathedral, Orvieto

65 *Madonna and Child* (before removal of sixteenth-century frame) (Cat. XVII)
Cathedral, Orvieto

66 *Madonna and Child* (detail of Pl. 64)
(Photo Raffaelli Amoni)

67 *Dais* (detail of Pl. 64)

68 *Coffering* (detail of Pl. 64)

69 *Reconstruction of Orvieto Madonna and Child* (See Appendix)

70 *Madonna and Child* (Cat. XVIII)
Museo Capitolare, Velletri (Photo Instituto

Centrale per i Catalogo e la Documentazione —Francesco Miani)

71 Detail of Pl. 70

72 *Head of David* (Cat. XIX)
Museo Cristiano, Vatican

73 Follower of Borromini *Drawing of fresco cycle at S. Giovanni Laterano prior to 1647*
Kunstbibliothek, Berlin

74 Follower of Borromini *Jeremiah, Jonah, unidentified prophet, and symbols of the Evangelists* (detail of Pl. 73)

75 Zanino di Pietro *Madonna and Child with Angels* (Cat. XX)
National Gallery, Athens

76 Jacopo Bellini *Madonna and Child* (Cat. XXI)
Accademia Carrara, Bergamo

77 Pelegrino di Antonio *St. Michael* (Cat. XXII)
Museum of Fine Arts, Boston

78 Follower of Gentile *Madonna of Humility with a donor* (Cat. XXIII)
Isabella Stewart Gardner Museum, Boston

79 The Staffolo Master *St. Mary Magdalene* (Cat. XXIV)
Cathedral, Fabriano

80 The Staffolo Master *St. Venanzio* (?) (Cat. XXIV)
Cathedral, Fabriano

81 Venetian, fourteenth century *St. Francis* (Cat. XXV)
Harvard University, Villa I Tatti, Florence

82 Ventura di Moro (?) *Decoration of lilies* (Cat. XXVII)
S. Trinita, Florence (Photo Gab. Fotografico, Florence)

83 Francesco di Antonio *St. Ansanus* (Cat. XXVI)
S. Niccolo sopr' Arno, Florence (Photo Gab. Fotografico, Florence)

84 Giambono or Niccolò di Pietro (?) *St. Benedict repairs a broken sieve* (Cat. XXVIII)
Uffizi, Florence (Photo Gab. Fotografico, Florence)

85 Giambono or Niccolò di Pietro (?) *St. Benedict tortured by a blackbird and about to cast himself on thorns* (Cat. XXVIII)
Poldi-Pezzoli, Milan

86 Giambono or Niccolò di Pietro (?) *The monks attempt to poison St. Benedict* (Cat. XXVIII)
Uffizi, Florence (Photo Gab. Fotografico, Florence)

87 Giambono or Niccolò di Pietro (?) *St. Benedict exorcises a monk* (Cat. XXVIII)

TEXT FIGURES

187

188

INDEX